HOLLYWOOD BLACK

TURNER **CLASSIC** MOVIES

HOLLYWOOD BLACK

THE STARS, THE FILMS, THE FILMMAKERS

DONALD BOGLE

FOREWORD BY JOHN SINGLETON

RUNNING PRESS
PHILADELPHIA

Running Press
Hachette Book Group
1290 Avenue of the Americas
New York, NY 10104
www.runningpress.com
@Running_Press

Printed in China

First Edition: May 2019

Published by Running Press, an imprint of Perseus Books, LLC, a subsidiary of Hachette Book Group, Inc.
The Running Press name and logo is a trademark of the Hachette Book Group.

The Hachette Speakers Bureau provides a wide range of authors for speaking events.
To find out more, go to www.hachettespeakersbureau.com or call (866) 376-6591.

The publisher is not responsible for websites (or their content) that are not owned by the publisher.

Image credits: pages xii (also cover), xvi, xvii, 2, 7, 11, 13, 15, 17, 18, 19, 26, 30–33, 35, 37, 39–43, 45, 49, 50, 52–57, 59,
69, 71, 72, 73, 75 (also cover) , 77 (also cover), 82, 87, 88, 95, 96, 100, 106–108, 111, 113, 116, 117, 120, 121, 124, 126–129,
132, 134, 135, 138, 142, 144, 145, 146 (also cover), 148, 149, 151, 152, 155–157, 164, 167–169, 173, 175–179, 182 (also
cover), 183, 185, 188 (also cover), 192, 193, 195 (also cover), 199 (also cover), 201–203, 205–210, 212, 215, 215, 218,
224–226, 228–231, 235, 237, 238, 241, 242, 244 (also cover), 245, 246, 248: Courtesy Photofest; pages 3, 12, 21, 36,
44, 79, 85, 117 (bottom): Author's Collection; all other photography courtesy Turner Classic Movies, Inc.

The "Oscar" statuette © Academy of Motion Picture Arts and Sciences® "OSCAR®," "OSCARS®,"
"ACADEMY AWARD®," "ACADEMY AWARDS®," and the "Oscar" design mark are trademarks
and service marks of the Academy of Motion Picture Arts and Sciences

Print book cover and interior design by Joshua McDonnell.

Library of Congress Control Number: 2018959810

ISBNs: 978-0-7624-9141-4 (hardcover), 978-0-7624-9140-7 (ebook)

RRD-S

10 9 8 7 6 5 4 3 2 1

For my parents, Roslyn and John.

And for three terrific Bogles:
Roger, Jerry, and Jay.

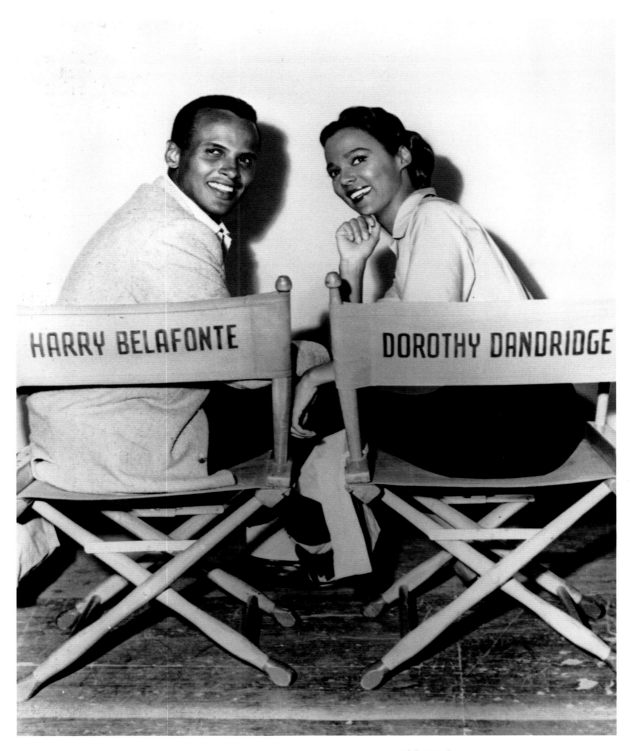

Harry Belafonte and Dorothy Dandridge on the set of *Bright Road*.

Contents

FOREWORD

BY JOHN SINGLETON

I grew up living behind a Los Angeles landmark, the Century Drive-In theater. At night, I'd watch the images on two giant screens. Without hearing any sound, I could see horror movies, action films, and my favorites, Blaxploitation movies right outside my bedroom window. Images of Ron O'Neal running in platform shoes and Pam Grier kicking ass and looking sexy occupied my young mind. I think that marked the beginning of my lifelong movie odyssey to see as many films as I could and to figure out the way that directors, writers, and actors told stories on screen. Because I was most affected by the black movies, I asked myself how those black people got on screen? Who put them there? Even then, my struggle was to make the fantasy of filmmaking become my reality.

Later, when I was a film student at the University of Southern California, I would glean everything I could about the history of blacks in cinema. As I began to watch the older pre-World War II movies and then the post-war black films that ran into the '60s and '70s, I noticed a significant change in the way African Americans were depicted. I could sense that in the early films, black actors were told by white filmmakers to smile broadly or to pop their eyes wider in this shot or that one. Those films were created for mainstream audiences; hence the various stereotyped racial tropes. The grinning, bug-eyed cartoonish images were there to make white folks feel comfortable. A lot of pure talent was twisted and distorted. But I also noticed other films in which black performers gave more nuanced, often moving performers, such as Louise Beavers and Fredi Washington as the black mother and her light-skinned daughter who are torn apart because of race in the original version of *Imitation of Life*. I also was impressed by the great Paul Robeson in the 1933 *Emperor Jones*. Here was a proud, defiant, strong, even arrogant black man determined to call the shots in his life, to be a master of his own destiny. Later, with the dramatic ascent of Sidney Poitier as a powerful actor in 1950s films like *No Way Out* and *Blackboard Jungle*, black Hollywood began to evolve. Watching the smoldering and sexually charged heat and passion of Dorothy Dandridge and Harry Belafonte in *Carmen Jones*, I know now that Dandridge's strong screen presence was a revolutionary precursor to Halle Berry's Oscar winning performance in *Monster's Ball*.

At USC, my knowledge of movies that had come before, good and bad, was something that fortified me for my future as a filmmaker. I also had the benefit of entering college after having just seen *She's Gotta Have It*. I was knocked out by it. And when I met its director, Spike Lee, I had the feeling I could be a part of a revolution, a new wave of African American filmmaking.

Reading *Hollywood Black*, I'm carried back to my sense of discovery of black movie history, and

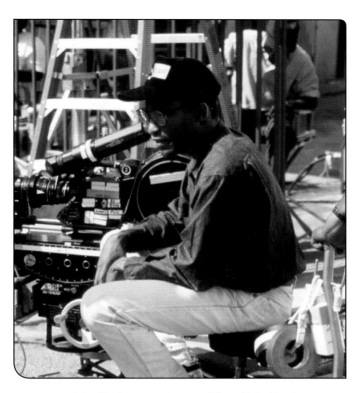

John Singleton on the set of *Boyz N the Hood*.

looking through the pictures in this book, I am reminded of my emotions as I watched the films for the first time. Those emotions and images are indelible: Richard Roundtree in *Shaft* walking through Harlem head high, owning the street with his stroll; Cicely Tyson and Paul Winfield running to each other in *Sounder*; Richard Pryor in all his comic genius in *Which Way Is Up*; or Eddie Murphy with his cool swagger in *Beverly Hills Cop*. I recall the emotional surge I felt when seeing *Do the Right Thing*, a seminal film that pushed me as a film student to write the screenplay for *Boyz N the Hood*. I also remember the well in my heart at seeing the movie version of my childhood comic book hero, *Black Panther*.

This book brings all that back to me, and I've been all the more enlightened by the great historical links between black filmmakers like Oscar Micheaux and Noble Johnson in the silent era to those bold dudes of the late 1960s and 1970s, such as Gordon Parks, Sr., and Melvin Van Peebles right up to filmmakers like myself and into the new millennium. It also shows the links between actors as diverse as Paul Robeson, Sidney Poitier, Denzel Washington, Will Smith, Viola Davis, Angela Bassett, and so many others. I found this book to be an enjoyable, insightful reflection of how, despite tremendous obstacles, black film artists triumphed in showing their humanity and their brilliance to the world.

Donald Bogle's *Hollywood Black: The Stars, the Films, the Filmmakers* encapsulates the historical essence of the black movie-going experience in this country, and I'm proud to be a part of it. This is an invaluable book that moviegoers have been waiting for and will treasure.

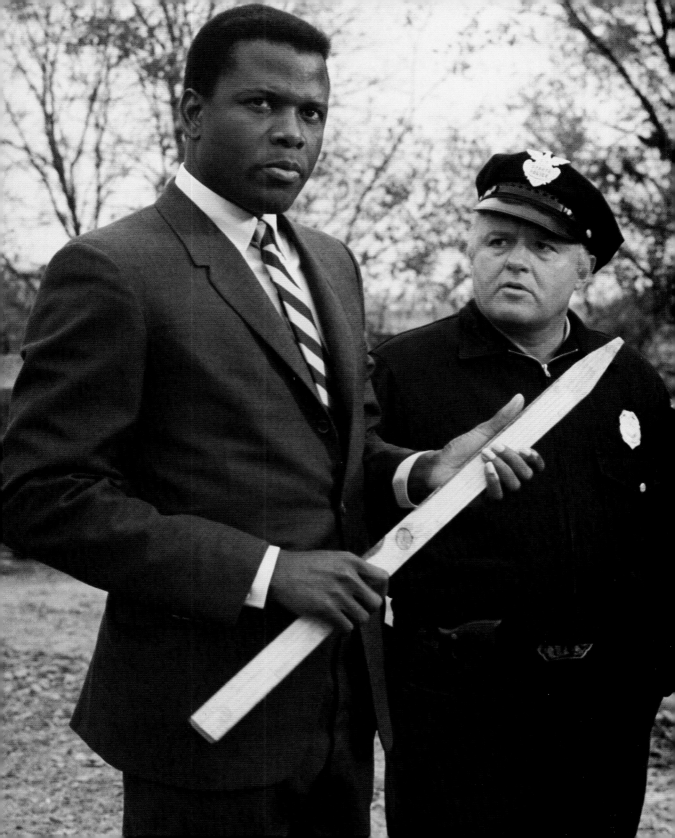

INTRODUCTION

For blacks in American movies, it's been a long, sometimes turbulent, and often rocky journey throughout the twentieth century, into the twenty-first. Foremost, it is a journey that, surprisingly, is often unknown and rarely explored. Some moviegoers mistakenly assume that African Americans first worked in films sometime in the 1950s, with the emergence of such Eisenhower-age stars as Sidney Poitier and the often-neglected Dorothy Dandridge. Others also mistakenly believe that black filmmakers did not arrive on the scene until Spike Lee in the mid-1980s or—for those with deeper knowledge—in the 1970s, with such bold and daring directors as Melvin Van Peebles and Gordon Parks Sr. and such well-known movies as *Shaft* or *Super Fly*. But, of course, these stars and filmmakers are only part of the story.

The history of blacks in American films is long, rich, and extraordinarily extensive, with remarkable achievements stretching back to the era of silent films (before Hollywood was even Hollywood as we now think of it), and progressing with the advent of sound into the late 1920s, through the Depression and the World War II years, right up to the present. There is a whole body of work that has been ignored or glossed over.

Hollywood Black seeks to set the historical record straight. It charts that long journey,

Sidney Poitier and Rod Steiger in *In the Heat of the Night*.

examining cinema that is often disturbing but also often compelling and engrossing. This book spotlights the way that films and film stars reflect the social and political attitudes and perspectives of the eras in which they first appeared—and the way those films and film stars looked both in the past and to later generations. Often we may find it hard to fathom how past moviegoers could have accepted Hollywood's stereotyped view of black America. But while some films and personalities are stuck in the past, others gloriously transcended it. *Hollywood Black* presents a gallery of important talents, both in front of the camera and behind it—actors, actresses, writers, directors, producers—who struggled against the odds to make unique statements on-screen. More than we might imagine, some fought to overturn stereotypes and to speak to audiences—especially African American moviegoers—in personal and often striking terms: such disparate figures as Paul Robeson, Eddie "Rochester" Anderson, Hattie McDaniel, Ethel Waters, Puerto Rico–born Juano Hernandez, Ruby Dee, Rex Ingram, Cicely Tyson, Louis Gossett Jr., Denzel Washington, Angela Bassett, Harry Belafonte, Viola Davis, Spike Lee, John Singleton, Julie Dash, Jordan Peele, and Ryan Coogler.

Having written previously about African American movie history in a series of books, notably *Toms, Coons, Mulattoes, Mammies, and Bucks: An Interpretive History of Blacks in American Films*

Daniel Haynes with Victoria Spivey as the "good girl" in *Hallelujah*.

as well as in *Dorothy Dandridge: A Biography* and *Bright Boulevards, Bold Dreams: The Story of Black Hollywood*, I've found that writing *Hollywood Black* has been a unique adventure. The history, while still comprehensive, is told more concisely here. In a manner different from my previous books, I also let an array of photographs illustrate the tale. Some of the photographs here have rarely been published. These seldom-seen photographs serve to bring a movie and an era to startling life. For those who have seen the films, the photographs no doubt will summon up long-forgotten movie-going experiences. In other cases, the photographs may introduce the reader to films or performers they haven't seen and will very much want to. Seeing such photographs of Nina McKinney, Rex Ingram, Daniel Haynes, Stepin Fetchit, Fredi Washington, Theresa Harris, Eartha Kitt, Cicely Tyson, Lena Horne, Lupita Nyong'o, Will Smith, Whoopi Goldberg, or Eddie Murphy can be an involving, and sometimes enlightening experience. The photographs speak in a voice of their own.

Hollywood Black presents an up-close view of some of the most important cinematic works of the past one hundred–plus years as well as some of the more neglected. Sometimes popular—though not critically acclaimed—movies comment on issues, concepts, and dilemmas in an immediate way, minus fanfare or pretentions. Popular films can strike a nerve that jolts us. A drama like the original 1934 version of *Imitation of Life*—with its tear-jerker subplot about a submissive black mother rejected by her assertive, light-skinned daughter who sets out to fulfill herself by passing for white—took America by surprise and *suggested*, without fully examining, a long-festering race problem that most Depression-era movies chose to ignore. In the end, *Imitation of Life* affected the African American community in a gut-wrenching manner, unlike most other Hollywood film fare of the day.

A movie like the 1943 *Stormy Weather*, with its array of major black performers, such as Lena Horne, Bill "Bojangles" Robinson, Fats Waller, Katherine Dunham, Cab Calloway, and the

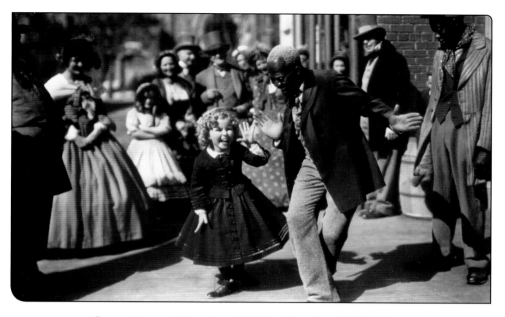

Depression-era "dream team": Shirley Temple and Bill Robinson.

astounding Nicholas Brothers, appeared to be rewriting American entertainment history, revealing dazzling talents whose sheer brilliance often went unacknowledged. The same is true of the other black film released in 1943, *Cabin in the Sky*, with its all-star cast of Ethel Waters, Eddie "Rochester" Anderson, Duke Ellington, Lena Horne, Louis Armstrong, Rex Ingram, Mantan Moreland, Butterfly McQueen, that smooth-gliding dancer John "Bubbles" Sublett, and the stride piano player Ford L. "Buck" Washington. These movies remain vibrant cultural documents.

Other films sent out covert messages. *Carmen Jones*, starring that underappreciated screen goddess Dorothy Dandridge, was not only a deliciously heady melodrama about a "strumpet" who destroys her lover but rather a bold statement, told through Dandridge's mesmerizing performance, of a woman seeking the right to make choices as men do, to liberate herself from the chains of a woman's role in a male-dominated society. Such films as *Home of the Brave*, *Lost Boundaries*, *Pinky*, and *Intruder*

in the Dust, all released in 1949, were Hollywood's attempts to pick up on the race theme that had been so important to independent director Oscar Micheaux. And later, the Oscar-winning Best Picture hit *In the Heat of the Night* still stunned audiences, especially African American moviegoers, when Sidney Poitier, after having been called a boy and addressed with the n-word, announced, "They call me *Mister* Tibbs." When slapped by a white bigot, he also slapped the man back! Such films still resonate in our imagination and rightly deserve to be a part of our collective moviegoing experience.

In *Hollywood Black*, I have also aimed to show an equally significant aspect of movie history: from one decade to another, black artists have often taken Hollywood forms, genres, shapes, spheres, and themes and shrewdly reconfigured them with African American points of view, cultural markers, signs, and insights. Race movies—black-cast films made outside the Hollywood studio system— such as *The Bronze Buckaroo* and *Harlem Rides the Range*—present a contrary view to traditional

lily-white Westerns. Within their entertaining stories, they tell us there were indeed people of color on the prairie and the range. Oscar Micheaux films like *Within Our Gates* and *The Symbol of the Unconquered* might be viewed as springing from traditional storytelling arcs, but his twists on narratives deliberately and daringly uncover issues of race and racism in America that were of supreme importance to African American moviegoers. Micheaux can be viewed as *Hollywood*, but no: he is *Hollywood Black*.

The same was true decades down the road, when Gordon Parks Sr. directed Richard Roundtree as a new-style, hip detective clad in a leather jacket while rhythmically navigating the streets of New York to the beat of Isaac Hayes's music in *Shaft*—the kind of *brother* African Americans had seen many times on city streets but never before seen in a movie. It also happened when black British director Steve McQueen reconfigured the plantation drama with *12 Years A Slave*, dramatizing the

fierce brutality and emotional pain that previous Hollywood slave stories hadn't touched; when Jordan Peele both saluted and battered the teen horror film with racial satire in *Get Out*; and when Ryan Coogler made the entertaining superhero film *Black Panther* that was influenced by past superhero films as well as James Bond, yet in its own sense was revolutionary. Old-style movie action narrative, coupled with new-style black political perspectives and sometimes humor, made *Black Panther* again, not Hollywood, but *Hollywood Black*.

Finally, *Hollywood Black* seeks to reveal that while we rarely go to the movies to learn anything, we learn something nonetheless. Movies may horrify and enrage us with their distortions. And when it comes to black images, we can have very conflicted feelings. We often like the actors and actresses on-screen even when we feel uncomfortable with what the script has them do. But movies also can amuse, move, and enlighten us. And as we sit there in the dark staring up at that huge screen, we understand, for better or worse, that we will not be quite the same after we've seen the picture and left the theater. *Hollywood Black* reminds us that, thanks to films, filmmakers, and unique stars, we always take something home with us.

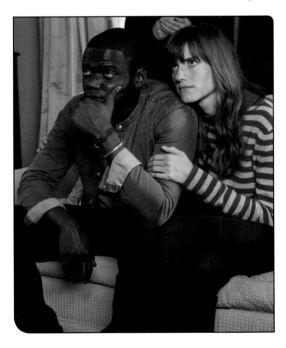

RIGHT: Dandridge in her Oscar-nominated role as Carmen Jones. **BELOW:** *Get Out* with Daniel Kaluuya and Allison Williams.

CHAPTER

1

THE EARLY YEARS

DAWNING ERA OF FILMS AND STEREOTYPES

The movies started small. Kinetoscopes. Peep shows. Then nickelodeons. Those makeshift theaters in converted storefronts with wooden seats that charged five cents for admittance and were popular from 1905 to 1915. In time, those early venues for exhibiting motion pictures led to the grand movie palaces of the 1920s and '30s. From the start, budding audiences were excited by the flickering images, by movement itself, and, eventually, narratives that gave shape, form, and dimension to the play of light and movement. Early two- to three-reel shorts, usually crude, often comic, told stories through the use of characters and situations that were frequently stereotyped depictions of various groups, ethnicities, and cultures. No racial group or ethnicity was more blatantly distorted than African Americans.

The history of African Americans in movies would be one in which for decades talented black entertainers struggled against their stereotyped roles to come up with often remarkable, even subversive performances that sent out covert messages. Surprisingly, the early history would also be one in which independent filmmakers working outside the evolving established film industry made entertaining and informative films that often moved

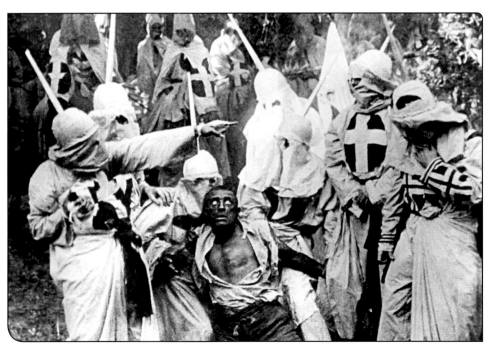

The use of white actors in blackface and the triumph of the Ku Klux Klan in D. W. Griffith's *Birth of a Nation*.

George Walker, Bert Williams, and Ada Overton Walker.

away from prevailing caricatures. And in time, more African American filmmakers—working both outside and within Hollywood—would alter the look, the feel, the perspective, and the stories of American movies.

But mostly during the very early years, the movies were a parade of embarrassing, insulting, demeaning caricatures— often offsprings of the rigid stereotypes of the minstrel shows that had been so popular in the nineteenth century. Most offered portraits of the Negro as a comic, childlike, often enough grotesque Dark Other—an oddity in American life and culture. The titles of early shorts often tell a story themselves: *The Wooing and Wedding of a Coon* (1905), *The Dancing Nig* (1907), *Ten Pickaninnies* (1908), and the *Rastus* series: *Rastus and Chicken* (1911), *Rastus among the Zulus*

(1913), and *Rastus and the Game Cock* (1913).

Occasionally, there were attempts to tell a story with some meaning. That was certainly the case with Edwin S. Porter's *Uncle Tom's Cabin* (1903). Adapted for the Edison Company from Harriet Beecher Stowe's novel, the short twelve-minute movie was a sentimental and simplified version with a title character who was supposedly the essence of Christian stoicism without any of the shading or significance of Stowe's protagonist. Poor Tom looked like a self-sacrificing dolt. Worse, Tom was played by a white actor in blackface (the director himself), as would be the case with the portrayal of other black characters in the early silent period. Still, for better or worse, a black character and a type of black story had come to the infant movies.

Another attempt at a different direction for

black movie images in this period was a long-lost 1913 film produced at Biograph (fragments of which were rediscovered in 1976), *Lime Kiln Club Field Day*. It spotlighted America's first black mainstream star, Bert Williams, who had performed in all-black Broadway shows and then in *The Ziegfeld Follies* and later in the 1916 shorts *Fish* and *A Natural Born Gambler*. From the fragments of *Lime Kiln Club Field Day*, there emerges a story of a romance of sorts with Williams, in blackface, courting a young African American woman who also has two other suitors eager for her hand. Interestingly enough, none of the others are in blackface. But apparently the film was never completed, leaving us only with tantalizing bits and pieces.

Otherwise, stereotyped depictions of African Americans flourished and took root in American film, just as they had in American theater and popular culture in general. But nowhere did those distorted and damaging depictions have greater prominence or cultural impact than in D. W. Griffith's *The Birth of a Nation* (1915). The epic twelve-reel feature film ran over three hours and was technically innovative with its bold, expressive lighting and editing; imaginative use of the close-up, the iris, and the split-screen shot; and dazzling displays of crosscutting to build suspense and pull the viewer into the story itself. It was a huge hit—the first of blockbusters with patrons lined up to see it around the country. Its leading players, Lillian Gish and Henry B. Walthall, emerged as stars.

The film dramatized the Old South with its supposedly idealized way of life, in which master and slave knew and accepted their racially designated places in society. Then it moved to the supposed chaos caused by the Civil War, and on the social upheaval and supposed white disenfranchisement of the Reconstruction Era. It ended with the "return" of order to the South with the emergence of "upright," "stalwart" white Southern men in sheets and hoods. Drawn from Thomas Dixon's novel and play, *The Clansman*, as well as his book *The Leopard's Spots*, *The Birth of a Nation* celebrated the Ku Klux Klan and brought to shocking full life basic black stereotypes that would be a part of American cinema for decades to come: the renegade and dangerous black bucks and brutes, often in pursuit of white women; the loyal Southern mammy and tom; the comic coons; the restless, troubled mulatto. Adding to the grotesque distortions was the fact that, while some actual African Americans appeared in minor roles, the major black characters were again played by whites in blackface. Like other early filmmakers, Griffith did not view African American actors as even capable of playing themselves on-screen.

The film won critical praise as "an elaborate new motion picture taking on an ambitious scale" that was "an impressive new illustration of the scope of the motion picture camera," wrote the *New York Times*. Upon seeing the film at a private White House screening, President Woodrow Wilson reportedly exclaimed; "It is like writing history with lightning. And my only regret is that it all is terribly true."

But while *The Birth of a Nation* was heralded as a technical masterwork, it would also be remembered as perhaps the most racially disturbing and distorted feature in American film history. Its glorification of the Ku Klux Klan led to an increase in the membership of the organization. Within the African American and liberal white communities, protests sprang up. Seeing the power of the filmic image as propaganda, the NAACP denounced the film and in a major campaign, sought to have it banned. Indeed, *The Birth of a Nation* was censored in several cities and ultimately banned in other areas.

THE BIRTH OF BLACK FILMMAKERS

In this era, the first black filmmakers appeared, determined to tell stories that saluted African American heroism and achievement, or that presented nuanced expressions of struggle and triumph. Earlier, the black filmmaker William Foster (also known as Juli Jones) had crafted such comedy shorts as *The Railroad Porter* (c. 1912) and Peter P. Jones had created newsreel-style films. Now other African American filmmakers stepped forward. Among the first to appear was actor Noble Johnson, one of the earliest African Americans to work successfully in Hollywood movies, beginning his screen career in such films as *A Western Governor's Humanity* (1915), *Kinkaid, Gambler* (1916), and later appearing in *Intolerance*, *The Ten Commandments*, *The Four Horsemen of the Apocalypse*, and *The Adventures of Robinson Crusoe* and working in the sound era, too. Playing a variety of ethnic roles, he might appear in one film as a Native American and in others as an Arab, Egyptian, or African American. Sometimes his roles were short, little more than walk-ons. Sometimes he received billing in his movies; other times he didn't. Still, the black press dubbed him "the race's daredevil movie star" and "America's premier Afro-American screen star."

Tall, muscular, dashing, and handsome, Johnson had the stamp of "leading man" written all over him. But he knew that would not happen in Hollywood movies. Instead, he became one of the founders of the Lincoln Motion Picture Company in Los Angeles, which produced such three-reel black-cast films as *The Realization of a Negro's Ambition*, *The Trooper of Company K*, and *The Law of Nature*, all emblems of pride, racial uplift, and accomplishments, and all produced for African American audiences. An advertisement in Los Angeles's black newspaper *The California Eagle* read:

THE LINCOLN MOTION PICTURE CO.

PRESENTS THEIR SECOND PRODUCTION

"THE TROOPER OF CO. K"

A THRILLING, INTERESTING, AND PATRIOTIC THREE-REEL

MOTION PICTURE DRAMA FEATURING

NOBLE M. JOHNSON

SUPPORTED BY MISS BEULAH HALL AND JIMMIE SMITH

Over 300 people used in making this production, consisting of ex-9th and 10th Cavalrymen, Mexicans, Cowboys and horses.

Colored Persons Shown True to Life On the Screen at the

NEW ANGELUS THEATER

Like later independents throughout film history, the Lincoln Motion Picture Company was ultimately plagued by problems of finance, distribution, and exhibition, and did not last long. Still, it led the way to the emergence of other filmmakers and companies determined to tell stories about African American life and to provide entertainment for black movie audiences.

Noble Johnson, one of the founders of the Lincoln Motion Picture Company, starring in *The Realization of a Negro's Ambition*.

Pioneering filmmaker Oscar Micheaux.

MAKE WAY FOR MR. MICHEAUX

nterestingly enough, not long after its formation, the Lincoln Motion Picture Company's search for material to produce led the way to the arrival of one of the most remarkable figures in movie history. His name: Oscar Micheaux. Born in 1884 in Metropolis, Illinois, the fifth of thirteen children of a farmer and his wife, Micheaux moved to Chicago by age seventeen, for a time living with his brother, then setting out on his own, working a series of jobs: a laborer in the stockyards and the steel mills; the operator of his own shoeshine stand in a Chicago suburb. When he landed a job as a Pullman porter, he traveled widely and met a variety of moneyed people who proved helpful to him later. Afterward, he settled as a homesteader in South Dakota. Observing the world around him, absorbed in issues of race and class, power and disenfranchisement, influenced by Booker T. Washington, and committed to the idea of racial uplift and self-advancement, Micheaux set out on a writing career, using his own life and experiences as the basis of his work, including the collapse of his unhappy first marriage. Charismatic and fiercely ambitious, he wrote seven self-published novels, which he financed by establishing the Micheaux Book Corporation and selling stock in his company to whites in the area.

Micheaux's novel *The Homesteader* drew the attention of the Lincoln Motion Picture Company. It was the perfect vehicle for the studio, with a leading role for Noble. Negotiations began between Micheaux and George Johnson, the brother of Noble, who was Lincoln's booking manager, but abruptly fell apart when the bold and brash Micheaux decided he'd write, direct, and produce the film himself. It's doubtful that anyone could take him seriously. Who did this upstart with no experience in film and no knowledge of movie world basics of finance, distribution, and exhibition, think he was? He looked doomed to disappointment and failure—but no one knew Micheaux. He established the Micheaux Book and Film Company, and, against the odds, produced *The Homesteader*, released in 1919.

Thus began Micheaux's extraordinary career, in which he daringly tackled serious, unusual themes; developed strong, independent heroines and noble forthright heroes; and created a star and studio system of his own making just as Hollywood was establishing its star system. He was one of the most provocative filmmakers—black or white—of his era, determined to make motion pictures that spoke to African American audiences in the most personal ways.

The Homesteader was followed by the startling and searing eight-reel *Within Our Gates*. Gathering funds from investors, he shot the exteriors of the film in and around Chicago, with interiors filmed at Capital City Studios. In many respects, *Within Our Gates* might be viewed as a race uplift drama (as most Micheaux films were in one form or another). In other respects, *Within Our Gates* was Micheaux's response to *The Birth of a Nation*. The film told the story of young schoolteacher Sylvia Landry (Evelyn Preer) who after a visit to Boston leaves to teach at the Piney Woods School for Negroes in Mississippi, only to return to Boston to raise funds to keep the school operating. In actuality, a school with

precisely that name existed in Mississippi, which added a certain immediacy to the drama. In telling Sylvia's backstory, Micheaux dove into the heart of the film as he dramatized the plight of his heroine's adoptive father Jasper Landry (William Starks), a black sharecropper who has been cheated out of money by his unscrupulous white landlord. When he is falsely accused of killing that landlord, he and his family must flee from a hateful white mob. Ultimately, the farmer and his wife are lynched. Focusing on the family, Micheaux captured the fear and terror that African Americans in the South lived with at the hands of white mobs.

Micheaux also explored other issues in *Within Our Gates*. He masterfully turns the tables on Griffith's portrayal of the threatening, bestial black man as rapist. In a gripping sequence, Micheaux's heroine Sylvia finds herself cornered in a cabin by an older white man (the brother of the landlord), who sets out to rape her. At one point, he rips open her blouse only to see a scar on her chest that reveals to him that she is the child of a black woman he impregnated so many years earlier. He is about to

ravage his own daughter. So much comes to mind in this scene, above all, the torturous, debasing history of African American women during slavery who found themselves brutalized by white slave owners.

Intertwined in his story is also Micheaux's unflagging belief in education as a way upward and out of poverty and despair for Colored America, and his view of contradictory forces in the African American community, as seen in his turncoat black characters who sell themselves out to the whites in power. There is also a love story with a heroic black doctor (Charles D. Lucas) who comes to Sylvia's defense. Micheaux cast his film with actors from the famed Lafayette Players, notably Evelyn Preer who worked in other films for Micheaux, including *The Homesteader* and his next film, *The Brute* (1920). In the end, *Within Our Gates* was a powerful dramatic social document that captivated *and* entertained African American audiences. The film, however, ran into problems with local censors in Chicago and afterward disappeared for decades. It was a lost film until the 1970s, when a print was discovered in Spain then restored in 1993 by the Library of Congress.

Then came *The Symbol of the Unconquered*, another eight-reel drama focusing on ambitious African Americans struggling against the forces of a corrupt white power system, again represented by the Ku Klux Klan. With his keen awareness of an audience in need of human dramas, Micheaux incorporated a love story between an enterprising young black homesteader, Hugh Van Allen (Walker Thompson), and a young woman named Eve Mason (Iris Hall), who moves to the Northwest upon being willed a mine by her grandfather. When Van Allen discovers oil on his property,

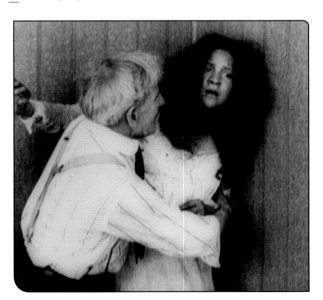

Evelyn Preer in *Within Our Gates*'s startling "rape" scene.

he is targeted by the whites and a turncoat black character who is passing for white. They want his land. In a visually stunning sequence, Micheaux shows Klan night riders with their white sheets, hoods, and torches set in stark contrast against a black sky. Perhaps no other film in history has quite encapsulated the nightmarish, threatening madness of the Klan. *The Symbol of the Unconquered* raised the question of racial identity as well as that of the miscegenation laws. Van Allen fears professing his love for the young Evon because he believes she is white. Only at the film's conclusion does the hero learn that he is free to proclaim his love to a woman who, as it turns out, is indeed African American. The heroine herself is no shrinking violet. As with *Within Our Gates* and other films, Micheaux favored forward-looking, assertive women. In one sequence, actress Iris Hall is alarmed about the safety of the man she loves, and leaps onto a horse and sets out to rescue him. It is a dazzling moment.

Micheaux's films were also empowered by their realism. Shooting on location, whether it be city streets or backwoods areas and cabins, his films transport us back to an earlier time and place. Rarely do they look fake or insular. Yet within that realism, Micheaux saw the importance of glamour. It was a gift to his African American audiences, who in the years to come would see black characters in Hollywood films depicted as unglamorous, dimwitted servants. In both *Within Our Gates* and *The Symbol of the Unconquered*, Micheaux has key sequences in which his heroines, played by Evelyn Preer and Iris Hall, are splendidly arrayed in fur shawls and hats. Viewers could not help but pause to appreciate the style of the women on-screen. There were also moments with his male characters when they too were decked out in stylish suits and ties. Male and female alike were the embodiment of well-attired professionals—emblems of the black bourgeoisie, a class otherwise ignored in early Hollywood cinema.

While Micheaux's unflinching depiction of corrupt white characters and his flirtation with the theme of interracial love appealed to black audiences, such characterizations also led to problems with the exhibition of his films. His pictures were repeatedly dogged by local censors. Often scenes were cut, and some films were mangled to alleviate fears about the powerful social/racial messages of his dramas. Yet no matter what changes or cuts were made to the versions of *Within Our Gates* and *The Symbol of the Unconquered* that survive today, they retain their power and entertainment value.

A born showman, Micheaux also developed a method for financing his films. According to a later Micheaux star Lorenzo Tucker (sometimes called the black Valentino), Micheaux went from theater to theater, showing pictures of his glamorous stars, and urging investments always in his *next* film. For his early films, he sought major talents. His 1925 drama *Body and Soul* brought newcomer Paul Robeson to the movies. He hired experienced white cameramen who knew the ropes of movie production. Like other directors and producers, he assumed ultimate responsibility for everything about his films: from the way they were shot to the way his actors performed to the way his scripts delineated the issues and tensions he sought to dramatize. Ultimately, Micheaux's long career spanned both the silent and sound eras, going from the post–World War I era into the post–World War II years.

Along with Noble Johnson's Lincoln Motion Picture Company, Micheaux gave birth to independent black cinema and what came to be known as "race movies": films made outside the Hollywood studio system that featured African American casts; had African American cultural references and signifiers; and were intended primarily for African

American audiences. From 1910 to 1950, approximately 150 race movie companies, some black-owned, others white-controlled, flourished, with their films being produced in such cities as Fort Lee, New Jersey; Jacksonville, Florida; Philadelphia; Chicago; and Los Angeles to name just a few. Often enough, such companies were founded and controlled by white filmmakers. Sometimes the films had racial stereotypes. Still, race movies could boast of some very entertaining pieces of work as well as striking achievements, such as the haunting 1927 *Scar of Shame*, which dramatized issues of class within the African American community.

Lucia Lynn Moses in *The Scar of Shame*.

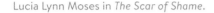

During the mid-1920s, Hollywood itself and the studio system took shape as more filmmakers, following the lead of Cecil B. DeMille and D. W. Griffith in the teens, journeyed west to the land of sunshine and blue skies, where the climate was conducive to year-round production. Hollywood's major players were soon in place. In 1924, Columbia Pictures was formed. That same year MGM, a consolidation of Metro, Goldwyn, and Louis B. Mayer studios, was incorporated. By 1925, Warner Bros. expanded by taking over First National. There was also Paramount and later Twentieth Century-Fox. A star system emerged, and names such as Valentino (the "dark lover"), Swanson, Chaplin, Pickford, Fairbanks, Gilbert, and Garbo were emblazoned on movie marquees around the world.

Though black Americans were excluded from any chance of major league stardom, gradually, some performers in Hollywood made names for themselves within the African American community. The Negro press—such newspapers as the *California Eagle*, the Los Angeles *Sentinel*, the *Pittsburgh Courier*, the *Chicago Defender*, the *Philadelphia Tribune*, and scores of others—began publicizing those few figures who worked in films and were their own publicists. One of the first was a native of Kentucky, born Nellie Wan (so she said) until she married and became Nellie Conley. Having worked in tent shows, carnivals, and circuses, and any place where she might find an audience, she moved west with her young sons. There, she decided she wanted a piece of the action in the flickers and wrangled an introduction to—of all people—D. W. Griffith. By then, Nellie Conley had another name change, and henceforth, was known as Madame Sul-Te-Wan.

"There were practically no Negro actors in California then," recalled Griffith's leading-lady Lillian Gish. "But one Negro woman did play in the film—Madame Sul-Te-Wan. . . . She was first employed to help us keep our dressing rooms clean

at the studio." Then Griffith decided to put her on-screen. "Madame Sul-Te-Wan played many small parts," said Gish. "We never did discover the origin of her name." No doubt, Madame believed the name gave her a grandeur in line with the larger-than-life figures who would dominate the screen. Oddly enough, especially in light of the controversy around *The Birth of a Nation*, she and Griffith became lifelong friends. "Later, when Madame was having financial difficulties," said Gish, "he sent her money to help herself and her small sons." Years later she would also attend Griffith's funeral. Always a mysterious figure, given to wearing extravagant clothes off-screen, Madame (like Micheaux) understood she had to be a master of self-promotion, always utilizing the Negro press. Her film career continued from silents (bits in films by DeMille and Erich Von Stroheim) into sound films: *Maid of Salem* (1937) *In Old Chicago* (1938), *The Story of Sea Biscuit* (1949), *and* as the unbilled grandmother of Dorothy Dandridge's character Carmen in *Carmen Jones* (1954).

Early black film actress Madame Sul-Te-Wan in Erich von Stroheim's *Queen Kelly*.

CHILD STAR: ERNEST "SUNSHINE SAMMY" MORRISON

In the silent era, the performer who came closest to Hollywood's idea of a star was a little boy, born Ernest Morrison. His father, Ernest Morrison Sr., worked for the wealthy Doheny family in Beverly Hills. At their home, little Ernest caught the eye of visiting moviemakers. From 1917 to 1919, he acted in fourteen films that featured child star Baby Marie Osborne and worked in *The Sheriff* starring Roscoe "Fatty" Arbuckle. He was often billed as Sambo or Little Sambo.

Once producer Hal Roach—a master at bringing exuberant comedy to the screen—spotted him, the boy was on his way to stardom. Impressed by Morrison's charm and comic timing, Roach, whose roster of stars included Harold Lloyd, Laurel and Hardy, and Harry Langdon, believed the kid was a natural for the movies. He cast him in films that starred comedians Charley Chase and Snub Pollard. In 1919, the *California Eagle* reported that Roach signed Morrison to a two-year contract. By then, the child was called Sunshine Sammy Morrison.

Morrison had his share of stereotyped roles, playing kids whose eyes pop at the sight of ghosts or strange occurrences. But when working unbilled in such films as *Get Out and Get Under* and *Number, Please?* (both in 1920), both starring Harold Lloyd, he often was presented simply as a kid, not a stereotype. In 1921, Roach set out to star him in a film to be called *The Pickaninny*, planned as the debut of a series built around Sunshine Sammy. For that time, it was an audacious move. But movie house exhibitors balked at the idea of a Negro star, be he young or old. The film went nowhere.

Still, Hal Roach liked the idea of spotlighting a talented black child actor. In 1922, the *California Eagle* reported that Sammy "just signed a 5 year contract with a local motion picture corporation calling for a yearly salary of $10,000," which was "indeed pleasing to the thousands of admirers of the 7-year-old Race lad who is now the highest salaried member of the Race in movies today." That same year, Roach successfully created a series about a group of kids who play together, go to school together, and get in and out of comic scrapes together. The kids were white and black. Though the black children were often depicted with watermelons or showing fear of ghosts, there was a lopsided kind of egalitarianism between the kids of different races. His series was called *Our Gang*, later known as *The Little Rascals*. Roach featured Sunshine Sammy in twenty-eight episodes of the series.

Other African American child stars appeared in the series. Allen Hoskins played Farina. Matthew

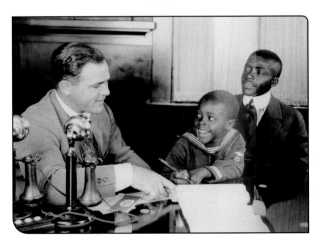

Child star Ernest "Sunshine Sammy" Morrison signs a contract with Hal Roach, with his father sitting nearby.

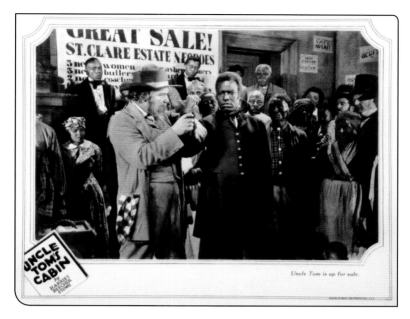

Lobby card of the 1927 *Uncle Tom's Cabin* with James B. Lowe as Tom.

Beard was cast as Stymie. Eugene Jackson appeared as Pineapple. Billie Thomas played Buckwheat. For decades, they were familiar to movie fans, especially in the 1950s when episodes of the old *Little Rascals* were aired on the new medium of television.

Some of these early black stars kept working as they got older. Eugene Jackson sometimes did bits

Billie "Buckwheat" Thomas, one of the child stars of *Our Gang*.

but he also had prominent roles in films, such as *Cimarron* (1931), and later in the age of television did a guess spot in the series *Julia*. Beard acted in numerous later films, including *Jezebel* (1938) and the 1942 race movie *Broken Strings*. Morrison also appeared in another successful series, *East Side Kids*, playing the character Scruno, alternately billed as Sunshine Sammy or Sunshine Sammy Morrison, or simply Sammy Morrison, in such films as *Smart Alecks*, *Ghosts on the Loose*, and others.

But despite the success of these child stars, rigid, stereotyped depictions of African Americans continued, becoming part and parcel of mainstream movies to the point where it was hard to find an African American character that was not a caricature. Time and again, black characters were used for comic effect. They performed senseless shenanigans. Their eyes popped. Their faces were etched with looks of fright and terror. A movie like 1920's *Haunted Spooks* had its black characters, including Sunshine Sammy, hopping about, terrified of ghosts.

With its love of epics, Hollywood produced a sprawling 1927 version of *Uncle Tom's Cabin*, directed by Harry Pollard and released by Universal at a reported then-astronomical budget of $1.5 million. During the silent era, no less than nine adaptations of the Harriet Beecher Stove novel appeared—a clear indication of the movie industry's fascination with dramas centered on the Old South. A 1914 version had featured black actor Sam Lucas in the title role. Now another African American actor, James B. Lowe, was cast as Tom. Brought to life for audiences were some of Stowe's famous characters: Eliza, George Harris, Cassy, the outrageously comic Topsy, and a villain to end all villains: Simon Legree. Once again, major black characters except for Tom were played by Caucasian performers. Again the film chose to spotlight the self-sacrificial traits of Tom as he bonds with the young white heroine Little Eva (Virginia Grey).

The theme of the black man determined to comfort and protect a white child clicked with the mass audience and would be repeated later with the films starring Bill "Bojangles" Robinson and Shirley Temple.

The preposterous aspect of the film was its depiction of Union soldiers during the Civil War. Stowe's novel had been published in 1852, before the Civil War had even occurred. Nonetheless, the film sought to bring to life some horrifying aspects of slavery: the separation of slave families, the cruelty of the slave traders, the beatings. Though Tom seems far too passive, actor Lowe worked hard at investing his character with some thought and reflection. Because of his impressive performance, which indicated the power a real African American could bring to a role, James B. Lowe was sent to England on a promotional tour but afterward disappeared from the movies.

LET'S HEAR IT FOR SOUND

In 1927, Warner Bros. transformed the film industry with its release of *The Jazz Singer*, starring the legendary Al Jolson. At one point, Jolson sings in blackface. But it wasn't the blackface that startled audiences. Instead, it was the *sound* of Jolson's renditions of "Mammy" and "Blue Skies," along with his few spoken words, that thrilled moviegoers. They literally had never heard anything like it. The "talkies" had arrived. And it was the "talkies"—*sound*—that also altered the status of African American actors working in Hollywood.

Significantly, sound demanded a new type of realism. Acting styles became more natural, seemingly truer to life. With that new realism, the old blackface tradition—using darkened white actors to play black roles—eventually became a thing of the past, though there were some embarrassing exceptions.

Because of sound, Hollywood anxiously turned its eyes to the theater world of the East in search of performers trained for the stage. Actors, actresses, and even elocution coaches were called west. During the socially relaxed and progressive

1920s—in the giddy post–World War I era, when independent flappers and dashing playboys reigned supreme—the concept of the Negro as Entertainer had become acceptable in big cities around the country. In New York, swank niteries like the Cotton Club were packed with patrons, often all white, waiting with bated breath to see an array of glamorous black singers and dancers—-and those tall, tan, and terrific chorus girls. Broadway was alive with black musicals, like Eubie Blake and Noble Sissle's *Shuffle Along*. A one-time chorus girl named Josephine Baker dazzled audiences, and then ran off to Paris for international acclaim. Blues singers like Bessie Smith, Clara Smith, and Ethel Waters had hit records, as did those early giants of jazz Duke Ellington and Louis Armstrong. The Jazz Age wouldn't have been the Jazz Age without these one-of-a-kind African American stars. As early as 1923, the self-described "father of radio" and pioneering master of sound-on-film recording, Lee de Forest, experimented with sound in a short that featured composers Blake and Sissle. After *The Jazz Singer*, narrative musical shorts were filmed in New York with black talents. *St. Louis Blues* (1929) showcased the great Bessie Smith. *Black and Tan* (1929) starred Duke Ellington and his orchestra with the girl of Ellington's dreams, stage actress Fredi Washington. Now the Hollywood studios rolled out the red carpet for such major recording stars as Waters, Ellington, and Armstrong using them in musical interludes in films.

Still, the artists had to work around prevailing attitudes to bring their musical magic to the screen. Warner Bros. hired Waters to sing "Am I Blue" in Alan Crosland's *On with the Show*. Despite the sophistication of her singing style—and the sophistication of the song itself—Waters holds a

Ethel Waters performing in the early 1929 talkie *On with the Show!*

basket and stands in front of a backdrop of a cotton field. But when she performed "Birmingham Bertha," she looked like a flashy flapper. RKO enlisted Ellington and his band to perform in *Check and Double Check* (1930). Drawn from the hugely popular *Amos 'n' Andy* radio show in which the white creators Freeman Gosden and Charles Correll played the program's black characters using broad, distorted dialects, *Check and Double Check* also starred Gosden and Correll in blackface, no less. When Ellington and his orchestra performed

onscreen, two band members—Puerto Rican–born trombonist Juan Tizol and Creole clarinetist Barney Bigard—were darkened because it was said the film's director, Melville Brown, didn't want movie audiences to think they were seeing an integrated group on screen. Louis Armstrong appeared in *Ex-Flame* 1930) but wasn't billed.

Regardless, they all lifted music to a new level in the sound film. Waters, Ellington, and Armstrong would work in and out of Hollywood for the duration of their careers.

ALL-TALKING, ALL-SINGING BLACK-CAST FEATURE FILMS

In 1929, Hollywood released two black-cast musicals. From the Fox Film Corporation came *Hearts in Dixie*. Directed by Paul Sloane, it was partly a series of sketches showing Negro life in the South, all loosely tied together by the story of old Nappus, who has a lazybones son-in-law called Gummy and a young grandson he hopes will have a better chance in life. The film ends with the boy heading North for an education. Throughout, the dialects were thick and there was an air of condescension. But without browbeating or promoting itself as a message film, *Hearts in Dixie*'s subtext mirrored the Great Migration of African Americans who left the Jim Crow South for opportunities and a new lifestyle in the North. Throughout there were songs and dancing unlike that seen in mainstream movies in the past.

Among the actors were newcomer Clarence Muse, aged to play old Nappus; Eugene Jackson

as the young grandson; Dorothy Morrison, the sister of Ernest "Sunshine Sammy" Morrison; and Gertrude Howard, Mildred Washington, and Bernice Pilot. The real surprise was a long, lanky comic actor who had already worked in such silent films as *In Old Kentucky* and *The Ghost Talks*. His rendering of dialogue was more of an inarticulate mumble than recognizable speech. He seemed to be speaking a language of his own. But in this all-black setting, all in sync to a special rhythm of its own, the actor was indeed funny, something he wouldn't always be in the years to come. The comic actor was the soon-to-be-famous Stepin Fetchit.

The second feature was *Hallelujah*, directed by a master of cinema, King Vidor, celebrated for such films as *The Big Parade*, *The Crowd*, *The Patsy*, and *Show People*. Under contract to MGM, Vidor fought hard to make his first sound film that was about Negro life, focusing in particular on

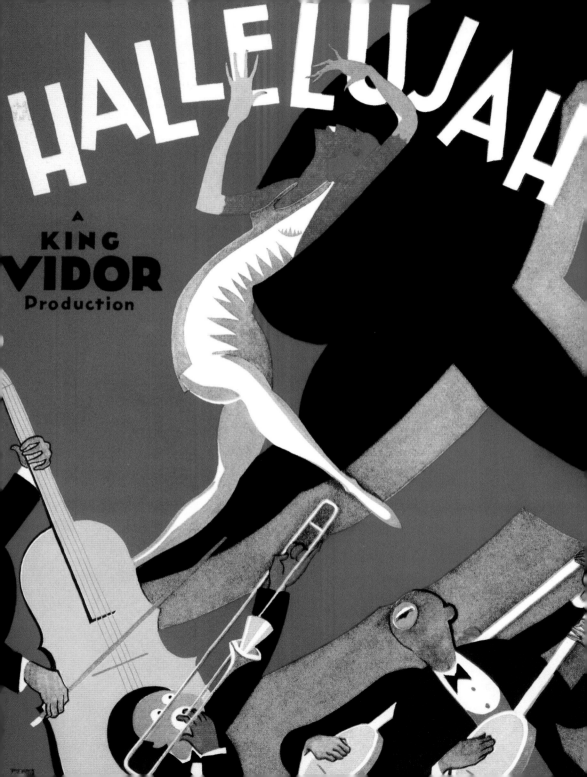

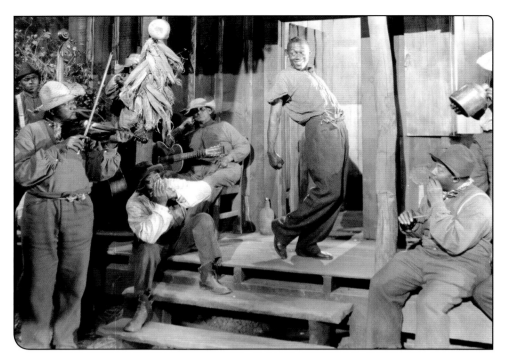

At the top of the stairs, Stepin Fetchit, stealing the scene *and* the picture in *Hearts in Dixie*.

the African American religious experience. Vidor had grown up in Galveston, Texas, where he was exposed to African American life and culture. But because MGM did not have confidence in the commercial prospects for such a film, Vidor finally put up his salary to get *Hallulejah* made. He shot on location in Tennessee and Arkansas, using new-comers for his cast. Interiors were filmed at MGM. Visually stunning, especially in its riverside baptism sequence, *Hallelujah* proved to be a masterly piece of work. Part of the film's brilliance was its focus on the use of sound itself. The buzz of a saw in a lumber plant was startling and innovative. So too was Vidor's skill in bringing to the screen the sound of Negro voices in song and in dialogue. Wisely, African American choral director Eva Jessye was hired to perfect the music, some of which was authentic to African American culture. Under her direction, the Dixie Jubilee Choir was heard

throughout the film. Vidor also used Irving Berlin's "Waiting at the End of the Road" and "Swanee Shuffle." Those songs had a cultural "authenticity" because of the Negro voices performing them.

By Vidor's own admission, *Hallelujah*'s story was a familiar triangle tale: a good, clean-cut backwoods colored man deserts family and friends (including a sweet-tempered girlfriend) for a sexy urban temptress who in turn dumps him for a devi-ous city slicker. Too often the film relied on familiar stereotypes: contented workers in the cotton fields; crap shooting roustabouts; overwrought religious zealots. But as the sound medium proved, African American performers, given the opportunity, could come up with something altogether new, distinct, and enjoyable. Lead actor Daniel Haynes as Zeke (in a role intended for Paul Robeson) had a commanding baritone voice. In a supporting role as the "good girl" that Zeke shuns was New York

Daniel Haynes and Nina Mae McKinney with director King Vidor.

blues singer Victoria Spivey, skillfully dramatizing vulnerability, passion, and acute emotional pain. Appearing as the family matriarch was Fanny (sometimes Fannie) Belle DeKnight. In a memorable sequence, as her children go to bed, she sings a Negro lullaby. In a small role as a young man about to marry the lady of his dreams was Sam McDaniel, the older brother of Hattie McDaniel, who had not yet come to Hollywood.

Then there was Vidor's star, newcomer Nina Mae McKinney, who the director had spotted in the chorus of the hit Broadway show *Blackbirds of 1928*. Originally, he wanted Ethel Waters, and film history might have gone in a wholly different direction had he been able to cast her. Hollywood would have had a brown-skinned woman as the romantic, glamorous sexual ideal. Instead by casting the light-skinned McKinney as the desirable, sexually appealing character, audiences saw an emerging color caste system in Hollywood dividing African American woman into color categories. Here McKinney vied with the browner Victoria Spivey for the hero's affections. Though Vidor had not intended it, for decades to come, Hollywood's vision of African American movie goddesses would be light-skinned actresses. Nonetheless, McKinney was a blazing talent, a terrific singer and dancer and a skilled actress. She was indeed Hollywood's first black love goddess. Vidor recalled that executives at MGM believed McKinney clearly had what it took for stardom. Yet with the exception of William Wellman's *Safe in Hell*, there were few roles for her in Hollywood. Returning to New York, she appeared in such entertaining shorts as *Pie, Pie Blackbird* and *Black Network* with the Nicholas Brothers. Like Josephine Baker, Nina Mae McKinney went to Europe in search of better opportunities. She was Paul Robeson's leading lady in the British

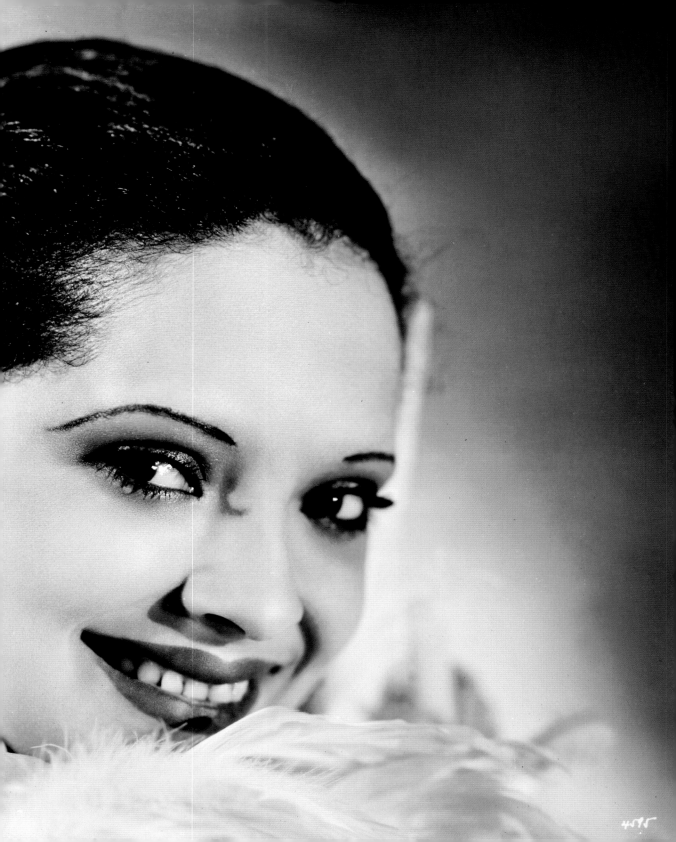

film *Sanders of the River*. Once back in the States, such race movies as *The Devil's Daughter* and *Gang Smashers* provided her with a career lifeline.

Neither *Hearts in Dixie* nor *Hallelujah* were box-office bonanzas. Still, though the Academy Award honors were new in Hollywood, Vidor won a nomination as Best Director for *Hallelujah*. None of the performers in *Hallelujah* joined the ranks of major stardom but Stepin Fetchit and Clarence

Muse of *Hearts in Dixie* were for a time integral parts of the growing film history.

Significantly, Robert Benchley wrote that with *Hearts in Dixie*, "the future of the talking movie has taken on a rosier hue. Voices *can* be found which will register perfectly. Personalities *can* be found which are ideal for this medium. It may be that the talking-movies must be participated in exclusively by Negroes, but, if so, then so be it. In the Negro the sound-picture has found its ideal protagonist."

Sound pictures had opened a door for African American talents.

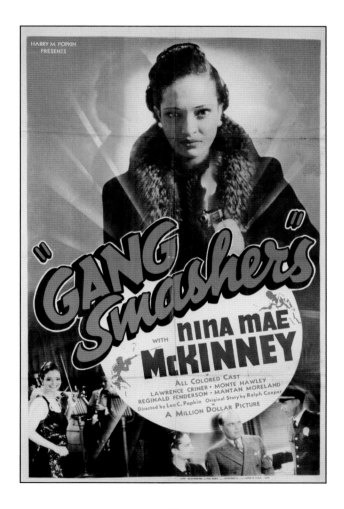

CHAPTER
2
THE 1930s

CHARISMATIC VOICES IN TOUGH TIMES

In the '30s, the screen came alive with the distinctive, exhilarating sound of actors' voices which brought their screen personas to exciting life and even helped define those personas. Such big stars as Clark Gable, Jean Harlow, Katharine Hepburn, Cary Grant, Greta Garbo, Mae West, Bette Davis, James Cagney, James Stewart, and Jean Arthur became immediately identifiable by their voices—their inflections, pitch, enunciation, their sometimes mannered or affected speech. In time, the same was true of the African American actors and actresses who became well-known to mainstream audiences during the Depression era. There would be Paul Robeson's baritone; Clarence Muse's stentorian, sometimes enjoyably pretentious tones; Stepin Fetchit's incomprehensible pronunciation; Eddie "Rochester" Anderson's gravelly, sandpapery voice; Hattie McDaniel's sonic boom as she gave orders and commands; Butterfly McQueen's high-pitched hysterics; Louise Beavers's cheery, butter-would-melt-in-her-mouth laughter; and Fredi Washington's heavy, melancholic laments.

Though the talkies reinvigorated the movies—with studios rushing to construct huge soundstages—Hollywood was also hard hit by the devastating economic upheaval that led to the Great Depression. "Wall St. Lays an Egg," was the famous headline in *Variety* on October 30, 1929, the day after the stock market crash. Nearly half the banks in America would close. Farmers would lose their land. The unemployment rate would soar to nearly a fourth of the population, leaving some fifteen million without jobs. Hollywood was also shaken. Studio revenues had been $720 million in 1929. By 1933,

those revenues had dropped to $480 million. RKO, Paramount, and Fox either slid into bankruptcy or receivership.

Yet, in time, Hollywood was back on its feet and would be remembered for the glittery or gritty forms of escape and empowerment that it produced during the Depression, whether it was through the gangster saga, the musical, the screwball comedy, or the tearjerker melodrama. African American performers would prove to be an important part of Hollywood's mass entertainment. Though consigned to traditional stereotyped roles, black performers—through their talent, charisma, and sheer magnetism—became familiar to moviegoers. In some startling cases, they challenged prevailing attitudes and stereotyped conceptions.

Among the Depression-era African American performers who made strides in Hollywood were Willie Best, Bill Robinson, Rex Ingram, Theresa Harris, Louise Beavers, and, the most famous of all, Hattie McDaniel. Some came from New York and the theater; others from the world of minstrel shows and black vaudeville. Families of performers migrated to the movie capital. Actor Sam McDaniel was followed by his sisters, Etta, Orlena, and Hattie. Viola Nicholas brought her two sons, Harold and Fayard, to California and in time they signed a contract with Twentieth Century–Fox, where they worked in such movies as *Sun Valley Serenade* (1941) and *Stormy Weather* (1943). Another ambitious mother, Ruby Dandridge, left her husband in Cleveland and traveled west with her daughters, Vivian and Dorothy. Against the odds, Ruby got her children in films such as *The*

Big Broadcast of 1936. Later, the Randolph sisters, Amanda and Lillian, would appear in movies, primarily in the 1940s, and in the 1950s in television.

In the 1930s, black performers believed there were real opportunities in the movies—and so they headed west.

DEPRESSION-ERA STAR: STEPIN FETCHIT

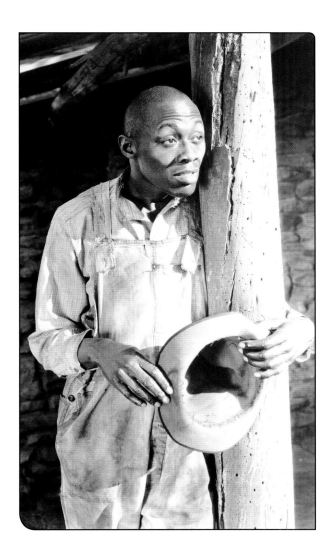

Stepin Fetchit

The first black star of the Depression, also for a time the most famous and then the most controversial, was Stepin Fetchit. Born Lincoln Theodore Monroe Andrew Perry in 1902 in Key West, Florida, Fetchit ran away from home around the age of twelve, worked various jobs, and made his way into show business by first appearing in carnivals and black vaudeville. For a time, he teamed up with another comic, Ed Lee, as Step and Fetchit. The idea underlying the name was that of acquiescent black servitude: a black man being summoned to *step into* the big house, *fetch it* (some object), then go his way. Fetchit and Lee parted ways. But Fetchit kept the name of the act. By the late 1920s, he made it to the film capital and played roles in *The Ghost Talks*, *Hearts in Dixie*, and *Fox Movietone Follies*. The black newspaper the *California Eagle* touted him as "truly one of the greatest colored actors ever to appear on the silver screen" and as "one of the few people of our race enjoying a movietone [sic] contract."

Director John Ford cast Fetchit in such films as *Salute*, *Judge Priest*, *Steamboat Round the Bend*, and *The Sun Shines Bright*. The characters played by Fetchit rarely had their wits about them. A distinguishing characteristic was their apparent

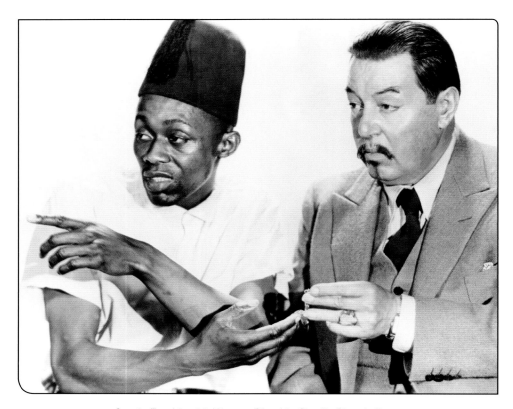

Stepin Fetchit with Warner Oland in *Charlie Chan in Egypt*.

befuddlement as they scratched their heads or were stooped over in confusion or bewilderment. And as in the past, Fetchit's characters seemed incapable of uttering a comprehensible sentence. They came to personify the coon stereotype: a lazy, dimwitted, inarticulate black.

Yet despite the stereotype, Fetchit could convey other moods and traits. At times, a nihilism ran through his performances, a portrait of a man who withdraws into himself as an escape from a world he knows means him no good—a world that could be unjust, humiliating, cruel. In *Judge Priest*, he sits in a courtroom full of Southern white men ready to convict him as a chicken thief. The proposed punishment? A sentence of hard labor on a chain gang. Rather than vigorously defend himself, Fetchit's character is asleep during the proceedings, having

seemingly removed himself from the room.

For later generations, it can be unsettling and painful to watch his antics. Yet in *Judge Priest*, there were glimmers of a theme that proved important in the decades to come: interracial male bonding. Will Rogers—as the maverick Judge Priest—and Fetchit represent the white man and the black man who are "friends" with a camaraderie that is outside the social norm. Yet Rogers also seems to treat Fetchit like a pet, and he's fascinated to learn how Fetchit manages to bait his hook to successfully catch fish. Here, too, the black is regarded as a part of the natural world.

But this slow-moving, slow-talking actor was a master of timing who never let anyone rush him through a sequence, using valuable screen time to draw attention to himself.

The off-screen Fetchit was the polar opposite of his on-screen persona. Away from the studios, there was hardly anything meek or kowtowing about him. Fetchit was known for his extravagant lifestyle: fancy cars, cashmere suits, lavish homes, adoring (sometimes exasperated) girlfriends and wives. Future producer Jean Bach commented that when she met him as a young woman, she quickly saw that in real life he spoke in a different way from his screen characters. No heavy fake dialect. No incomprehensibility. Like other stars who saw themselves magnified larger than life on giant movie screens, he developed an outsized ego that led him to clash with his studio, and when he became difficult on the set

of *The Littlest Rebel*, starring Shirley Temple, he was dropped from the picture.

Leaving Hollywood at the end of the 1930s and drifting in and out of show business, he later appeared in such race movies as *Big Timers* and *Miracle in Harlem* and worked again in Hollywood in the 1950s—*Bend of the River* and *The Sun Shines Bright*—then again in the 1970s films *Won Ton Ton: The Wonder Dog That Saved Hollywood* and *Amazing Grace*. He also developed a friendship with Muhammad Ali in the 1960s. Fetchit was the first of the Hollywood black stars; the first to see his name in lights and also to see that he could be easily replaced.

REPLACING FETCHIT: WILLIE BEST

One of the first replacements for Fetchit was another long, lanky actor, Willie Best—in some respects a Fetchit-clone or, perhaps better stated, a Fetchit spin-off. Born in Sunflower, Mississippi, in 1916, Best came to California as the chauffer for a white couple, or so the publicity handouts said. Like white performers, black actors and actresses found that once they began to make names for themselves, studio publicists crafted bios for them. Sometimes the performers created their own backstories, which were distributed to the Negro press. These bios could be partly true, partly fabricated, partly embellishments on events or circumstances in the actual lives of the performers.

In Los Angeles, Best was bitten by the showbiz bug, no doubt, once he had seen Fetchit. Surprisingly, it didn't take Best long to find work in such features as the Harold Lloyd comedy *Feet First*, *Up Pops the Devil*, and *West of the Pecos*. Throughout his career, he was cast as porters, cooks, laundrymen, chauffeurs, and just about any kind of servant you could think of. Sometimes the names of his characters said quite a bit, being used ironically or as a signal to the defining stereotyped aspect of his characters. In the Shirley Temple film *Little Miss Marker*, he had an uncredited role as Dizzy Memphis. In *Thank You, Jeeves!*, he played Drowsy. In *I Take This Woman*, he was cast as Sambo. In *Busses Roar*, he was Sunshine. Sadly, most telling was the fact that until 1935, he was billed (in about six films) as Sleep 'n' Eat, a take-off of the Step and Fetchit name. With that early screen name for Best, the idea was that here was an African American man without drive or ambition; a lazy, likable roustabout like Fetchit who was content as long as he had a place to sleep and enough

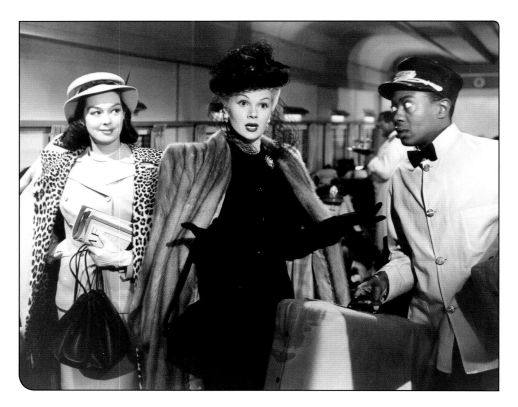

Forever cast as a servant, Willie Best with Rosalind Russell (left)
and Adele Jergens in *She Wouldn't Say Yes*.

to eat. Like Fetchit, Best was also often befuddled and easily frightened.

Yet Best developed his own persona. Generally, he was more articulate and could be understood, although his scripts never had him speak the King's English. He also seemed more aware of the action happening around him. He had none of Fetchit's nihilism. Nor did he have his odd and unexpected kind of strength. There was something indestructible about Fetchit. One always felt he could survive just about anything, whereas Best's physical vulnerability was apparent. Best looked as if he could collapse at any minute. But like Fetchit, Willie Best could steal a scene as he worked with such stars as the Marx Brothers, Laurel and Hardy, and Shirley Temple. When he appeared with Bob Hope in *The Ghost Breakers* (1940), Hope had to work hard to keep up with Best and reportedly called him "the best actor I know."

Best acted in over 120 movies into the late 1940s. In the '50s, he appeared in such television series as *My Little Margie* and *The Stu Erwin Show*. He died at age forty-five in 1962 in Woodland Hills, California.

TAPPING TO STARDOM: BILL "BOJANGLES" ROBINSON

While Best worked fast and hard to make himself known in Hollywood, Bill Robinson arrived in the film capital with his name and legend firmly in place, having already won acclaim and popularity as a great dancer in vaudeville and on Broadway. Born in Richmond, Virginia, in 1878, he ran away from home at age thirteen, teamed up with a dancing partner, and soon was headlining on his own at theaters. He perfected a Stair Dance routine in which he tapped his way up a staircase. Robinson was a big enough vaudeville star that by 1930, he appeared in the film *Dixiana*. But his great movieland success came when he was cast in the Shirley Temple film *The Little Colonel* (1935). Playing a genial older servant, he befriends little Shirley (as do other black servants), who lives in the household of her cantankerous grandfather, played by Lionel Barrymore. In one of the great "musical" sequences in the history of American cinema, he comforts little Shirley by teaching her his famous routine: to tap dance up the staircase. The two are perfectly in sync both rhythmically and personally. He's a wise counselor to a child in need of assurance and friendship. It's one of those Depression-era sequences with a subtext that hard times (including domestic difficulties) can be endured and triumphed over if black and white work together.

Robinson and Shirley became an ideal team in a trio of other films: *Rebecca of Sunnybrook Farm*, *Just Around the Corner* (both 1938), and their biggest hit, *The Littlest Rebel* (1935). In *Rebel*, he is protector and shield of Shirley during the hard times of the Civil War, when pint-sized Southern belle Shirley finds herself alone on her family's plantation. Shirley's Confederate officer father has been hauled into a Yankee prison camp. Her fragile mother has died. Throughout the war, Robinson remains by Shirley's side, ultimately helping her make her way up North to see who else but President Lincoln. Here Robinson has some of his most shameless dialogue and actions. His character was written so that he doesn't seem to understand what the Civil War is about—and that his freedom is at stake. He cares only about Shirley. His supposedly mature sobriety and sense of responsibility are contrasted with the dimwitted shenanigans of fellow servant played by Willie Best. Bojangles's

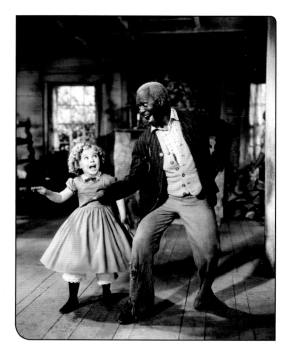

Shirley Temple and Bill "Bojangles" Robinson.

Hollywood's "cheery" view of plantation life: Willie Best, Bessie Lyle, Karen Morley, Shirley Temple, and Bill "Bojangles" Robinson in *The Littlest Rebel*.

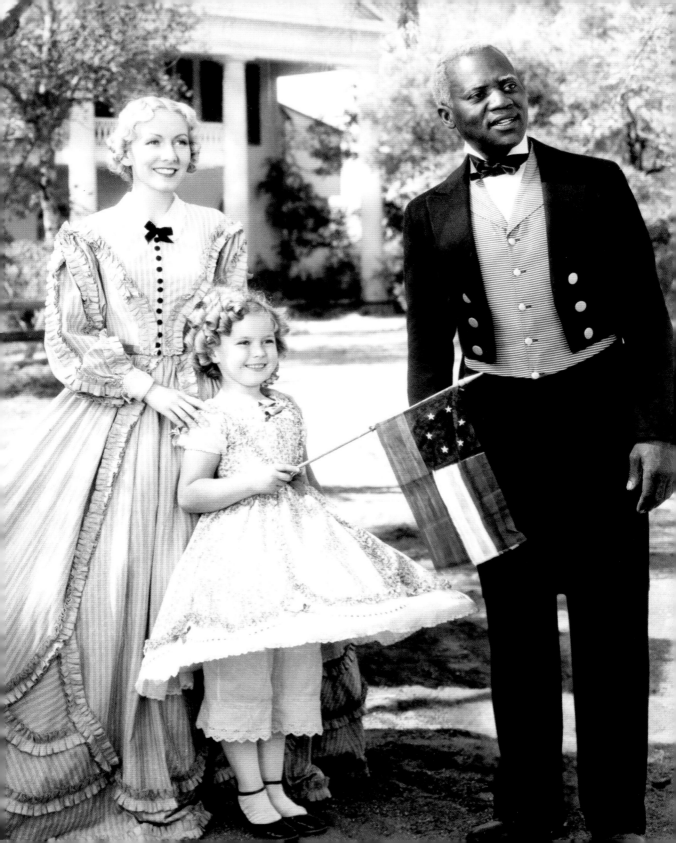

Robinson as the faithful servant to Will Rogers in *In Old Kentucky*.

performance was that of a definitive *tom*: basically an asexual, self-sacrificing, steadfastly loyal, unquestioning figure. Later generations would be appalled by the script—and the fact that Bojangles as an actor doesn't invest another meaning into his dialogue. Yet the saving grace of Bojangles was his supreme dancing skills that were on dazzling display. And true to the need of mainstream Depression audiences, he projected through dance his optimism and enthusiasm for life in the midst of great travails. That was but one way of looking at his character; for later generations, Bojangles's contented servant may appear delusional.

In other films, Robinson sometimes had a chance to take on different types of roles. In *One Mile from Heaven* (1937), he was an earnest cop. In *Stormy Weather*, he played a character—an entertainer—loosely based on his own personality and his own career. As the movies made him all the more a household name, Robinson ascended to special heights. Shirley Temple herself developed a friendship with him and admired him until the day he died. In New York, he was known as the Mayor of Harlem, and he hobnobbed with major celebrities and politicians of his day. But offscreen, Robinson was also known for his foul temper and his inflated ego. Having experienced all types of rejection and blatant racism in the early years of his career, he had broken down barriers to become a star in vaudeville, on Broadway, and in movies, and he wanted star treatment. Understandably, he demanded respect. The slightest thing could set him off. Audiences, however, didn't see this side of him (although there were press accounts of some of his public fights and gambling—and that he carried a thirty-two caliber, gold-inlaid, pearl-handled revolver with him). Instead he was held in high, affectionate regard.

FLIPPING MASTER-SERVANT ROLES:
EDDIE "ROCHESTER" ANDERSON

Occasionally, some actors like Eddie "Rochester" Anderson found unique, less stereotyped characters to play. A master of the double take and comic timing, Anderson was born in Oakland in 1905, the son of a minstrel performer father and a circus high-wire walker mother. While working his way around nightclubs in Los Angeles as a dancer and comic, he also played uncredited bits in such films as *What Price Hollywood?*, *Hat Check Girl*, and *Melody for Two*. He had a star role in one of the era's important black movies, *The Green Pastures* (1936), but what changed the direction of his film career and took him to a new level of stardom was a role on the radio.

In the Depression era, Americans sat huddled in their living rooms, listening to such shows as *Fibber McGee and Molly* and *Amos 'n' Andy*. Or they followed programs with such stars as Bing Crosby, Edgar Bergen, Red Skelton, or Jack Benny, one of radio's most enduringly popular comedians

and star of *The Jack Benny Program*. After fans responded enthusiastically to Anderson's appearances on episodes of Benny's show, Benny and his writers decided to make Anderson a regular. The role created was that of Benny's clever, manipulative manservant named Rochester. In no time, radio listeners were won over by Rochester's wit, confidence, and shrewd assertiveness. Never did he seem like a servant. He thought too highly of himself. One of his distinctive characteristics was his gravelly voice. It sounded as if sandpaper had been run over his vocal cords.

By 1939 into the 1940s, his independent, resourceful qualities were on display in movie theaters around the country, when Anderson as Rochester appeared with Jack Benny in such comedies as *Man about Town*, *Buck Benny Rides Again*, *Love Thy Neighbor*, and *What's Buzzin', Cousin?* In time, the role of Rochester—or Rochester Van Jones, which was the character's full name—became so associated with Anderson that he was sometimes billed in movies as Eddie "Rochester" Anderson. Though Anderson's character in the Benny films was never entirely free of stereotyping, he rarely went through the demeaning type of antics that actors such as Fetchit and Willie Best endured. Instead, he brought to the screen something wholly unique: Anderson had a beat, a perspective, and an attitude unlike that of any other black

Perhaps Hollywood's first interracial comedy team: Jack Benny and Eddie "Rochester" Anderson.

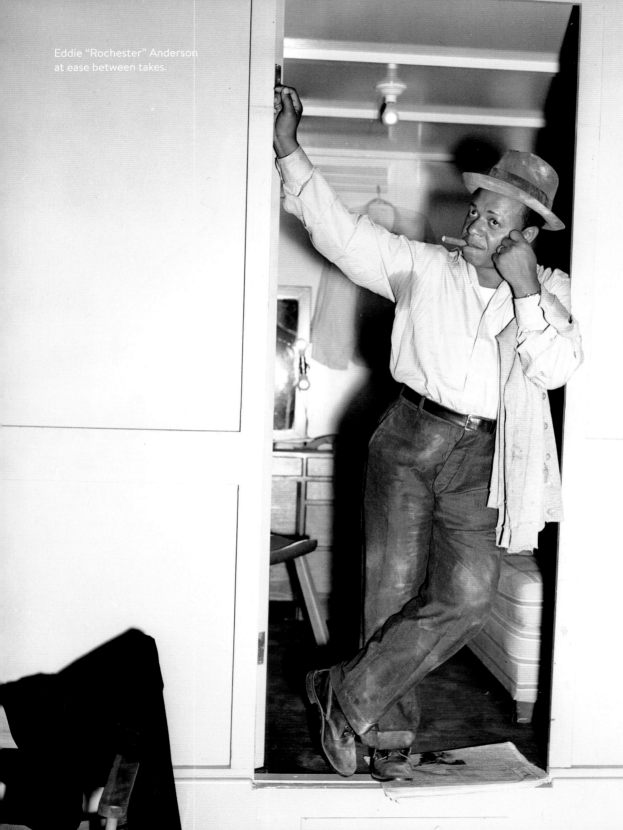

Eddie "Rochester" Anderson
at ease between takes.

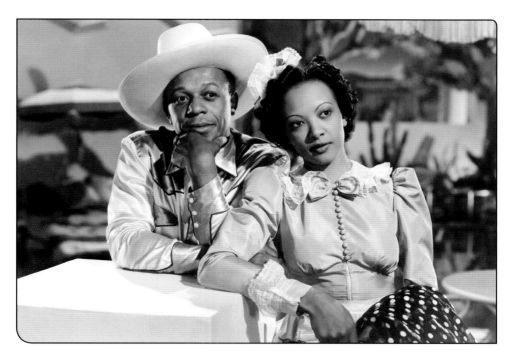

Rochester and Theresa Harris.

actor working in Hollywood. Short, articulate, quick-witted, confident, and ever ready to speak his mind, he was something of an Everyman—a bold Chaplinesque Little Guy who rarely could be put down or kept in his place. Lena Horne considered him the first modern black comedian. Moreover, when he worked with Benny, he was usually more interested in his own affairs and comforts than those of Benny. In *Buck Benny Rides Again*, Benny, about to go on a date, wants to wear his dress suit and top hat—and he wants Rochester to chauffeur him. Rochester, however, persuades Benny to dress casually and to get a cab. The film then cleverly cuts to the next sequence—and who was seen in his boss's dress suit and top hat and driving the car to pick up *his* girlfriend? Rochester. "Eddie Anderson (Rochester), as in *Man About Town*, has a particularly meaty portion of the lines and dialogue," *Variety* wrote, "to deliver a highlighted performance. Anderson also handles two dance routines

in showmanship style." Usually, he even put a spin on the word *boss* when he addressed Benny—to cue audiences in to the fact that he, Rochester, knows who indeed should be the real boss: himself! With dialogue especially written for Anderson's persona, he and Benny skillfully played off one another in dialogue and attitude to the point where they may have been our first interracial movie comedy team.

Anderson's assertive, nonservile persona could be seen in films he appeared in without Benny, such as Frank Capra's *You Can't Take It with You* (1938), *Broadway Rhythm* (1944), and *Brewster's Millions* (1945). When he first worked on Benny's show, Anderson was paid $35. Within a few years, he earned $100,000 a year—and was the highest paid black actor. He worked throughout the 1940s and when Benny's radio program went to television in the 1950s, Anderson was again playing Rochester. In 1963, he joined a cavalcade of comedians in Stanley Kramer's *It's a Mad, Mad, Mad, Mad World*.

A DIFFERENT KIND OF MOVIE MAID: THERESA HARRIS

Another performer who brought new dimensions to her roles was Theresa Harris, who appeared in almost a hundred films, although she was often unbilled. Most of the important black character actresses of the Depression era, such as Louise Beavers and Hattie McDaniel were larger, browner women, who offered comfort and advice, solace and sympathy to white heroines. Cast as mammy figures and sometimes appearing in films that starred hot platinum blondes such as Mae West and Jean Harlow, the black actresses were never a threat or rival to the allure of the white actresses they served. That was not the case with the slender, sexy, and undeniably attractive Theresa Harris.

Some of her most interesting parts were in the era before the Production Code of 1934, which strictly enforced issues pertaining to sex and sometimes race. The Code prohibited Hollywood movies from dramatizing miscegenation: a romantic mixing of the races. In a number of "pre-Code" films, it was interesting to see how Hollywood filmmakers were struck by Harris's beauty, intelligence, and wit. Josef von Sternberg cast her as a slinky singer in the Harlem nightclub sequence of *Thunderbolt* (1929). Sternberg was not afraid to suggest she is a goddess. One of her most striking roles was as Chico, the close friend or "sidekick" of Barbara Stanwyck in the 1933 *Baby Face*. Stanwyck plays an ambitious young woman—a shady lady, actually—who doesn't hesitate to sleep her way to the top. Going with her is her longtime friend

Chico. A testament to their friendship occurs early in the film, when Stanwyck's father makes a crack about Harris. Stanwyck jumps to her defense and lays down the law. As Stanwyck prospers, so does Harris—with scenes in which she is glamorously dressed, a rare occurrence for an attractive young African American actress. (She is also glamorously dressed—surrounded by admiring white men—in a sequence from *Professional Sweetheart* [1933] in which she plays the hip maid of Ginger Rogers.) In *Baby Face*, the relationship between Stanwyck and Harris is never satisfactorily explained. What has drawn them together and what is at the heart of their atypical friendship? As Stanwyck's character uses one man after another, Harris serves as a commentator—in song—on her white friend's sexual prowess. Often she is heard singing or humming W. C. Handy's "St. Louis Blues," a symbol here of the sexually free and independent woman who can use a man the way men traditionally used women.

Theresa Harris with Clark Gable and George Reed (right) in *Hold Your Man*.

Theresa Harris on duty as Barbara Stanwyck's "maid" in *Baby Face*.

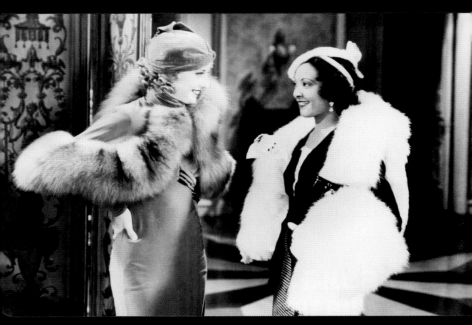

Harris performs the same song in a memorable musical scene in another Stanwyck film, the 1936 *Banjo on My Knee*. Here again "St. Louis Blues" was used to signal forbidden sexual desires.

One of her most intriguing roles, and perhaps least appreciated, was as Lily Mae Crippen in the Jean Harlow/Clark Gable 1933 drama *Hold Your Man*, directed by Sam Wood and written by Anita Loos and Howard Emmett Rogers. Though she received no billing, Harris was again wholly different from most other black female characters of the era. In *Hold Your Man*, the heroine Ruby, played by Jean Harlow, is sent off to a reformatory for wayward "girls." It is the result of a con scheme—devised by her boyfriend Gable—that has gone wrong. At the reformatory, Harlow is befriended by fellow inmate Harris. Black women were sometimes featured in women's prison movies such as *Ladies of the Big House* (1931) and *Ladies They Talk About* (1933). In those films, it was being suggested that white stars Sylvia Sidney and Barbara Stanwyck had fully hit the skids while in jail, a fact made all the clearer because they were then seemingly put on the same level as black female inmates. It's Louise Beavers as Ivory in *Ladies of the Big House*. (Evelyn Preer also had an uncredited role as a black inmate.) It's Madame Sul-Te-Wan in *Ladies They Talk About*. Also in the latter film was a singing inmate played by black operatic performer Etta Moten. Yet jailhouses were depicted partly as the great equalizers. No matter what their class or race, past lives or crimes, the imprisoned women were forced in many ways to live on equal terms with their fellow sisters. A theme of sisterhood slowly raises its head.

Some of the same women's-prison tropes were apparent in the reformatory sequences of *Hold Your Man*. Speaking clearly and directly, Harris's character Lily Mae is free of the stereotypical heavy dialect. Lily Mae also doesn't see herself as greatly different from any of the incarcerated young white women. Yet no matter how seemingly progressive the treatment of a black character, there were still racial digs at Lily Mae's expense. When an inmate is about to be released from the reformatory, she says: "Goodbye, Lily Mae, you're the only dark cloud I ever liked." Generally, however, the young women treated Lily Mae respectfully, and she was included in their conversations and exploits.

The screenwriters also go a different route with the character in a late sequence when Clark Gable arrives at the reformatory and wants to marry Harlow's character Ruby, who though the script cannot concretely spell it out, is pregnant. As it turns out, Lily Mae's minister father (George Reed) has come to visit her. He leads her in a prayer, a sensitive recitation of the twenty-third Psalm, "The Lord Is My Shepherd." Gable asks the minister to perform a marriage ceremony between Harlow and himself. "I think you ought to get your own kind," the Negro minister says. But Lily Mae has already told her father: "This Ruby is a sweetheart, Papa, that you heard about." Now she says: "Please, Papa. If you do it, I promise to be good." The minister performs the ceremony. Here, of course, African Americans are associated with a spirituality and religious conviction that white characters do not always possess. Nonetheless, it was a quiet, sensitive moment in the film.

Theresa Harris was so lovely in *Hold Your Man* and other films that moviegoers must have hoped she'd find other roles that would give her a chance to display her relaxed, assured sense of identity. But in such films as *The Toy Wife* and *Jezebel* (both 1938) she was stuck with the typical dim black servant role.

Harris also played Josephine, the girlfriend of Eddie Anderson's Rochester in the Jack Benny movies *Buck Benny Rides Again* and *Love Thy*

Theresa Harris with Kent Smith and Jane Randolph in *Cat People*.

Neighbor, and Blossom with Rochester in *What's Buzzin' Cousin?* In *Buck Benny Rides Again*, she and Anderson performed "My! My!" and just about walked away with the film. Both were terrific dancers and singers (although Anderson skillfully maneuvers his way around a song without really singing it). They were a screen rarity: a romantic black couple.

"I never felt the chance to rise above the role of maid in Hollywood movies. My color was against me," Harris told the Negro press in 1937, becoming one of the few performers in Hollywood to speak out about the racial casting. "The fact that I was not 'hot' stamped me either as an uppity 'Negress' or relegated me to the eternal role of stooge or servant. I can sing but so can hundreds of other girls. My ambitions are to be an actress. Hollywood had no parts for me." Harris also worked in race movies, hoping for the opportunity for more challenging roles.

Still, turning up in an unbilled role as a waitress in Jacques Tourneur's *Cat People* (1942), Harris projects intelligence and a workplace professionalism again rarely seen among African American women in Hollywood films of the period. The same could be said of her characters in two other Tourneur films, *I Walked with a Zombie* (1943) and *Out of the Past* (1947).

THE BIG STUDIO PICTURES

John Stahl's *Imitation of Life* (1934) remains one of the most important and moving films of the era. Based on the bestselling novel by Fannie Hurst, it told the story of two women, one black (Louise Beavers), the other white (Claudette Colbert), each a widow with a young daughter to raise, who meet by chance and end up, during hard financial times, living together. The white character, Bea, goes out daily to work at her career. The black character, Delilah, stays at home, taking care of the children. Fortune comes their way because of a pancake recipe which has been passed down in the family of the black woman. The white woman markets a mix based on the recipe, which becomes a national success. But with financial success comes heartache for both women. Bea's daughter, Jessie (Rochelle Hudson), falls in love with her mother's lover. The young light-skinned daughter of Delilah, who is named Peola (Fredi Washington), rejects her mother's submissiveness and daringly decides to cross the color line. Though the screenplay was not explicit about her reasons for passing for white, the movie certainly suggests that Peola understands that her white friend Jessie, with whom she has grown up (in the same home), will have a world of opportunities, while she will have almost none as a black woman. Peola's decision breaks her mother's heart. The film ends with the funeral of Delilah and the return of Peola crying that she killed her mother.

Here was the one film of the Depression to *suggest* that a contemporary race problem existed in America. It also was an unintentional comment on the exploitation of its African American character Delilah. As the pancake mix pulls in huge profits, Bea offers Delilah a 20 percent interest in the company. *Twenty-percent?* Without Delilah's family recipe, there would be no company. With her face on the box of the pancake mix, her image is also a marketing device used to sell the product. But the screenplay has Delilah say she doesn't want any money. Nor does she want a home of her own. All

Louise Beavers and Claudette Colbert as the two mothers who meet by chance and then struggle to stay financially afloat and care for their young daughters in *Imitation of Life*.

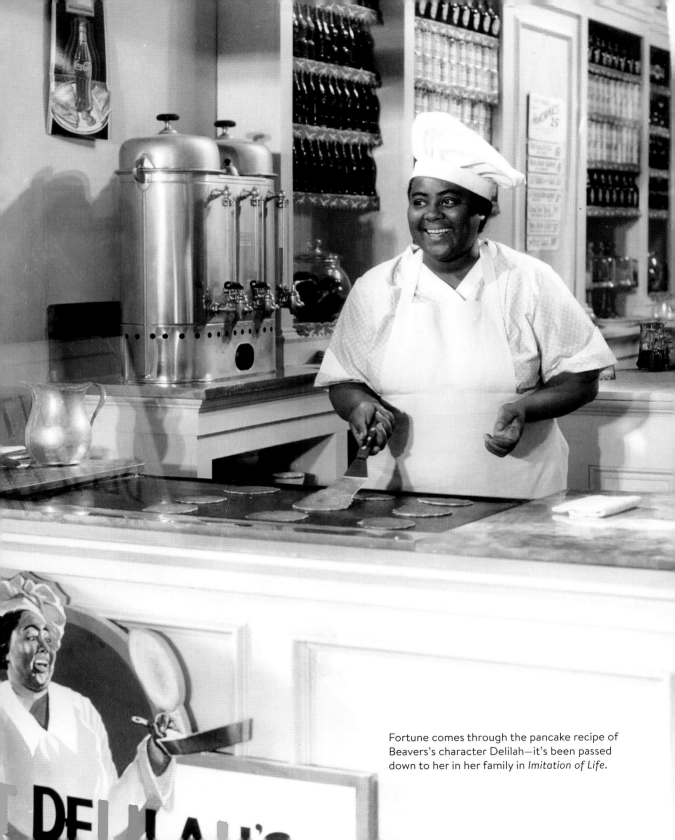

Fortune comes through the pancake recipe of Beavers's character Delilah—it's been passed down to her in her family in *Imitation of Life*.

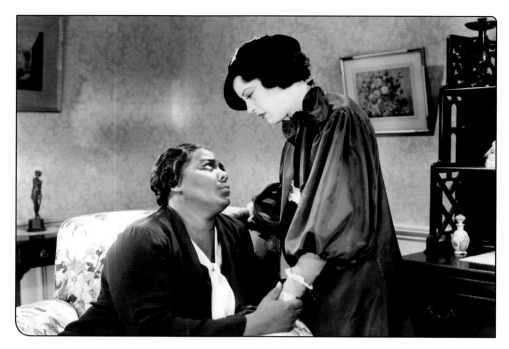

Louise Beavers as the distraught mother with Fredi Washington, as the daughter who has rejected her to cross the color line and pass for white in *Imitation of Life*.

she aspires to is to take care of Bea. *Imitation of Life* was a subtle critique of American capitalism— coming during the Depression, when some feared the capitalistic system might collapse. It served as comment that in a decadent capitalistic culture there is a price tag on everything, including skin color. Actress Fredi Washington always maintained that her character did not want to be white for the sake of *whiteness*. Rather, the character sought *white opportunities*.

Imitation of Life was a huge hit. Black and white moviegoers wept at the death and funeral of the gentle Delilah—and Louise Beavers's convincing performance. Even powerful Hollywood columnist Louella Parsons was reported by the *Pittsburgh Courier* to have cried while watching it. Within the African American community, discussions sprang up about the film. Black newspapers ran articles about the questions the film raised, mainly through

its subtext. According to actress Fredi Washington, Negro ministers preached sermons about it. Both Washington and Beavers had shown that African American actresses were capable of strong dramatic roles—and not simply playing giggling maids. There was even talk that Beavers should have gotten an Oscar nomination. At that time, the Academy Awards did not have supporting role categories. Ironically, Claudette Colbert won the 1934 Best Actress Oscar for another film, *It Happened One Night*. Still, few other Hollywood films of the era can match *Imitation of Life* in power and in its subtext about race in the nation.

Louise Beavers continued working nonstop in such movies as *Bullets or Ballots*, *Made for Each Other*, *Rainbow on the River*, and in 1948's *Mr. Blandings Builds His Dream House*. A New York-based actress, Fredi Washington found few opportunities in Hollywood and returned to the East,

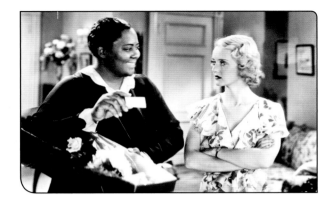

where she acted on the stage into the early 1950s. Later she helped found the Negro Actors Guild in New York, which fought for better roles for African Americans.

❖◆❖

Two years after *Imitation of Life*, the James Whale-directed *Show Boat* was released, based on the ground-breaking 1927 Jerome Kern/Oscar Hammerstein Broadway musical. A generational drama that spans the 1880s to the early 1920s, *Show Boat* is part love story and part family saga with an underlying social/racial commentary. Life on the show boat that travels along the Mississippi in the late nineteenth century is harmonious. The black workers played by Paul Robeson and Hattie McDaniel are basically accepting of their racially designated place in society. So too are the white characters who operate the show boat. But the harmony is broken in a tense, gripping scene when a secret is revealed that leading lady Julie is a mulatto—the daughter of a black mother and a white father—who has been passing for white and is married to a white man. The town sheriff warns of "a miscegenation case on board" the show boat, "a criminal offense" in the state of Mississippi. "One drop of Negro blood," says the sheriff, "makes you Negro in these parts." Thereafter she is expelled from the show boat.

Julie's story—like Peola's in *Imitation of Life*—was the film's most compelling narrative. But her plight was both ignored and glossed over as the

TOP: Beavers with Bette Davis in *The Dark Horse*.
MIDDLE: Beavers as the mammy figure in *General Spanky*, with George "Spanky" McFarland (bottom), Carl "Alfalfa" Switzer, and Rosina Lawrence.
BOTTOM: Beavers with Myrna Loy in *Shadow of the Thin Man*.

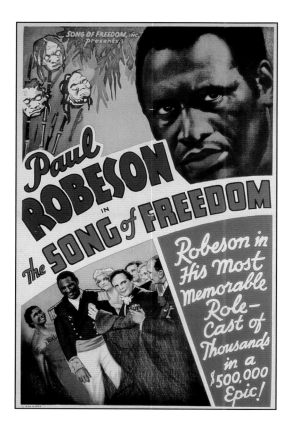

film followed the ups and downs of Julie's young white friend Magnolia, the daughter of the show boat's captain. Matters were also not helped by the fact that Julie was played by white actress Helen Morgan (who originated the role on Broadway). The character was perfect for Nina Mae McKinney or Fredi Washington, but because of the Production Code, those actresses could not be cast. Yet casting a white actress was also a hypocritical way for the studio to ensure mainstream audience sympathy. On screen, a white actress was suffering, not an African American one. But even though *Show Boat*'s questions about racism are safely tucked into the past, the film still gives its audience a powerful commentary with one of the greatest sequences in movie musical history: when Paul Robeson sits on the dock and sings "Ol' Man River." The song

summed up its character's awareness of racial injustices, and ultimately, his stoic acceptance.

Show Boat was one of Paul Robeson's rare Hollywood films. His concert hall performances in the States and abroad and eventually his 1943 stage performance in *Othello* as well as his strong political convictions all formed his legendary status. Early in his career, he had given a jolting performance in Micheaux's 1925 *Body and Soul*. He also starred opposite Fredi Washington in the independently produced 1933 film *The Emperor Jones*, based on Eugene O'Neill's play. Otherwise, he worked mostly in films abroad: *Sanders of the River*, *Song of Freedom*, *King Solomon's Mines*, *The Proud Valley*. Much as he hoped for non-stereotyped roles abroad, his British films were problematic, and he often regretted having made certain movies, though he managed to avoid some of the more servile antics of Hollywood.

Also appearing in 1936 was *The Green Pastures*, an adaptation of Marc Connelly's 1930 Pulitzer Prize winning Broadway play. With an all-black cast and directed by William Keighley, it was a morality tale of sorts with dramatizations of biblical stories and a portrait of an all-Negro heaven where angels prepare for a fish-fry and where all is presided over by a stately De Lawd, played by Rex Ingram. Hollywood's first black-cast feature film in seven years proved a great success. *Variety* praised *The Green Pastures* as "a simple, enchanting, audience-captivating cinematic fable that should reach the masses. . . . the first all-Negro film to click. It will appeal equally to white and colored folks." It was "a credit to Warner Bros. and the entire motion picture industry." But the paper also cautioned: "It'll require plenty of ballyhoo, considering the two major mass-mentality handicaps—the all-colored cast and the complete absence of anything resembling a marquee name."

Paul Robeson as he is about to sing "Ol' Man River."

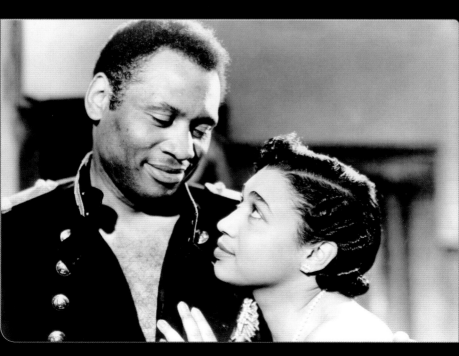

Paul Robeson and Elisabeth Welch in the British film *Song of Freedom*.

THE GREEN PAS

A WARNER BROS. PIC

URES

E

Hollywood's first blac
seven years.

For later audiences, it might look dated, slow-moving, even patronizing. Unlike *Imitation of Life*, the black characters of *The Green Pastures* were removed from then contemporary race issues, placed into a fantasy setting. But the talents of the cast were undeniable. Along with Ingram (who played three roles in the film: De Lawd, Adam, and Hezdrel), Eddie "Rochester" Anderson, Edna Mae Harris, Ernest Whitman, George Reed, Oscar Polk, and the Hall Johnson Choir all brought to the Hollywood film a new style, a new rhythm, and an unabashed enthusiasm for their work. The Connelly play was a staple of American dramas for years. Two television versions appeared in 1957 and 1959, each starring Eddie "Rochester" Anderson repeating his role as Noah.

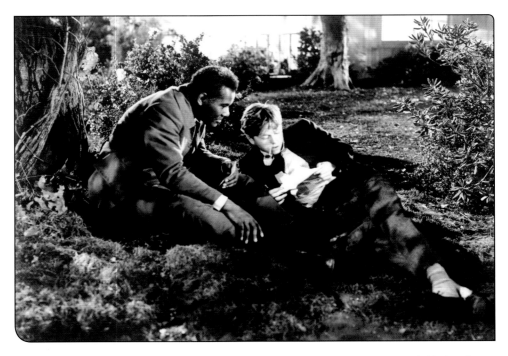

The Green Pastures also brought Rex Ingram to the attention of a broader audience. His background was an unusual one for an actor. Born in 1895 near Cairo, Illinois, he graduated from Northwestern University's medical school. "My career as an actor was quite by chance," he said. "I was standing on a Hollywood corner waiting to cross the street when I was discovered by a movie talent scout. I was persuaded that I was just what was needed to play a native of the jungle in the first Tarzan pictures. What I thought would be a short diversion from my work as a physician became my career." By 1918, he began working in silent films in unbilled small parts: *Tarzan of the Apes*, *The Ten*

Ingram gave a composed portrayal of Jim in the 1939 *Adventures of Huckleberry Finn* with Mickey Rooney.

Commandments, and *The King of Kings*. Ingram said that from 1920 to 1928 he "did everything from porters to butlers to natives." Starting in 1929, he performed on the stage in New York.

In the movies that followed *The Green Pastures*, such as *The Thief of Bagdad*, *The Talk of the Town*, *Cabin in the Sky*, and *Sahara*, Ingram was a commanding presence, performing without the buffoonery then expected of African American actors. In 1939, he was cast as Jim in the Mickey Rooney-starrer *The Adventures of Huckleberry Finn*. Never an easy role to play, Jim can appear to be something of a noble savage—childlike and dependent on Huck. But never in that film, nor any other, was there anything servile about Ingram. Similar to Paul Robeson, he projected an inner sense of his own worth. Both actors presented a new definition of black masculinity. That 1939 version of Mark Twain's novel—though simplified without Twain's wrenching social commentary—also has a fairly realistic scene (for the period) in which white townspeople are set on lynching the imprisoned Jim.

⬦⬦⬦⬦⬦⬦⬦⬦⬦⬦

Also veering in a different direction in its depiction of black masculinity was Archie Mayo's 1936 adaptation of Robert Sherwood's play *The Petrified Forest*, starring Bette Davis, Leslie Howard, and Humphrey Bogart as gangster Duke Mantee. Cast as one of Mantee's henchmen was black actor Slim Thompson, a former boxer (and the husband of actress Evelyn Preer) who gives a riveting performance as a tough, aggressive, take-no-prisoners character. In a telling sequence, he clashes with another black character, a conciliatory submissive chauffeur (John Alexander). One can see traces of the black buck type, but Thompson conveys the drive and sense of empowerment a black man of crime can experience in a white man's world.

Then there was the startling performance of Clinton Rosemond in Mervyn LeRoy's 1937 *They Won't Forget*. His character is a janitor in the South, falsely accused of having killed a white teenager, played by a very young Lana Turner. When grilled about the girl's death, Rosemond is frightened, anxious, panicky, emasculated. But that's precisely how this black man in the South—who understands the law will not be friendly or fair to him—is supposed to look. It was a fine performance. Rosemond could be counted on for composed characterization in other films: *Cabin in the Sky* (as the doctor), as Conover in *Young Dr. Kildare* and *Calling Dr. Kildare*, and the 1938 short *The Story of Doctor Carver*, in which he plays George Washington Carver.

Slim Thompson (third from right) as one of Humphrey Bogart's tough henchmen in *The Petrified Forest*.

MICHEAUX MOVIES TALK!

Away from the studios, race movies continued to provide entertainment for African American audiences—and at the same time, continued to struggle with problems of financing, distribution, and exhibition, as well as the new technological challenges of sound. Like the Hollywood studios of the late 1920s, independents wrestled with fundamental issues of where to place the mic, how to maintain sound levels, or how to shoot effectively when on location. It took the race movie creators time to pull everything together. Some independents couldn't keep up and fell by the wayside.

Oscar Micheaux, however, successfully made the transition, although his sound features did not have the sweep or social grandeur of silents like *Within Our Gates*. He started with the talkie *The Exile* in 1931—another examination of Micheaux's experiences as a homesteader—and followed with such features as *Veiled Aristocrats*, *Ten Minutes to Live*, *The Girl from Chicago*, *Lying Lips*, and *Swing!*. In a film like 1938's *God's Step Children*, he returned full force to the passing theme. He also remade his 1924 silent film, *Birthright*.

In the deliriously loopy and enjoyable 1937 *Underworld*, Micheaux explored the moral conflicts of life in the Big Bad City (Chicago in the film) as African Americans moved to the north during the Great Migration. Here Bee Freeman—sometimes dubbed the black Mae West—plays a wicked woman who is the mistress/would-be-wife of a powerful underworld crime boss (Oscar Polk). Though cunning and manipulative, she is another of Micheaux's independent, assertive heroines, and though Freeman's performance is hampered by shoddy editing and fairly bad sound, she is fun to watch and very much in control of her character. As in many of his films, Micheaux's good lead characters, played by Ethel Moses and Sol Johnson, are lighter. Again too is a subtext that illustrates W. E. B. DuBois's Talented Tenth theory: those forward-looking, purpose-driven African Americans who are exemplars leading to a better tomorrow for the Negro.

Micheaux's sound films continued to offer African American actresses unusual roles that they never would have had in Hollywood, including Micheaux's second wife Alice B. Russell (who worked closely with him). Black actors such as Lorenzo Tucker, Sol Johnson, Carmen Newsome, and Slick Chester were all a part of Micheaux's star system too. As one watches Micheaux's films, with an awareness of the tremendous struggles that always confronted him, he becomes all the more a heroic figure, dedicated to making movies and managing—even with his talkie "entertainments"—to incorporate the theme of racial uplift.

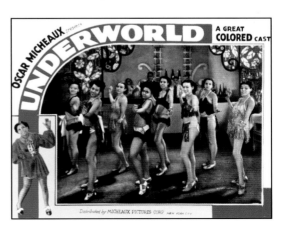

RACE MOVIE MANIA

During the Depression era into the 1940s, race movies grew more genre-oriented with an outpouring of black westerns, musicals, gangster tales, and romances. Because independent filmmakers were still hemmed in by budget constraints, their products, in some respects, resembled Hollywood B-movies. Rarely did they have the high-end production values. Yet B-movies could have their pleasures and their appeal—and their unique perspectives. Some also addressed subjects that Hollywood would never have touched but spoke in a personal way to African American audiences. Watching the movies at black theaters, moviegoers were part of a great communal experience.

In a very direct and earnest way, *Spirit of Youth* (1938) told the story of the Brown Bomber, the great boxing champion and cultural hero for black America: Joe Louis. Playing the fictionalized Joe Thomas was Joe Louis himself. As two women vie for him—one a "good girl" (Edna Mae Harris), the other a sophisticated temptress (Mae Turner)—the film followed formula but was quick to point out Joe's devotion to the number-one woman in his life, his mother (Cleo Desmond). Aware that Louis was a novice to acting as well as a man of few words, the filmmakers gave him a minimum of dialogue, preferring to let him "speak" in his boxing ring sequences.

Edgar Ulmer's 1939 *Moon Over Harlem* appeared to be typical crime melodrama, but beneath its familiar surface was a look at life—and class conflicts—in Harlem. With its shots of the Harlem of the past, including a view of 125th Street and the Apollo Theater, and its musical numbers, the film gave cultural validity to the world many of its viewers lived in. Playing small roles were jazz clarinetist Sidney Bechet and his wife, Marieluise.

African American performers were excited about the opportunities in race movies. Coming to the West Coast to shoot *The Duke Is Tops* was a striking singer from the East making her feature film debut: Lena Horne. While Hollywood ignored Nina Mae McKinney, she found a secure level of stardom in race movies. Louise Beavers appeared as a school matron in *Reform School* (1939) and later starred in *Life Goes On* (1938). Comedians Jackie "Moms" Mabley, Dewey "Pigmeat" Markham, and Dusty "Open the Door" Richard were among the stars of the "chitlin circuit"—the network of black clubs and theaters around the country—to show up in race movies.

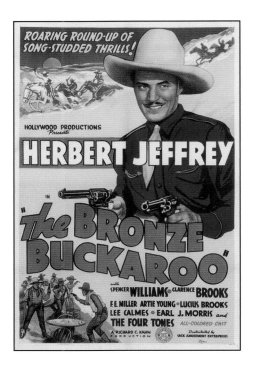

HERB JEFFRIES: SINGING COWBOY

One of the most likable and distinctive stars of independent cinema was the singing cowboy, Herb Jeffries, also known as Herbert Jeffrey or Herbert Jeffries. Born in Detroit in 1913, he grew up in a boarding house run by his mother. Afternoons were spent at movie theaters, where he was absorbed by the exploits of such cowboy stars as Tom Mix and Jack Holt.

Dropping out of high school to support himself, Jeffries made use of his great asset: he was a talented singer, a full-throated baritone who could make every song a sexy, romantic come-on. Performing in speakeasies, he caught the attention of Louis Armstrong, who encouraged him. Later he was a favorite of Duke Ellington and had women swooning as he sang the hit song "Flamingo" with Ellington's orchestra. Moving to Chicago, Jeffries sang at clubs and later toured the South as a vocalist with the orchestra of pianist Earl "Fatha" Hines. During downtime in the South, he slipped into black movie houses. Just as he had done as a kid, he watched Westerns.

Though historians estimated that 20 to 30 percent of the actual cowboys in America were black, Mexican, or Native American, cowboy movies were strictly white affairs. An exception was black rodeo star Bill Pickett, who was featured in *The Bull-Dogger* in 1923. Later African Americans sometimes had supporting roles in westerns: Ernest Whitman as Pinky in the Hollywood sagas

Herb Jeffries aka Herbert Jeffrey, the singing cowboy.

Jesse James and *The Return of Frank James*; Louise Beavers as the devoted Mammy Lou in *Belle Starr* (1941), and as Maum Maria in DeMille's *Reap the Wild Wind* (1942). Still, there was no such thing as black leads in Hollywood's Old West.

Herb Jeffries, however, was determined to make black westerns. Finally, he persuaded B-movie producer Jed Buell to back such a project and to star him under the name Herbert Jeffrey. Therein began a series of giddy black westerns for black moviegoers: *Harlem on the Prairie* (1937), *Two-Gun Man from Harlem* (1938), *The Bronze Buckaroo* (1939), and *Harlem Rides the Range* (1939).

Tall, limber, and handsome with wavy hair and a rakish mustache, Jeffrey cut a dashing figure as he rode horseback, wearing a Stetson and his boots and spurs. Usually, he played a cowpoke named Bob Blake. Also around in the films was Spencer Williams (cowriter on the screenplay for *Harlem Rides the Range*, who would direct important race features in the 1940s). Having seen Gene Autry and Roy Rogers sing as they rode the range, Jeffries decided to make use of his own singing voice and style, to the delight of audiences. As his character Bob sang his way through adventures (basically replays of standard cowboy movies), he had his background quartet accompanying him, the Four Blackbirds, billed often as the Four Tones. There was also a leading lady for him, someone he could protect and rescue, and when played by Artie Young, she was smart and resourceful.

With a career that spanned some eight decades, he later appeared opposite Angie Dickinson in the title role in *Calypso Joe* (1957) as well as in episodes of TV's *I Dream of Jeannie* and *Hawaii Five-O*. In 2004, Jeffrey was inducted into the Western Performers Hall of Fame. For his singing career, he was given a star on the Hollywood Walk of Fame. He died in 2014 at the age of 101.

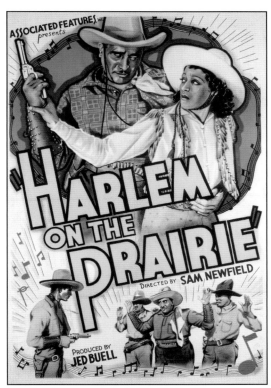

RALPH COOPER: MILLION DOLLAR PRODUCTIONS

While Jeffries cornered the market of black cowboy pictures in the 1930s, actor Ralph Cooper was the hero of black gangster films. Born in Harlem in 1908, he began his career as a dancer in small clubs in Harlem. Cooper hit it big when he became the smooth master of ceremonies at Harlem's Apollo and helped found the famous Amateur Night at the theater—where newcomers Sarah Vaughan, Ella Fitzgerald, Billie Holiday, and Michael Jackson made names for themselves. Cooper knew just about everybody in the world of black entertainment of the time, and his reputation spread beyond Harlem. Representatives from Twentieth Century-Fox showed up at the Apollo to ask Cooper to come west to replace an ailing Bill Robinson, who was scheduled to choreograph the Shirley Temple feature *Poor Little Rich Girl*.

That marked the start of Cooper's movie career. In addition to choreographing the Temple movie, he did uncredited bits in *White Hunter* (1936) and *Lloyds of London* (1936). Good-looking and suave, he knew that although he had the stuff to be a leading man (just as Noble Johnson had known), it wouldn't happen for him at the Hollywood studios. He decided, again like Johnson, to star in his own movies. In Los Angeles, along with the black actor George Randol and white producers Harry and Leo Popkin, Cooper formed Million Dollar Productions in 1937. He was the writer (sometimes credited, sometimes not; sometimes the man who came up with the story) on Million Dollar Productions' *Dark Manhattan, Gangsters on the Loose* (also known as *Bargain with Bullets*), *The Duke Is Tops*, and *Gang Smashers*.

Ralph Cooper, debonair star of *The Duke Is Tops*, with his young costar, making her movie debut, Lena Horne.

"*Dark Manhattan* was the first story penned by me," Cooper recalled. "It was a gangster picture, and it became a huge hit in Harlem. . . . at the Apollo, it broke all attendance records." He was also the uncredited director on both *Dark Manhattan* and *The Duke Is Tops*. Cooper remembered: "There were a total of nine hundred black theaters in the U.S. then, and our film played in about six hundred of them."

In this era when James Cagney, Humphrey Bogart, and Edward G. Robinson turned the American gangster into an iconic figure, Cooper wisely understood there was an African American audience fascinated by Harlem warlords—and the social forces that could lead a black man to a life of crime as a way to survive and assert himself.

Other African American talents, such as Clarence Muse, saw the importance of controlling their images or having some say over it within the studio system. Educated at Dickinson College in Pennsylvania, Muse performed with the New York black theater company, the Lincoln Players, and helped found the famed Lafayette Players. Arriving in Los Angeles in the late 1920s, he was confident and perhaps a bit pompous, but most important, he was not about to be pushed around. Muse spoke up about roles and on-set discrimination. Studio technicians, who often referred to a darkening device in the lighting process as the *nigger*, didn't seem to think twice about using the word. But when Muse—on the set of *Hearts in Dixie*—heard someone say, "Bring that nigger over here," he spoke his mind to director Paul Sloane. According to former child actor Eugene Jackson, the production was halted that day. "Clarence, being a man of high principles and standards, would not back down. He stuck to his guns, his beliefs, until a change was made."

At another time when Muse questioned the actions of his character in director King Vidor's 1935 Old South feature *So Red the Rose*, Vidor recalled that Muse was quite vocal in expressing his concerns. A change was made. Vidor could not recall exactly what the issue was, but he never forgot Muse's vigorous objections.

Muse also cowrote the song "Sleepy Time Down South," which became a jazz standard when Louis Armstrong recorded it. The song was used in the 1931 William Wellman film *Safe in Hell*. When the Screen Actors Guild was formed in 1933, Muse urged black actors to become members. The goal for Muse and other African American performers was not so much to abandon the studio system (it was too powerful, with an important distribution system and the highest production values), but to make the industry open itself up to more roles for African Americans, and more varied roles at that.

Muse also realized the importance of African Americans working behind the camera. In the late 1930s, he joined forces with Harlem Renaissance writer Langston Hughes to write the script—and spirituals—for another plantation film, *Way Down South*, starring Bobby Breen and produced by

Clarence Muse (right) with Matthew "Stymie" Beard (left), Charles Middleton, and Bobby Breen in *Way Down South*, which Muse cowrote with Langston Hughes.

Sol Lesser in 1939. During filming, Muse helped director Bernard Vorhaus work not only with black cast members Lillian Yarbo and Matthew "Stymie" Beard but also white actors. The movie proved a disappointment—indeed, an embarrassment—to both Muse and Hughes. Nonetheless, a significant push within studio culture had been made. Muse also worked in race movies, where he realized there was still a real chance for significant roles and narratives.

HATTIE McDANIEL: WINNING OSCAR

As the decade closed, Black Hollywood turned its eyes to one performer—Hattie McDaniel—whose talent indeed compelled the industry to give her its highest honor. Born in Wichita, Kansas, in 1893, one of thirteen children, McDaniel entertained as a teenager and traveled in road shows with her father (a Civil War veteran who became a minister and performer) and her oldest brother Otis—and later with George Morrison's Melody Hounds. In the mid-1920s, she performed on radio as well as made records for Okeh and Paramount in Chicago. But when work became scarce, she took jobs as maids or washroom attendants—anything to bring in money, especially once the stock market crashed.

After her older siblings—brother Sam and sisters Etta and Orlena—migrated to Hollywood, Hattie journeyed to the film capital in 1931. Sam worked in over two hundred Hollywood movies, often in unbilled roles, playing one servant after another in such films as *The Public Enemy*, *Captains Courageous*, *The Great Lie*, and *Double Indemnity*, to name but a few, and such race movies as *Am I Guilty?* and *Dark Manhattan*. He also appeared on the radio and later in television's *Amos 'n' Andy* and *Racket Squad*. Etta appeared in movies including *The Prisoner of Shark Island*, *Hearts in Bondage*, and memorably in an unbilled role as a servant who raises a gun and kills the villain in *The Arizonian*. Orlena ran a boardinghouse for Pullman porters.

With help from Sam, Hattie found work on the radio and began a slow but steady climb in movies, often unbilled. Regardless, moviegoers took notice of her extraordinary screen presence as she held her own during a long career acting with the biggest names in the industry: Clark Gable, Jean Harlow, Barbara Stanwyck, Bette Davis, Olivia de Havilland, Katharine Hepburn, Marlene

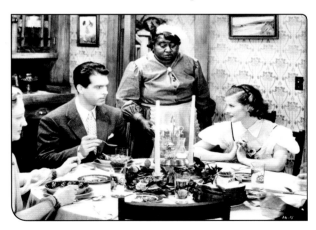

McDaniel as the maid-for-hire who feels she's slumming by serving Katharine Hepburn and Fred MacMurray with Ann Shoemaker in *Alice Adams*.

Dietrich, among others. Generally, her characters—conforming to the mammy stereotype—were there to comfort, assist, or reassure white stars. In *Blonde Venus* (1932), she befriended Marlene Dietrich, who was traveling with her young son (Dickie Moore) while on the run from the law. In *I'm No Angel* (1933), she was one of the full-figured black maids tending too-hot-to-trot blonde Mae West. In *The Little Colonel*, she was one of the servants for Shirley Temple's family.

But McDaniel also often had *attitude*—not as compliant as moviegoers might have expected. One of her great assets was her powerful, thundering voice. Her screen persona was almost always apparent: she was confident, tough, resilient, assertive. In some respects, her performances were radical. Facing the white stars eye to eye, she was neither intimidated nor threatened by them. Though she had her share of fake hearty laughs or giggles, McDaniel retained her sense of power and personal identity. Readily apparent was her refusal to completely submit to servant follies. In *Alice Adams*, she was the maid-for-hire who seemed to feel she was slumming by working for the poor family of Katharine Hepburn. In *Saratoga*, she matched wits with Jean Harlow. In the ocean liner drama *China Seas*, she again was a maid to Harlow, but with a twist. She was first seen relaxing while reading a magazine. An insecure Harlow questioned her about the manner in which she (Harlow) has been gossiped about. McDaniel played on Harlow's doubts, yet proved herself someone the blonde star should confide in. Her attitude works perfectly, to the point where she persuades Harlow to give her

Hattie with her brother Sam McDaniel in *The Great Lie*.

a dress she has wanted apparently for some time. Of course, the joke was that in no way would the heavyset McDaniel be able to squeeze herself into something the slim blonde Harlow had worn. But who knows? McDaniel just might be able to do it. The role was written in an unusual way. Moviegoers assumed she was Harlow's domestic, but she seemed more like a traveling companion. Her scenes also did not appear to be fully woven into the ongoing narrative. Instead they looked like inserts, added to give the film humor and some drive.

By the time David O. Selznick's *Gone with the Wind* was in pre-production, McDaniel was known within the industry. Both Bing Crosby and Clark Gable were said to have suggested her for the role of Mammy. McDaniel tested for the part along with Louise Beavers and Hattie Noel. But in the screen tests that still survive, she had a confidence that the other actresses lacked. Dialogue and actions that were those of another character in the Margaret Mitchell novel were written into McDaniel's role instead. In the classic early sequence when Mammy attempts in vain to persuade a resistant Vivien Leigh's Scarlett to eat her breakfast before going to the big Wilkeses' barbecue, ultimately she threatens Scarlett. Aware of something no other character in the film yet knows—that Scarlett is in love with Ashley Wilkes—she says: "I ain't notice Mr. Ashley askin' for to marry you." The camera goes to McDaniel, who gives a sly knowing smile. Not wanting her secret revealed to anyone else, Scarlett gobbles down some of her meal. Here clearly the director, the writer, and the producer are aware of the power McDaniel exerted.

Determined that his film not have the controversy that *The Birth of a Nation* generated, Selznick took precautions. He invited a representative from the Negro press on set to watch the film in progress. He was in communication with Walter White, the executive secretary of the NAACP, who advised Selznick to have production people read W. E. B. DuBois's *Black Reconstruction*. The n-word was removed from the screenplay. Carefully combing the novel, he altered in the film a sequence in which the Klan retaliates against blacks in shantytown who have threatened Scarlett. In the movie, it's become a group of *valiant* white characters—including Ashley Wilkes and Frank Kennedy—standing up for the honor of a wronged white woman. Yet try as Selznick did and entertaining as the film was, *Gone with the Wind* saluted the Old South and, in turn, the Confederacy. At its opening, moviegoers read:

There was a land of Cavaliers and
Cotton Fields
called the Old South . . .
Here in this pretty world
Gallantry took its last bow . . .
Here was the last ever to
be seen of Knights and their
Ladies Fair of Master and
of Slave . . .
Look for it only in books,
for it is no more than a
dream remembered.
A Civilization Gone with the
Wind . . .

Cavaliers! Knights! The movie maneuvered its way around the issue of slavery and a brutal system by ignoring it altogether. The slaves of *Gone with the Wind* were content and unconcerned about

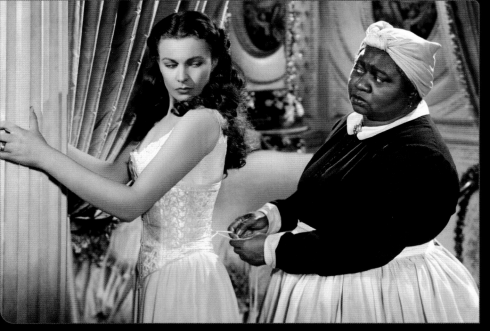

One of *Gone with the Wind*'s most famous scenes, with McDaniel and Vivien Leigh as Scarlett, preparing for the Wilkeses' barbecue.

McDaniel's Mammy "threatens" Scarlett, making her eat before the barbecue in *Gone with the Wind*

their fate—quite similar to Bill Robinson's character in *The Littlest Rebel* and other black characters in other plantation movies.

Gone with the Wind's script mostly leaves the personal side of Mammy stranded. Never are we told where Mammy resides. In a room in the Big House? In the slave quarters? (Of course, there were no slave quarters in *Gone with the Wind*.) The same is true of those other black characters—Prissy, played by Butterfly McQueen, and Pork, played by Oscar Polk. Nor are moviegoers told anything about Mammy's relationships with those other black characters.

All the black actors worked hard to make use of their screen time, and usually they succeeded, with indelible sequences that linger in the moviegoer's mind long after the film has ended. Generally, Polk's Pork was viewed as a pathetic, emasculated figure. But that appeared to be precisely the portrait he aimed for: a black man who's been pounded down over years to the point where he understands that self-assertion could endanger him. It was similar to what Clinton Rosemond had done in *They Won't Forget*. If only *Gone with the Wind* had invested the characters played by McDaniel, Polk, and McQueen with a backstory that would have provided at least a glimpse into their psyches—and that also possibly illuminated the explicit effects slavery has had on them. The evasions about slavery were *Gone with the Wind*'s greatest dishonesty. The black characters were given no *voice*. Shockingly, in a scene in Atlanta when Scarlett runs into the character Big Sam (Everett Brown) and other slaves from Tara, they are off to help the Confederate troops!

At Scarlett's lumber company, one scene touches on the issue of slavery. Upon learning of Scarlett's plan to hire convicts to work in the lumber mill—"freed darkies" would be too expensive—Ashley objects, saying the heavy-handed foreman will "starve them and whip them. . . . Scarlett, I will not make money out of the enforced labor and misery of others." Scarlett responds: "You weren't so particular about owning slaves." Though Ashley protests that the slaves were treated differently and that he would have freed them, Scarlett's comment is the film's one honest observation about the cruelty of slavery. Vivien Leigh coolly delivers the line perfectly. Aware of the cruelty, Scarlett does not care.

Gone with the Wind succeeded, however, especially during the Depression, for other reasons. Moviegoers transposed the idea of having lost everything from the Old South to their own financial hardships during the Depression. There was the comfort and appeal of the idea of returning home (which the film indicates as it draws to a close); that was also part of the appeal of the conclusion of 1939's *The Wizard of Oz*. Then there were Rhett and Scarlett, who stand outside the codes of the Confederacy, who live by their own rules. There was also Scarlett's great scene when she makes her vow that she'll never be hungry again. The themes of endurance and survival still rouse moviegoers.

McDaniel's performance retains its power in part because of her assurance and her covert anger. Though she ultimately supports Scarlett, she understands how ruthless and manipulative she can be. She confronts Scarlett about plans to go to Atlanta to ensnare Ashley Wilkes—and when Ashley returns to Melanie after the war, her Mammy stops Scarlett from running to meet him. What elevates McDaniel's performance is an underlying anger exhibited by her character. Like Rhett, McDaniel's Mammy knows Scarlett is no lady, and the camera comes in for close-ups to show McDaniel's displeasure at some of Scarlett's actions, notably when she sits on the side of the horse-drawn wagon and hears

Scarlett lie and mislead Frank Kennedy by saying her sister Suellen has a new beau.

Perhaps her most dramatic and powerful scene comes late in the film, as she tearfully informs Melanie of the bitter, hateful anger in the marriage of Rhett and Scarlett after they've lost their child, Bonnie. She has witnessed the couple in their most private and shocking moments, revealing that she has an emotional depth greater than that of any other character.

Throughout, she has a degree of agency. The film itself cannot explain Mammy. But McDaniel created her own backstory for the character. Actress Ruby Dee, who admired McDaniel's performance, said that McDaniel was "coming from a real place."

For her performance in *Gone with the Wind*, Hattie McDaniel won the Academy Award as Best Supporting Actress of 1939, the first time the industry's highest honor went to an African American performer. At the Academy Awards ceremony that night, all eyes were focused on her as she gave her moving acceptance speech, in which she said she always hoped she'd be a credit to her industry—and her race. It's been said that the speech was written for her in advance by someone from the studio. But McDaniel invested it with sincerity and clarity. And her composure, poise, and passion on Oscar night—when she was seated separately from other cast members—was a whole other *image* from that of her character in the film.

McDaniel continued working in such movies as *The Great Lie* and *Since You Went Away*, but with the notable exception of John Huston's *In This Our Life*, rarely did she find challenging roles. By the time she appeared in *Song of the South* (1946), frankly she looked worn and lacked much of her old feisty spirit. Still, she remained the beacon of hope for other African Americans who came to the film capital. She was also the queen of Black Hollywood's professional and social worlds. Known for her palatial home on Harvard Boulevard—it was the most exquisite home Lena Horne said she had ever seen—she entertained lavishly. During the years of World War II, she was part of the war effort within Hollywood, and she paid close attention to the Negro troops. Off-screen, she was also hardly the asexual mammy figure. Instead she had four husbands.

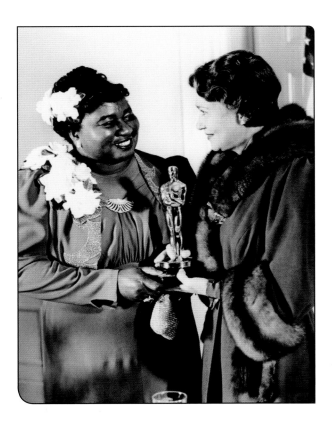

McDaniel on Oscar night, receiving her award for Best Actress in a Supporting Role for *Gone with the Wind* from actress Fay Bainter.

CHAPTER
3

THE 1940s

WAR YEARS IN HOLLYWOOD

As the nation slowly recovered from the Great Depression, Americans were soon confronted with a new crisis. On Sunday, December 7, 1941, the Japanese bombed Pearl Harbor, leaving some 2,403 Americans dead and 1,178 injured. President Franklin Delano Roosevelt addressed the nation, and suddenly, America was thrust into the Second World War. White and black, men and women, became part of the war effort, whether as members of the armed forces that fought overseas or as patriotic residents on the home front, where the daily life of the nation changed. Families rationed food and gasoline. Women took jobs outside the home, often in munitions plants and factories and often in positions that in the past had been reserved for men only.

Popular entertainment also underwent changes. Hollywood produced films that directly addressed the war, as well as escapist fare to take the nation's mind off the grim realities of the war years. Such stars as Betty Grable and Rita Hayworth emerged as wartime pinup goddesses—their photographs peering out from the lockers of GI's around the world. Discussions sprang up in the Negro press about the need for victory abroad *and* victory at home for the rights of black citizens. A new consciousness emerged about Hollywood's black movie images—mainly the contented comic servants—that had been so popular in previous eras.

In 1942, the NAACP's executive secretary, Walter White, accompanied by the NAACP's counsel and former Republican presidential candidate Wendell Willkie who was on the board of Twentieth Century-Fox, traveled from New York to Hollywood to meet with studio heads—those who would agree to see White—to urge the industry to abandon its stereotypes and to depict "the Negro as a normal human being and an integral part of human life and activity." White also understood the urgency for better representation of other minorities: Asian Americans, Native Americans, and Latinos.

The 1940s—the war years and their aftermath—proved a very fertile era for African Americans in Hollywood. Dramatic stars from the previous era, such as Rex Ingram, continued to work. So did such comic stars as Mantan Moreland, Willie Best, Louise Beavers, Butterfly McQueen, and, of course, Hattie McDaniel, fresh off her Oscar win. Eddie "Rochester" Anderson's career was clearly on a roll as he became the most successful and highest-paid black actor working in Hollywood. But roles would dramatically change as the era progressed.

The movie studios would have to ask basic questions about the way African Americans were presented in mainstream films. Popular tastes and attitudes were shifting. Two big all-black films were released by the major studios in the first half of the decade, and a series of provocative films appeared in the second half. Race movies also flourished, with a number being made in Los Angeles. By the end of the decade, however, race movies would be standing on their last legs.

ETHEL AND LENA:
BROADWAY DIVA AND NEWCOMER GODDESS

In the early '40s, the big news circulating within the corridors of Black Hollywood was that two singers from the East had arrived in town—and perhaps they would shake up Hollywood. One was an established performer, although no one was sure what kind of career she could hope for in the movies. She was older ("older" in Hollywood terms, meaning she was in her forties), and she had grown heavier. Both her age and her weight gain were strikes against her. Yet she was too great a star to be ignored. The other singer was young and vibrant, still in the early phase of her career, and she immediately captured the spotlight. The two women were very different in terms of their talents, temperaments, attitudes, and fundamental appeal. The established star was Ethel Waters, known by everyone on the West Coast. The newcomer was Lena Horne.

In the East, Waters had made short films but hadn't been in a Hollywood production since

Ethel Waters

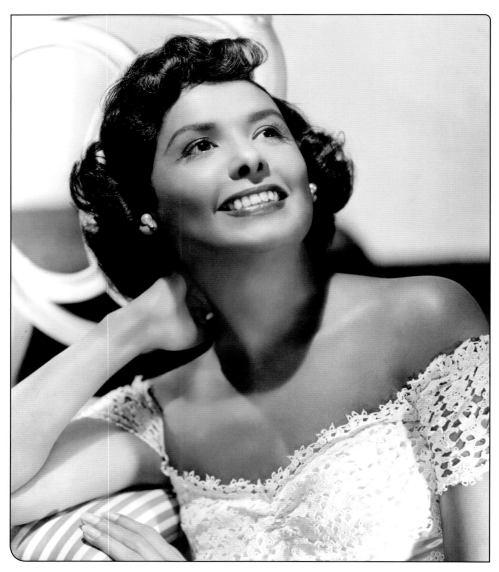

Lena Horne

On with the Show in 1929. Returning to the film capital, she had a personal and professional history that was relatively well-known. She had already stretched the boundaries for the kind of career an African American woman could have. Born in 1896 in the Philadelphia area and growing up in poverty, she had married at thirteen. By the next year, the marriage was over. Taking a job as a chambermaid at a Philadelphia hotel, she eventually left to perform in road shows, where audiences were struck by her blues songs and her hot presence. Very sexy onstage with bumps and grinds, and for a time called Sweet Mama Stringbean, she settled in New York in the 1920s. There she refined her image, used her birth name, and began recording. Her music sold to record buyers, black and

white. Her career went into a new direction when she sang "Stormy Weather" at the Cotton Club in 1933. Patrons flocked to see Waters, including Irving Berlin, who offered her a starring role in his upcoming Broadway revue *As Thousands Cheer*. It was a white show with few African Americans. As it turned out, Waters, who sang such songs as "Supper Time" (about a woman preparing dinner even though she knows her husband will not return home because he has been lynched) and the sexy "Heat Wave," walked off with the show. There followed the Broadway musical *At Home Abroad* and a powerful dramatic performance in *Mamba's Daughters* in 1939 She was hailed as an all-around entertainer who could sing, dance, and perform comedy and drama.

In 1940, Waters's most recent Broadway success had been as the star of *Cabin in the Sky*, which was staged by George Balanchine. MGM had plans to do a film adaptation. But first the studio cast the performer in *Cairo*, which starred Jeannette McDonald and Robert Young. She was also one of the stars in the "Negro segment" of Columbia's *Tales of Manhattan* (1942), along with Paul Robeson and Eddie "Rochester" Anderson. Most of the film focused on a lineup of other stars: Rita Hayworth, Charles Boyer, Ginger Rogers, Henry Fonda, and Edward G. Robinson. The black segment—about a tailcoat that goes from one owner to another and then falls (packed with money) from an airplane onto the land of backwoods sharecroppers who see it as a gift from the Lord—was met with a hail of criticism. The black characters seemed hopelessly naïve and childlike. Protests shot up against the film. The studios took note. Maybe the time had come for the end of old images. But, in the meantime, MGM still had high hopes for its version of *Cabin in the Sky*.

◇◇◇◇◇◇◇◇◇◇◇◇◇

Most of the excitement in Black Hollywood in 1941 was about the *new* star—who looked as if she might alter the course for African Americans in the film industry. Amid the call for image changes and better roles for African Americans, Lena Horne arrived at the perfect time: perfect for her, perfect for the movie industry, and perfect for the nation.

She took the industry by complete surprise. Born in 1917 into a middle-class family in Brooklyn, Horne began her career at age sixteen as a chorus girl at the Cotton Club. She later was the girl–singer with Noble Sissle's Society Orchestra. Horne was the subject of endless talk because of her beauty: the electric eyes, the chiseled features, the dark hair, and what was then known as the café-au-lait copper coloring. Temporarily putting her career on hold, she married and became the mother of two children while living in Pittsburgh. But when Horne's marriage ended, she resumed her career and ultimately performed at New York's chic club Café Society Downtown—known for its integrated audiences and as a haven for New York's ultra-sophisticated cultural and intellectual elite. That led to a West Coast engagement where Horne was spotted by a representative from MGM, the most powerful of Hollywood's studios, and thereafter was signed by the studio. The NAACP's Walter White took a special interest in her career. He did not want to see her playing maids. If Horne were given the right opportunities, White believed she could do much to affect movie images.

Perhaps MGM had a similar idea—to a certain extent. Excited by her potential, the studio went through meticulous efforts to present her to the

public, providing the kind of attention and care that had rarely been given to black performers. This was more significant than one might initially think. Tests were made to photograph and light her to the best effect. Experiments were conducted with various makeups to bring out her skin tones and, of course, her great beauty. As Horne once said, the makeup devised for her proved all wrong. And there were some problems. MGM's great hair stylist, Sydney Guilaroff, recalled that none of the white hairdressers at MGM would touch her hair. To him, it clearly was a case of racism

at the studio, though he did not use that word. Guilaroff created her hairstyles and hired black hairdressers to be on the set with Horne, who always appreciated what Guilaroff had done. When she returned to Hollywood to film sequences of *That's Entertainment III* in 1994, she insisted that Guilaroff do her hair.

Yet though the studio glamorized her, it did not make her into a full-fledged movie star, at least not in the classic sense. MGM put her in musical interludes of such big productions of the 1940s as *Panama Hattie*, *I Dood It*, *Swing Fever*, *Ziegfeld*

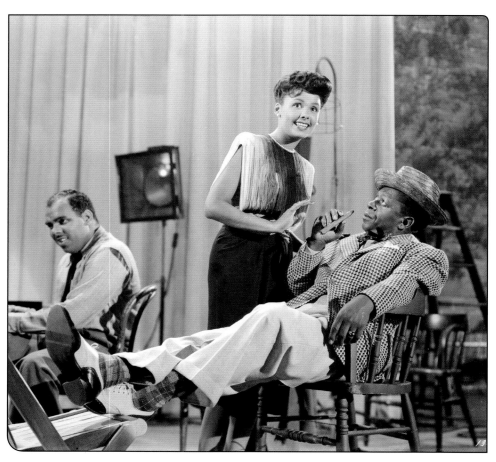

ABOVE: Lena Horne on the set of *Broadway Rhythm* with costar Eddie Anderson and arranger/composer Phil Moore at the piano.

Follies, and *Words and Music*, all of which featured white stars. Looking like a million dollars, Lena Horne would come on, sing a song or two, and then disappear from the balance of the picture. "I sang separately by myself in a scene. And I never had any conversation with the white people in the cast," said Horne. "I sang in a number that could be separated from the rest of the picture and cut very easily. Because during the forties and fifties, some places in the south and in certain countries like South Africa they wouldn't show a black on the screen with somebody else."

Only twice in the 1940s did she actually play roles that proved significant for her—and for African Americans in Hollywood. One was in MGM's Vincente Minnelli-directed *Cabin in the Sky*—a musical fantasy about an all-black heaven

and an all-black hell fighting for the soul of Little Joe Jackson. Headlining the film were Ethel Waters (given top billing), Eddie "Rochester" Anderson, and Horne, along with Duke Ellington, Louis Armstrong, John "Bubbles" Sublett, Rex Ingram, Butterfly McQueen, Mantan Moreland, Willie Best, and Kenneth Spencer. MGM also lent Horne out to Twentieth Century-Fox for the musical *Stormy Weather*, directed by Andrew Stone and with another all-star black cast that included Bill "Bojangles" Robinson, Katherine Dunham and her dance troupe, Fats Waller, Cab Calloway, Flournoy Miller, Johnny Lee, Dooley Wilson, and topping it off, the Nicholas Brothers.

Both *Cabin in the Sky* and *Stormy Weather* presented more humanized, softened images of its black characters. Neither was entirely free of the old

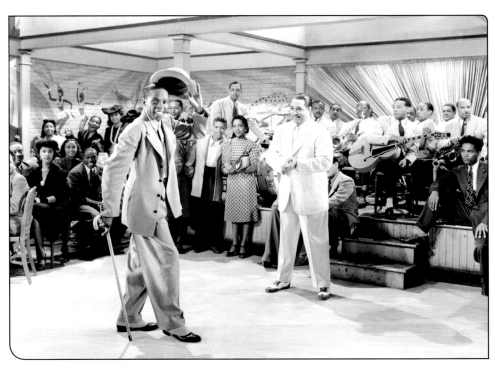

John "Bubbles" Sublett performs "Shine" as a dapper Duke Ellington looks on.

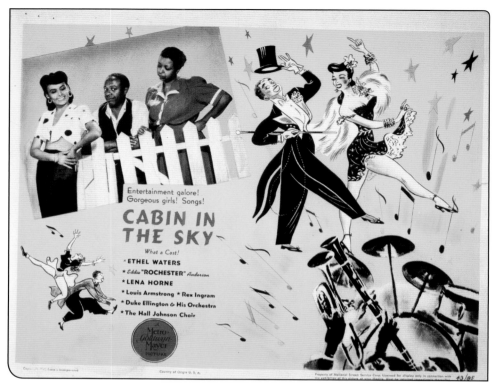

The Devil's crew: Louis Armstrong, Rex Ingram, and Mantan Moreland in *Cabin in the Sky*.

typing, but each remains among the most entertaining movies in the history of Hollywood. Aware that their appearances are a big moment—a time when their talents can be showcased—the African American performers are at their brilliant best in both films. And directors Minnelli and Stone let the talents of their casts shine to perfection. In *Stormy Weather*, the Nicholas Brothers, possibly the two greatest dancers in Hollywood, performed an energetic, dazzling climactic staircase number that took dance in cinema to new heights. Generation after generation has marveled over the sequence. In *Cabin in the Sky*, Ethel Waters, who clashed with Horne, fearful that the younger, slimmer performer was getting preferential treatment from Minnelli, sang "Happiness Is a Thing Called Joe," giving it a warm glow and a heartfelt sincerity, and in the climactic nightclub sequence, she danced up a storm and called a lie to Hollywood's long-standing edict that browner, heavier, older black women cannot be sexy! Ironically, despite Waters's success in the film, her on-set clashes and outbursts resulted in what she always believed was being blacklisted from movie work for six years.

For Lena Horne, there was pleasure in knowing that *Cabin in the Sky* and *Stormy Weather* lifted the spirits of black GIs on military bases where it was shown and where Horne became a pinup girl for black soldiers. But neither film propelled her movie career into a new direction. Her heart was set on playing the mulatto character Julie in MGM's 1951 remake of *Show Boat*. Though she performed numbers from *Show Boat* in *Till the Clouds Roll By*, the role of Julie in the 1951 version went to her friend Ava Gardner. That proved one of Horne's great career disappointments, and it may have forever left a bitter aftertaste. Not until 1969 did she play another dramatic role—in *Death of a Gunfighter* with Richard Widmark.

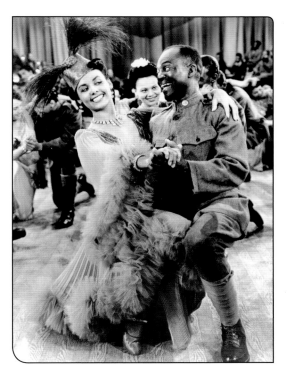

ABOVE: Horne and Bill "Bojangles" Robinson in *Stormy Weather*. BELOW: Cab Calloway

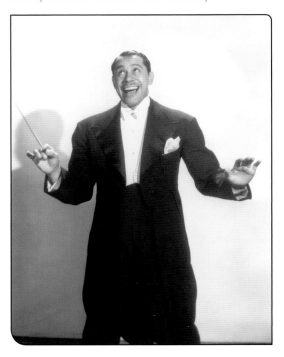

ABOVE: Fats Waller **BELOW:** Two of the greatest dancers in Hollywood history, the Nicholas Brothers—Fayard and Harold.

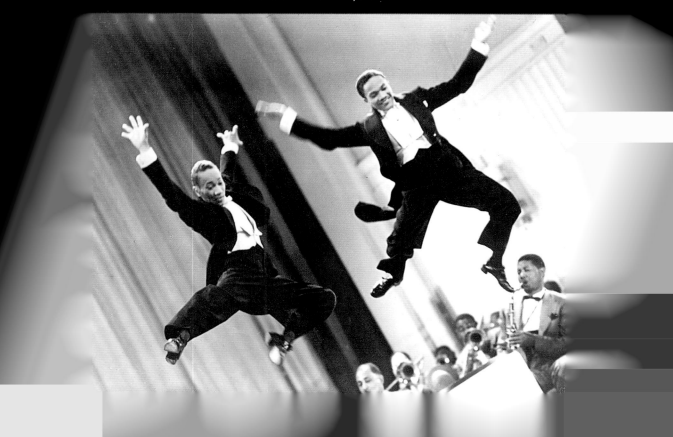

Hazel Scott

Still, in the 1940s, Lena Horne ushered in the image of an elegant, intelligent black woman. Curiously, sometimes on screen and off-screen in her smashing nightclub appearances, she also projected the image of an aloof, distant beauty (some felt she was gloriously icy) who could not be touched, who kept her pride and poise intact. "The image I chose to give is of a woman the audience can't reach and therefore can't hurt. They were not getting *me*, just a singer." That gave a generation of moviegoers a new and potent symbol, and certainly led the way for such stars as pianist/singer

Hazel Scott and choreographer/dancer Katherine Dunham, who appeared in musical interludes of films in the 1940s. Billie Holiday worked in Hollywood, too, in the 1947 pseudo-jazz film *New Orleans*. Here she was cast as a maid. But in her musical sequences with Louis Armstrong, she was magnificent, altering the whole rhythm and style of the film. In an unexpected manner, Lena Horne also helped clear the path for those great dramatic stars of the 1950s, Dorothy Dandridge and Sidney Poitier.

STEPS FORWARD

More serious depictions slowly crept up, especially and unexpectedly in two films—Michael Curtiz's *Casablanca* and John Huston's *In This Our Life*. In *Casablanca*, no moviegoer would ever forget Dooley Wilson as Sam, the man at the piano who sang what became a war-era favorite, "As Time Goes By." In this story of the cynical and disillusioned club owner Rick (Humphrey Bogart)—whose cafe in North Africa during the war serves as a hub for the shady and the corrupt as well as the desperate seeking passports, phony papers, and visas

that will enable them to escape Axis terrors and, if lucky, flee to the United States—the war becomes a tense backdrop for an ill-fated romance. At his café, Rick has a surprise reunion with a woman, Ilsa (Ingrid Bergman), whom he had loved and lost in Paris. Dooley Wilson's Sam, who had worked for Rick in Paris, is the only other character aware of the past love affair. Because he also understands the emotional pull and power that "As Time Goes By" has over Bogart's Rick (it is a song that both Ilsa and Rick felt summed up their love), Sam refuses

Dooley Wilson as Sam with Humphrey Bogart and Ingrid Bergman in *Casablanca*.

to perform it but finds that he must, first at Ilsa's request and later at Rick's command.

The relationship of Wilson and Bogart touched on Hollywood's *huck-finn fixation*: the black and white men who become close friends. It is a bromance of sorts. Usually, the white character is something of an outsider, a renegade, a loner, seemingly emotionally adrift. The black friend, who generally will be older, serves as a spiritual guide of sorts or a wise counselor for his white friend. (This was also a variant on the theme of interracial male bonding that later became so popular in American movies.) Sometimes race plays a thematic part in the exploration of that friendship, such as in the various adaptations of *The Adventures of Huckleberry Finn*. Other times race is a subtext with the movie steadfastly avoiding an open examination of the racial/cultural differences between the two men that must be bridged in order for them to truly bond. But as Wilson—his face tense and anxious—performed "As Time Goes By," audiences may have felt that no one understood Rick as well as Sam. Understated and unexplored as the huck-finn fixation was in *Casablanca*, it was there nonetheless and added to the film's appeal.

Initially, *Casablanca* producer Hal Wallis had considered both Lena Horne and Hazel Scott for the role of the piano player. Wilson's performance and persona, however, proved winning and were noted by the mainstream press. In *The New York Times*, Bosley Crowther wrote: "Mr. Wilson's performance as Rick's devoted friend, though rather brief, is filled with a sweetness and compassion which lend a helpful mood to the whole film." Wilson appeared in such other films as *Cairo*, *Higher and Higher*, and *Come to the Stable*. On the TV series *Beulah*, he played Ethel Waters's boyfriend, Bill Jackson.

A movie in which race as subtext rears its head mightily to the point where it endows the drama with its real distinction and power was John Huston's adaptation of Ellen Glasgow's Pulitzer Prize–winning novel *In This Our Life*. In some respects, the film version is enjoyable old-school melodrama. Bette Davis plays a destructive and spoiled young woman who steals her sister Olivia de Havilland's husband and causes her family much emotional turmoil. One evening—in a fit of anger—Davis recklessly drives her car and accidentally hits a mother and her daughter, then drives off. Later it's revealed that the mother was badly injured, but the child was killed. Afterward she pins the blame for the accident on the son of her family's loyal maid.

The audience learns some unexpected facts about the young man, played by Ernest Anderson. Mild-mannered, gentle, intelligent, and sensitive, he works diligently for the family but also is at the head of his class in school and has hopes of becoming a lawyer. He explains: "A white boy, he can take most any kind of job and improve himself. . . . But a colored boy can't do that. He can keep a job or he can lose a job. But he can't get any higher up. So he's got to figure out something he can do that nobody can take away. And that is why I want to be a lawyer."

Though *In This Our Life* doesn't state it explicitly, he believes in a new day for himself and his race. Yet, he says, his mother, Minerva (Hattie McDaniel), "is afraid for a colored boy to have too much ambition." Her worst fears seem confirmed when her son is falsely accused of the crime. Solemnly, McDaniel tells Olivia de Havilland's character: "Child, this seems hard to say but what Miss Stanley told the police about my poor boy, there ain't a word of truth, so help me." She also says when apprehended by the police her son, "tried to tell them [of his innocence]. But

Hattie McDaniel in one of her most sensitive performances in *In This Our Life* with Olivia de Havilland.

they don't listen to no colored boy." This is Hattie McDaniel in perhaps her most serious movie role. In her brief appearance, McDaniel infuses her character with a poignancy that is altogether convincing and compelling.

The subtext is: Minerva hoped for her son to have the opportunities denied her but now after having worked for this white family so many years, she feels ruthlessly discarded and betrayed by family member Davis. Here, without it being a race-themed drama, the black characters reveal their earnest endeavor to create substantive lives for themselves. Director Huston uses a different approach for his two story lines. The main narrative

is fast-moving, heated, a bit crazed, and also familiar. It's been portrayed in one way or another onscreen before. But the subplot is directed by Huston at a slower, reflective pace with an altogether new viewpoint. "This last, as a matter of fact," commented critic Bosley Crowther in the *New York Times*. "is the one exceptional component of the film—this brief but frank allusion to racial discrimination. And it is presented in a realistic manner uncommon to Hollywood, by the definition of the Negro as an educated and comprehending character. Otherwise the story is pretty much of a downhill run." *In This Our Life* foreshadowed the post-war race stories to come.

RACE MOVIES: 1940s STYLE

All the more aware of an audience in need of engrossing stories, independent race movies also provided energetic wartime entertainment. Still on the scene and as ambitious as ever was Clarence Muse, who starred in and co-wrote additional dialogue for 1942's *Broken Strings*. Here was a compact, enjoyable tale of a serious concert violinist who is a stern taskmaster for his two children and who, by the way, cannot abide the new jazzy swing music. His teenage son, of course, loves it. After suffering an injury that prevents him from performing, the father must alter his ways and, of course, his perspective on music. The role of the pretentious, snobbish father was perfect for Muse, who effortlessly makes his character vaguely

obnoxious yet somehow likable. *Broken Strings* ends with the violinist able to perform again and with a reconciliation with his children as well as a newfound respect for swing music. In its own way, *Broken Strings* commented on shifting generational tastes in popular culture within the African American community while revealing the way music can unite a family—and a community.

Because many race movies were now being filmed in and around Los Angeles, Hollywood's black stars or aspiring future stars worked in them. Some went back and forth from studio features to race movies, happy for the work at the studios and happy for a chance at other types of roles in the independents. A fresh-faced Dorothy Dandridge

Mantan Moreland in Hollywood's Charlie Chan mystery *The Shanghai Cobra* with Benson Fong (next to Moreland) and Sidney Toler as Chan.

turned up in the Fox film *Sundown* (1941), starring Gene Tierney, and as the charming island servant girl in *Bahama Passage* the same year. But away from Hollywood's soundstages, she starred with Niel Webster (sometimes billed as Pete) in the mystery *Four Shall Die*. Like other black performers, she also appeared in a series of "soundies": short films done to popular music of the time and which could be seen on devices similar to jukeboxes—precursors to music videos! Dandridge was the young dream

girl in the Mills Brothers soundie "Paper Doll," and appeared in "Moo Cow Boogie," "Yes, Indeed," and "Easy Street."

Mantan Moreland was featured as the chauffeur, Birmingham Brown, in the popular Charlie Chan mystery series at Monogram Pictures, but in the 1940s he also emerged as a star on the race movie circuit, heading the cast in such films as *Mantan Messes Up* and *Mantan Runs for Mayor*. His very name seemed to guarantee some kind of audience.

❖❖❖❖❖❖❖❖❖

During the war years and afterward, the most important of the race movie directors was Spencer Williams. Seemingly low-key and easygoing, he was actually enterprising and forward-looking, taking chances and usually getting results.

Throughout his long career, he wore different hats as an actor, writer, and director. Born in 1893 in Vidalia, Louisiana, he attended Wards Academy in Natchez, Mississippi, and then moved to New York, where he met and was mentored by Bert

Williams. He served in the military, and by the early 1920s, was in Hollywood, where he appeared in a brief bit in the 1928 Buster Keaton film *Steamboat Bill, Jr.* and played other small roles whenever the opportunity arose. Once sound came in, he wrote, directed, and starred in 1931's *Hot Biskits*. Williams also worked on two-reel black-cast comedies at Al Christie's studios—*The Melancholy Dame*, *Framing of the Shrew*, and *Music Hath Charms*. Later he wrote the screenplay for what is considered the first black horror film *Son of Ingagi* (1940) as well the script for *Harlem Rides the Range*, in which he also acted. Other acting credits included *Harlem on the Prairie*, *Two-Gun Man from Harlem*, and *Bronze Buckaroo*. As an actor, williams was always relaxed, casual, seemingly not doing much of anything. But he had the power to hold the screen and not get lost in a crowd of other magnetic performers. In essence, Williams had his own brand of charisma.

Then in 1941, he wrote and directed a film that acquired a reputation in later years, *The Blood of Jesus*, a tale of redemption and salvation. Opening with a riverside baptismal sequence of black churchgoers, signaling to viewers that this was a faith-based drama, *The Blood of Jesus* dramatized in a very straightforward, rather literal way the moral dilemma of a woman at the crossroads of her life. Williams himself played a well-meaning but rather errant husband, Ras, whose rifle accidentally fires and shoots his wife, Martha (Cathryn Caviness). As Martha lies in her bed, hovering between life and death, she undergoes a spiritual journey, indeed an awakening. An angel appears by Martha's bedside and transports her to another place and another life. Martha finds herself employed in a juke joint, a den of iniquity, which leads to a battle for her soul between heaven (represented obviously by the angel) and hell, personified by a character named Judas Green, an emissary of Satan (played by James

The Blood of Jesus

B. Jones). Ultimately, Martha is pursued by a mob that believes she is a thief. Waiting for her at the crossroads between heaven and hell is Satan himself. The crowd stones her. But a voice is heard saying to let he who is without sin cast the first stone. Then in a striking sequence, an unconscious Martha lies at the foot of the cross of the crucified Jesus. There, the blood of Jesus literally falls onto her face. *The Blood of Jesus* then cuts to Martha as she reawakens in her bed to a husband thankful that his wife's life has been saved. It's a second chance for both. It might be easy to dismiss the film as corny, clumsy, and far too literal, but somehow the urgency and sincerity of the production carry the sequences (especially with the angel and then the cross) and the film itself to a new height.

Shooting his movie in Texas on a shoestring budget of $5,000, Williams worked with an inexperienced cast of locals. As was true of many independents, he obviously did not have the finances to reshoot scenes, nor to use lighting and editing, to polish the scenes to glowing perfection. Sometimes the acting is so strained as to be distracting (and embarrassing) yet the non-actors clearly believe in

the material, and that belief sustains their scenes. Music also adds to the film's effect: "Give Me That Old Time Religion," "Were You There When They Crucified My Lord," "I've Heard of a City Called Heaven," and "Swing Low, Sweet Chariot." Williams's passionate connection to his material also elevates *The Blood of Jesus*, making it a totally unique and inspirational piece of filmmaking and leaving an indelible mark on a moviegoer. Clearly, *The Blood of Jesus* was made for an African American audience in search of more meaningful movie-going fare. The film was a hit with African American audiences, notably in the South, and remains a wholly original piece of work.

Much the same was true of another Williams-directed 1944 film: *Go Down Death*. Here, too, was a story in which religion—and the forces of good and evil—was at the core of its meaning and its strange inspiration. A third now lost film in what might be viewed as Williams's religious trilogy was the 1942 *Brother Martin: Servant of Jesus*.

In many respects, Williams's dramas anticipated later faith-based movies like *The War Room* (2015) that a segment of black moviegoers would respond to strongly—and perhaps to some sequences in the films of Tyler Perry with their lopsided tales of redemption, or some of those of Bishop T. D. Jakes, such as 2004's *Woman Thou Art Loosed*.

Williams directed other films: *Of One Blood, Marching On, Dirty Gertie from Harlem, USA* (which starred his wife, Francine Everett, in a replay of Somerset Maugham's *Rain*), *The Girl in Room 20, Beale Street Mama,* and his last film, the deliriously enjoyable *Juke Joint* (1947). Williams retired from show business, or so he had assumed, until he learned of a casting call for a role in CBS's television series *Amos 'n' Andy*. He won the part of Andy Brown, and despite the controversy surrounding the stereotyped images in the series, Williams kept his dignity intact and brought to Andy Brown a mild-mannered air and a light touch that balanced the mood.

<div style="text-align:center">◇◇◇◇◇◇◇◇◇◇◇◇◇</div>

During this decade, other African Americans worked successfully behind the scenes. In 1944, the documentary *The Negro Soldier* appeared, with a script by black writer Carlton Moss, who worked closely with director Stuart Heisler under the supervision of Frank Capra. A wartime effort intended to encourage African Americans to enlist and fight for their country, *The Negro Soldier* opened with a black minister (played by Moss) preaching a sermon in which he salutes the achievements of African Americans—from military heroes (such as Crispus Attucks in the Revolutionary War) to educators (Booker T. Washington), scientists (George Washington Carver), singers (Marian Anderson), musicians, lawyers, and doctors. In some respects, it celebrated black excellence. In other respects, it celebrated the black soldier and his/her contributions to the fight for freedom.

Production on the film had not gone smoothly for Moss. There was a concerted effort by the American war office that the film not be incendiary, that it in essence should soften any suggestion of deeply ingrained racism in American life. Once it was completed, a general, who wanted changes, had asked Capra: "Who is going to see the Negro picture?" Though the script was toned down, the film was still an effective, admirable piece of work. When screened in Harlem, *The Negro Soldier* was praised by Richard Wright and Langston Hughes. Originally, the film was to be exhibited only in black movie houses in the South. But the response was so enthusiastic that it was shown in the North

The Negro Soldier, spotlighting black achievements.

and the West, too. White audiences watched it. In its own way, *The Negro Soldier* contributed to an image change for African Americans in films.

WARTIME AND POST-WAR BATTLES

As the Negro press urged for better roles and stories for African Americans, there was a heightened awareness that Hollywood's depictions of African Americans would have to change. Fearing they would lose work, some black actors who played comic servants were unable to envision an industry that would provide them with any other types of roles. Lena Horne understood those fears and spoke of the resentment against her from some of Black Hollywood's old-guard. But Horne also was quick to point out that one of her defenders was Hattie McDaniel. In 1943, McDaniel requested that the Screen Actors Guild form a committee to discuss problems faced by black performers. That same year, Lena Horne became the first African American to serve on the board of the Screen Actors Guild. Also joining the board was actor Rex Ingram. Actor Joel Fluellen

also urged the Guild to abandon its way of casting of minorities. By 1947, when Ronald Reagan replaced actor Robert Montgomery as president of the Screen Actors Guild, Louise Beavers had become a board member. Character actor William Walker also served on the board.

An anti-discrimination committee was formed in 1946. Actress Marsha Hunt recalled that the committee, which later included Clarence Muse, Betsy Blair, and Boris Karloff, urged the studios "to show that not all blacks were servants, not all Filipinos houseboys, not all Chinese ran laundries, not all Japanese were gardeners, not all Indians had been scalpers, not all Italians were gangsters."

By the time World War II had ended, on September 2, 1945, the demise was in sight for the old-style servant characters, although in one form or another, African Americans in Hollywood

Lillian Randolph as the composed housekeeper Bessie, with Myrna Loy in *The Bachelor and the Bobby-Soxer*.

would still face stereotyped and distorted roles. But the most blatant and embarrassing roles would fade. Even in the servant roles that still existed, care was taken to create less caricatured figures. At the opening of 1947's *The Bachelor and the Bobby-Soxer*, Lillian Randolph as the maid Bessie—for the sisters played by Myrna Loy and Shirley Temple—is a composed, poised, intelligent professional who keeps the household running and in order. The same could be said years later of the performances of Marietta Canty and Maidie Norman, respectively, in the cult classics *Rebel Without a Cause* (1955) and *What Ever Happened to Baby Jane?* (1962). Each is a voice of heroic reason.

Still, resistance to change sprang up among some Hollywood power players who preferred the submissive, gentle characters. Gossip columnist Hedda Hopper fought to see that black actor James Baskett be awarded an honorary Oscar for his performance as Uncle Remus in the 1946 Disney production *Song of the South*. In this partly animated, mostly live action feature, Remus's primary concern in life appeared to be comforting a troubled white child (Bobby Driscoll). As Remus joyously sings "Zip-A-Dee-Doo-Dah" and tells his little white plantation buddy about the adventures of Joel Chandler Harris's character Brer Rabbit, moviegoers indeed marveled over seeing animated images swirl around him. But this happy-go-lucky, contented servant was for many in the post-war era an embarrassing relic. Baskett, however, walked off with his honorary Oscar. But the movie proved controversial. There were protests. Even after its initial successful run, Disney kept it out of circulation for more than thirty years.

New images appeared in Robert Rossen's

Body and Soul starred John Garfield as a young boxer caught in the sometimes corrupt world of professional boxing. One of his opponents in the ring is an exploited punch-drunk fighter played by Canada Lee—a sensitive, sympathetic figure that was hardly the butt of jokes.

Though the studios still avoided alienating the Southern market, the plantation drama, which the industry had long been so fond of, occasionally underwent a shift as darker, more disturbing visions of the antebellum South started to emerge, as in the 1947 adaptation of African American writer Frank Yerby's novel *The Foxes of Harrow*. In *The Foxes of Harrow*, Yerby paused to draw a more realistic portrayal of some aspects of slavery. The movie version, which Twentieth Century-Fox had reportedly purchased for the sum of $150,000, was directed by John Stahl with a script by Wanda Tuchock. Attention was paid to the plight of a proud, defiant slave woman, Belle (Suzette Harbin). Her husband Achille (Kenneth Washington) is the trusty slave of the plantation's master (Rex Harrison). Upon learning that her newborn son has been selected to be the playmate—actually, the personal childhood slave—of the plantation owner's young son, a horrified Belle proclaims that her child is born of royalty. Rather than see her son enslaved, she attempts to drown him. The child is rescued. Belle, however, dies in the river. Though far too short and far too undeveloped, this was a startling sequence in the history of plantation dramas. "One passage where one of the slaves on Harrow's plantation declaims that her newborn is not going to grow up into slavery but be a warrior son," noted *Variety*, "is likely to run into difficulties in many Southern states." Interestingly, neither Suzette Harbin nor football star Kenneth Washington received billing in the film.

<hr />

As changes slowly came to Hollywood features, race movies technically looked better and had relaxed storylines without an emphasis on social problems. The 1946 *Sepia Cinderella* starred singer Billy Daniels as a bandleader struggling to get to the top of the music world. Moviegoers may have been caught off-guard by a cameo appearance by former MGM child star Freddie Bartholomew, who shows up as a patron in a nightclub sequence. No one has ever been able to say how or why he came to be in the picture. But there he was. The 1948 mystery/crime drama *Miracle in Harlem* starred William Greaves and Sheila Guyse, along with other familiar names from race movies of the '40s, as well as from earlier independent films: Ken Freeman, Monty Hawley, Sybil Lewis, and Lawrence Criner. A surprise was an appearance by Stepin Fetchit, playing a character called Swifty. Basically, Fetchit was still doing what he had done decades earlier. But in an all-black context, he appeared funny rather than demeaned. In 1948, Oscar Micheaux's last film, *The Betrayal*, opened at a downtown New York theater, perhaps indicating a new phase in Micheaux's career with the possibility of going mainstream. But the film received poor reviews and soon disappeared. Two years later, the filmmaker died in Charlotte, North Carolina.

During the war years, William Alexander, who landed a job with the Office of War Information in Washington, D.C, had begun directing newsreels that focused on African American military personnel. Under Alexander's supervision, some 250 newsreel episodes were also produced as part of *All-American News*, a bold endeavor that documented

events and personalities that otherwise would have been lost to us. After the war, William Alexander settled in New York, where he founded Associated Film Producers of Negro Motion Pictures. Among the feature films he produced were the 1948 *The Fight Never Ends*, which starred Joe Louis as himself opposite a young New York actress, Ruby Dee. He also made *Souls of Sin* (1949) again starring the young Ruby Dee and William Greaves. Alexander was launching a new wave of race movies—-sadly, at a time when the race movie movement was about to end.

In the years to come, such Hollywood films as *The Harlem Globetrotters*, *The Well*, *Bright Road*, *Red Ball Express*, *St. Louis Blues*, even *Carmen Jones* and Spike Lee's breakthrough feature *She's Gotta Have It* would bare the positive mark of past race movies. Filmmakers sought to reach their audience in an entertaining and thoughtful way—contextualizing their films with African American cultural signs, markers, references, and signifiers. The African American actors and actresses also relate to one another in a communal way in terms of their rhythms and signals to each other in certain scenes. Hollywood seemed to understand, without openly acknowledging, that there was an audience for such films. But the industry still clearly believed that the audience was limited, and thus such films were commercially risky and had to be shot on low budgets.

THE NEGRO PROBLEM PICTURES

By the late 1940s, the traditional independent race movies made outside the studio system rapidly ceased production. What may have really led to the race movie's demise was that Hollywood began to tackle more provocative themes that examined long-ignored and festering social issues and problems indicating that something was eating at American society. That was apparent in such movies as Edward Dmytryk 's *Crossfire* and Elia Kazan's 1947 Oscar-winning *Gentleman's Agreement*, which focused on anti-Semitism. Then 1949 marked the release of a quartet of riveting dramas *Home of the Brave*, *Lost Boundaries*, *Intruder in the Dust*, and *Pinky*—that placed black/white conflict front and center, all arriving just at the dawn of the civil rights movement.

These four "Negro Problem Pictures" proved startling. Working in secret, young producer Stanley Kramer and director Mark Robson brought to the screen Arthur Laurents's play *Home of the Brave*, which had focused on anti-Semitism in the armed forces. Kramer and Robson turned it into a tale of racism directed against an African American soldier. On a special mission with other soldiers, the black man endures racial taunts and slurs, which lead to his mental breakdown—and his ultimate realization that even before the military experience, much of his life had been spent as the target of racism. In the star-making role of the soldier was actor James Edwards.

Louis de Rochemont's independent production *Lost Boundaries*, based on a true story, recounted the experiences of a young light-skinned Negro doctor and his light-skinned black wife (played, respectively,

by white performers Mel Ferrer and Beatrice Pearson), who move to a small white community in New England. There, in search of opportunities, he sets up a successful medical practice as the two pass for white, and even raise their two children as such. When their deep, *dark* secret is revealed, their otherwise placid community is thrown into turmoil and must examine itself. Though most of the cast in this Problem Picture was white, a standout was the refreshing young African American actor William Greaves in a supporting role. Having already appeared in theater productions and as a lead in the last wave of race movies, Greaves looked as if he might be poised for movie stardom, just as James Edwards did, but big roles did not come. Greaves gave up his acting career (much too soon, really) to become an esteemed documentary filmmaker. Edwards acted in movies and TV throughout the 1950s and 1960s, until his death in 1970.

Of the Negro Problem Pictures, perhaps most unflinching was the 1949 MGM release *Intruder in the Dust*, based on William Faulkner's novel and directed by Clarence Brown. Many were surprised that MGM, the studio that prided itself on presenting a wholesome brand of entertainment, released this hard-hitting film. Also surprising was Brown at the helm. No one could ever question the talent of this director, whose well-made and engrossing films had featured such major stars as Garbo, Crawford, Gable, and the young Elizabeth Taylor in *National Velvet*. But in *Intruder in the Dust*, he stretched his creative muscles and crafted an emotionally involving and racially provocative film that examined racism in the deep South.

James Edwards, Lloyd Bridges, and Frank Lovejoy in *Home of the Brave*.

When a black man, Lucas Beauchamp, is wrongly accused of having killed a white neighbor, some in the community want to lynch him. The man himself, played magnificently by Juano Hernandez, refuses to be cowed by the community's racism. He's so assured that he doesn't feel compelled to prove his innocence. Ultimately, he makes the community examine itself, as in *Lost Boundaries,* but in a far deeper manner. Such white actors as Claude Jarman Jr., Elizabeth Patterson, Porter Hall, and Will Geer gave fine performances. The movie was shot in Faulkner territory—Oxford, Mississippi. Real townspeople played roles. It was reported that director Brown was drawn to the Faulkner novel because he himself had once witnessed a lynching in Atlanta.

Hernandez's performance was uniformly praised. Born in Puerto Rico, Hernandez had begun his career in such race movies as Micheaux's *The Girl from Chicago* (1932) and *Lying Lips* (1939). Later he appeared in such films as *Young Man with a Horn, Breaking Point, Stars in My Crown,* and, most startlingly, in Sidney Lumet's *The Pawnbroker,* which starred Rod Steiger. But like James Edwards, Hernandez never had the kind of stardom that his talent deserved. Though the *New York Times* named *Intruder in the Dust* one of the year's best films and though it was praised abroad, MGM studio chief Louis B. Mayer disliked the film and did nothing to promote it.

Twentieth Century-Fox's *Pinky,* directed by Elia Kazan, also focused on racism in the South. Here was the story of a light-skinned young black woman called Pinky (played by white actress

Juano Hernandez as the proud Lucas Beauchamp in Clarence Brown's *Intruder in the Dust*.

Jeanne Crain) who, having studied in Boston, where she has passed for white, returns home to the South to see her grandmother, played by Ethel Waters. She also has had a love affair with a white doctor who wants to marry her. But now as a black woman in the South, she is subjected to repeated humiliations. She must decide if she will remain in the South or if she will deny her racial heritage and return North.

Pinky was a troubled production that was a great challenge for Ethel Waters. After her complaints and outbursts on the set of *Cabin in the Sky*, she said she learned that in Hollywood you could win the battles but lose the war. Afterward, Waters went for six years without a movie role. It was true that word had spread in the film capital of her difficult personality.

Despite all her experience, Twentieth Century-Fox had her test for the film. Originally, *Pinky*'s director was John Ford, but he and Waters clashed. Fox chief of production, Darryl F. Zanuck, was impressed enough with Waters that he took Ford off the picture and replaced him with Elia Kazan. "Ford's Negroes were Aunt Jemima. Caricatures," said Zanuck. "I thought we were going to get into trouble." Kazan had reservations about the film. He felt that white actress Jeanne Crain as Pinky was wrong for the part; she seemed disconnected from her character. The casting of a white actress in this role was the film's greatest dishonesty. The same had been true of *Lost Boundaries*. Interestingly, later Kazan felt that disconnection somehow became appropriate for the character, who is torn between two worlds: white and black. Kazan, however, had

no major problems with Waters. She appeared to need a director who took her seriously. In the end, she turned in a sensitive characterization, though the conception of the role as written retained the familiar devoted servant traits. Nonetheless, *Pinky* became the most successful of the Negro Problem Pictures, with a cast that also included an older Nina Mae McKinney, Ethel Barrymore, and Frederick O'Neal. *Pinky* garnered three Oscar nominations—for Best Lead Actress (Jeanne Crain), and two Best Supporting Actress nominations, for Ethel Barrymore and, most significantly, Ethel Waters. Though *Pinky* won no awards in those categories, Waters had become the first African American nominated for an Oscar since ten years earlier when McDaniel won for *Gone with the Wind*.

All four films had compromises. In a covert manner, they still relied on modified stereotypes, such as the tragic mulatto and the mammy. Also promoted was an idealized theme of racial reconciliation and unity between black and white—when, in reality, off-screen racial tensions would soon build and escalate. Nonetheless, Hollywood had an awakening. Ralph Ellison said, "they are all worth seeing, and if seen, capable of involving us emotionally. That they do is testimony to the deep centers of American emotion that they touch." The studios now also acknowledged that black performers could be cast in serious, dramatic leading roles, and that movies could reflect racial dynamics (even if compromised) in the nation. The 1934 *Imitation of Life* had *suggested* there was a race problem in America. The Negro Problem Pictures indicated there *was* a race problem in the country and led the way to others that would come in the next decade.

Ethel Waters in her Oscar-nominated Best Supporting Actress role in *Pinky* with Jeanne Crain.

CHAPTER
4

THE 1950s

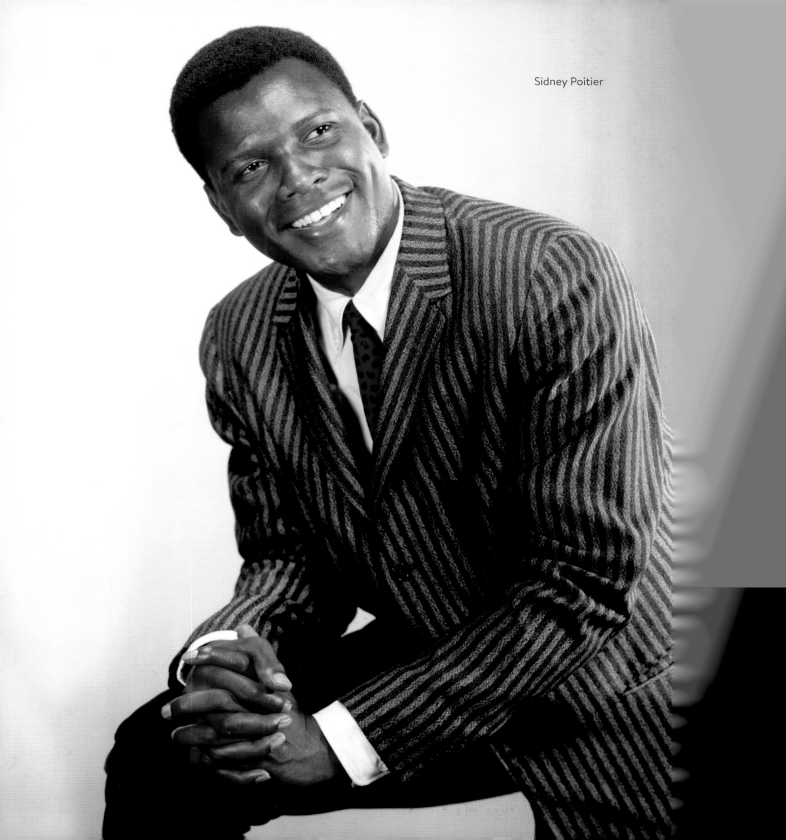

Sidney Poitier

NEW ON THE SCENE: SIDNEY POITIER

In the 1950s, as the Truman era drew to a close and the Eisenhower decade began, Hollywood's race-themed movies continued. Black actors and actresses were cast in more dramatic roles. During the era, the political landscape also shifted, putting some careers in jeopardy. On occasion, movies reflected the political paranoia and societal conformism that gripped part of America. Yet films also revealed sparks of rebellion and discord. As the decade progressed, the emerging civil rights movement affected the perspective and characterizations in mainstream films. Interestingly enough, the era's important movies were tied to the new generation of black stars.

Appearing at the opening of the new decade was a New York actor making his Hollywood debut, Sidney Poitier. Born in 1927 in Miami of Bahamian parents, growing up on his family's farm on Cat Island, and the youngest of the couple's eight sons, he fell into acting almost as a fluke. After having briefly served in the army, Poitier moved to New York where he worked a variety of odd jobs, unsure what to do with his life. When he saw what he thought was an advertisement for the American Negro Theater in the black newspaper *The Amsterdam News*, he decided to audition. This was the theater company that trained a new postwar generation of black actors and actresses who would soon work in movies, television, and theater: Ruby Dee, Ossie Davis, Harry Belafonte, Isabel Sanford, Hilda Simms, and both Earle Hyman and Clarice Taylor, who later played the parents of Cliff Huxtable on TV's *The Cosby Show*.

They marked a new style of acting, with dramatic roles as their goal. At the American Negro Theater, they were sticklers for stage technique and seriousness. With no acting experience whatsoever, Poitier auditioned and was just about laughed out of the theater, in part because, frankly, he didn't know what he was doing and in part because of his thick West Indian accent.

That rejection sparked something in the young Poitier who, oddly enough, had found his calling. Thereafter, he studiously worked to rid himself of his accent. He listened continually to the radio to learn to speak "American." He rehearsed and studied—*and* rehearsed and studied. Perhaps even he was surprised by his own discipline and focus. He returned to the American Negro Theater, won roles, appeared in an army training film, and then, against all odds, was cast in a lead role in Twentieth Century-Fox's *No Way Out* (1950), directed by Joseph L. Mankiewicz. Portraying a young doctor who withstands the racist slurs of a young white thug (played by Richard Widmark)—who is his patient—Poitier projected (like those actors of the Negro Problem Pictures) a new image for African Americans in the movies: here was an intelligent, disciplined, dignified young black man, who lives by a code of fundamental decency and integrity—and is clearly prepared to make his way into a changing, soon-to-be-integrated American society.

With a cast that included Linda Darnell, Ruby Dee, Ossie Davis, Mildred Joanne Smith, Amanda Randolph, and Stephen McNally, *No Way Out* presented post-war images of educated young African Americans preparing themselves for a new day in America. On occasion, the film slipped into the

trap of modified old images. As the faithful servant to a liberal white doctor, Amanda Randolph was comforting and motherly, ever ready with a smile and nurturing warm advice for the white characters around her. She even has a glass of milk to nourish her employer after he has had a long, demanding day at work. Randolph plays her character well but in this film one wishes she had been given something else to do and say.

At the same time, *No Way Out* explored the racial conflicts that were rising to the surface in post-war America, particularly its big cities. During the war years, race riots had erupted in Detroit, Harlem, Mobile, Alabama, and other cities. But the movies had ignored such unrest and uprisings. *No Way Out*, however, had a striking sequence when the city has a clear black/white confrontation. Director Mankiewicz said that "it was the first time racial violence was shown on-screen—except for *The Birth of a Nation*—in modern times." Conscious of recent racial explosions in their city, Chicago censors demanded that Fox delete "charged scenes showing blacks (with clubs) and whites (with chains and broken bottles) preparing for combat." Censorship boards in Pennsylvania, Virginia, and Ohio also objected to the race riot scenes. Poitier's character, Luther, represents the voice of reason. For later generations, Poitier's character in *No Way Out* (and other films) might appear too noble and idealized. But for moviegoers of the time, he appeared to be the model actor just as the civil rights movement was about to take off. Poitier also had the closing line of the film. Having saved the life of the racist who has tormented him, he says: "Don't cry, white boy. You're gonna live." That line still resonates.

Still, stardom did not come easily for Poitier. After *No Way Out*, the movie studios were not pounding down his door with offers. Through the suggestion of Joseph Mankiewicz, however, director Zoltan Korda tested and cast him, along with actor Canada Lee, in the screen adaptation of Alan Paton's acclaimed novel about racial discrimination in South Africa, *Cry, the Beloved Country* (1951). Because of the apartheid laws in South Africa, where *Cry, the Beloved Country* was filmed, both Poitier and Lee entered the country under the guise of being indentured servants to the film's director. Lee played a priest from the countryside who journeys to Johannesburg in search of his troubled son. What he finds is a city divided by rigidly drawn racial lines where most blacks live in unrelenting hardship and abject poverty. His ally in his quest to find his son is a young priest played by Poitier. With a cinematic style that was part naturalistic and part gritty realism, *Cry, the Beloved Country* had a tragic grandeur and power that the American-made Negro Problem Pictures pictures—despite their significance—had lacked. Like the American films, though, it too promoted a theme of racial reconciliation. It also had fine, sensitive performances.

But the emotional center of *Cry, the Beloved Country* was Canada Lee. His career at this time also indicated a change in the post-war political climate. Born in 1907 in New York, Lee had traveled many a road before becoming an actor. At various times, he was a jockey, a musician, a boxer. Once he turned to acting, he was praised for his stage performances: as Banquo in Orson Welles's 1936 Federal Theatre Project production of *Macbeth*, set in Haiti with an all-black cast and sometimes called *Voodoo Macbeth*; and in 1941, as Bigger Thomas in Welles's stage adaptation of Richard Wright's novel *Native Son*. He had also worked in the 1939 race movie *Keep Punching*, starring black boxer Henry Armstrong; and in dramatic roles in such Hollywood productions as Hitchcock's *Lifeboat*, Robert Rossen's *Body and Soul*, and *Lost*

Sidney Poitier and Canada Lee in *Cry, the Beloved Country*.

Boundaries. In *Cry, the Beloved Country*, Lee looked worn, weary, almost defeated by life, yet possessing an unshakable moral authority. When he witnesses the way Johannesburg has eaten at the moral fiber of his sister and how it has beaten his son, his eyes communicate the fears and despair of a man who has seen too much. There is not a false moment in his brilliantly calibrated characterization.

Though acclaimed at the Cannes Film Festival, *Cry, the Beloved Country* had a limited release in the United States. It was Canada Lee's last film. Plagued during the years of the growing anti-communist witch hunts, which affected many in the entertainment community, Lee found himself blacklisted because of his relationships with associates and friends suspected of being communists. Unable to find work, suffering financial difficulties, and in poor health, Lee died in 1951. He was forty-five.

As one of those great unheralded actors, Lee was also a hero for the young Poitier.

Other African American performers were affected by the blacklist. Listed in *Red Channels*, a publication that cited the names and political activities of performers viewed as either communists or communist sympathizers, were Lena Horne, Fredi Washington, and Hazel Scott. Before being contracted to do an important film, Poitier was asked to repudiate Paul Robeson. Dorothy Dandridge was asked to sign a loyalty oath before MGM would sign her to star in *Bright Road*. She refused, but she was compelled to write a letter to explain some of her political activities. In retrospect, many careers of both blacks and whites—actors, actresses, writers, directors—were severely impeded, damaged, or destroyed during the rise of McCarthyism.

ON A ROLL: ETHEL WATERS

Following her Oscar-nominated success in *Pinky*, Ethel Waters had a remarkable roll. Her autobiography, *His Eye Is on the Sparrow*, published in 1951 became a national bestseller. Most importantly, she was critically acclaimed for her performance as the one-eyed cook Bernice in the Broadway production of Carson McCullers's *The Member of the Wedding*. Soon she was back in front of the cameras in Hollywood for the film adaptation. Directed by Fred Zinneman, Waters was cast along with the other two stars of the Broadway version, Julie Harris, as troubled teenager Frankie, and a young Brandon de Wilde as the little boy, John Henry. In the conformist 1950s, the production might best be described as an oddball drama about nonconventional outsiders—the cook, Bernice, and the two lonely white children she cares for— who find comfort in the presence of one another.

In a powerful monologue, shot mostly in close-up, Waters's Bernice speaks of the man she loved and lost. Rarely had a film gone this emotionally close to a particular black woman's internal torment. As in the play, a memorable moment occurs when Waters seats the children on her lap as she sings what became her signature song "His Eye Is on the Sparrow." In its own way, *The Member of the Wedding* captured some of the alienation, loneliness, and growing fires of rebellion of the era—much as such other films as *Rebel without a Cause*, *East of Eden*, and *The Wild One* did, each in its distinct way. Though the character of Bernice still exhibits characteristics of the nurturing, all-knowing mammy figure, Waters delivered a powerful performance. There was talk that she would be nominated for an Oscar again, but it didn't happen. Throughout the decade, Waters worked in television as the star of the series *Beulah* and dramatic productions and then as Dilsey in Martin Ritt's 1959 film adaptation of William Faulkner's *The Sound and the Fury*. Later generations would be unaware that for a time, Ethel Waters was possibly the most famous African American actress in the country.

Ethel Waters and Julie Harris in *The Member of the Wedding*.

DOROTHY DANDRIDGE: MOVIE STAR

No African American actress, however, had a greater impact on moviegoers than the high-voltage Dorothy Dandridge. The second daughter of a draftsman, Cyril Dandridge, and his ambitious, show business–obsessed wife Ruby Dandridge, Dorothy was born in 1922 in Cleveland, Ohio. She and older sister Vivian were brought to Los Angeles by Ruby in the early 1930s. The girls had already appeared in an act called "The Wonder Children." But now Ruby had other ideas. No doubt, it sounded preposterous at the time, but she wanted to get her daughters into the movies.

Through perseverance and unadulterated drive, Ruby hit the studios and casting offices, looking for work for her daughters as well as for herself. Ruby fashioned a successful career of her own, playing comedy roles in such films as *Midnight Shadow*, *Cabin in the Sky*, *Dead Reckoning,* and *A Hole in the Head,* and providing voices for the black cartoon *Coal Black and de Sebben Dwarfs.* She teamed her daughters with another girl named Etta Jones in a singing trio known as the Dandridge Sisters. Together they performed in such movies as the Marx Brothers' *A Day at the Races*, in which Duke Ellington's favorite vocalist Ivie Anderson also performed; and *Going Places*, which starred Dick Powell with spectacular appearances by Louis Armstrong and singer Maxine Sullivan. As a girl, Dorothy's burning ambition was to be a dramatic film actress.

In the 1940s, she did bits—walk-ons, really—in films including the Alan Ladd–starrer *Lucky*

Comedienne Ruby Dandridge—the mother of Dorothy— with Marjorie Main in *Tish*.

Jordan and David Selznick's *Since You Went Away.* She found supporting roles or musical numbers in such movies as *Lady from Louisiana*; *Bahama Passage*; *Hit Parade of 1943*, in which she performed with Count Basie's band; and *Atlantic City* and *Pillow to Post*, both of which featured her in giddy numbers with Louis Armstrong. Dandridge's most memorable early appearance was in *Sun Valley Serenade* (1941), in which she performed "Chattanooga Choo Choo" with the Nicholas Brothers. No film fan has ever forgotten her as a dream girl with the brothers.

In 1942, Dandridge and Harold Nicholas married. With stellar acrobatic flips, splits, and dazzling taps in such films as Twentieth Century-Fox's

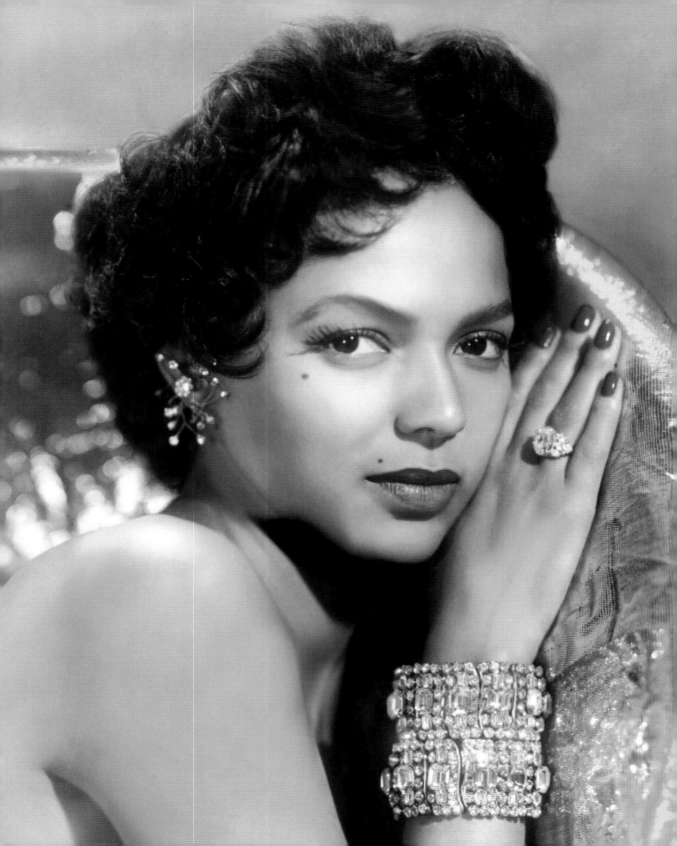

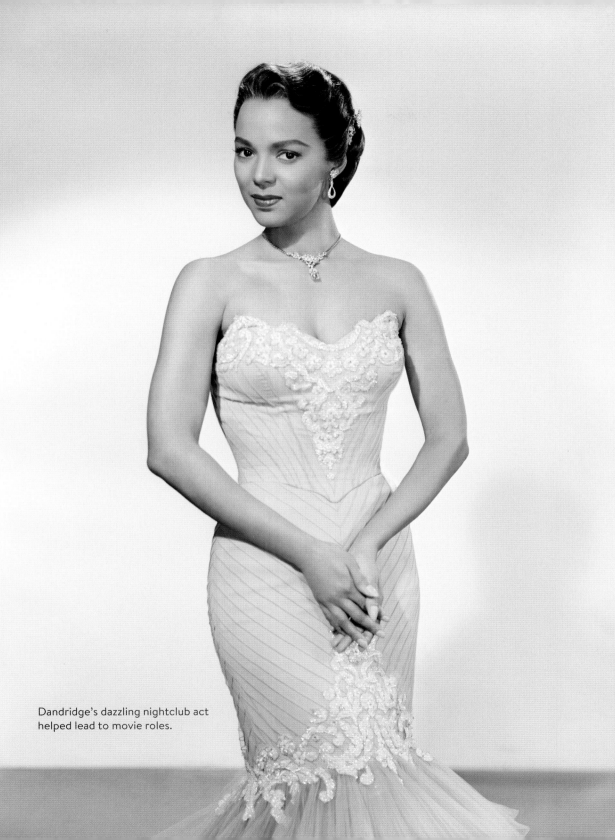

Dandridge's dazzling nightclub act
helped lead to movie roles.

Down Argentine Way, *Tin Pan Alley*, and *Stormy Weather*, the Nicholas Brothers were among the greatest dancers to ever work in American motion pictures—and they never played servants. For Black Hollywood, Dandridge and Nicholas were a dream couple, but the marriage was fraught with tensions. When Dandridge learned that their only child, Harolyn, had been born brain damaged and would never be able to speak or develop mentally, it was a heartache from which she never fully recovered. Her troubled life was known to African American moviegoers and became a part of her legend.

Once Dandridge and Nicholas divorced, she channeled all her energies and her frustrations into her career. At the progressive acting school, the Actors Lab in Los Angeles, she became one of the institution's first black students. She was also a part of a more socially integrated Hollywood. The same was true of Lena Horne. One of Dandridge's classmates at the Lab was another actress working to perfect her craft, Marilyn Monroe. The two became friends.

Training with the African American vocal coach and composer/arranger Phil Moore—who at various times worked with Lena Horne, Marilyn Monroe, Ava Gardner, and Frank Sinatra, among others—Dandridge created a nightclub act that played to packed houses in Las Vegas, New York, Los Angeles, and other US cities, as well as in Havana, Rio de Janeiro, São Paulo, and London.

Searching for film roles, she caught the eye of moviegoers in a trio of low-budget films. In *Tarzan's Perils*, she played an African queen who was kidnapped by an African chieftain but rescued by mighty Tarzan, played by Lex Barker. In close-ups as Barker's Tarzan and Dandridge gazed into one another's eyes, the king of the jungle appeared to have interests other than his mate Jane. Here were suggestions of an interracial romance that

ABOVE: Dandridge with Billy Brown (next to her) in *The Harlem Globetrotters*. **BELOW:** Dandridge as the jungle queen Tarzan couldn't take his eyes off in *Tarzan's Peril*.

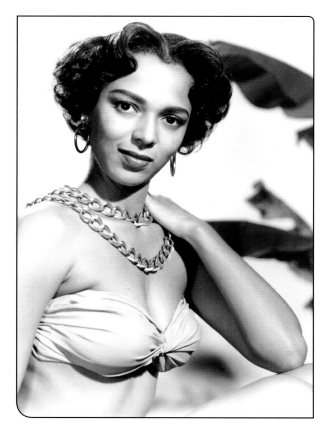

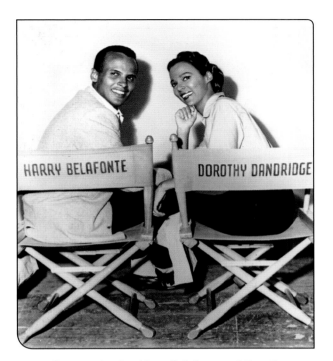

Stars on the rise: Harry Belafonte and Dorothy Dandridge in *Bright Road* in 1953.

the studio didn't dare explore. But audiences were titillated. *Variety* commented that the character Jane, "has only a few scenes. There's more emphasis on Dorothy Dandridge, queen of the tribe that is saved by Tarzan." *Ebony* magazine put her on the cover with the banner: "Hollywood's Newest Glamour Queen."

Dandridge also appeared as the young wife of a basketball player in Columbia Pictures' *The Harlem Globetrotters*, which dramatized the exploits of the legendary black basketball team. In some respects, this mostly black-cast film was a studio-style race movie. "Commercial possibilities are obvious, either in the regular twin bill market or for special handling to attract eager fans or colored audiences," *Variety* wrote about the film. "Its outlook is profitable, film being turned out at a nominal enough budget to permit extra outlay for pushing." The same was no doubt true of MGM's

mostly black-cast *Bright Road*, a drama about a teacher (Dandridge) trying to reach a wayward elementary school boy (Philip Hepburn). Also starring in the film was Harry Belafonte and, in a small role, Vivian Dandridge. In the opening scene of *Bright Road*, MGM gave Dorothy a stunning star buildup: she walks through the door of a classroom, looking gorgeous, as moviegoers heard in voiceover, "I'm Dorothy Dandridge." MGM also put her in a musical segment—singing "Taking a Chance on Love"—in the 1953 feature film *Remains to Be Seen*, starring June Allyson and Van Johnson.

Clearly, MGM, which had signed her to a two-picture contract, realized it had a star on the scene. Such publications as *Ebony, Life, Look,* and *Jet* contributed to the star buildup with important glossy features on her. But a star needs a big role. At MGM, there was nothing on the horizon.

Finally, Dandridge won *the* black actress's movie role of the decade, the title lead in Otto Preminger's black musical *Carmen Jones*. Based on the 1943 Broadway version of Bizet's classic opera *Carmen*, the film told the story of a love triangle with a destructive but fiercely independent siren at the center. Carmen Jones seduces straight-laced young military man Joe (Harry Belafonte), whom she persuades to desert the army to run off with her. In the first half of the film, in which Bizet's dynamic score advances the story line, *Carmen Jones* was engrossing. In the second half, the music sometimes got in the way of a highly dramatic story. (Dandridge's operatic voice was dubbed by the young lyric soprano Marilyn Horne; Belafonte by LeVern Hutcherson.) But director Preminger brought a rousing realism to the drama, effectively using the new widescreen process of CinemaScope, and putting to excellent use the talents of his all-star cast. The array of dazzling talents included Pearl Bailey, Olga James, Diahann Carroll, Brock

Peters, and, in a cabaret sequence in which the film's energy level peaks, drummer Max Roach and the dancers Alvin Ailey, Carmen de Lavallade, and Archie Savage.

Though surrounded by such a stellar cast, Dandridge's Carmen was the film's focal point. Concerned that Carmen might come across as a black-woman-as-a-whore, Dandridge used her training at the Actors Lab to define the character as a woman determined to have a liberated life, to make the same choices that are granted to men, who she dominates in every scene. In a world controlled by men, Dandridge's Carmen defies the patriarchal system to live by her own rules. In some ways, she anticipates the heroine Nola Darling of Spike Lee's 1986 *She's Gotta Have It*, who also wants to live as men do, making her romantic choices as she desires. At the film's conclusion, Carmen, of

course, is punished in traditional movie terms for her independence (just as Nina Mae McKinney was in *Hallelujah*) with death at the hands of her spurned lover.

For African American audiences, *Carmen Jones* presented not only an independent, assertive woman (granted, the movie predicates that independence on her romantic choices) but also a modern love story. Dandridge and Belafonte were as exciting and beautiful a screen couple as Elizabeth Taylor and Montgomery Clift had been in 1951's *A Place in the Sun*. For mainstream moviegoers, the film no doubt had much of the same appeal. In the end, *Carmen Jones* was one of the great movie pleasures of the decade.

Life magazine celebrated Dandridge's triumph with a full cover portrait of her, a major breakthrough at the time for an African American

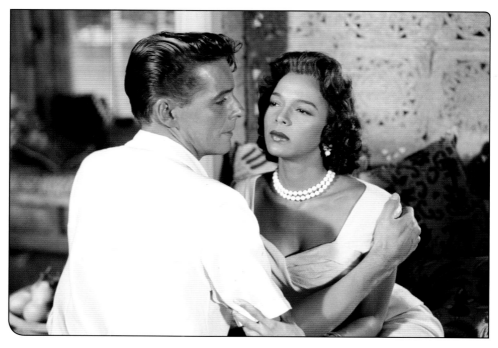

ABOVE: Dandridge and John Justin in *Island in the Sun*, in which the studio would not permit the two to kiss. RIGHT: *Island in the Sun*

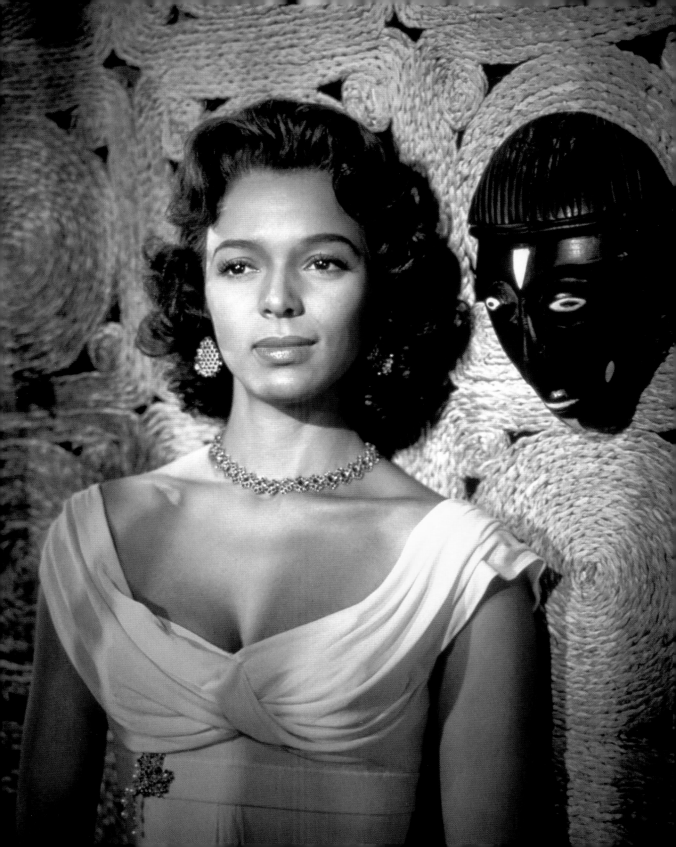

actress. The film received international attention with a special screening at the Cannes Film Festival that Dandridge attended with director Otto Preminger with whom she had a love affair. Such international publications as *Paris Match* and *Der Stern* were quick to run her on their covers. No African American star in films had ever garnered this type of attention. But the grand prize was Dandridge's groundbreaking Academy Award nomination as Best Actress, the first for a black performer in that category. Though Grace Kelly won the award for *The Country Girl*, Dandridge's success marked the arrival of the first bona fide black movie star in Hollywood history. In the age of Liz, Marilyn, Audrey, and Grace, Dandridge had joined the ranks of glamorous, compelling movie icons. Interestingly enough, *Carmen Jones* was released in 1954, the very year of the Supreme Court's historic decision on *Brown V Board of Education*, which ruled that segregation in public schools was unconstitutional. Social/political/racial history was being remolded.

Sadly, three years passed before Dandridge appeared in another movie, Robert Rossen's 1957 *Island in the Sun*. With a cast that included Harry Belafonte, James Mason, Joan Collins, Joan Fontaine, and Stephen Boyd, the film dealt partly with self-rule on a fictional British-controlled Caribbean island and partly with the then-daring theme of interracial love. Produced by Darryl F. Zanuck, the film was wrecked by compromises. The supposed "romantic" scenes between Belafonte and white actress Fontaine were tepid and evasive; even at that, Fontaine said she received hate mail about the film. Dandridge and her white costar John Justin fought with the studio to let his character say he loved her. They also fought for an on-screen kiss. But the studio—battling a now modified Production Code—refused to let the two

Dandridge's underrated performance as Bess with Sidney Poitier in *Porgy and Bess* in 1959.

kiss. Instead, in what should have been a passionate love scene, Dandridge and Justin have a laughable rubbing of one another's cheeks.

The rest of Dandridge's career proved frustrating as she struggled to find roles. Though she had signed a three-picture contract with Twentieth Century-Fox, she had turned down the supporting part of Tuptim in *The King and I*. Afterward, Fox appeared to lose interest in her. Rita Moreno played the role. Dandridge starred in *The Decks Ran Red* (1958) with James Mason and she worked abroad in John Berry's *Tamango*. It focused on a revolt on a slave ship and also had a theme of interracial love. Her last important performance—and a vastly underrated one—was as Bess in the Gershwin opera *Porgy and Bess*. Directed by Otto Preminger and produced by Samuel Goldwyn, this major production that costarred Sidney Poitier with a cast that included Sammy Davis Jr. (as Sportin' Life), Pearl Bailey, Diahann Carroll, Brock Peters, Ivan Dixon, and, in brief appearances as dancers, future writer Maya Angelou and future *Star Trek* actress Nichelle Nichols. Looking haunted and despairing, Dandridge cast a spell over the movie. Her fragile Bess was far different from the traditional carnal interpretations of the character. In her scenes

with Brock Peters (as the villainous Crown), the movie had tension and a complex characterization. Throughout, her performance had a powerful, disturbing personal subtext: a magnificent woman at emotional loose ends as she heroically strives to put her life in order. Using her own personal tensions (growing out of the industry's neglect of her as well as her private demons), Dandridge endowed the character with a despair the script could never quite grasp. The film, however, was not a hit.

Afterward she worked abroad again in Laslo Benedek's *Malaga* (1960) opposite Trevor Howard and Edmund Purdom. Her final film was another foreign production: *Marco Polo* (1961), which costarred her with the French heartthrob Alain Delon, as well as Mel Ferrer and France Nuyen.

Dandridge's last years were lonely and sad as she struggled to find work. A second marriage left her financially and emotionally bankrupt. Her daughter by Harold Nicholas became a ward of the state. Having signed a contract to star in two films in Mexico and preparing for performances at New York's Basin Street East, she was found dead in her Los Angeles apartment in 1965. The coroner's final report attributed the death to an overdose of an antidepressant prescribed by her physician. She was forty-two years old. Poitier said Hollywood was not ready for the unique gifts she had to offer. Belafonte said that she was the right person in the right place at the wrong time. Her legend, however, lived on within the African American community. Later she was the one tragic African American film star that young actresses such as Halle Berry, Vanessa Williams, Janet Jackson and others yearned to play.

POITIER: SOCIAL SYMBOL

Sidney Poitier's career had bumpy patches and detours, but still he rose to unprecedented heights for a black actor. He dominated the latter years of the decade. Poitier proved well-suited to an age that soon sought a social symbol. Following *Cry, the Beloved Country*, he briefly worked in television, then starred in *Red Ball Express*, a lackluster film that sought to record the heroics of the mostly black military unit taking supplies to General Patton during World War II. That was followed by *Go, Man, Go*, another film that highlighted the exploits of the black basketball team, the Harlem Globetrotters. It was directed by legendary cinematographer James Wong Howe. Both were low-budget dramas with positive messages for

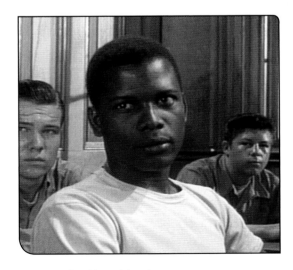

Poitier in *Blackboard Jungle*.

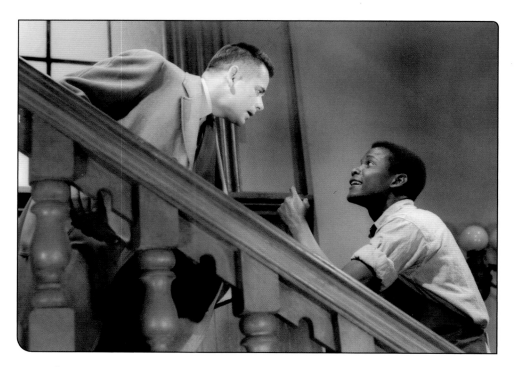

Poitier as the rebellious high school student with Glenn Ford in *Blackboard Jungle*.

black audiences. Neither, however, offered Poitier star-making roles.

Richard Brooks's 1955 *Blackboard Jungle* helped change the direction of Poitier's career. In this story of rebellious high school students in New York, he played the intelligent Gregory Miller, a born leader in need of support. One of the first films to focus on restlessness and rebellion in America's high schools, *Blackboard Jungle*—with "Rock Around the Clock" famously performed on the soundtrack by Bill Haley and the Comets— touched on the anger and discontent of a new generation. It foreshadowed themes of dissent that proved important in Poitier's other films. Like such rebels of the era as Brando, Montgomery Clift, and James Dean, Poitier's hero found himself in an oppressive system that threatened to overpower him. But unlike those other antiheroes, Poitier's characters basically sought to make it within the

system, not to smash it apart. The theme of reconciliation, as well as the Poitier screen code of intelligence, decency, and honesty, became hallmarks of his persona.

Afterward came roles with big stars: Raoul Walsh's *Band of Angels*, an Old South/Civil war–era drama that starred Clark Gable; Richard Brooks's *Something of Value* with Rock Hudson and Juano Hernandez, which looked at the Mau Mau rebellion in Kenya; later the war movie *All the Young Men* with Alan Ladd. There were pleasant, oddball diversions: *Goodbye, My Lady* and *Virgin Island*. He also appeared opposite Eartha Kitt in another Africa-set drama, *The Mark of the Hawk*. Both *Something of Value* and *Mark of the Hawk* may have been influenced by *Cry, the Beloved Country*. Despite notable failings, they accurately depicted Africa as a continent of political turmoil and exploitation.

Politics and basic human rights were very much on the mind of the nation as Poitier gradually rose to stardom. In 1955, the Montgomery bus boycott raised the issue of America's apartheid South, with its Jim Crow laws and regulations—and resistance to those regulations. Ultimately, with the rise of sit-ins and protests, America's long-standing attitudes on race were challenged. As Martin Luther King Jr.'s marches and demonstrations—as well as those of other African American leaders and the NAACP—came to national attention, calls for a fully integrated country rang loud and clear. In many respects, Poitier's movie characters came to represent the post-war Negro who was ready to enter an integrated social/professional America.

A breakout role came in Martin Ritt's 1957 *Edge of the City*, in which Poitier played Tommy Tyler, a New York freight car loader who befriends a fellow worker—a troubled loner, who is an army deserter (John Cassavetes). Poitier and screen wife Ruby Dee invite Cassavetes to their home and even introduce him to a young woman (Kathleen Maguire). The two couples have fun together, like any others enjoying each other's company. Like other Poitier films, an underlying message of *Edge of the City* stressed the significance of integration, that indeed black and white could live, work, and even socialize together. At a climactic moment, as Poitier's hero defends Cassavetes from a bigot on their job, Poitier is brutally attacked and killed by the other worker. He dies in Cassavetes's arms, seemingly content that he's been loyal to his friend. *Variety* commented that *Edge of the City* was "courageous, thought provoking and exciting" and "a milestone in the history of the screen in its presentation of an American Negro." As would be true of other Poitier films, *Edge of the City* had the theme of interracial male bonding—again the huck-finn fixation. Later generations might feel that Poitier's character has sacrificed himself to save his white

Poitier and Tony Curtis in *The Defiant Ones*.

One of the great ones!

STANLEY KRAMER presents

TONY CURTIS and SIDNEY POITIER

THE DEFIANT ONES

with Theodore Bikel · Charles McGraw
Lon Chaney · King Donovan · Kevin Coughlin and Cara Williams
Written by NATHAN E. DOUGLAS and HAROLD JACOB SMITH
Produced and Directed by STANLEY KRAMER · UNITED ARTISTS Released thru UA

buddy. Ultimately, his death leads Cassavetes to a new maturity and an awakening.

The next year, Stanley Kramer's *The Defiant Ones* carried Poitier to the top. In this drama, again centered on interracial male bonding, Poitier and Tony Curtis play two convicts who escape from a prison van. The men are chained together, however, as they flee. If they are to survive, they must understand one another. Significantly, the Curtis character must see life from the black man's point of view, to thereby comprehend American racism, including his own. Throughout, Poitier is a self-assured, resourceful hero who speaks his mind and stands up for his rights. At the film's very opening, he refuses to let Curtis call him a nigger. Later he tells him, "Don't call me boy." In one sequence, he movingly speaks of the wife and young son he has left behind while in prison. In another, the crime of assault and battery for which he's been imprisoned is revealed to have been an act of self-defense against a man who pulled a gun on him. Much like *Edge of the City*, *The Defiant Ones* climaxes with a sacrificial act: Poitier jumps from a train (that could lead to his freedom) to aid Curtis. The film closes with Poitier cradling an injured Curtis in his arms as law enforcement arrives to reimprison the men. African American moviegoers may have felt the ending was hokey and a skewed depiction of a black man who denies himself his own fulfillment for the benefit of a white buddy, but no one could deny Poitier's powers as an actor: his justified anger in key scenes; his articulation of the dissent and self-empowerment of his character.

"Poitier, always a capable actor, here turns in probably the best work of his career," noted *Variety*, "a cunning, totally intelligent portrayal that rings powerfully true and establishes Poitier as one of the best actors on the screen today." *The Defiant Ones* received Academy Award nominations for Best Picture, Best Director, Best Cinematography, Best Screenplay, and Best Actor for Tony Curtis. But most significant, for his performance, Poitier became the first black actor to receive a Best Actor Oscar nomination. Though *The Defiant Ones* won Oscars for Best Screenplay and Cinematography, Poitier's nomination—coming four years after Dandridge's for *Carmen Jones*—was recognition that indicated fundamental but slow shifts in the industry.

Porgy and Bess was Poitier's last film of the decade. It proved to be a difficult shoot. When he and Dandridge were announced as the stars, it appeared to be ideal casting, but protests sprang up within the African American community about this version of Gershwin's classic musical. The images of poor blacks living on Catfish Row and fighting it out among themselves seemed dated and embarrassingly stereotyped. Even the lyrics, including "I've got plenty of nothin', and nothin's plenty for me"—sung by Poitier's Porgy—seemed all wrong for an age in which African Americans were demanding their rights. Harry Belafonte turned down the role of the beggar Porgy. Poitier himself had not wanted to do the film and was pressured into signing for it only out of fear that if he turned down the role, he would not be able to do *The Defiant Ones*. Producer Samuel Goldwyn was determined to have him. In the end, the music in *Porgy and Bess* was moving and powerful, and it was a pleasure to see such talented black performers share the screen. Poitier, however, seemed lost as Porgy, unable to give himself to the role.

In retrospect, Poitier's body of work in the 1950s amounted to him becoming the first black actor to consistently play leading roles in a gallery of films, good or bad. The same would be true in the next decade.

THE 1950s

RUBY DEE: QUIET POWER

This era saw the rise of other extraordinary talents, including a distinct actress who played important supporting roles, Ruby Dee. Born Ruby Ann Wallace in Cleveland in 1922, she had been raised in Harlem and was absorbed in its rich cultural life. Following a short-lived marriage to the jockey Frankie Dee Brown, she was known thereafter as Ruby Dee. Graduating from Hunter College with a degree in Romance languages, she studied acting at the American Negro Theater. She also married actor Ossie Davis. The two became prominent figures on New York's cultural, social, and political scenes.

An important performance was in the 1947 touring company of the all-black stage drama *Anna Lucasta*, in which she played the title role. Originally, the play had been centered on Polish American characters. When the African American version reached Los Angeles, it was seen by many in the film capital, including Charlie Chaplin who spoke of filming it. When *Anna Lucasta* was first filmed, however, in 1949, it was with a white cast that starred Chaplin's former love, Paulette Goddard. But it was the black-cast *Anna Lucasta* that was best remembered. It may have led to Hollywood's interest in dramatic works with important black characters, namely the Negro Problem Pictures. Significantly, it no doubt brought Dee to the attention of the industry.

Having already appeared in such race movies of the 1940s as *That Man of Mine*, *What a Guy*, and *The Fight Never Ends*, Ruby Dee began working in Hollywood movies and television in the 1950s. Small, delicate, and seemingly vulnerable, she was paradoxically an actress of great interior strength, never a shrinking violet. In *No Way Out*, she had a supporting role. But in *The Jackie Robinson Story* (1950)—the dramatization of the life and career of the legendary baseball player who joined the Brooklyn Dodgers in 1947 and changed the face of major league baseball—Dee had the important role of the baseball hero's wife. Robinson played himself while Louise Beavers gave a subdued, endearing performance as his mother. Joel Fluellen portrayed Robinson's older brother Mack, who had been a track star along with Jesse Owens at the 1936

Ruby Dee at the start of her film career.

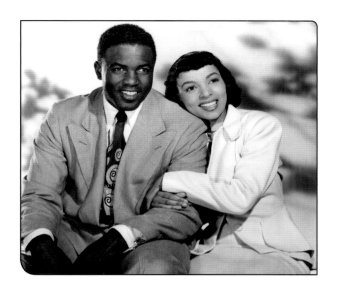

ABOVE: Jackie Robinson and Ruby Dee in *The Jackie Robinson Story*. BELOW: Ruby Dee with Johnny Nash as the troubled adolescent in *Take a Giant Step*.

Olympics in Berlin. This low-budget film—again a kind of race movie—had an earnestness and charm that has made it enduringly appealing.

"What is surprising," wrote the critic for the *New York Times*, "is the sincerity of the dramatization and the integrity of Mr. Robinson playing himself." *Variety* noted that Robinson "gets a very capable assist from Ruby Dee." In their scenes together, Dee appeared to put Robinson at ease, to just be himself, not giving any thought to the camera. The entire cast exhibits a commitment to a story they believe is important and inspiring. In some circles, this version is more fondly remembered than the 2013 "remake," titled *42*.

Dee's dramatic skills were soon on display in other movies. In Anthony Mann's underrated 1951 *Tall Target*, which focused on a would-be assassination attempt on Abraham Lincoln, she gave a sterling performance as a servant who understands her enslavement. Director Mann gives her tight close-ups in which she communicates her character's anguish. In *Edge of the City*, Dee had a gripping scene in which she lashes out at the man (John Cassavetes) who has failed to speak up about the way her husband (Poitier) was murdered. It's a tour-de-force sequence. Later, in a cast of powerful, extroverted actors in *A Raisin in the Sun*, her gentle character Ruth (again as Poitier's wife) is at times the most moving of the actors. It is quiet power at its best. The caliber of her performances in all three films should have brought her Oscar nominations, at the least, if not the big award itself.

One of Dee's most unusual films was Philip Leacock's *Take a Giant Step* in 1959. Based on a coming-of-age Broadway play by black playwright Louis Peterson (who co-wrote the screenplay with the film's producer, Julius J. Epstein), its hero Spencer was an alienated adolescent. At his integrated school, he rebels against the distorted

views being taught about the Civil War. He also struggles with his crush on a white classmate. At home, he clashes with his parents, especially his father (Frederick O'Neal). Singer Johnny Nash gave a convincing performance in the role of the youth, conveying an angst that rang true and creating a black adolescent totally different from any other one of the era. There are shades here of James Dean's character in *Rebel without a Cause*.

The surprise and most engrossing aspects of *Take a Giant Step* were the actresses. Here was a variety of African American women eager to express themselves: the light-skinned Ellen Holly, who would have been perfect for Douglas Sirk's remake of *Imitation of Life*, as an "older woman" Nash meets in a bar; Beah Richards as Nash's mother, struggling to reach her wayward son; Estelle Hemsley as the understanding grandmother; Ruby Dee as the family's young servant, who seems to understand him best; plus Pauline Myers, Royce Wallace, and Frances Foster. Watching the actresses

who are so impressive, a viewer is bound to ask where they came from and significantly, what happened to them after this film? Few had the careers they deserved, though some kept working. Estelle Hemsley won a Golden Globe nomination as Best Supporting Actress, a rare recognition for the period. Richards worked in and out of films and theater for years to come.

Finding some of her most challenging roles in television, Ruby Dee won nine Emmy nominations, taking home the award for 1990's *Decoration Day*. Dee also published volumes of poetry and co-wrote the screenplay for Jules Dassin's 1969 *Uptight*. In 2001, she and Davis were awarded the Screen Actors Guild Life Achievement Award. Finally, she was Oscar-nominated as Best Supporting Actress for her performance as the mother of Denzel Washington in Ridley Scott's *American Gangster* (2007). Though she did not win the Oscar statuette, she did take home the Screen Actors Guild Award for Best Female Actor in a Supporting Role.

MAKING BIDS FOR STARDOM

Also exerting star power first in concert halls and on television was Harry Belafonte, who introduced calypso folk music to the masses. Known for his good looks and physique, he emerged as a sex symbol onstage. In the movies, however, his sexuality was kept under wraps. Still, he was leading man material in *Bright Road*, *Carmen Jones*, and *Island in the Sun*, all of which costarred him with Dorothy Dandridge. In the last film, he played an impassioned man of the people, fighting for his island's self-rule in opposition to the British. He also had

what turned out to be a non-existent interracial relationship onscreen with actress Joan Fontaine. Afterward, he appeared opposite Inger Stevens in the 1959 apocalyptic drama *The World, the Flesh, the Devil*, which promised to deal frankly and provocatively with the theme of interracial love. But in the end, the filmmakers lost their nerve. In the Eisenhower era, interracial love was a topic the movies were both fascinated by and frightened of.

Though Belafonte never had Poitier-level success in movies, he nonetheless was ambitious

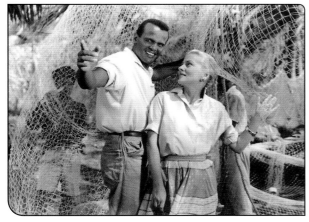

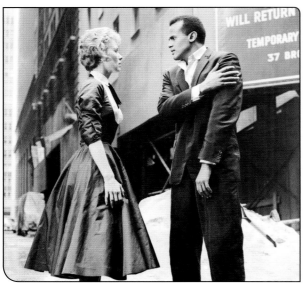

and political. A great supporter of Martin Luther King Jr., Belafonte helped introduce King and the civil rights movement itself to many in the entertainment community. He also formed his own production company Har-Bel Productions and puts its muscle behind the 1959 film *Odds Against Tomorrow*. Blacklisted writer Abraham Polonsky was hired by Belafonte to do the screenplay, but because of political concerns, credit was given to black writer John O. Killens. Years later, the Writers Guild of America restored Polonsky's credit. With Robert Wise directing and producing, Belafonte went against leading man type to appear in this bank heist drama with a strong race theme. The cast included Robert Ryan, Gloria Grahame, Shelley Winters, Kim Hamilton, Ed Begley, and Carmen de Lavallade.

Belafonte kept working into subsequent eras, playing enjoyable character roles in *Buck and the Preacher* (1972) and *Let's Do It Again* (1975).

<div style="text-align:center">◇◇◇◇◇◇◇◇◇◇◇</div>

Coming from Broadway and the world of chic supper clubs was singer/actress Eartha Kitt, who made a bid for leading-lady stardom. In the Africa-set 1957 *Mark of the Hawk*, she seemed out of place, still more a sexy nightclub performer than a dramatic actress. But in the 1958 black film version of *Anna Lucasta*, she gave a more convincing portrayal as the prostitute Anna, struggling for respectability and love while in contention with her vengeful father, played by Rex Ingram. Also in the cast as a sailor enamored of Anna was Sammy Davis Jr., along with James Edwards, Isabel Cooley,

TOP: Belafonte and Dandridge in *Carmen Jones*. **MIDDLE:** Harry Belafonte and Joan Fontaine in *Island in the Sun*. **BOTTOM:** Belafonte and Inger Stevens in *The World, the Flesh, and the Devil*.

Belafonte and Sammy Davis Jr. with Dr. Martin Luther King Jr.

Frederick O'Neal, Henry Scott, and Ike Jones.

In 1958's *St. Louis Blues*, Kitt was pure charisma as the "bad girl" in this biopic about black composer W. C. Handy. The drama charted Handy's climb to success, and his temptations and setbacks along the way. Playing Handy was one of the era's most popular singers, Nat "King" Cole. Also in the cast were Ruby Dee, Pearl Bailey, Ella Fitzgerald, Juano Hernandez, Cab Calloway, Mahalia Jackson, and Billy Preston as the young Handy. Not a great film, but pleasurable. Cole appeared in movies including 1953's *Blue Gardenia* and memorably as one of the singing troubadours in 1965's *Cat Ballou*. His mellow sounds on a soundtrack were enough to make you want to see the movie.

Other performers coming to the fore were Pearl Bailey, Brock Peters, Ossie Davis, and Diahann Carroll. An unexpected leading man was writer Richard Wright, who starred as Bigger Thomas in a production (shot in Brazil) of his novel *Native Son*. Then there was William Marshall. Tall, muscular, and resplendently assured, with a thunderous voice, Marshall was a wonder to behold in two unusual roles: as the bold gladiator in Delmer Daves's *Demetrious and the Gladiators* (1952) with Victor Mature and Susan Hayward; and, the same year, as the masterful King Dick in Jean Negulesco's rousing drama about the Haitian revolt from Napoleonic France, *Lydia Bailey*. Though the film starred Dale Robertson and Anne Francis, Marshall stole the show and brought a semblance of gravitas to this robust (but historically misleading) adventure tale. "William Marshall, who could be likened to history's Jean Christophe," wrote Bosley Crowther in the *New York Times*, "makes an

RIGHT: Nat King Cole

LEFT: Pearl Bailey as the boozy singer in *All the Fine Young Cannibals*. TOP-LEFT: Sammy Davis Jr. and Eartha Kitt in *Anna Lucasta*. TOP-RIGHT: Juanita Moore in her Oscar-nominated Best Supporting Actress role as the long-suffering Annie in the 1959 *Imitation of Life*.

imposing and indestructible patriot whose voice is as commanding as his figure."

As the decade drew to a close, Douglas Sirk directed an updated version of *Imitation of Life*, starring Lana Turner, John Gavin, and Sandra Dee. Most attention was focused on the performance of Juanita Moore as the sacrificing, gentle mother Annie, who is rejected by her light-skinned daughter Sarah Jane, played by Susan Kohner. Once again, the story's climax—the funeral of the African American mother—was a tearjerker, perhaps all the more so because of Mahalia Jackson, who soulfully sang in the sequence. For African American moviegoers, the film was important because of the race theme, but it might have been far more involving if a light-skinned black actress, such as Ellen Holly, had been cast as the rebellious daughter. Still, Kohner and Moore gave undeniably moving performances that earned each an Oscar nomination as Best Supporting Actress. Moore's nomination marked the first for a black woman in ten years, since Waters's Oscar nod for *Pinky*.

The 1950s had not only brought black stars to the screen but also had occasionally given dramatic performers formal industry recognition. It was a beginning but still far from enough.

CHAPTER

5

THE 1960s

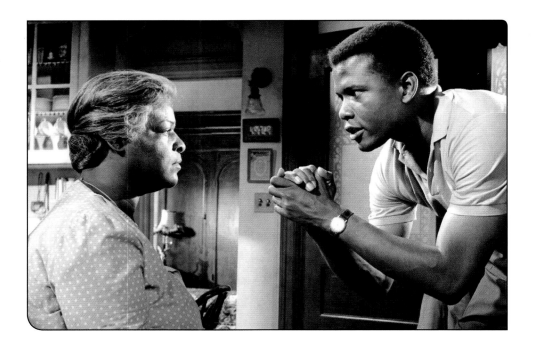

SIDNEY POITIER: BOX-OFFICE CHAMP

In the 1960s, Sidney Poitier carried black movie history on his shoulders. He became a bona fide box-office champ and as he had been in the second half of the previous decade, the dominant black actor of this politically turbulent era. As the sit-ins, protests, marches, and demonstrations of the 1950s continued amid a wave of student activism, Poitier was a constant in American movies.

His best role and perhaps finest performance came in the 1961 screen adaptation of playwright Lorraine Hansberry's *A Raisin in the Sun*, the first drama by an African American woman to run on Broadway. Poitier had appeared in the original 1959 Broadway production, as did other members of the movie cast—Ruby Dee, Claudia McNeil,

Diana Sands, Louis Gossett, Ivan Dixon, and John Fieldler. *A Raisin in the Sun* was an instant classic, an iconic work. The New Drama Critics Circle had named it the Best Play of 1959. It had earned four Tony nominations: for Poitier, Claudia McNeil, director Lloyd Richards, and Best Play.

In this family drama, directed by Daniel Petrie, Poitier plays Walter Lee Younger, a chauffeur who battles with his mother, his wife, and his kid sister, always feeling frustrated that his life has been stunted and that he's been stripped of his manhood. The chance for fulfillment comes with the funds from his deceased father's life insurance policy, which he sees as the opportunity to start a new life for himself. His mother Lena (Claudia

Poitier and Claudia McNeil in A Raisin in the Sun.

McNeil), however, plans to use the policy for fulfillment of her own—to move the entire family out of their cramped Chicago apartment and to buy a home in the suburbs. A constant, nonstop clash erupts among the principals. Only after he appears to have lost everything does Walter come into his own, asserting himself and assuming his place as the man of the household. Though in many respects, the film is tightly tied to the play with stagy entrances and exits of its characters, the theme and the performances are riveting and make the movie essential viewing

In Walter Lee, Poitier found a role he could fully connect to, and in which he was not the Negro symbol or moral conscience for white America. Here he was not positioned as a force to help a white friend to come to some new awareness of himself. His was a passionate, sensitive performance in which he attained a stunning emotional truth in just about every line of dialogue. As in *Take a Giant Step,* the women of *A Raisin in the Sun* were also strongly and vividly drawn. Yet powerful as the movie performances were, not one actor or actress received an Oscar nomination. That was one of the great injustices in American movie history.

Curiously, the Poitier films that followed often lacked the bite and insight of *A Raisin in the Sun.* Instead, they once again promulgated the idea that the Poitier hero—representing the Negro as a fine, upstanding person—was deserving of respect and acceptance. Such was the case in Martin Ritt's 1961 *Paris Blues,* which afforded Poitier the rare chance for movie romance. Portraying two American musicians on Paris's Left Bank, Poitier and Paul Newman respectively court Diahann Carroll and Joanne Woodward. Despite a score by Duke Ellington and an appearance by Louis Armstrong, the film would have been of greater interest had it dealt more seriously with the expatriate experiences of Americans abroad.

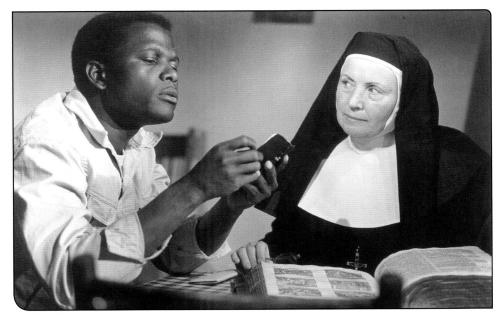

Poitier and Lilia Skala in *Lilies of the Field.*

In the taut *Pressure Point*, directed by Hubert Cornfield and produced by Stanley Kramer, Poitier appeared as a prison psychiatrist treating a paranoid racist/Nazi-sympathizing inmate (Bobby Darin). Forced to maintain his composure as he listens to racist diatribes (which can be hard to watch) Poitier gave a controlled, thoughtful performance. But Poitier was used again to help a troubled white character.

Ralph Nelson's *Lilies of the Field*, however, was a surprise box-office smash that put Poitier over the top. Here he was cast as army vet Homer Smith, a handyman enlisted by a group of German nuns to help them build a chapel in the Arizona desert. The nuns cannot even pay him, but he becomes attached to the women—and their dream. Enduring any number of hassles, he gets the chapel built. *Lilies of the Field* had its absurdities. Poitier's Homer finds a job not only to keep himself going but to pay for supplies for the chapel! So demanding is the Mother Superior (Lilia Skala) that you may be perplexed as to why Homer sticks around. Mainstream audiences, however, loved *Lilies of the Field*—the ultimate feel-good movie, enlivened by Jester Hairston's song "Amen," which moviegoers left theaters singing.

Though Poitier gave a spirited performance, he had given far stronger ones in *The Defiant Ones* and *A Raisin in the Sun*. Yet he became the first black actor to win the Academy Award as Best Actor of 1963 for *Lilies of the Field*. At the 1964 awards ceremony, when he accepted his Oscar from presenter Anne Bancroft, it was a historic moment at a time when civil rights were all the more on the nation's mind. In August 1963, Martin Luther King Jr. had

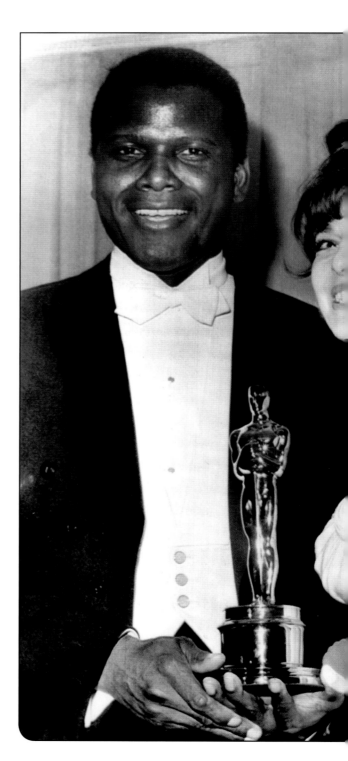

Sidney Poitier on Oscar night when he became the first black actor to win the Best Actor award for *Lilies of the Field*, presented to him by Anne Bancroft.

given his "I Have a Dream" speech at the March on Washington, at which some twenty-five thousand people had gathered in front of the Lincoln Memorial calling for equal rights. Now, less than a year later, Poitier's Oscar had symbolic significance.

Two years later Poitier, had another hit—again as a helpful aide to a distressed character—with *A Patch of Blues*. Here was the story of a young blind woman (Elizabeth Hartman) who is shamelessly mistreated by her hateful mother (played by a rowdily enjoyable Shelley Winters) and who seems utterly alone in the world—until she's befriended by a young black man (Poitier). Though the young woman develops a crush on him and even—perhaps daringly for the era—kisses him, he dutifully sends her off to a school for the blind. As might be expected, the Poitier hero has helped her acquire a new self-confidence. Parts of *A Patch of Blue* may have been laughable, but again moviegoers packed theaters to see it. Shelley Winters even won a Best Supporting Actress Oscar for her performance. With this second huge hit, Poitier himself was now a box-office power—another historic first for the actor.

Nineteen sixty-seven proved to be a banner year for him with three huge hits: *Guess Who's Coming to Dinner*, *In the Heat of the Night*, and *To Sir, with Love*. Under the direction of Stanley Kramer, *Guess Who's Coming to Dinner* was a contemporary interracial romance and family drama. Having fallen in love with a handsome doctor, young Joey Drayton (Katharine Houghton) brings him home to meet her parents, played by Spencer Tracy and Katharine Hepburn. The problem for the white Draytons is that the doctor is black. As played by Poitier, he's near perfect. Highly educated, articulate, and polite, he will not marry Joey without the consent of her family. It doesn't matter to the doctor that his own father has objected to the union. In the end, the Drayton patriarch gives his blessing for the couple's forthcoming marriage.

Critical reactions were mixed. *Variety* called it "an outstanding Stanley Kramer production" while Bosley Crowther of the *New York Times* considered it "a most delightfully acted and gracefully entertaining film." But for a movie that purported to address the thorny topic of interracial love, only once was the couple seen briefly kissing—through the rearview mirror of a taxicab. Even Katharine Houghton said that her character was underwritten and that the scene that might have better explained her—and, in essence, the romance—ended up on the cutting-room floor. But moviegoers didn't care. *Guess Who's Coming to Dinner* was an Oscar nominee for Best Picture. Also nominated for Academy Awards were Tracy (it was his last film) and Hepburn, who won the Best Actress award. Significantly, Beah Richards, who played Poitier's mother, won a Best Supporting Actress nomination.

Norman Jewison's *In the Heat of the Night* was a murder mystery that also focused on the theme of interracial male bonding. Poitier plays Philadelphia police detective Virgil Tibbs, who while visiting Sparta, Mississippi, is pressured into aiding a

Poitier with Roy Glenn and Academy Award–nominated Beah Richards in *Guess Who's Coming to Dinner*.

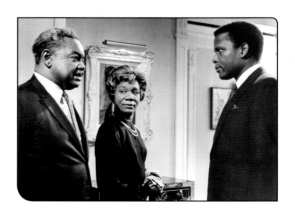

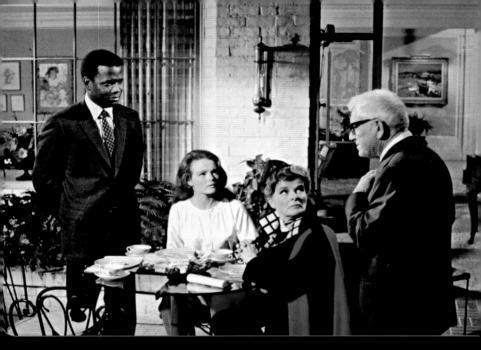

The New Hollywood meets the Old Hollywood: Poitier and Katharine Houghton with Spencer Tracy and Katharine Hepburn.

An interracial love story without love scenes: Poitier and Katharine Houghton in *Guess Who's Coming to Dinner*.

bigoted sheriff, Gillespie (Rod Steiger), solve the murder of a prominent white man. Of course, Tibbs knows more than anyone around him. It's at times amusing (in a good way) to see how shrewd, skilled, and smart he is. Tibbs is everything that black male characters of Hollywood films of the 1930s and early 1940s could not be. Throughout, however, Poitier's Tibbs is subjected to racial slurs and humiliations. But he maintains his composure and dignity. Ultimately, Tibbs and Gillespie develop a mutual respect and friendship.

Though much attention focused on Steiger (in a fine, scenery-chewing, engaging performance), Poitier gave one of his best and perhaps least critically acknowledged characterizations. In key scenes, as he holds back on revealing his character's tensions and anger until they build to an explosive point, Poitier shows his mastery of the *slow burn*. Two scenes stand out. In the first, Gillespie calls Virgil both *boy* and *nigger* and asks what he's called up North, to which Poitier responds: "They call me *Mister* Tibbs!" It's a terrific moment that African Americans in movie theaters cheered. In the second scene, an older bigoted white Southerner (Larry Gates) is outraged to be questioned by Tibbs, a Negro. He slaps Poitier. Without missing a beat, Poitier slaps him back. Again there were cheers among black moviegoers. The Tibbs character made such a strong impression that Poitier played him again in two other movies: *They Call Me MISTER Tibbs* (1970) and *The Organization* (1971). Adding to the film's mood was the bluesy soundtrack by composer Quincy Jones with the title song performed by Ray Charles. *In the Heat of the Night* beat out *Guess Who's Coming to Dinner*, *The Graduate*, *Bonnie and Clyde*, and *Dr. Dolittle* to win the Best Picture Oscar. It also won Best Screenplay, Best Editing, and Best Actor for Rod Steiger.

Poitier's third box-office triumph of 1967 was *To Sir, with Love*, in which he played a teacher struggling to reach rebellious working-class high school students in London's East End. The movie marked a reversal from Poitier's portrayal of the rebellious student in *Blackboard Jungle*. By now, he had become an establishment hero who upholds the system. The title song from the soundtrack—sung by British pop star Lulu, who also played one of the students—rose to the top of the music charts. Once again, Poitier had a feel-good movie, loved by millions. But cracks in his screen armor would show as a politically restless age would search for grittier, anti-establishment heroes.

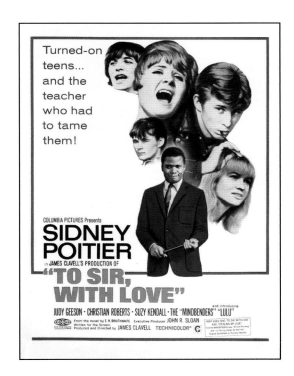

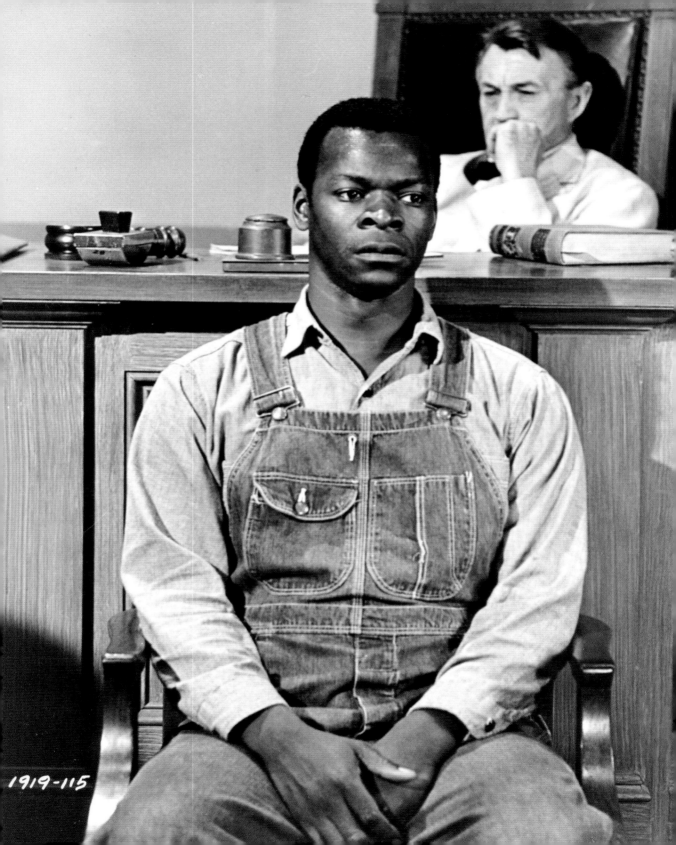

TROUBLED TIMES, TROUBLED HEROES

Other films addressed the race question. John Ford did an about-face from his films with Stepin Fetchit to direct 1960's *Sergeant Rutledge* which starred Woody Strode as a black sergeant in the 1880s falsely accused of the rape and murder of a white woman at a military fort.

A similar case was at the heart of the critically praised *To Kill a Mockingbird* (1962). Based on the novel by Harper Lee, directed by Robert Mulligan, and produced by Robert Benton with an Oscar-winning screenplay by Horton Foote, the film recounted the trial of a black man, Tom Robinson (Brock Peters), also wrongly accused of having raped a white woman but in a small town in Alabama. Defending him and challenging the racism that infects the community is white attorney Atticus Finch (Gregory Peck), whose two young children see their father's decency and honesty.

Though at times *To Kill a Mockingbird* seemed too eager to congratulate itself on its moral conscience and its white savior hero Atticus, the film had emotional power. Watching Brock Peters as Tom Robinson sitting on the witness stand—in a world where he must struggle to maintain his manhood—gave the film stature, as did Gregory Peck's measured and moving Oscar-winning performance. Most of the African American actors/characters were relegated to the sidelines—Estelle Evans, Kim Hamilton, Jester Hairston, Pauline Myers, and William Walker as Reverend Sykes—but their solemn sincerity reveals their belief in the story and its theme. Near the end, Walker tells Atticus's daughter Scout to stand for her father. That may well be the movie's crowning touch. It remains hard not to be emotionally affected. Sadly, Walker was one of the actors not given billing in the movie. That had happened before, in a career in Hollywood which stretched back to the mid-1940s. Regardless, Walker could always be relied on to grace a film with a dignified reserve that went unacknowledged.

LEFT: Brock Peters as the man falsely accused in *To Kill a Mockingbird*. RIGHT: Another man falsely accused: Woody Strode with Jeffrey Hunter and Constance Towers in *Sergeant Rutledge*.

FROM NIGHTCLUB LEGEND TO RAT PACKER

Also drawing attention and winning audience favor was Sammy Davis Jr., who by the 1960s already had a storied career. Born in 1925 in New York, he was the son of entertainers Sammy Davis Sr. and Afro-Cuban Elvera Sanchez, who separated soon after Sammy's birth. At the age of three, he performed with his father and Will Mastin in an act known as the Will Mastin Trio. Sammy was a pint-sized dynamo who sang and tap-danced with a ferocious energy. At age eight in 1933, he came to the movies in a rigidly stereotyped short, *Rufus Jones for President*. Young Rufus dreams of being president. His reward will be, so he hopes, pork chops! Playing his mother was a slender Ethel Waters, who performed her hit "Am I Blue?" At one point, she sits Sammy on her lap as she croons him to sleep. Despite all the things that went wrong with the short film's images, this nonetheless was an iconic moment: two of the greatest all-around entertainers of the twentieth century performing together

During War World II, Davis served in the army, where he was the butt of relentless racism from white G.I.s. From his painful military experiences, he said he believed that if he entertained them, he'd win them over. In a way throughout his career, the subtext of his performances was his need for the audience's love—and the idea that, as an entertainer, he'd do anything to win that love, which added to the urgency and sometimes the poignancy of his song and dance.

After the war, Davis performed again with the Will Mastin Trio in nightclubs and on television.

A major breakthrough came with the trio's 1951 opening act for singer Janis Paige at Hollywood's famed and glamorous Ciro's. Major stars packed the club: Clark Gable, Humphrey Bogart and Lauren Bacall, and William Holden. Sammy's show-stopping energy, his enjoyably frenetic dancing, and his ability to put a song over, certified him as a star in his own right, without being a part of the trio. He also daringly (for the time) did impersonations of such white stars as Sinatra, Bogart, James Stewart, and James Cagney. The

Sammy Davis Jr. and the Rat Pack.

Sammy Davis Jr., already a legend before he made movies.

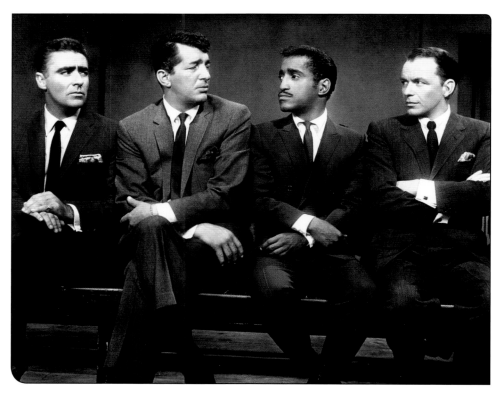

Davis with Peter Lawford, Dean Martin, and Frank Sinatra in *Ocean's 11*.

applause was thunderous. Janis Paige was no pushover as a performer, but standing in the wings, she realized in no way could her act really compete. Not long afterward, the engagement was revamped to spotlight Davis.

In 1954, he made headlines. Following a performance in Las Vegas, Davis was in a terrible car accident. He lost his left eye. Forever afterward, he would wear a glass eye or sometimes an eye patch. Unsure if he would ever be able to perform again, he struggled for months in physical therapy. To dance again, he had to regain his basic sense of balance. The big test was an engagement back at Hollywood's Ciro's, where he appeared again as part of the Will Mastin Trio. The opening night audience was again composed of stars: Cary Grant, Bogart and Bacall, Spencer Tracy, Gary and Rocky

Cooper. Again Davis triumphed. In time, he left the trio. By then, he had become a young legendary entertainer.

He carried the legend with him to the movies. He won the role of Sportin' Life in *Porgy and Bess*. But his best known films were the Rat Pack movies of the late 1950s and early '60s that costarred him with his friends Frank Sinatra, Dean Martin, Peter Lawford, and sometimes Joey Bishop: *Ocean's 11*, *Sergeants 3*, and *Robin and the 7 Hoods*. He also appeared with Shirley MacLaine in *Sweet Charity* and costarred with Peter Lawford in such films as *Salt and Pepper* and *One More Time*. There were countless appearances on television. Davis never emerged as a full-fledged film star, yet his name meant something on movie marquees.

CHANGING VISIONS

s the 1960s continued, a new wave of militant black political leaders came to the fore, demanding their rights: Stokely Carmichael, H. Rap Brown, Fannie Lou Hamer, and later Angela Davis. The concept of passive-resistance during protests was questioned. Malcolm X led the way with his philosophy of "By any means necessary" to ensure equal rights for black Americans. In time, the civil rights movement evolved into the Black Power movement.

Riots and uprisings erupted among blacks in cities across the country: New York, Newark, Philadelphia, Detroit, and the Watts neighborhood of Los Angeles, where there were five days of civil unrest in August 1965. During these years, the nation was also shaken by a series of terrifying political assassinations. In June 1963, NAACP leader Medgar Evers was shot in the driveway of his home in Jackson, Mississippi. A few months later, President John F. Kennedy was assassinated in Dallas. Others followed: Malcolm X in 1965; Martin Luther King Jr., in 1968; and Robert Kennedy also in 1968. Could all of this be happening in the land of the free and the home of the brave? Gradually, Hollywood was affected by these upheavals and racial changes in American society—both in front of and behind the camera.

In time, Poitier's conciliatory, idealized heroes would start to look dated and be criticized by a new generation. Some independent productions won audiences, starting in the mid-1960s. Michael Roemer's *Nothing But a Man* starred Ivan Dixon,

Former football star Jim Brown, who brought his macho image from the gridiron to the movies.

Abbey Lincoln, Julius Harris, and the intensely interior actress Gloria Foster, in a story about a black man who refuses to kowtow. Larry Peerce's *One Potato, Two Potato* featured Bernie Hamilton and Barbara Barrie in a heartbreaking story of an interracial marriage. Sidney Lumet's *The Pawnbroker* starred Rod Steiger as a concentration camp survivor running a pawnshop in New York where he witnesses another kind of imprisonment—of black victims struggling to survive urban tensions and pressures. Lumet brought to the screen exciting performers: Thelma Oliver, Raymond St. Jacques, and the great veteran from *Intruder in the Dust*, Juano Hernandez. George Romero's classic zombie horror film (a forerunner of much to come later) *The Night of the Living Dead* featured African American actor Duane Jones as a resourceful hero who had young audiences, black and white, on the edge of their seats. During the mid- and late 1960s, another kind of African American movie hero

emerged when former football star Jim Brown left the gridiron to work in such Hollywood movies as *The Dirty Dozen*, *Ice Station Zebra*, and *100 Rifles*.

At the same time, the very nature of film production was gradually questioned. Who tells the stories of black Americans on-screen? What's being said? What's not being said? Though major African American filmmakers were still absent at the Hollywood studios, some new faces worked in significant ways behind the scenes. A sign of the shift was 1966's *A Man Called Adam*, the story of a self-destructive, alcoholic, exploited jazz musician that starred Sammy Davis Jr., Ossie Davis, and Lola Falana. Significant was the sensitive dramatic leading lady, Cicely Tyson, who was unlike any female lead in Hollywood history. Dark-skinned with vibrant eyes and a short Afro—at a time when the Afro had not yet received wide acceptance—Tyson challenged Western standards of beauty.

Also significant was the fact that one of *A Man*

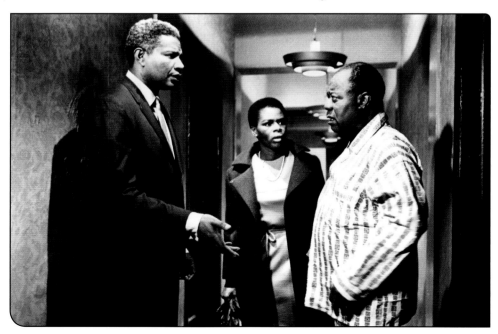

Ossie Davis, Cicely Tyson, and Louis Armstrong in *A Man Called Adam*.

Cicely Tyson

Called Adam's producers was Ike Jones, considered the first African American producer on a major Hollywood production. Born in Santa Monica, Jones had studied film production at UCLA and was credited as being the first black graduate of the university's film school. Also a star football player on the school's Bruins, he was offered a contract by the Green Bay Packers but turned down the offer. Movies were in his blood. He became the assistant director on the 1953 low-budget *Joe Louis Story*, played small roles in movies (including *Carmen Jones* and *Anna Lucasta*), and was an assistant producer at the Hill-Hecht-Lancaster Company of which actor Burt Lancaster was a founder. He was also a vice-president of development at Harry Belafonte's Har-Bel Productions and the head of Nat "King" Cole's Kell-Cole Productions. His position on *A Man Called Adam* clearly was a signal of a new day to come.

Others worked behind the camera. Actress Ruby Dee not only played a role in Jules Dassin's *Uptight* but she also co-wrote the script. Though *Uptight* proved disappointing, it sought to capture the political rebellion of the period and to spotlight an emerging generation of black actors of the 1960s—Raymond St. Jacques, Janet MacLachlan, Roscoe Lee Browne, Max Julien, Robert DoQui, James McEachin—as well as veterans Frank Silvera and Juanita Moore.

Then appeared Gordon Parks Sr., who wrote, directed, and produced 1969's *The Learning Tree*, a coming-of-age story based on Parks' semi-autobiographical novel about a black teenager in rural Kansas in the 1920s. Parks came to film directing after a distinguished career as one of the first African American photographers on the staff of *Life* magazine. Also mastering fashion photography, his work appeared in *Vogue*. Sophisticated and

stylish, Parks was a dashing figure on New York's social scene. Fascinated by film, he closed a deal with Warner Bros. for his film debut, generally considered the first African American to produce *and direct* for a major Hollywood studio. Working with the cinematographer Burnett Guffey, Parks brought an impressive, sweeping visual style to *The Learning Tree* and worked well with such actors as Joel Fluellen, Estelle Evans, Richard Ward, Dub Taylor, and his young lead, Kyle Johnson, who was the son of TV star Nichelle Nichols. Afterward, he directed such films as *Shaft* (1971), *Shaft's Big Score* (1972), and *Leadbelly* (1976). The stage was set for the next era—when more black filmmakers would make their way to the studios.

Still more developments occurred at the close of the decade, one being the 1969 appearance of black actor Rupert Crosse with Steve McQueen in the movie adaptation of William Faulkner's *The Reivers*. Directed by Mark Rydell, the film was likable and engaging. Crosse had been around, working mainly in television, but as Ned McCaslin in *The Reivers*, he gave a spirited performance that earned him an Academy Award nomination as Best Supporting Actor.

That same year marked the release of Robert Downey Sr.'s satire *Putney Swope*, which focused on a group of African Americans who overtake an advertising agency. A revolution was in the air. And so the restless, rebellious 1960s closed on an optimistic note as, once again, black images were changing—along with the creative powers in Hollywood.

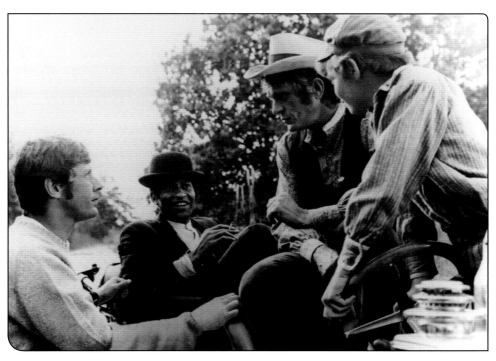

ABOVE: Oscar nominee Rupert Crosse (in black hat) on the set of *The Reivers* with director Mark Rydell (left) and star Steve McQueen (second from right). **LEFT:** *Life* magazine master photographer–turned–film director, Gordon Parks, Sr.

CHAPTER

6

THE 1970s

A SIGN OF HEROES TO COME

Out of nowhere there appeared in the early 1970s a new movie genre that knocked the film industry on its head. No one could have anticipated *Blaxploitation cinema*.

Many in Hollywood watched closely the movie adaptation of Howard Sackler's Broadway drama *The Great White Hope* (1970), loosely based on the life of boxer Jack Johnson, who had shocked Americans when he became the first black world heavyweight champion in 1908. Neither meek nor modest, the flamboyant Johnson also shocked and outraged the nation with three marriages to Caucasian women. A search was on to find a white opponent to beat him—as a warning to black Americans who might forget their place. Johnson had died tragically in a car accident in 1946. With the controversies swirling around boxing champ Muhammad Ali—over his refusal to fight in the war in Vietnam and his pride in having joined the Nation of Islam to become a black Muslim—comparisons were drawn between Ali and Johnson.

Repeating on-screen his stage role of Johnson (called Jack Jefferson in the production) was James Earl Jones. Directed by Martin Ritt with a cast that included Jane Alexander, Joel Fluellen, Beah Richards, Chester Morris, and Moses Gunn, the movie version brought to the big screen a defiant African American hero, not ready to back down from anyone as a nation's racism closes in on him. In the end, however, the film often was stagy and static. Even Jones's broad, overstated performance, did not seem scaled for the intimate demands of a medium that comes in for a close-up. Yet James Earl Jones became the first black actor since Poitier to win a Best Actor Oscar nomination. His costar, Jane Alexander, was also nominated as Best Actress.

James Earl Jones and Jane Alexander in *The Great White Hope*.

SWEETBACK, SHAFT, AND SUPER FLY

Interest in *The Great White Hope* indicated that African American moviegoers were eager now for bold, assertive heroes who challenged the status quo and were ready for a day of racial reckoning. Yet the studios failed to comprehend the needs of this audience. It was an industry outsider—an independent black American filmmaker who had worked in Europe but was back in the States—that had his hand on the pulse of young black America. Chicago-born Melvin Peebles (he added the Van later) had lived in Mexico and San Francisco and then Paris, where he directed *The Story of a Three-Day Pass* (1968). A strong supporter of Van Peebles was Henri Langlois of the Cinémathèque Française, and the film received other international attention.

Afterward, Van Peebles signed with Columbia Pictures to direct an off-beat comedy/drama, *Watermelon Man*, about a racist white advertising executive (Godfrey Cambridge) whose life is turned upside down when he awakens one morning to discover that has become black! *Watermelon Man* was social/racial satire with a distinct African American perspective. But its studio did not seem to know what to do with it. The film was not well-promoted; nor was it pitched to an African American audience.

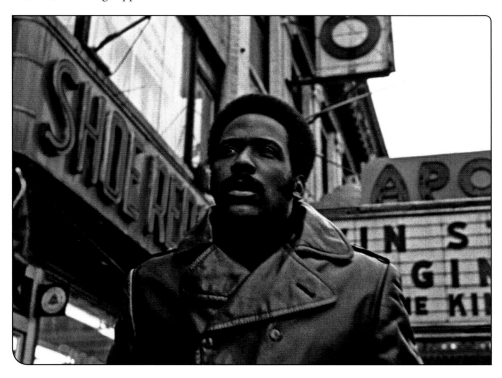

He's the cat who won't cop out when there's danger all about. Richard Roundtree as John Shaft in *Shaft*.

Melvin Van Peebles, star and director of the revolutionary *Sweet Sweetback's Baadasssss Song*.

Van Peebles made his next film as an independent. Using his own money with $50,000 lent by Bill Cosby, he directed, produced, scored, edited, and starred in *Sweet Sweetback's Baadasssss Song*, released in 1971. Here audiences saw the radicalization of a superstud (played by Van Peebles), who—when he witnesses the brutality of two corrupt white Los Angeles cops on a defenseless black man—retaliates with a brutal vengeance of his own. Afterward, in a series of episodes, Sweetback is on the run from the law. Helped by the African American community and at one point a sympathetic white, he crosses the California border to Mexico. But he lets viewers know a Baadasssss is coming back to collect some dues—to right past injustices. Throughout, there was violence and explicit sex with images of women that were disturbing. But moviegoers were struck by the film's daring black hero.

Black Panther leader Huey P. Newton called *Sweetback* "the first truly revolutionary black film." Aware that the usual outlets for publicizing a film would be closed to him—having promoted the film as being "Rated X by an all-white Jury"—Van Peebles utilized black radio and the black press to inform African Americans they were in store for a different kind of movie experience, told from a different perspective. Performing the score of the movie was the group Earth, Wind, and Fire. Indeed, Van Peebles's film reached a young audience. In the process, he became a hero for a new generation, as well as for later independent filmmakers. It's not an overstatement to say that Van Peebles changed the landscape of American movies.

The next year, two other films with bold, defiant black heroes appeared. Gordon Parks Sr.'s *Shaft* centered on a black New York City detective John Shaft (Richard Roundtree), who searches for and rescues the kidnapped daughter of a black mobster (Moses Gunn) within a seedy underworld. Gordon

Parks Jr.'s complicated, morally ambivalent *Super Fly* followed a New York City drug dealer, played by an enigmatic Ron O'Neal, fighting to get out of the cocaine business.

In both films (as in *Sweetback)*, the music added to the excitement and definition of their heroes. Isaac Hayes's *Shaft* soundtrack saluted its tough hero. In song, Hayes asked who was the cat who wouldn't cop out/when there's danger all about, to which a chorus replied: "Shaft. John Shaft." Hayes sang that he was a bad mother—the point at which the chorus sang to "Shut your mouth!" The lyrics were clever and witty, and the guitar's *wah wah* strum was a brilliant new sound. For "Theme from Shaft," Hayes walked off with an Oscar for Best Original Song of 1972. On the other hand, Curtis Mayfield's *Super Fly* soundtrack was a sometimes moody, often sexy, sometimes questionable commentary on the hero's drives and the drug trade itself. It filled in some of the holes in the script with some backstory for the characters.

Sweet Sweetback's Baadasssss Song, Shaft, and *Super Fly* were all successful at the boxoffice, indicating that there was an African American audience for films that touched on political issues of the day. The three films launched a new era in the history of American cinema, similar to the race movie movement, but with a broader social/political reach. Here again were motion pictures with cultural markers, signifiers, references, and tropes speaking directly to the African American audience. Their existentialist heroes lived in the face of violence, injustices, and inequities. In their urban settings, the filmmakers were intent on showing that law enforcement—the supposed upholder of order and justice—was corrupt and repressive, determined to corner and control African American men. In *Super Fly,* the mean streets of the city that hero Priest must navigate are a brutal collective character unto

themselves—a terrain where violence or death can occur at any moment. In many respects, the films echoed the city upheavals that had transpired with the riots of the 1960s. In other respects, the films suggested that the violence of Vietnam—and, in later Blaxploitation features, the government corruption of Watergate that would lead to the president's resignation—were part of American life. The themes and issues would resonant then and later with younger generations of moviegoers.

Other films with outspoken black heroes appeared in a period that roughly spanned five years, from 1971 to 1976: *Slaughter, Slaughter's Big Rip-Off, The Mack, Hit Man, Trouble Man, Across* *110th Street, The Legend of Nigger Charley, The Soul of Nigger Charley, Boss Nigger, Black Eye*, and those sadomasochistic Old South epics *Mandingo* and *Drum. Shaft* had two sequels: *Shaft's Big Score* and *Shaft in Africa. Super Fly* was followed by *Super Fly TNT*. Sometimes it may have looked as if the same movie was being made time and again. Such actors as former football stars Jim Brown, Fred Williamson, and Bernie Casey; former boxer Ken Norton; Raymond St. Jacques; Max Julien; and Calvin Lockhart were enjoyed by black moviegoers. From Hollywood's past came William Marshall who starred in *Blacula* and *Scream, Blacula, Scream*, the story of Dracula revamped with a black hero.

Ron O'Neal (right) and Julius Harris in *Super Fly.*

During this era, more African American filmmakers worked. Actor Ossie Davis had a big hit with his adaptation of Chester Himes's novel *Cotton Comes to Harlem*; a follow-up to Davis's film was *Come Back Charleston Blue*, directed by Mark Warren. Davis also directed *Black Girl* and Nigerian playwright Wole Soyinka's *Kongi's Harvest*. Actor Ivan Dixon, who had starred in *Nothing but a Man* and the TV series *Hogan's Heroes*, directed Robert Hooks in *Trouble Man*, (1972) as well as a cult favorite about an African American working for and spying on the CIA, *The Spook Who Sat by the Door* (1973), based on the novel by black writer Sam Greenlee.

Coming from television in New York, Stan Lathan directed 1974's *Amazing Grace*, with a cast that included such stars from the old network of black theaters (the chitlin circuit) as Jackie "Moms" Mabley and Slappy White, and, incredibly enough, Stepin Fetchit. The script was by African American writer Matt Robinson, who had played Gordon on TV's *Sesame Street*. Writer Robinson and director Lathan also collaborated on the 1973 concert film *Save the Children*. Afterward, Lathan embarked on a long career in television. Robinson wrote episodes of TV programs, including *Sanford and Son* and *Eight Is Enough*, and later became a staff writer for *The Cosby Show*. Other directors, such as Hugh Robertson and Michael Schultz, also worked during the era. It was a busy, creative time for African Americans in Hollywood.

African American publications like *Jet* and *Ebony* wrote about this movie phenomenon, as did *Time* and *Newsweek*. In many respects, the films were often male fantasies that celebrated African American male empowerment and sexuality, which had long been suppressed in Hollywood movies. Sometimes the films appeared set on rewriting movie history by flipping old images on their heads.

In Griffith's *The Birth of a Nation*, pure, virginal white heroines had been put on pedestals, to be adored and protected—clearly from the "lustful" pursuit of black men. But now heroes such as Priest in *Super Fly* had women at their disposal, white as well as black. The covert idea was that the white woman could be *had* by black men, who indeed were drawn to African American men.

At the same time, black women were marginalized in many of these films and given little character development. The black heroine Shelia in *Super Fly* was defined primarily as she related to the hero: she listened to his plans and aided him in his big triumph. But she was no more drawn out (or given a backstory) in terms of her goals than Petunia was in *Cabin in the Sky*.

Criticism sprang up within a segment of the African American community that felt the movies glorified drug dealers, violence, and sexism. In *Ebony*, Lerone Bennett wrote a lengthy article decrying the images in *Sweet Sweetback's Baadasssss Song*. In some films, the heroes stomped down the villain Whitey and then waltzed off into the sunset with their money and their women. Left unresolved were significant social issues. This new movie phenomenon, or genre, was labeled *Blaxploitation cinema*: a film that touched on the need of the African American audience for heroic figures but does not necessarily answer the need in realistic terms. Still, the movies of the Blaxploitation era were enjoyed for their brazen attack on the system—whether well-delineated or not—and their triumphant, take-no-prisoners heroes.

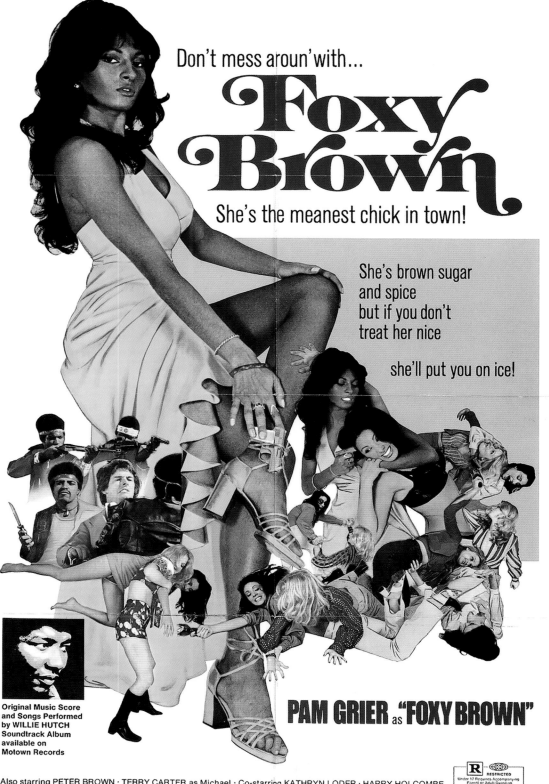

HEROINES FRONT AND CENTER

Though most of the emphasis in the early to mid-1970s was on the hero, talented African American actresses did become fan favorites: Diana Sands, Rosalind Cash, Vonetta McGee, Denise Nicholas, Lonette McKee, Lee Chamberlain, Brenda Sykes. Some actresses rose to stardom.

Pam Grier and Tamara Dobson played tough, resilient heroines at the center of such films as *Coffy*, *Foxy Brown*, *Sheba, Baby*, *Cleopatra Jones*, and *Cleopatra Jones and the Casino of Gold*. Crossing, reversing, and transcending gender lines, the women exhibited what had traditionally been considered male power symbols and skills: they, too, were assertive, resourceful, physically strong, physically fearless. Like their male counterparts, because they could fight, punch, pound, and kick ass, or in the case of Dobson, master karate, they were not to be messed with! Like strong-willed, sexy matriarchs, their characters were often out to rid their communities of drugs and drug pushers. Not only did they defeat corrupt men *and* women, Grier and Dobson sometimes protected men as well.

There could also be contradictory messages. In the case of Grier, it once was said that she used her sexuality as a weapon to ensnare villainous men. Possibly, yes—but moviegoers may have felt the actress was also exploited by the male gaze of the director (and camera) that highlighted and lingered on her physicality, her breasts, her hips. Not as well remembered as Grier, Dobson's sexuality, on the other hand, was rarely exploited by her directors. Nonetheless, Grier and Dobson were cultural heroines for segments of the feminist movement of the 1970s. *Ms.* and *New York* magazines ran Grier

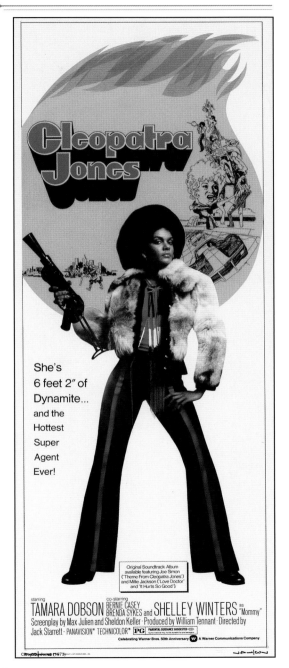

THE 1970s

· 145 ·

on their covers with articles that indicated her importance.

Once the black movie boom ended, the actresses had to adjust to changing times and attitudes. Grier made a transition, appearing later in such films as *Fort Apache: The Bronx* (1981), *Mars Attacks* (1996), and Quentin Tarantino's *Jackie Brown* (1997), and on television in episodes of *Miami Vice* and later *The L Word*. Moviegoers saw little of Dobson, who sadly died in 2006 at the age of fifty-nine, reportedly from pneumonia and complications from multiple sclerosis.

Two actresses drawing critical attention were Diana Ross and Cicely Tyson. Growing up in Detroit's Brewster Projects, Ross had talent, drive, and energy to spare. As everyone of that past era knew, Ross had been the lead singer of Motown Records' great girl group the Supremes, which in the 1960s astonishingly had twelve number-one hits. Ross also exemplified an old-style goddess glamour. Confident that the singer would become as great a movie star as she'd been a recording artist, Motown founder Berry Gordy Jr. threw the might of his company behind her to star her in *Lady Sings the Blues* (1972). The film was based on the memoirs of jazz singer Billie Holiday, whose life and tragic death at the age of forty-four had been widely covered, discussed, and dissected in American media. Perhaps best remembered for her haunting recording "Strange Fruit," in which she sang of a Southern lynching, Holiday represented a tormented artist—victim of a demeaning music business and a brutalizing, racist system. Shrewdly, Motown used the drama and image of a past music diva to give urgency and some gravitas to a current one.

Ross approached the role with a seriousness and dedication that glowed on the screen. Heartthrob Billy Dee Williams was cast as her lover, Louis McKay, and Richard Pryor played her friend Piano Man. Though it romanticized and glossed over incidents in Holiday's life, *Lady Sings the Blues* was highly entertaining, the kind of movie that Holiday herself would have enjoyed. Together, Ross and Williams were a glamour dream couple, perhaps the most romantic black movie couple since Dandridge and Belafonte in *Carmen Jones*.

In 1972, moviegoers saw Martin Ritt's *Sounder*, the story of an impoverished black family in the South during the Depression. When the father (Paul Winfield) is imprisoned for stealing food to feed his family, his wife (Cicely Tyson) must hold their home and three children together. The oldest child (Kevin Hooks, the son of actor Robert Hooks) is also on a precarious journey to maturity as he struggles for an education.

Sounder brought Tyson to stardom. It had been a long time in coming. Having grown up in Harlem, the daughter of a carpenter-father and a domestic worker-mother, she took secretarial jobs. When she made the decision to pursue an acting career, her religious mother threw her out of the house. Slowly and tenaciously, Tyson found roles in New York theater, mostly notably in a daring all-black production of Jean Genet's *The Blacks*. She also worked as a model. In the mid- and late 1960s, she found roles in such television programs as *Naked City*; *East Side, West Side*; *The FBI*; *I Spy*; and *Gunsmoke*. There were also scattered movie parts in

Singer Diana Ross in her movie debut as Billie Holiday in *Lady Sings the Blues*.

LEFT: Old-style romantic hero, Billy Dee Williams in *Lady Sings the Blues*.
RIGHT: Paul Winfield and future director Kevin Hooks as father and son in *Sounder*.

Carib Gold, a 1957 independent film that starred Ethel Waters; *The Last Angry Man* (1959) starring Paul Muni in his last movie role; *The Comedians* (1967); and *The Heart Is a Lonely Hunter* (1968). In *Sounder*, her character Rebecca became "the first great black heroine on screen," said Pauline Kael. "She is visually extraordinary. Her cry as she runs down the road toward her husband, returning from prison, is a phenomenon—something even the most fabled actresses might not have dared."

Both Diana Ross and Cicely Tyson were nominated for the Academy Award as Best Actress, the first time two African American women were up for the award in the same year and the first such nominations since Dandridge in 1954. Nominated for Best Actor was Paul Winfield, who gave a strong performance that was a modern statement on African American fatherhood and masculinity, in stark contrast to the heroes of Blaxploitation. Black writer Lonne Elder III was nominated for the screenplay for *Sounder*. The film was also

nominated as Best Picture. Also nominated in the screenplay category was one of the writers of *Lady Sings the Blues*, Suzanne De Passe. Though none of the black nominees won in his/her categories, the 1973 Oscar nominations were historic.

Going on to star in *Mahogony* (1975)—again opposite Billy Dee Williams—and in *The Wiz*, Diana Ross was a more talented actress than she was sometimes given credit for, and was especially successful with a classic kind of movie star performance: larger-than-life and centered on her own distinct star persona.

Cicely Tyson gave celebrated Emmy Award-winning performances as the title character in 1974's *The Autobiography of Miss Jane Pittman* and in 1994's *Oldest Living Confederate Widow Tells All*. For a dramatization of the life of Harriet Tubman, *A Woman Called Moses*, Tyson not only starred as the abolitionist heroine of the Underground Railroad but served as an executive producer, a ground-breaking move for an African American woman.

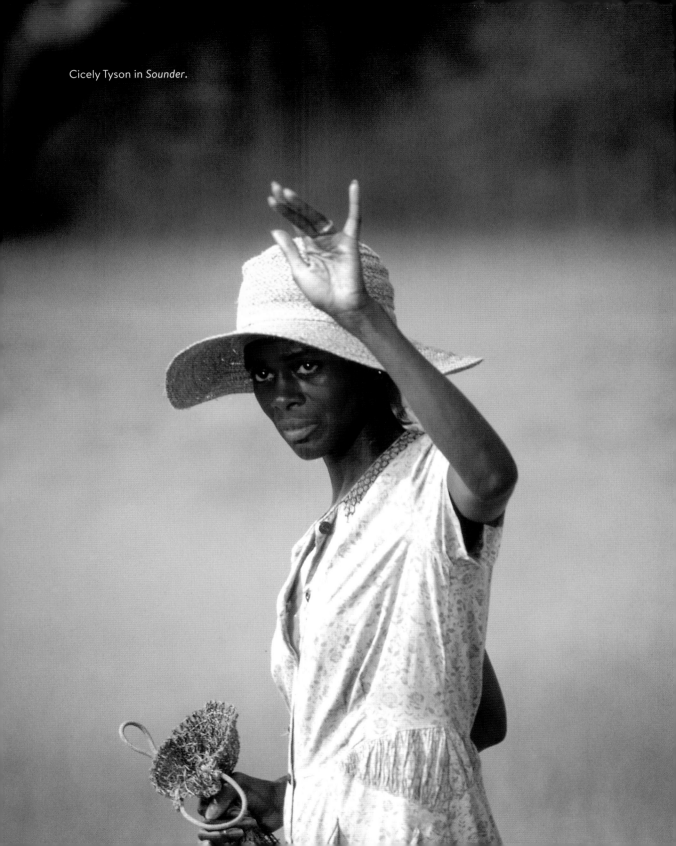

Cicely Tyson in *Sounder*.

Selective about her parts, she did not play a large number of leading roles in the movies but nonetheless worked through decades. Memorably in *Bustin' Loose* (1981), Tyson was Richard Pryor's leading lady. They were an unlikely pairing that brought to mind Katharine Hepburn and Humphrey Bogart in *The African Queen*: she was prim and proper, he was loose and loony. In her eighties, she turned up in such Tyler Perry movies as *Diary of a Mad Black Woman* and *Why Did I Get Married Too?* and in Tate Taylor's *The Help*. Tyson also had a much-discussed marriage to jazz musician Miles Davis. In 2018, she became the first African American woman to be awarded an honorarey Oscar.

Other notable actresses of this era included Diana Sands, who made a name for herself as an acclaimed stage actress in James Baldwin's *Blues for Mr. Charlie*; the title role of Shaw's *St. Joan*; and, most memorably, as kid sister Beneatha, searching for her African roots, in *A Raisin in the Sun*, a role she reprised in the film version. Sands looked as if she could play any kind of character.

Though her movie roles rarely matched her talents, she was cast in two particularly absorbing dramas—*Georgia, Georgia* (1972) and *The Landlord* (1970). In the former she played a troubled American singer who falls in love with an army deserter while traveling abroad. Also in the film, which was written by Maya Angelou, was character actress Minnie Gentry as Sands's traveling companion. Initially, Gentry looks as if she represents an older, less political generation. But when she speaks, you realize that she's voicing the film's 1960s-style political messages. Seeing these two dramatic powerhouses at odds with one another remains fascinating.

Sands's strongest performance was in Hal Ashby's offbeat 1970 comedy/drama *The Landlord*. When a wealthy young white man (played by Beau Bridges) buys an apartment building in Brooklyn—with plans to renovate it and push out the black occupants—his life unexpectedly becomes entwined with his tenants', especially a young woman (Sands) and her militant husband (Louis Gossett Jr.). His affair with the woman leads to her pregnancy—and to her husband's emotional breakdown. Lying in a hospital bed after having given birth to her child, Sands tells Bridges, who seems oblivious to the emotional pain that has ruined her marriage, that she wants the child put up for adoption.

"I want one thing though," she says.

"What's that?"

"I want him adopted as white."

"Why?"

"Cause I want him to grow up *casual*—like his daddy."

It was a wrenching heartfelt moment. Both Sands and Gossett gave two of their finest performances in this underrated film. An adaptation of African American writer Kristin Hunter's novel of the same title, the screenplay was by black writer Bill Gunn, who brought a thoughtful, reflective perspective to all the characters, especially his African American ones. The cast included Pearl Bailey, Lee Grant, Mel Stewart, Robert Klein, and Marki Bey. Three years after *The Landlord*, Bill Gunn directed a cult favorite, *Ganja and Hess*.

Another standout performance was that of singer/actress Diahann Carroll in John Berry's comedy/drama *Claudine*. As a domestic worker and a single mother of six children, the title

Diana Sands and Beau Bridges in *The Landlord*.

Diahann Carroll as the single working mother who juggles family life and a romance with a new man in her life, played by James Earl Jones, in *Claudine*

character Claudine must juggle the demands of her family life with the pressures of her romance with a sanitation worker (James Earl Jones). Known for her glamour, and as the star of the TV series *Julia*, Carroll created a portrait of a seemingly ordinary yet striking woman. *Claudine* brought to the fore pertinent and pressing issues confronting then-contemporary working mothers. It remains her finest performance, one for which she was nominated for an Academy Award as Best Actress of 1974.

Another actress of power was Rosalind Cash, who starred in Hugh Robertson's murder mystery *Melinda*. In one respect, the film was the story of two women (Cash and Vonetta McGee) in competition for the love of a slick disk jockey played by Calvin Lockhart. But Cash infused her character with a burning pathos and emotional passion that were achingly real and wholly apart from the formulaic aspects of the film. In a masterfully acted sequence at a bank where white bank officials are denying her access to an account, she unleashes her rage at the kind of racial discrimination she no doubt has experienced in the past. In actuality, the account is not hers but that of a murdered woman Melinda (her rival). Cash worked with and around the screenplay by Lonne Elder III to bring out her character's complex psychology, in an example of the manner in which an actress can use personal experiences, frustrations, or knowledge to bring heightened tensions or awareness to the drives of her character. Having acted with the Negro Ensemble Company in New York, Cash brought *attitude* to many of her characters.

On occasion, Hollywood producers and directors, seeing the appeal of African American

Rosalind Cash and Charlton Heston in *The Omega Man*.

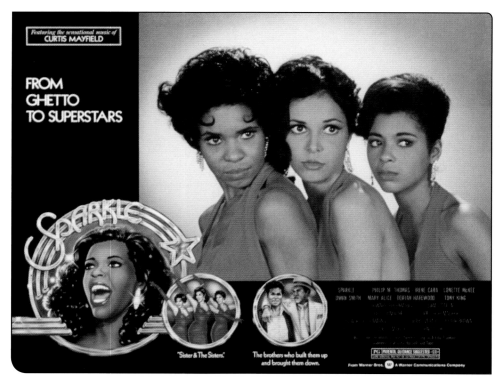

Featuring the sensational music of
CURTIS MAYFIELD

FROM
GHETTO
TO SUPERSTARS

Sparkle

"Sister & The Sisters."

The brothers who built them up
and brought them down.

The cult favorite, *Sparkle*, the story of three sisters off on the bumpy road to success as a singing group: Dwan Smith, Lonette McKee, and Irene Cara.

actresses, cast them opposite major white stars. The ravishing Rosalind Cash was Charlton Heston's leading lady in *Omega Man* (1971). Directing *The Eiger Sanction* (1975), Clint Eastwood chose Vonetta McGee as his leading lady.

Under the direction of Sam O'Steen, actresses Irene Cara, Dwan Smith, and the mesmerizing Lonette McKee revealed the pressures and heartaches as well as the chance for triumph within the music industry in another cult classic, the original 1976 *Sparkle*. In a story inspired by the success of the Supremes, three sisters form a singing group that is on the road to fame and fortune until derailed by the oldest sister's descent into a drug-fueled sadomasochistic relationship. Its

cast included such new faces as Dorian Harewood, Philip M. (Michael) Thomas (later one of the stars of TV's *Miami Vice*), Tony King, and as the mother of the young women, Mary Alice. The music, by Curtis Mayfield, was recorded in a separate hit album by Aretha Franklin. Later Franklin herself performed a smashing rendition of her hit "Think" in the 1980 film *The Blues Brothers*.

Vonetta McGee and Clint Eastwood in *The Eiger Sanction*.

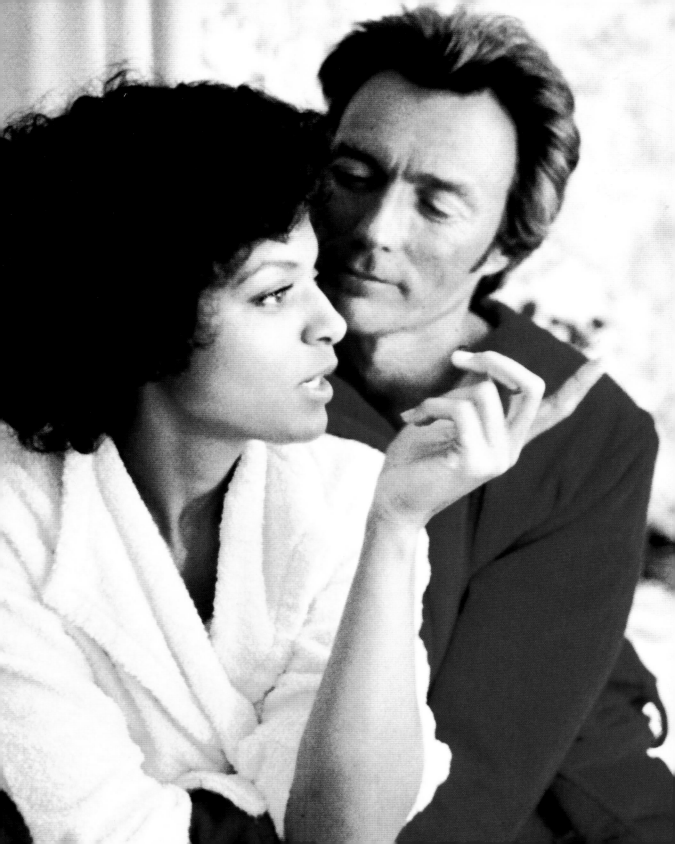

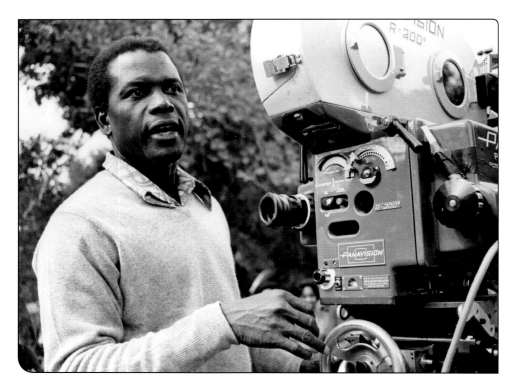

POITIER: RECONSTRUCTING AN IMAGE

With the influx of films and new stars of the 1970s, the career of Sidney Poitier looked almost passé, as if headed for a sad demise. After his trio of hits in 1967, Poitier struggled to meet the demands of a changing age and shifting attitudes. To his credit, he sought to update his idealized image by making *For Love of Ivy* (1968) in which he played something of a romantic hero opposite jazz singer Abbey Lincoln. Next he starred in *The Lost Man* (1969) as a revolutionary (not his most convincing performance), and two movies in which he again played Virgil Tibbs: *They Call Me MISTER Tibbs!* and *The Organization*. He also starred in the mystical and mysterious *Brother John* (1971) as a Christlike figure. None of these films advanced his career. In his autobiography, *This Life*, a frank and honest Poitier discussed this difficult period as he dealt with criticism.

Finally, Poitier had a surprising turn-around when he began directing: first with *Buck and the Preacher* (1972) a rousing western starring himself with Harry Belafonte (funny as the Preacher) and Ruby Dee; then a less successful but at times engaging romance, *A Warm December* (1973), with a real discovery, actress Esther Anderson. After that, Poitier hit the jackpot when he directed

Now a director, Sidney Poitier on the set of *Uptown Saturday Night*.

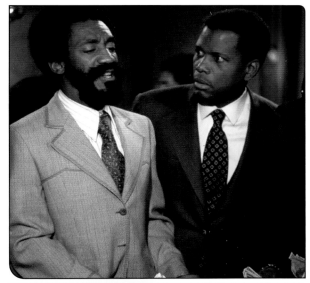

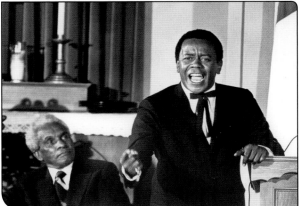

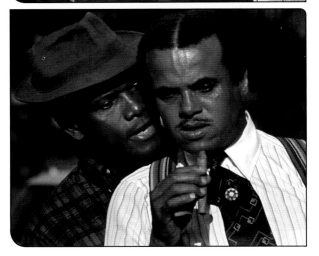

comedies with scripts by African American play-wright Richard Wesley and in which he costarred with Bill Cosby: *Uptown Saturday Night* and *Let's Do It Again*. Interestingly enough, the nation's mood had altered by the time of the release of the films in the mid-1970s; it was less politicized, more a time of personal reflection and goals, which Tom Wolfe described as "The Me Decade." In the casts of one or another of the comedies was a gallery of talents: Harold Nicholas as Little Seymour, Richard Pryor, Rosalind Cash, Roscoe Lee Browne, Lee Chamberlain, Calvin Lockhart, Ketty Lester, Denise Nicholas, John Amos, and the singing heartthrob of the 1940s/'50s, Billy Eckstine. Poitier and Cosby appeared in 1977 in a third comedy, *A Piece of the Action*, also directed by Poitier. By the late 1970s, Poitier stayed away from acting roles for about ten years, not returning until 1988 as the star of *Shoot to Kill* and *Little Nikita*. Afterward, he worked sporadically in supporting film roles in *Sneakers* and *Jackal* (a remake of *Day of the Jackal*) but mainly appeared in television dramas, including *Separate But Equal* (as Thurgood Marshall), *To Sir, with Love II* (a mistake), and *Mandela and de Klerk* (as Nelson Mandela).

Scenes from *Uptown Saturday Night*. **TOP:** Bill Cosby and Sidney Poitier. **MIDDLE:** TV star Flip Wilson, one of the great comedy stars. **BOTTOM:** Poitier and Harry Belafonte.

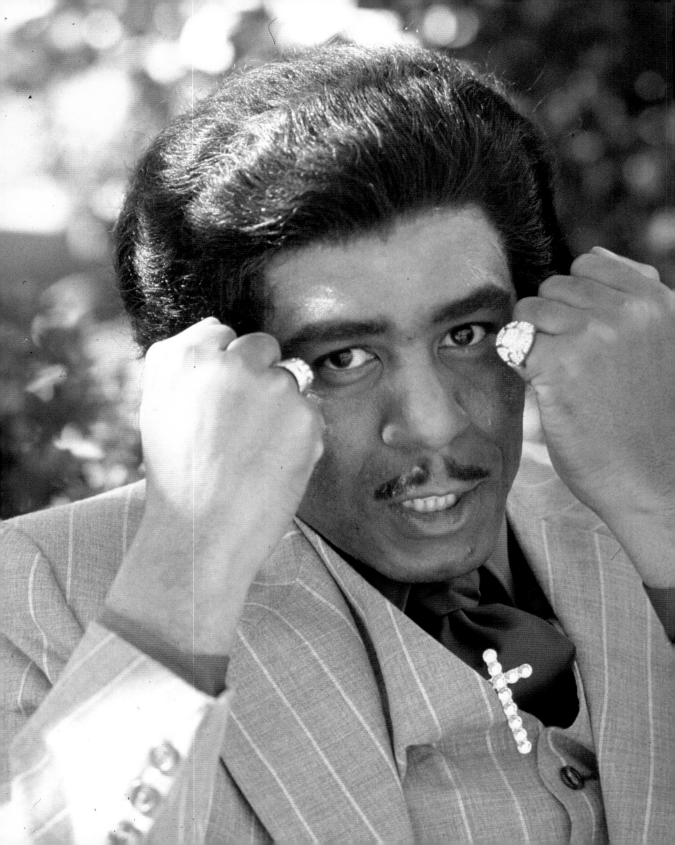

PRYOR: SUPERSTAR IN THE MAKING

The era drew to a close with the unexpected rise of Richard Pryor to superstardom. In the late 1970s and early '80s, Pryor reached an artistic peak. Born in 1940 in Peoria, Illinois, he had survived a difficult childhood. His grandmother ran a brothel where his mother worked as a prostitute. His father was a former boxer. As a teenager, Pryor left home to join the army. Often in trouble and spending time in the brigade, his was not a distinguished military career. Having always told jokes and made wisecracks to his fellow soldiers, he pursued a career as a standup comic after leaving the military. In the beginning, he modeled himself after Bill Cosby. He wore suits and ties and told funny stories. But during a 1967 engagement in Las Vegas, he began to unravel, aware he had not found his true comic voice or persona. He walked off the stage. Afterward, he withdrew and did not perform. When he returned to standup, he was a ribald satirist, using language that was profane and jolting. In important ways, he spoke for the vast black underclass as he gave voice to figures that might be passed by on the streets: the winos, the junkies, the numbers runners, the despairing, and the disenfranchised. He often collaborated with the great comedy writer Paul Mooney.

Finding work in clubs, Pryor also wrote for

LEFT: Pryor as one of the multiple characters he played in *Which Way Is Up?*
ABOVE: Richard Pryor with Lonette McKee in *Which Way Is Up?*

such television programs as *Sanford and Son* and *The Flip Wilson Show* and appeared on late-night talk shows. His comedy albums, *This Nigger Is Crazy* and *Bicentennial Nigger*, were bestsellers. He played supporting roles in such movies as *Lady Sings the Blues*, *The Mack*, *Uptown Saturday Night*, *Adiós Amigo*, *The Bingo Long Traveling All-Stars & Motor Kings*, and as Daddy Rich in *Car Wash*. In each appearance he was spectacularly funny. Even major stars like Cosby, Diana Ross, and Poitier realized that his was such a unique, blazing talent that it was best simply to try to keep up with him or to get out of his way, and whatever you did, it was foolhardy to compete or try to outshine. Terrific as Pryor was, however, it still took time to find a star-making role. Hired as one of the writers for Mel Brooks's comedy *Blazing Saddles*, Pryor was originally set to play the lead role, as the black sheriff who finds himself trying to maintain law and order in a racist town. Pryor would have been perfect, but perhaps because of difficulties with Pryor, Cleavon Little played the role. Still, moviegoers could detect Pryor's iconoclastic hand in the script itself.

By this time, Pryor had a reputation for being difficult. Throughout his career, stories circulated about his troubled private life: the failed relationships, drugs, fights, outbursts. But the stories drew audiences to him, making him seem both all the more human and all the more larger-than-life—the true mark of a movie star.

The breakthrough came with his supporting role in the 1976 *Silver Streak*, a lopsided, sluggishly written movie about a murder on board the fast moving train The Silver Streak. Here Pryor worked with fellow comic Gene Wilder. Because the men were so different, no one could have predicted they'd have much of a comic rapport. But in the end, Pryor and Wilder connected perfectly to one another's timing, rhythm, and comic persona. Wilder came

A new comedy team: Richard Pryor and Gene Wilder in *Silver Streak* in 1976.

across as comically confused and bewildered. What was going on in the world around him? He looked as if he might not be able to cope with anything, as if he were a mass of vulnerabilities. On the other hand, Pryor was the crazed, fearless realist ready to speak out, although he too had his vulnerabilities that he usually managed to keep in check. In one sequence on the train, in which he pretends to be a waiter, he must contend with a racist passenger. Pryor ripped the scene apart to depict his common man character as transcendent, unable to be outsmarted, unable to be demeaned. In a sense, he was a more forceful Rochester, able because of the times to call racism by its name. Together, Pryor and Wilder became a great interracial comic team— much as Rochester and Jack Benny had been. For the late 1970s—following the Blaxploitation era— they reintroduced the theme of interracial male

bonding, which would dominate many movies of the next era. The two would costar in *Stir Crazy*; *See No Evil, Hear No Evil*; and *Another You*.

After *Silver Streak*, starring roles for Pryor came in films directed by Michael Schultz (who had previously directed the comedian in *Car Wash*): *Greased Lightning* (in which Pam Grier was Pryor's costar on screen and his girlfriend off) and *Which Way Is Up* (in which he played three roles). Under Schultz's direction, Pryor was always quick-witted, ironic, and a master of every scene. One of the few black directors to work consistently during the era, Schultz helmed such pictures as *Honeybaby, Honeybaby*; *Cooley High*; *Sgt. Pepper's Lonely Hearts Club Band*; and *Krush Groove*.

By 1977, Pryor had become so liked by audiences that he was a cohost of the forty-ninth annual Academy Awards ceremony. For industry executives, Pryor's ongoing success signaled that he was a crossover star: an African American performer who acquired a broad white audience as well as his minority base. The stars of Blaxploitation cinema had appealed primarily, though not exclusively, to African American audiences.

<hr/>

B y the late 1970s/early 1980s, Pryor was a superstar. He gave a fine unexpected dramatic performance in Paul Schrader's *Blue Collar*. One of his most likable movies was Oz Scott's *Bustin' Loose*, which had a classic sequence when an unknowing Pryor suddenly realizes he's in the midst of a KKK rally! It was also a pleasure to see him perform opposite Cicely Tyson as an exacting schoolmarm to his recalcitrant student. Together, they were splendid. He brought out her light touch. Pryor's boldest artistic move was his concert movies: *Richard Pryor Live in Concert* in 1979 and *Richard Pryor: Live on the Sunset Strip* in 1982. In both, Pryor turned his painful life experiences into searing, insightful artistic expressions. In *Richard Pryor: Live on Sunset Strip*, he recounted a harrowing incident that had made headlines. Later he admitted that while free-basing cocaine, he accidentally set himself on fire. Hospitalized, he once again had to come to terms with the disarray of his life, with the pain he had caused himself and others. He also revealed that he had made a revelatory artistic choice: in the past, he had flagrantly used the word *nigger*, reclaiming it comically to take the sting and ugliness out of the word, creating a wild man or *crazy nigger* comic persona. But in the concert film, he explained that during a trip to Africa he had seen the beauty and dignity of the residents, and he believed the word *nigger* could neither describe nor define them. That trip made him rethink his choices, and he vowed not to use the word again.

Ultimately, Pryor's accident also redefined him in the imagination of the public. It had looked as if he were near death or at the least would never recover fully, but he made a miraculous recovery. In a sense, he had faced death head on, and death had turned away. Now, no matter what the quality of his films—and many of the later ones, such as *The Toy* and *Jo Jo Dancer: Your Life Is Calling* (the story of his accident, which he directed) were indeed regrettable—the public nonetheless would always be fascinated by him—and would connect to him in a personal way up to the time of his death in 2005.

CHAPTER

7

THE 1980s

OG-5092-3A

LEADING THE WAY: LOUIS GOSSETT JR.

At the start of the 1980s, Richard Pryor remained a box-office champ, the lone African American in the firmament of mainstream movie superstars. But within the next few years, others would join his rarefied rank: Eddie Murphy, Louis Gossett Jr., Denzel Washington, Whoopi Goldberg, and Morgan Freeman. On their way to stardom were Samuel L. Jackson, Halle Berry, and a TV personality named Oprah Winfrey. Here and there would be Oscar nominations as well as two surprising and welcomed Oscar wins. Before the end of the 1980s, the directorial vision and voice of writer/director Spike Lee would take everyone by surprise. All this momentum occurred in the politically conservative decade; the early 1980s movies often presented a world without deep-seated racial tensions. Or if racism reared its ugly head, it was a subject for humor, not necessarily angry drama.

The emergence of new stars happened quickly. Early in the decade, audiences flocked to see high-powered stars Richard Gere and Debra Winger in Taylor Hackford's *An Officer and a Gentleman*. In this military drama, a restless young man (Gere) joins the Navy Aviation Candidate School. There, he must find himself as much as his calling in life. Of course, adhering to standard movie narratives, he discovers who he is through the love of a young woman (Winger) and, more significantly, through the strict demands and discipline of a tough drill sergeant, Emil Foley, played by Louis Gossett Jr. Never does Foley let up on the young candidate.

Louis Gossett Jr. in his Academy Award–winning performance as the tough drill sergeant in An Officer and a Gentleman.

Not much backstory was provided for Gossett's sergeant. You may never be sure why he is so focused on Gere's character. But Gossett played Foley with such panache that those who went to see *An Officer and a Gentleman* because of Gere and Winger, no doubt left the theater bowled over by Gossett. He simply stole the show.

Interestingly, the script did not specify that Foley was an African American character, but Gossett got an audition and won the part. His success indicated that casting directors should consider black performers for roles apart from the obvious race-specific characters. A few script changes, however, might have given Foley more complexity. Perhaps if we knew how hard it had been for an African American military man to have risen in the ranks, it might have explained why Foley was such a rigid disciplinarian. Because of the casting, though, the relationship of Gere and Gossett touched on the theme of interracial male bonding, the Huck Finn fixation, in this case once again an older black man helping to bring a young white man to manhood. The truth of the matter was that black men rarely had those types of intense relationships with white males without some serious thought about racial distinctions and cultural differences.

Regardless, Louis Gossett gave a sometimes enjoyably hammy, bravura characterization. Having first acted in New York theater in the late 1950s, he had already given impressive performances, notably in 1970's *The Landlord*. On television, his moving portrayal as Fiddler in 1977's *Roots* won him an Emmy. Audiences had been waiting for him to find another great part. Foley

was it. For his performance, Louis Gossett Jr. won the Best Supporting Actor Oscar for 1982, the first time a black actor had won in that category *and* the first time a black actor had won a major Academy Award since Poitier.

<center>◇◇◇◇◇◇◇◇◇◇◇◇◇</center>

Also appearing in 1982 was *Losing Ground,* directed by playwright Kathleen Collins. An independent production, the film examined the complex relationship of a philosophy professor Sara (Seret Scott) and her artist husband Victor (Bill Gunn). During a memorable summer, the two rent a home outside New York where both can work; he on his paintings, she on a theoretical paper about "ecstatic experiences." But discontent sets in as Sara becomes resentful that her husband does not appear to value her work with the same significance he does his own. On a trip back to the city, she participates in a student film—and finds herself drawn to the young filmmaker's uncle Duke (Duane Jones). Thereafter, *Losing Ground* explores the tangled relationships of Sara, Victor, Duke, and Celia, a Puerto Rican woman Victor paints and has an affair with. Here was personal filmmaking, a far cry from the studio products of the era, and a film that harkened back to Micheaux and Spencer Williams. It was also possibly the first feature-length movie directed by an African American woman. The performance of Seret Scott remains a complex portrait of an intellectual black woman. Her logical, highly thought-out life is contrasted with the instinctual, artistic spirit of her husband. Without a distributor, it played on the film festival circuit, as did other independent films. *Losing Ground* was not formally released until decades later. Its director Collins died in 1988, six years after the film's 1982 debut. She was forty-six years old.

Seret Scott in the independent production *Losing Ground.*

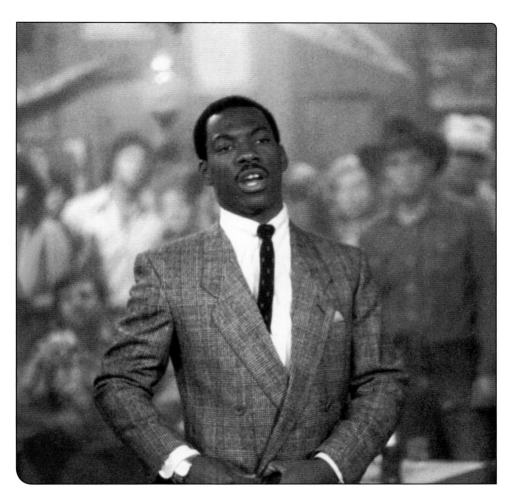

HERE COMES EDDIE

In 1982, mainstream movies were jolted by the arrival of Eddie Murphy. In many respects, Richard Pryor had cleared the way for Murphy's ascent, preparing audiences for an iconoclastic, tough-talking, profane African American comedian. Born in Brooklyn in 1961, Murphy had shot to fame as a cast member of TV's *Saturday Night Live*, often creating controversial characters, such as the pimp Velvet Jones, the convict Tyrone Green, and the angry Gumpy. He also did a satirical take-off on the character Buckwheat from the *Our Gang* series.

He was soon off and running in a series of hit movies, starting in Walter Hill's fast-moving

Eddie Murphy, bold and brash in *48 Hrs.*

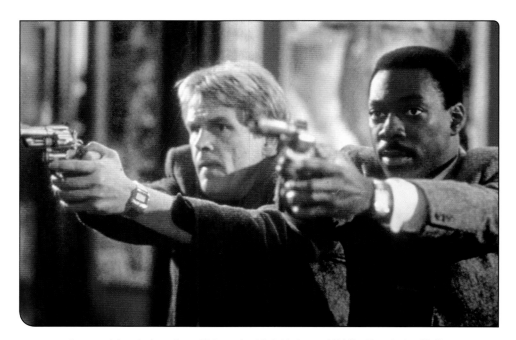

Interracial male bonding—'80s style: Nick Nolte and Eddie Murphy in *48 Hrs.*

1982 action-comedy *48 Hrs.* As the prison inmate Reggie Hammond, who is sprung from jail to help white cop Jack Cates (Nick Nolte) track down two killers, Murphy was quick on the draw and able to hold the screen with the same ease and dexterity as his far more experienced costar. Most believed the scene of Reggie, posing as a police officer in a redneck bar, spotlighted the comic at his assured best. Even if you don't believe in the scene (that he uses his badge to strike fear into the dopey crowd), it was hard not to enjoy the way his brash, hip black character uses his street smarts to outwit them.

Criticized for its violence in its day, for later generations *48 Hrs.* also had a misogynistic streak as Nolte battles it out with his girlfriend (Annette O'Toole) and Murphy's character has a fling with a young African American woman (Olivia Brown), whom he appears to wrongly regard as a whore. But that's not all that could make contemporary audiences in the twenty-first century squirm in their seats. As Nolte's character hurls racist slurs and epithets at Murphy, moviegoers are to laugh at the remarks, as if we're all adult enough now to realize it's just talk, that's all. At the close of the action, Cates makes a halfhearted apology to Hammond, the way a macho tough guy might. But viewers still may feel uncomfortable with this aspect of a very popular film (the seventh highest-grossing movie of 1982). The film also again pushed the theme of interracial male bonding. It is considered the first of the white/black buddy cop pictures, a new genre that continued throughout the 1980s. Eight years later, a disjointed sequel appeared, *Another 48 Hrs.*

Murphy's next film was John Landis's *Trading Places*, which also toyed with the bonding theme while exploring comically the long-debated theory of heredity versus environment in determining one's place in society. Here two rather sinister older white men (Ralph Bellamy and Don Ameche) manipulate two young men to test the theory. One

is white investment broker Louis Winthorpe (Dan Aykroyd); the other, a wily black conman, Billy Ray Valentine (Murphy). Winthorpe is stripped of his class and status; Billy is elevated to a position of wealth and privilege for which he is not prepared.

An unsettling strain of possible racism runs through the depiction of the black character, forever crude and coarse, forever trying to get over. Murphy does not always work against the script to bring some nuance to his character, and, frankly, at times with his broad grin and popping eyes, his characterization bordered on caricature. Nonetheless, moviegoers responded to his bodacious confidence, assertiveness, and refusal to be racially submissive, all of which *did* infuse his character with a different dimension. Let's hope!

Murphy's biggest hit of the era was another action comedy, Martin Brest's *Beverly Hills Cop* (1984). Here he played a Detroit police officer, Axel Foley, who goes to Beverly Hills in search of the killers of his best friend. Underlying the story line was

the contrast of high and low: the plush, ritzy world of Beverly Hills as a backdrop for the gritty street smarts of the dude from Detroit. The Beverly Hills police force doesn't know what to make of Foley, but in time two white cops, Detective Billy Rosewood (Judge Reinhold) and Sergeant John Taggart (John Ashton), bond with him. Once again, Murphy's appeal was his brash confidence, which enabled him to demolish the pretensions of others, and to surprise the unsuspecting with his savvy intelligence and uncanny awareness of the world. For most, it was an enjoyably formulaic old-style Hollywood film, but with a new brand of hero.

Interestingly enough, Murphy didn't have a significant romantic love interest. His relationship with a young white woman who runs a gallery in Beverly Hills is strictly platonic, something that would not have been the case had Sylvester Stallone (originally considered for the role of Axel) played the character—leading to questions about Hollywood's ongoing fear of strong, sexual,

Eddie Murphy as an African prince, with Arsenio Hall in *Coming to America*.

romantic African American men. The same kind of questions had been asked about Poitier characters. *Beverly Hills Cop*, however, thrust Murphy into the superstar category. The number one box-office hit of 1984, it spawned two sequels, *Beverly Hills Cop II* in 1987 and *Beverly Hills Cop III* in 1994, neither of which matched the appeal of the original.

Murphy's career continued on a roll with the 1988 comedy *Coming to America*. But Murphy must have considered the criticism of his screen characters, because he appeared to take more control over his image, including having an on-screen romance this time around. Murphy played an African prince, Akeem (in a totally fake and preposterous view of African culture), who comes to America—Queens, New York, to be exact—in search of a bride. James Earl Jones and the terrific Madge Sinclair portrayed his parents, and Arsenio Hall (a real-life friend of Murphy's) played his sidekick.

Also in the cast were Cuba Gooding Jr., Samuel L. Jackson, John Amos, Eric La Salle, Calvin Lockhart, Shari Headley, Garcelle Beauvais, and Allison Dean, as well as cameo appearances by *Trading Places* costars Ralph Bellamy and Don

Ameche. But Murphy was the centerpiece, playing three other characters in addition to Prince Akeem, revealing the actor's great skill at timing and parody. Director John Landis had the good sense to stay out of Murphy's way. The studio, Paramount, reportedly had not been enthusiastic in backing this basically black-cast film. Would Murphy's large white constituency go to see it? The answer was yes. *Coming to America* was another hit that grossed $160 million worldwide. It proved that moviegoers could be far ahead—in their views of what a black movie hero could be—of those who ran the studios.

Murphy again exerted more image control as the star and director of *Harlem Nights* in 1989. Here essentially was another comedy with a mostly all-star African American cast: Richard Pryor, Redd Foxx, Jasmine Guy (who had risen to fame as Whitley on TV's *A Different World*), Della Reese, Arsenio Hall, Stan Shaw, and Danny Aiello. An admirable attempt was made to depict a glamorous Harlem of the past, but not much gelled. The most pleasurable thing about the film was seeing legendary black stars working together.

Another homage to a Harlem of the past was Francis Ford Coppola's *The Cotton Club* (1984), which looked at the famous nightclub that had helped define New York's cultural life in the 1920s and '30s and, of course, that was important to the careers of Duke Ellington, Ethel Waters, and the Nicholas Brothers, among others. Much of the focus was on the characters played by Richard Gere and Diane Lane, which seemed to miss the point of what the movie should have been. Here was a film with black subject matter that was geared to please a large white audience. Nonetheless, African

American stars Gregory Hines and Lonette McKee lent an air of authenticity, as did supporting players Maurice Hines (brother of Gregory), Laurence Fishburne, and Woody Strode. Perhaps most interesting was a return to the "passing" theme. It was obvious that McKee's character considers crossing the color line mainly to serve as a gateway to opportunities. A high point was her soulful rendition of "Ill Wind." Also in the cast: Nicolas Cage, Andy Warhol star Joe Dallesandro, and the great dancer Gwen Verdon.

THE NEW LEADING MEN

One of the era's more unusual and engrossing films was Norman Jewison's *A Soldier's Story* (1984), an adaptation of playwright Charles Fuller's Pulitzer Prize–winning drama *A Soldier's Play*. The story is set on a Louisiana military base in 1944. Negro sergeant Vernon Waters (Adolph Caesar) has been murdered, and a black captain Richard Davenport (Howard Rollins) has been sent to investigate. Uncovering a tangled mass of racial tensions, Davenport is treated dismissively by the commanding white officers, who have little confidence in him and merely want the investigation completed quickly. Davenport, however, learns of the suicide of a likable black soldier, C. J., and ultimately of Waters's resentment of the dead solider. Thereafter, the clashes and class divisions within the black unit slowly unfold. A murder mystery and a social/psychological drama, *A Soldier's Story* was taut and fascinating, with unexpected plot developments and an insider's view of conflicts in the African American community.

All the performances were exciting, bringing to the fore such actors as Adolph Caesar, Denzel Washington, Robert Townsend (soon to be a director), Larry Riley, Art Evans, David Alan Grier, William Allen Young, Wings Hauser, and singer Patti LaBelle. The film earned three Oscar nominations: for Best Picture, Charles Fuller for Best Screenplay Adaptation, and Adolph Caesar for Best Supporting Actor.

Though he was not among the nominees for this film, the center of the story was Howard Rollins Jr., who had previously won critical attention and an Academy Award nomination as Best

A Soldier's Story's breakout star, Denzel Washington.

Supporting Actor for his performance as Coalhouse Walker in 1981's *Ragtime*. Eyes were glued to the actor. Would he become the heir to Poitier's throne as Hollywood's most important dramatic black actor? He certainly met the requirements. Not only was he a powerful, yet relaxed personality but he also was handsome and engaging. *A Soldier's Story* looked as if it would propel his journey to major stardom. But, sadly, the career was derailed; in part because the industry still was not ready for this kind of African American male movie star, in part

A Soldier's Story's star Howard Rollins Jr., ahead of his time.

possibly because of Rollins's own personal demons. There were arrests for cocaine possession and for driving under the influence. When film roles were few and far between, Rollins appeared on television and as the costar with Carroll O'Connor of the series *In the Heat of the Night* from 1988 to 1995. He played Poitier's former character Virgil Tibbs. Then Rollins suddenly died at age forty-six in 1996.

The irony of Rollins's position in the movies, of having arrived just a bit before changes would come about for dramatic African American actors, was that the breakout star in *A Soldier's Story* was Denzel Washington, who would indeed become a major movie star. Portraying the cynical Private Peterson, Washington's performance was riveting: smart and intense, with dramatic surprises at every

turn. Few actors would have his powerhouse talent or charisma.

Having grown up in Mount Vernon, New York, Washington was the son of a father who was a Pentecostal minister and a mother who was a beauty parlor operator. At age fourteen, he was sent to the Oakland Military Academy, which he later credited with having changed his life. After graduating from Fordham University, he earned a master's degree from the American Conservatory Theater in San Francisco. Soon winning roles on television and in film, beginning with 1981's *Carbon Copy*, he was best known—for a time—as Dr. Phillip Chandler in the TV series *St. Elsewhere*. His career would start its mighty roar when he won a 1987 Best Supporting Actor Academy Award

nomination for his performance as South African revolutionary Steve Biko in Richard Attenborough's *Cry Freedom*. Washington heralded a truly new day for American motion pictures. His characters could

be both gritty and polished and always there was an air of commitment to some cause or way of life. The best was yet to come.

Another kind of star was at the center of the new-school 1984 musical *Purple Rain*. Prince! This Minneapolis-born singer/composer/instrumentalist—né Prince Rogers Nelson—had already shaken up popular music with his hit albums *Prince*, *Dirty Mind*, *Controversy*, and *1999*. Music lovers swayed to the sensual lyrics of his songs and danced up a storm to his masterful pop fusion of blues, funk, and rock. Like Michael Jackson, he was a phenomenon in his onstage live performances. Influenced by James Brown and Little

Richard—with an androgyny that was at the heart of his sex appeal—he was known for his flamboyant costumes and his flamboyant look: a carefully coiffed pompadour and heavily made-up eyes.

Directed by Albert Magnoli, *Purple Rain* was a movie-star-making vehicle that featured Prince as a brooding man-child known as the Kid, who wrestles with problems at home (a distant and demanding mother, played by Olga Karlatos, and a physically abusive father, played by Clarence Williams III), as well as conflicts with musicians (Morris Day

A new kind of musical and a new kind of musical star, Prince in *Purple Rain*.

and Dez Dickerson), and, naturally, hassles with the young woman he loves, Apollonia (Apollonia Kotero). The storyline was basic and pleasingly formulaic. But no one could have predicted the sheer entertainment power of the musical sequences. Morris Day and the group The Time were coordinated to the point of perfection: flashy, hip, with dance steps that were so imaginatively executed that moviegoers replayed them in their minds time and again. Or they saw the picture time and again. Throughout, Prince pouted, playfully teased, and knowingly *attitudinized* as he flirted through his dialogue. The flirting was not only with Apollonia but the audience as well. When he sang the title song while playing on his electric guitar, *Purple Rain* ascended to another stratosphere as Prince reinvigorated the movie musical, giving the genre a then wholly contemporary beat and rhythm with the sound of 1980s music emporiums.

The title song won the Academy Award for Best Song. After his 1986 follow-up movie, *Under the Cherry Moon*, was less successful, Prince returned to his music, and the movies lost what might have been its most unusual Movie Star.

ACTRESSES IN SEARCH OF ROLES

The 1980s was not remembered for its strong film roles for African American actresses. Alfre Woodard's career had some traction when she earned an Academy Award nomination for Best Supporting Actress in *Cross Creek* in 1983. One of her later films was *Down in the Delta*, directed by Maya Angelou. But most of her work was in television, where she won four Emmys. Jennifer Beals also won attention in *Flashdance* (1983). Star-making characters were rare.

In a white male-dominated industry, women in general, no matter how successful, found themselves taking a backseat to male stars. For years to come, white actresses would not earn as much as their male counterparts and as they hit forty, the roles started to dry up. This was a far cry from the glory days when great female stars like Greta Garbo, Jean Harlow, Bette Davis, Joan Crawford, and Katharine Hepburn ruled the roost and later Elizabeth Taylor had become the first million-dollar star for her role in *Cleopatra*. That kind of star no longer existed. During this era and for years to come, in the executive offices at studios as well as onscreen, white males reigned at the top of the totem pole, followed by white actresses (beset by problems unique to them), black actors, and, at the bottom, African American actresses.

The great exception for African American actresses (albeit temporarily) was Steven Spielberg's 1985 adaptation of Alice Walker's Pulitzer Prize-winning novel *The Color Purple*. With its exploration of incest, violence, same-sex relationships, racism, and the power of sisterhood, the novel had been an astonishing piece of work that affected the lives of African American women—and, indeed, white women.

Beautifully shot by cinematographer Allen Daviau with music by Quincy Jones, the film, like the novel, was set in rural Georgia during the early part of the twentieth century. Its teenage heroine

Whoopi Goldberg in *The Color Purple*.

Celie (Whoopi Goldberg) is separated from her children and forced by her brutal father, who has raped her, into a marriage with a sharecropper identified as Mister (Danny Glover). He too abuses Celie, imprisoning her in a life of unrelieved servitude. Yearning for reunion with her sister Nettie (Akosua Busia), from whom she has been separated, Celie writes her letters and waits for a response. But unknown to Celie, Mister hides the letters Nettie has sent. Hoping for relief from her torment and the harrowing path her life has taken, she observes and befriends another woman in distress, Sofia (Oprah Winfrey), who is also battered by her husband. A change in Celie's life comes through her relationship with Mister's former lover Shug (Margaret Avery)—which leads to Celie's emotional and sexual awakening. That empowers her to defy Mister. In the end, she is reunited with her sister Nettie. And there is a kind of reconciliation with Mister as well.

Spielberg's film was well-received but also criticized for sanitizing Alice Walker's themes and her perspective. The lesbian relationship of Celie and Shug was so neutralized as to be almost non-existent. The African American men—including Mister and the terrorizing father played by Adolph Caesar—often looked like the brutal buck stereotype. The movie was also criticized for being almost too beautiful, not showing the devastating poverty in which the characters lived. The Hollywood/Beverly Hills chapter of the NAACP protested against the film.

With that said, *The Color Purple* treated its African American women with sensitivity. Rarely had there been close-ups of black female characters so urgent and so loving. The actresses illuminated the inner conflicts, sorrows, and joys of their characters. For Whoopi Goldberg, the film was a special triumph. Born Caryn Elaine Johnson in 1955 in New York, she had worked in theater for years, notably in her one-woman production *The Spook Show*. Director Mike Nichols brought her

show, then retitled *Whoopi Goldberg*, to Broadway in 1984. When Spielberg saw it, he invited her to come west to perform for a select audience that included Michael Jackson and composer Quincy Jones. By then, Spielberg wanted her for *The Color Purple*. Refusing to alter her appearance, Goldberg led the way with her dreadlocks to a new "acceptable" look for black actresses in the movies. Another newcomer appeared in *The Color Purple*—Oprah Winfrey, who had hosted a daytime talk show in Chicago when Quincy Jones recommended her to Spielberg. After years of acting, Margaret Avery's performance as Shug brought her to prominence.

The Color Purple won eleven Oscar nominations, including Best Picture, Best Actress for Goldberg, and Best Supporting Actress for both Winfrey and Avery. Not nominated was Spielberg, although he won the Directors Guild of America's Best Director Award. In the end, *The Color Purple* won no Oscars. And the sad state of African American actresses seeking dramatic leading roles was apparent when none of the film's principals had major careers as dramatic film stars. Margaret Avery had few significant roles. Oprah Winfrey became a national phenomenon with the success of her national television show. She played dramatic parts in *Native Son* (1986), *Beloved* (1998), *Lee Daniels' The Butler* (2013) and *Selma* (2014), as well as in television dramas such as *The Women of Brewster Place,* but major movie stardom eluded her.

Winning a Golden Globe as Best Actress in a Motion Picture Drama for *The Color Purple*, Whoopi Goldberg appeared in important roles in such features as *Jumpin' Jack Flash* (1987) and *Clara's Heart* (1988). Though she played other dramatic leads, her primary success was in comedies.

Oprah Winfrey as Sofia in *The Color Purple*.

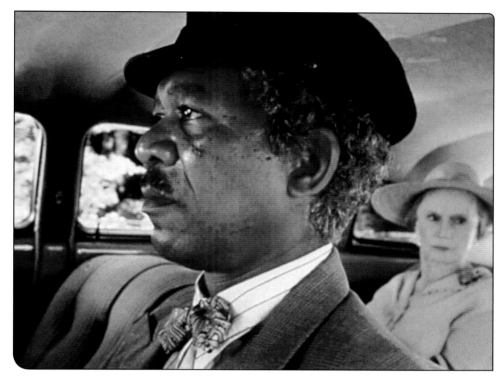

STAR-MAKING ROLES

As the decade continued, African American actors found important roles, although that did not mean Hollywood was yet a level playing field for black men. An interesting and likable actor was former Oakland Raiders football star Carl Weathers, who played the boxer Apollo Creed in the *Rocky* series starting in 1986 and continuing in three subsequent films. As the formidable opponent and later the friend of underdog Philadelphia fighter Rocky Balboa (Sylvester Stallone), Weathers projected the appropriate flashiness as well as the shrewd intelligence of a man (inspired by Muhammad Ali) who understands the self-promotion and professional brand merchandising of the new age of prize fighters.

Under John Avidsen's skilled direction of Stallone's well-crafted script, Weathers brought human dimensions to a character that, in the hands of a different kind of actor, might have slipped into a stereotypical (coon) category. For example, Rocky's opponent Clubber Lang (Mr. T) in *Rocky III* falls into the old-style, nightmarish buck type. But due to the casting of Weathers, Creed and Rocky had a credible bromance and as was true to the era, was another salute to Hollywood's theme of interracial male bonding. Weathers went on to

Morgan Freeman as the chauffeur Hoke with his passenger
Miss Daisy, played by Jessica Tandy, in *Driving Miss Daisy*.

Sylvester Stallone and, as Apollo Creed, Carl Weathers in *Rocky*.

starring roles in such movies as *Predator* (1987) and *Action Jackson* (1988), but most of his work was in television, including a 2008 remake of *The Defiant Ones*, in which he played the Poitier character, now called Cullen Monroe.

Interracial male bonding was clearly, actually *glaringly*, the predominant theme of *Lethal Weapon* in 1987 and the sequels that followed: *Lethal Weapon II* (1989), *Lethal Weapon III* (1992), and *Lethal Weapon IV* (1998). With Danny Glover as Roger Murtaugh to Mel Giblson's Martin Riggs, the two were Los Angeles police officers who become partners and best buddies. As might be expected, they are the most unlikely of friends. Gibson's Riggs is a loner, alienated, suicidal, and emotionally adrift after having lost his wife. Glover's Murtaugh is an older, stable, staunch family man who ends up offering comfort and counseling to the younger Riggs. Here there were no racial clashes or cultural differences that the men might have to overcome to connect to one another. It was refreshing, however,

to see that Glover's resolutely middle-class home life offers Gibson an emotional anchor. Yet that home had few African American cultural markers that would cue moviegoers in to the family's background, and the significant way culture helps define characters. The Riggs/Murtaugh relationship is meant to signal, despite whatever else happens in the *Lethal Weapon* films, the lopsided notion that fundamentally racism among good, decent people was a thing of the past.

Longtime jazz aficionado Clint Eastwood made a daring move with his decision to bring the story of jazz musician Charlie Parker to the screen in 1988's *Bird*, starring Forest Whitaker as Parker. In 1967, Dick Gregory had portrayed a character inspired by Parker, Richie Eagle Stokes, in *Sweet Love, Bitter*. That earlier movie featured Stokes as one of several musicians on New York's jazz scene in the 1960s. Eastwood's *Bird* focused exclusively on the troubled, self-destructive, drug-addicted saxophonist/composer. Much attention was devoted to

Morgan Freeman and Tim Robbins in *The Shawshank Redemption*.

ck soldiers during the Civil War in *Glory*: Jihmi Kennedy, Denzel Washington, and Morgan Freer

Buddies forever, Mel Gibson and Danny Glover, in the second of the *Lethal Weapon* series.

Bird's relationship with Chan Parker (well played by Diane Venora) and, to a certain degree, with white musician Red Rodney (Michael Zelniker). No doubt African American moviegoers would have preferred seeing more of Parker with his African American compatriots—Dizzy Gillespie and Miles Davis—as they boldly created bebop. And the film might have said more had there been some depiction, or at least an acknowledgment, of Parker's first three wives, each of whom was black. Another jazz film suffering from a problem of not providing an African American context for its protagonist was Bertrand Tavernier's 'Round Midnight (1986), starring real life jazz musician Dexter Gordon, who won an Oscar nomination for his performance. Interesting and involving as each film

was, both raised a familiar question: Who is telling the story of these African American characters, and what are we not being told?

Of the African American actors now coming to prominence, surely the most compelling was Morgan Freeman. A native of Memphis, Tennessee, Freeman had joined the United States Air Force and risen to the rank of Airman First Class. Afterward, he studied acting at the Pasadena Playhouse, danced at the 1964 World's Fair in New York, and made his Broadway debut in the all-black version of *Hello, Dolly*, starring Pearl Bailey and Cab Calloway. He also worked off-Broadway, winning Obie Awards for his performances in the title roles in *Coriolanus* and *Gospel at Coriolanus*—and praise for his performance as a wino in Richard Wesley's drama *The Mighty Gents*.

For years, Freeman was known primarily for his character Easy Reader on television's *The Electric Company*. His movie breakthrough, however, was as the pimp Fast Black in Jerry Schatzberg's *Street Smart* in 1987. Shrewd, manipulative, calculating, and king of his domain, he's a terrifying, complicated buck who can smile one minute and in the next threaten to cut out a prostitute's eye with scissors. Also in the cast were Kathy Baker, as one of Fast Black's prostitutes; Christopher Reeve as a journalist; and the underrated marvel, Anna Maria Horsford. *Street Smart* didn't provide much backstory on the Fast Black character, but behind Freeman's intelligent eyes, we know he's always assessing a situation, analyzing his opponents, and is ever ready for a possibly lethal pounce. Few actors of the era could match him in screen power. At this point, critic Pauline Kael asked the question: "Is Morgan Freeman the greatest American actor?" It looked as if he just might have been. He scored a Best Supporting Actor Oscar nomination for his performance as Fast Black.

Freeman's versatility was apparent two years later in the film adaptation of Alfred Uhry's play *Driving Miss Daisy*. Cast as the chauffeur, Hoke, to a demanding former schoolteacher, Daisy (Jessica Tandy), he masterfully delineated the mind and attitude of a man keenly aware of the Southern culture in which he lives. The film was set in Atlanta in 1948 and, true to the period, Freeman's Hoke is both civil and courteous, but he will not be demeaned or treated as anything less than a man. In a key sequence, he informs his testy employer that he has to leave the car in order to relieve himself and will do so no matter what she thinks. Freeman transcends what might have been a tom characterization. In most respects, *Driving Miss Daisy* was about a friendship and, later, old age.

Freeman and Tandy were two terrific actors, respectful of one another's talents. Still, the film created a network of relationships for Daisy: moviegoers saw her with her son (Dan Aykroyd) and his wife (Patty LuPone), with whom she does not get along; with her friends; with others at her place of worship. The screenplay depicts Hoke, however, mainly as he related to Daisy, failing to take him fully into his own community and family life. *Driving Miss Daisy* would have had an even deeper emotional resonance had it explored other aspects of Hoke. Still, the film won Oscars, for Best Picture, Best Actress (Jessica Tandy), Best Adapted Screenplay, and Best Makeup. Though nominated for Best Actor, Freeman did not take home the big award. He did, however, walk off with the Golden Globe for Best Performance by an Actor in a Motion Picture, Musical or Comedy.

In some respects, Freeman can be compared to such other great character actors as Juano Hernandez and Rex Ingram. In their films, they often played the most memorable characters. The actors were so strong, grounded, and invested in their roles that at times moviegoers sat spellbound by the majesty of their portrayals. Where Freeman was different from his brilliant predecessors was that he was a character actor who became a star and would be well known to audiences around the world. He would win other Oscar nominations, for *The Shawshank Redemption* (1994) and Clint Eastwood's *Invictus* (2009, playing Nelson Mandela). He would take home a Best Supporting Actor Oscar for his role in another Eastwood drama, *Million Dollar Baby* (2004). He also played the president of the United States in *Deep Impact* (1998), providing this disaster movie with a certain gravitas, as well as God (*yes*, God) in *Bruce, Almighty* in 2003 and *Evan Almighty* in 2007. True, some of his later characters would also have a saintliness that seemed to neutralize them of any threat, but it was impossible not to respond to the moral weight of his screen performances.

Freeman gave another of his strongest characterizations in the 1989 *Glory*, in which he matched wits and star power with Denzel Washington. Directed by Edward Zwick with a cast that included Matthew Broderick, Andre Braugher, Jihmi Kennedy, Cary Elwes, and Raymond St. Jacques as Frederick Douglass, *Glory* told the story of one of the first black military units—the Fifty-Fourth Regiment Massachusetts Volunteer Infantry— during the Civil War. Led by the white Colonel Shaw (Broderick), the black soldiers endure humiliation and discrimination as they fight for the Union—and the freedom of the slave population. They must maneuver their way around racism on their base.

Too much of the focus of *Glory*, however, was spent on the noble Colonel Shaw, the good white man or savior. The film took pains to depict Shaw before his life with the unit. The same, however, could not be said of the black soldiers, whose earlier lives and the forces that drove them to join

the Union army are not dramatized. In the end, however, the film examined an often unheralded piece of American history: of courageous black soldiers during the Civil War. Another rousing piece of history embedded in *Glory* was that Denzel Washington won the Academy Award as Best Supporting Actor of 1989 for his performance. It solidified his stardom.

INDEPENDENTS

In the 1980s, a wave of independent filmmakers launched a new era of black movies. Among the new talents was Martinique-born Euzhan Palcy. Having left for Paris at a young age, Palcy graduated from the Sorbonne with a degree in French literature, and then earned a film degree at the Vaugirard School in Paris. Her 1983 film *Sugar Cane Alley*, which recounted the experiences of a boy growing up in colonial Martinique, drew international praise. Afterward, she worked for years to film the South African apartheid drama *A Dry White Season*. When a deal with Warner Bros. fell through, she managed to find backing from MGM. What helped was that Marlon Brando believed so strongly in Palcy and the project that he agreed to star—at a scale salary. For his performance, Brando won a Best Supporting Actor Oscar nomination. Also coming onboard were Susan Sarandon, Donald

Spike Lee and Danny Aiello in Sal's pizza parlor, which will go up in flames in Lee's *Do the Right Thing*.

Sutherland, and the South African actors Zakes Mokae, Winston Ntshona, and John Kani. In the end, Palcy became the first black woman to direct a major studio production.

Also coming to the fore was Robert Townsend, who had acted in such films in the 1970s and '80s as *Cooley High*, *A Soldier's Story,* and *American Flyers*. In 1987, Townsend directed and co-wrote with Keenen Ivory Wayans the critically well-received low-budget production *Hollywood Shuffle*, a clever and biting satire on the experiences of black actors in Hollywood. He went on to direct the concert film *Eddie Murphy Raw*. He also directed, produced, starred in, and cowrote with Keenen Ivory Wayans *The Five Heartbeats* (1991), the story of a black singing group. Also in the cast were Diahann Carroll and, notably, Harold Nicholas of the Nicholas Brothers. Townsend's other films included *Meteor Man* (an early black superhero movie which he also wrote and produced); *B.A.P.S,* starring Halle Berry; and, in 2001, the MTV musical *Carmen: A Hip Hopera*, a hip-hop take on Bizet's *Carmen*, or to be more precise, on *Carmen Jones*, starring Beyoncé in her screen debut.

Also winning attention was independent film-maker Charles Lane, who directed *Sidewalk Stories* (1989), an ingenious salute to silent films. In the mostly silent black-and-white film, Lane himself played a Chaplinesque homeless street artist who cares for a little girl. At the Cannes Film Festival, *Sidewalk Stories* won the Prix du Publique and received a twelve-minute ovation. Lane went on to direct British comic Lenny Henry in Disney's *True Identity*.

The independent filmmaker who drew the most attention was Brooklyn-based Spike Lee. The oldest of four children of a mother who taught black literature and the arts and a father who was a jazz musician, Lee was born Sheldon Jackson Lee in Atlanta in 1957. He spent his formative years in Brooklyn, then returned to Atlanta as a student at Morehouse College. Afterward, he was awarded a master of fine arts degree from New York University's Tisch School of the Arts. His career took off quickly. Possessing the drive and appropriate "hustle" of an Oscar Micheaux, he wrote, directed, and produced 1986's *She's Gotta Have It*, which he shot in two weeks in Brooklyn on a budget of $175,000 with a cast of unknowns. He took the film to the Cannes Film Festival. There, an international audience was impressed by his directorial assurance and inventiveness. Island Pictures picked up the film for distribution. The stage was being set for the arrival of an important film and filmmaker.

She's Gotta Have It was at times shot like a documentary, as it provided sharp insights into evolving sexual/social attitudes among a new generation. The film told the story of Nola Darling (Tracy Camilla Johns), who is in the midst of a dilemma. She has three suitors: the stalwart Jamie (Tommy Redmond Hicks); the narcissistic Greer (John Canada Terrell); and the playful, uninhibited Mars Blackmon (played by Lee). She can't have all three. But the independent Nola believes she shouldn't have to choose. She should have the freedom to live by the same rules as men, indeed, to have more than one lover.

In some respects, *She's Gotta Have It* said more about the men. In a skillful, comic montage, Lee quickly taps into the feelings and dating ploys of young men as they use pickup lines to attract and seduce women. At other times, the men (Jamie and Mars) also have an unexpected camaraderie, best exemplified at a Thanksgiving dinner sequence in which they vie for Nola's attention and while doing so discuss politics and sports. Though Nola was a graphic artist, little was said of her career, and in dialogue, Nola was a bit of a blank slate. Through

Wynn Thomas's set decoration, however—the clippings on her wall of explosive racial incidents in New York as well as pictures (briefly glimpsed) of Billie Holiday and Josephine Baker—Nola was revealed to be a thoughtful, political young woman but for some reason, her beliefs were not stated emphatically enough.

She's Gotta Have It was not without controversy, notably with a sequence in which Nola was sexually violated by her lover Jamie. Yet the rape, which the screenplay has her describe as a "near rape," was never directly addressed. Years later, Lee himself said he regretted the sequence.

Nonetheless, much of the appeal of *She's Gotta Have It* were the African American cultural markers and references—whether it be comments about political leader Jesse Jackson or choreographer Alvin Ailey—that ran throughout, providing moviegoers with a portrait of a culturally cohesive African American community. And in an era when black women were too often marginalized or ignored in movies, Lee had put a seemingly independent African American woman front and center. Like Dandridge's Carmen Jones, Nola is set on making her own choices. Granted that again like Carmen Jones, those choices are predicated on her romantic inclinations, but underneath it all there was an intelligent drive and determination. The film also presented fresh faces, not only of the main characters but of the filmmaker's sister Joie Lee, who appeared in other Lee films, and Raye Dowell, who skillfully played the lesbian character Opal. Also in the film were S. Epatha Merkerson and Lee's father, musician Bill Lee.

With *She's Gotta Have It*, Lee took the burgeoning indie movement in a new direction. Independent films had often been shown at film festivals or conferences without reaching larger audiences. Like Micheaux, Lee was determined to connect to a broad audience in theaters around the country and abroad. He made himself a public figure, for some a folk hero, as he appeared on radio and television. He was a David against the Goliath of the system.

Lee's next film was *School Daze* (1988), set on a black college campus. Here he tackled the issues of colorism and conflicts within the African American community. *School Daze* also spotlighted a varied cast: former child actors Giancarlo Esposito and Laurence Fishburne, who had appeared in such films as *Cornbread, Earl, and Me* and later in Francis Ford Coppola's *Apocalypse Now*; Tisha Campbell; Kyme; Joie Lee; Jasmine Guy and Kadeem Hardison, both from the television series *A Different World*; musician Branford Marsalis; Alva Rogers; future director Kasi Lemmons; Tyra Ferrell; Samuel L. Jackson; and such veterans as Ossie Davis, Ellen Holly, and Art Evans. Though *School Daze* lacked the coherence and charm of *She's Gotta Have It*, the film was uncompromising and stands as a significant personal statement.

Lee closed the decade with 1989's *Do the Right Thing*, a blistering and often brilliant look at America's festering racial divisions. The film revolves around a day in Brooklyn as pizza delivery man Mookie (Lee) makes his rounds from Sal's Pizzeria. Throughout, there were telling portraits of a rich assortment of neighborhood characters: the often drunk but insightful Da Mayor (Ossie Davis), who cautions to *do the right thing*; the observant Mother Sister (Ruby Dee), who observes her community perched on her windowsill; Radio Raheem (Bill Nunn), who blasts his radio while walking through the streets; Buggin' Out (Giancarolo Esposito), who, aware that his neighborhood is being gentrified by outsiders, understands what will soon be lost; Tina (Rosie Perez), the girlfriend of Mookie and mother of his child;

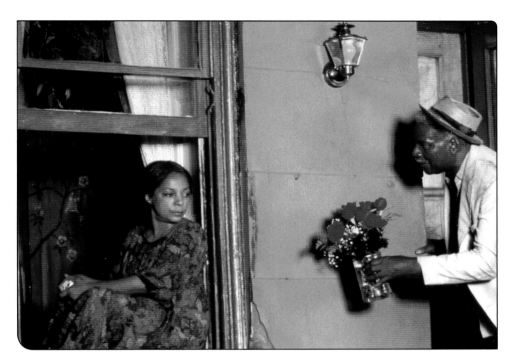

Ruby Dee as Mother Sister and Ossie Davis as Da Mayor in *Do the Right Thing*.

Jade (Joie Lee), the sister of Mookie; Smiley (Roger Guenveur Smith), who roams the streets with pictures of Malcolm X and Martin Luther King Jr.; Sal (Danny Aiello), the owner of the pizzeria that has been in the neighborhood for twenty-five years; Pino (John Turturro), Sal's racist son.; and Mister Señor Love Daddy (Samuel L. Jackson), the DJ who comments on the action. Also in the cast were comedians Martin Lawrence and Robin Harris. On the soundtrack was heard Public Enemy's "Fight the Power." The film culminates with an explosive racial confrontation between Buggin' Out and Sal. Throughout, the cinematography of Ernest Dickerson and set decoration of Wynn Thomas captured the intense colors (reds, oranges, blues) on the streets and in the interiors that bring the cultural energy of the community to urgent life.

Do the Right Thing was an entertaining and provocative release, primarily for its African American audience. During the politically conservative Reagan era and the start of the George Herbert Walker Bush period, some still preferred to believe that racial divisions had subsided, that there was a social/racial balance and calm in America and old problems had been resolved. *Do the Right Thing*, however, exposed a nation's denial of ongoing though suppressed racial conflicts. *Driving Miss Daisy*, also released in 1989, had taken a comforting look back to an idealized past. *Do the Right Thing* took a realistic look at the then–here and now. In the end, it still stands as one of the era's most significant films. Lee received an Academy Award nomination for his script, but he was overlooked for Best Director. Nonetheless, *Do the Right Thing* was the perfect way to close one era and open another.

CHAPTER
8

THE 1990s

WHOOPI HITS HER STRIDE

For moviegoers in general, much of the excitement in the early 1990s was to see stars like Whoopi Goldberg, Eddie Murphy, Denzel Washington, and Spike Lee in top form. Many familiar problems of image continued, but a new crop of African American filmmakers, both as independents and as studio directors, invigorated the decade with a fresh perspective and style. Some African American actresses also came front and center. With a stable economy, a balanced budget, and the promise of better days ahead, the early Clinton years had an optimism that made its way into movies.

Perhaps most enjoyable was seeing Whoopi Goldberg at her best. Her films following *The Color Purple*—*Jumpin' Jack Flash*, *Burglar*, *The Telephone*, *Clara's Heart*, and *Homer and Eddie*—had hardly brought fans rushing to movie theaters. Yet everyone appeared to be waiting to see if there was really a place for her in the movies.

Then, to the surprise of many, she started the year 1990 off with a bang, and its title was *Ghost*. The film was a love story between the spirit of a banker, Sam (Patrick Swayze), who has been murdered and the artist girlfriend, Molly (Demi Moore), that he left behind. The conduit for bringing them together and also for solving the mystery of Sam's death was

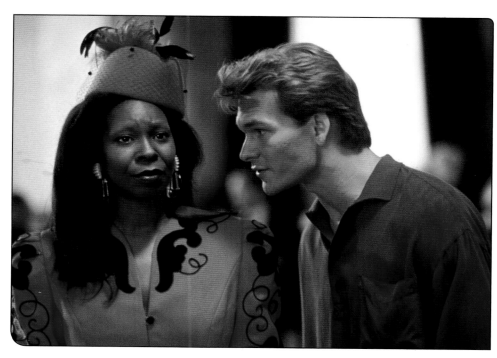

Whoopi Goldberg as Oda Mae with Patrick Swayze in her Academy Award–winning role in *Ghost*.

a fake medium named Oda Mae Brown, played to the hilt by an uninhibited Goldberg. In essence, Oda Mae is terrified of ghosts, and it takes time for the spirit of Swayze's character to convince her of his ghostly authenticity. In the scene in which his spirit first communicates with Oda, she and her sisters (the terrific Armelia McQueen and Gail Boggs) are in befuddled, frightened comic harmony, unable to figure out precisely what is going on.

Aspects of *Ghost* could be criticized. The movie played on an old concept of African Americans scared out of their wits by the very thought of the spirit world, something dating back to that 1920 silent film *Haunted Spooks* and even earlier. And ultimately the character of Oda was partially defined by a familiar nurturing quality. She was the only character who could offer Sam and Molly comfort. But there was a sweet, oddball quality to Goldberg. Her timing was perfect, and there were moments when she used her own brand of language to communicate. As she tries to alert an unsuspecting Demi Moore of trouble ahead, she finds that Moore does not quite comprehend. Finally, Goldberg's Oda simply says: "Molly, you in danger, girl!" It sent howls of laughter throughout movie theaters. So too did a scene in which Oda, dressed in her finery (inappropriately outlandish finery, it should be added) impersonates another woman and heads to a bank to close an account. In the tradition of other great black performers, who understood they had to utilize every second of screen time, she dominated all her scenes and frankly, was the movie's highlight—an unexpected realist in the midst of the film's romantic fantasy. In the end, Goldberg won the Oscar as Best Supporting Actress of 1990, the first time an African American woman had won an Oscar since Hattie McDaniel for *Gone with the Wind*. That had been fifty-one years earlier.

Afterward, Goldberg was sitting on top of the world. She appeared to be in a mad rush to do everything: the TV series *Bagdad Café*, in which she costarred with Jean Stapleton; guest shots on *Tales from the Crypt* and *A Different World*; and a *Star Trek* reboot, *Star Trek: The Next Generation*. She also appeared in one movie after another: Robert Altman's *The Player*, *Soapdish*, and *Sarafina*. To her credit, she sought dramatic roles, too: *The Long Walk Home*, in which she played a maid in the South during the civil rights era; *Ghosts of Mississippi*, as Myrlie Evers, widow of slain civil rights leader Medgar Evers, and *Boys on the Side*.

However, Goldberg's most successful films were her comedies *Sister Act* and *Sister Act 2: Back in the Habit*. Here she played Deloris Wilson, a Reno singer who is on the run after having witnessed a murder. A police lieutenant places her in an impoverished Catholic parish. There, she goes undercover, posing as a nun. Another life opens up for her as she helps the other nuns, becoming their choirmaster. In the first film, she appeared to relish the role of Deloris, known in the parish as Sister Mary Clarence, and to enjoy working with such veterans as venerated stage and screen actress Maggie Smith and longtime Hollywood character actress Mary Wickes, as well as Kathy Najimy and Jenifer Lewis. In the second *Sister Act*, under the direction of African American filmmaker Bill Duke, she again seemed ready to go the distance to get a well-deserved laugh. She also worked here with young actress Lauryn Hill, future music star of the group The Fugees. In December 1993, Goldberg told *Entertainment Tonight* that her huge salary for *Sister Act II* made her "the highest paid woman in the history of film." She added: "For a little while, I was Queen Bee."

Within the entertainment industry, Goldberg was liked and admired, with a reputation for being well-read and ever ready to express her opinions. A

sign of both her popularity and her talent occurred when she was selected to host the Academy Awards ceremony in four different years: 1994, 1996, 1999, and 2002. She also voiced the part of Shenzi in *The Lion King* in 1994 and ultimately achieved the elusive EGOT as a recipient of the Emmy, the Grammy, the Oscar, and the Tony awards. She was the most successful black comedienne since Pearl Bailey and Jackie "Moms" Mabley, who had a huge following at black theaters and clubs.

Actually, Goldberg was even more successful than her predecessors.

Unfortunately, the hits stopped coming. Other films, such as *Moonlight and Valentino*, *Eddie*, and *The Associate*, fell flat. A bright spot was her performance as the friend to Angela Bassett in *How Stella Got Her Groove Back* (1998). However, Goldberg remained a name, and in the new millennium, she would work for Tyler Perry and become an admired host on television's *The View*.

STILL RULING: EDDIE MURPHY

During the '90s, Eddie Murphy remained a major crossover star. Like Goldberg, Murphy appeared in films of varying quality: some good, some bad, some indifferent. Appearing eager to move away from the bonded buddy movies, he also seemed more interested in working with black casts. Moviegoers turned up in solid numbers to see him in *Boomerang* (1992), a satire with an all-star cast that included Halle Berry, Robin Givens (who made headlines with her marriage to boxer Mike Tyson), Martin Lawrence, David Alan Grier, Lela Rochon, Chris Rock, John Witherspoon, Geoffrey Holder, and those veteran goddesses of high-camp style, Eartha Kitt and Grace Jones.

As advertising executive Marcus, Murphy casually beds various women. He has a warped male view of women and how he should relate to them. For him, women are almost interchangeable. And disposable. But when the new head of his advertising agency (Givens) patronizes him in the same way he has treated women, a bewildered Marcus has to reassess his attitudes. As might be

expected, ultimately, he is redeemed by the love of a young woman (Berry). The film's images of women were questionable, and sometimes embarrassing. Halle Berry's character is so lovely and intelligent that you might wonder why she would be drawn to Murphy's Marcus. But *Boomerang* was refreshing because it had a black audience in mind, which it was speaking to.

The film's African American director, Reginald Hudlin, was one of the new filmmakers in the early 1990s. His brother, Warrington Hudlin, was one of the film's producers. Previously, Hudlin had directed *House Party*. Later he directed *The Great White Hype* and, in 2017, a biopic of Thurgood Marshall titled *Marshall*.

Murphy movies that followed—*The Distinguished Gentleman*, *Beverly Hills Cop III*, and *Vampire in Brooklyn*—were hardly earth-shattering. When plans were announced for him to star in a remake of the 1963 Jerry Lewis comedy *The Nutty Professor* (1996), most people shook their heads. What was he thinking, trying to duplicate

Eddie Murphy in one of his best roles in *The Nutty Professor* with Jada Pinkett Smith.

Lewis's manic classic? But Murphy surprised all the doubters with his Nutty Professor—in which he played an obese, shy college professor who develops a serum that transforms him into a nightmarish Don Juan called Buddy Love. *The Nutty Professor* turned out to be one of his best comedies with one of his best roles as the rotund Professor Sherman Klump. Murphy dug deep inside himself to reveal a rather touching vulnerability he had not shown before. His scenes with love interest Jada Pinkett Smith were convincing and endearing. Murphy also again revealed his magnificent gift for playing multiple characters, not only as the obnoxious Buddy Love but as a whole family of Klumps: he gave an individual stamp to Sherman Klump, Papa Klump, Mama Klump, Grandma Klump, and Ernie Klump. It was a tour de force. No one has ever forgotten the dinner table chant of "Hercules. Hercules." Also in the cast was the up-and-coming Dave Chappelle, another brilliant wiz of comedy.

An engaging sequel, *Nutty Professor II*, appeared in 2000. The second time around, Murphy's leading lady was Janet Jackson, in one of her best movie performances.

Later Murphy also remade *Dr. Dolittle*, the 1967 hit that starred Rex Harrison as a doctor who could talk to animals. He followed it with *Dr. Dolittle 2*. With the remakes of *The Nutty Professor* and *Dr. Dolittle*, Murphy looked as if he were rewriting history, making movies with an African American star that should have been produced decades earlier. He also voiced the role of the Donkey in the popular animated film series *Shrek*. He provided, however, a very stereotyped sound for his animated character. Such other films as *Metro*, *Mulan*, *Bowfinger*, *The Adventures of Pluto Nash*, *I Spy*, *Daddy Day Care*, and *The Haunted Mansion* came and went without making much noise. Yet Murphy was one of the movies' great comic stars. He never surpassed Pryor. He lacked the earlier

comedian's complexities and complications that brought out Pryor's comic humanity. Murphy was a dazzling, hard-edged surface. He had no loose ends. But generally Murphy's narrative films were better than Pryor's and better than those of such later comedians as Martin Lawrence (though he had some comically startling sequences in *Big Momma's House*), Chris Tucker, Chris Rock, and Eddie Griffin.

Eddie Murphy as a ladies' man who has the tables reversed on him by Robin Givens in *Boomerang*.

A WAVE OF NEW INDEPENDENTS

Away from the Hollywood studios, a wave of provocative independent filmmakers created a body of work that offered alternate visions of African American life and culture. Among them were Charles Burnett and Julie Dash.

Born in 1944 in Mississippi, Burnett grew up in the Watts section of Los Angeles. For his master's thesis at UCLA's Film School, he directed and produced his masterwork, *Killer of Sheep*. On a budget of $10,000, Burnett shot his film on weekends between 1972 and 1975. Set in Watts, *Killer of Sheep* proved to be an altogether extraordinary film, a somber tale of slaughterhouse worker Stan (Henry Gayle Sanders), who stoically leads sheep to their death. As the film solemnly follows Stan from one scene to the next, his life is revealed to be a steady grind without much to hope for.

Throughout, the images are disturbing, with unexpectedly moving moments. Without money for toys, his children play a game of war in an abandoned littered area; one child wears a Halloween mask most of the day, as if a spirit is hunting the viewer down. The question always is what will become of them. At home, Stan's wife (she's not given a name but the character is played by Kaycee Moore) quietly puts on makeup as he arrives back after a day's work. In a tender sequence, he and his wife dance to Dinah Washington's "This Bitter Earth." Not much seems to happen for Stan. At one point, he goes with a friend to buy a motor for his car. At another point, he drives his family to the racetrack, only to have a flat tire on the way and what might have been a joyful occasion ends as one more bleak day in a bleak life.

In some respects, *Killer of Sheep* may appear to be a series of striking scenes or incidents that

do not form a constructed narrative. But that is partly the point of the film, that in life there is no linear story line, and, for Stan, there is little to give his life a "narrative" meaning. Throughout, Sanders's nuanced performance as Stan adds to the film's sensitive power. On the soundtrack is music—from different eras with different modes of expression—by such African American artists as Dinah Washington, Etta James, Paul Robeson, and the group Earth, Wind, and Fire. Creating a mood and a part of the cultural context of the film, the music, when set to the images, is haunting. Upon completion, *Killer of Sheep* was shown at film festivals, but was not formally released. Its music rights had not been cleared. When UCLA restored the film in 2007, the cost of soundtrack rights for this $10,000 budgeted film amounted to $150,000. In 1990, *Killer of Sheep* drew much-deserved attention when it was put on the United States National Film Registry for preservation by the Library of Congress.

In 1990, Burnett's film *To Sleep with Anger*, which won the Special Jury Prize at the Sundance Film Festival, was released. Starring Danny Glover (who also executive-produced the film), Mary Alice, Vonetta McGee, Sheryl Lee Ralph, Carl Lumbly, Paul Butler, and Richard Brooks, *To Sleep with Anger* might be viewed as a sophisticated folk drama. When a family in South Central Los Angeles receives a visit from a mysterious old friend (Glover) from the South, their lives are dramatically altered. Long-held secrets and suppressed conflicts rise to the surface as the family must examine itself. The friend is something of a folkloric Trickster, there to stir the pot until things settle back in place. With that settling comes enlightenment. In 2017, *To Sleep with Anger* was also put on the National Film Registry. Burnett also directed *My Brother's Wedding* (1983), *The Glass Shield* (1994), and for

ABOVE: Henry Gayle Sanders in Charles Burnett's *Killer of Sheep*. BELOW: Barbara-O, Cora Lee Day, and Alva Rogers—heroines of Julie Dash's *Daughters of the Dust*.

television, the adaptation of Harlem Renaissance writer Dorothy West's *The Wedding*, starring Halle Berry, Lynn Whitfield, Carl Lumbly, Ethel Ayler, and Michael Warren and produced by Oprah Winfrey.

Other independent films drew attention: Wendell Harris's *Chameleon Street*, Matty Rich's *Straight Out of Brooklyn* (1991) and later *The Inkwell* (1994) and Leslie Harris's 1993 *Just Another Girl on the IRT*.

Perhaps no independent film of the early 1990s drew as much critical attention as Julie Dash's *Daughters of the Dust*. After graduating from City College of New York, the Queens-born Dash studied at the American Film Institute Conservatory, then earned a master's of fine arts from the UCLA Film School. Previously, Dash made documentaries and directed shorter films: *Illusions* and *Diary of an African Nun*. Influenced by the novels of Toni Morrison and Toni Cade Bambara, Dash began developing her story for *Daughters of the Dust* in the mid-1970s, finally putting it into production with an $800,000 donation from PBS in 1988.

Set on an island off the coasts of South Carolina and Georgia at the turn of the century (1902), *Daughters of the Dust* was a portrait of a family of women whose lives and culture are about to undergo a dramatic transition. The family matriarch, Nana Peazant (Cora Lee Day), is aware that as younger members move from the island to live on the mainland, they will leave behind or lose the rich cultural traditions and way of life that have sustained them since the years of slavery. Speaking in Gullah creole, the women are a stunning array of attitudes and visions. Arriving on the island is Yellow Mary (Barbara-O), along with her lover Trula (Trula Hoosier). The two will soon head to Canada. Having grown weary of the island rituals and traditions, a cousin, Haagar (Kaycee Moore),

is eager for the opportunities she believes the mainland will offer. Another relative, Viola (Cheryl Lynn Bruce), has already started a new life in Philadelphia.

The film is mostly narrated by the Unborn Child. Her mother, Eula (Alva Rogers), has been raped by a white man, but Eula's husband Eli will be the forthcoming child's father. A nonlinear film, *Daughters of the Dust*'s stories are woven together often enough through rituals and spiritual beliefs. Beautifully shot by Arthur Jafa, who won the 1991 Sundance Film Festival prize for cinematography, the film was also nominated for the festival's Grand Jury Prize. In 2004, *Daughters of the Dust* was selected for preservation on the National Film Registry. Later its influence could be seen in Beyoncé's *Lemonade*. Dash went on to direct dramas for television, including *The Rosa Parks Story* in 2002, starring Angela Bassett and Cicely Tyson, as well as *Incognito*, *Love Story*, and episodes of Ava DuVernay's *Queen Sugar* for the Oprah Winfrey Network.

Like Charles Burnett and Julie Dash, other graduates of UCLA's Film School, sometimes known as part of the LA Rebellion of innovative independents, also directed: Haile Gerima (director of *Bush Mama* and *Sankofa*), Jamaa Fanaka, Billy Woodbery, Alile Sharon Larkin, and Barbara McCullough.

BRINGING THE HOOD TO THE MOVIES

Within the Hollywood system, a great directorial debut occurred with John Singleton's *Boyz N the Hood* in 1991. The backstory on the making of the film was almost as well-known as the film itself. Growing up in south Los Angeles, Singleton had been a film student at the University of Southern California. There, he won three writing awards and while still a sophomore, he became represented by the powerhouse Creative Arts Agency. Ambitious and fired up with the desire to make movies (a true film student spirit), he secured a deal with Columbia Pictures—as writer *and* director of *Boyz N the Hood*, his first film. The studio had liked his script, but Singleton was determined that no one but himself direct it.

That audacious move paid off. With a $7 million budget, he gathered his cast, one of whom was Ice Cube of the hugely successful rap group N.W.A. Singleton had first met Ice Cube when the rapper appeared on *The Arsenio Hall Show*. At that time, Singleton was working as an intern on the program. Earlier he had met another future cast member, Laurence Fishburne, when Singleton was a production assistant on *Pee-wee's Playhouse*. At a very young age, Singleton understood the importance of contacts in the business. Conscious of his

John Singleton, the first African American to be nominated for a directing Oscar and the youngest directorial nominee overall—for *Boyz N the Hood*.

youth and fundamental inexperience, the studio arranged *Boyz N the Hood*'s shooting schedule so that it could be shot in sequence rather than the customary out-of-sequence procedure in which most movies are made.

A cry from the heart, *Boyz N the Hood* told the startling coming-of-age story of young Tre Styles. Growing up with his mother (Angela Bassett) in Watts, he is sent by her to live with his father (Laurence Fishburne) in South Central in the belief that he can lead their son to manhood. *Boyz N the Hood* focused on a troubled community in which children stumble upon dead bodies, in which gangs rule individual turfs, in which women and girls are often marginalized, in which there does not seem to be much hope unless one gets out of the hood, and in which, tragically, African American fathers are mostly absent.

The adolescent Tre (Cuba Gooding Jr.) witnesses the devastating course of the lives of his boyhood friends, the brothers Ricky (Morris Chesnut) and Doughboy (Ice Cube). In the movie's most harrowing sequence, the body of Ricky (a star athlete gunned down by a gang member) is brought to the home of his mother (Tyra Ferrell). Singleton hones in on the mother's confusion, anger, and pain, as well as that of other family members. It is almost too painful to watch. Steven Spielberg is reported to have said of the scene: "That's the room you don't want to be in." In the end, Tre survives a life in the hood in large part because of the guidance of his father, Furious Styles.

Though Furious was idealized and though questions remain about the depiction of women, *Boyz N the Hood* stands as one of the most emotionally affecting dramas of the era and perhaps in

movie history. It captured the nihilism of a new generation, and like an old Warner Bros. film, it seemed to have sprung from headlines of that period (and later): the drive-by shootings, the senseless violence, the feelings of entrapment within urban communities. Introduced was yet another generation of actors and actresses, not only the primary stars but also Nia Long and Regina King. Worthy of an Oscar nomination was Tyra Ferrell's performance. Few actresses could match her emotional intensity, but that did not happen. John Singleton, however, made history not only with an Oscar nomination for his screenplay but also as the first African American director—*and* the youngest director—to be nominated for a Best Director Academy Award. In 2002, *Boyz N the Hood* was put on the National Film Registry.

Afterward, Singleton directed (and sometimes produced) such films as *Poetic Justice*, starring rapper Tupac Shakur, Janet Jackson, Regina King, and again the underrated Tyra Ferrell; *Higher Education*; *Rosewood*; a remake of *Shaft* in 2000; *2 Fast 2 Furious*; and *Four Brothers*, as well as the Michael Jackson video "Remember the Time." He also co-created the TV series *Snowfall*.

Of the young actors in *Boyz N the Hood*, Cuba Gooding Jr. went on to win a Best Supporting Actor Oscar for his perfectly scaled, over-the-top performance in 1996's *Jerry Maguire*. He appeared in such later films as *Men of Honor*, *Pearl Harbor*, *American Gangster* (2007), and *Selma* (2014).

Other filmmakers focused on the "hood": its violence and its internal despair and nihilism. Prominent were two films by the Hughes Brothers: *Menace II to Society* and *Dead Presidents*, each of which acquired a following among the young, black and white.

Morris Chestnut, Cuba Gooding Jr., and Ice Cube in *Boyz N the Hood*.

SPIKE LEE: SPEAKING TO A NEW ERA

Spike Lee's films continued to speak in personal, political, and cultural terms, often to a young audience. *Mo' Better Blues* centered on a jazz musician (Denzel Washington) torn between two women (Joie Lee and Cynda Williams) and the demands of his art. Then came *Jungle Fever*, which examined an interracial love affair between a black architect (Wesley Snipes) and an Italian-American assistant at his firm (Annabella Sciorra). With its view of society's angry attitudes about such a relationship, *Jungle Fever* was a far cry from the tame portrait in Stanley Kramer's *Guess Who's Coming to Dinner*.

In a riveting dinner sequence, Ossie Davis and Ruby Dee were compelling as the parents of the Snipes character, who object to the young couple. Davis has a stirring monologue. At one point Dee leaves the table, goes to another room, and lets out a silent scream that you can hear (in your mind) nonetheless. In *Jungle Fever* as well as *Do the Right Thing*, Lee helped revitalize the careers of Davis and Dee, providing them with challenging roles and perhaps introducing them to a new generation of moviegoers. He also elicited exciting performances from Lonette McKee as Snipes's wife; Samuel L. Jackson, whose performance as the drug-addicted Gator won the big acting award at the Cannes Film Festival; and Halle Berry, then making her big-screen debut, also as a drug addict. Here, too, was Tyra Ferrell, giving a lovely performance as the young woman that John Turturro's character has a secret crush on. Both McKee and Ferrell should

Wesley Snipes and Woody Harrelson in *White Men Can't Jump*.

have gone onto major stardom. But the roles just were not there for them.

Lee also proved important for one of the new leading men of the era, Wesley Snipes, who appeared first in *Mo' Better Blues* in a supporting role and then as the star of *Jungle Fever*. Born in Orlando, Florida, and growing up in New York's South Bronx, Snipes studied at the High School for the Performing Arts. Though he didn't have the traditional handsome looks of a leading man, he was handsome nonetheless, as well as intense, athletic, and intelligent, with a cool yet sensitive demeanor. He went on to star as Nino Brown in Mario Van

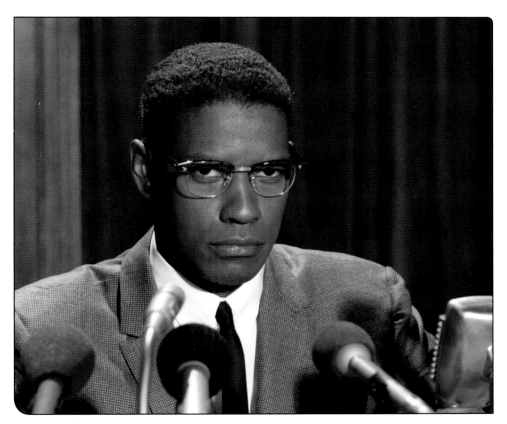

Denzel Washington in the title role in *Malcolm X.*

Peebles' *New Jack City*, a replay of *Super Fly* that became a favorite for young African American moviegoers in the early 1990s.

Co-starring with Woody Harrelson, Tyra Ferrell, and Rosie Perez, Snipes starred in another new generation favorite, *White Men Can't Jump*, in 1992. An offbeat role was as the drag queen in *To Wong Foo, Thanks for Everything, Julie Newmar!* Other films included *Rising Sun* (with Sean Connery), *Sugar Hill*, and the action sagas *Passenger 57*, directed by Kevin Hooks, *Demolition Man, Murder at 1600*, and *U.S. Marshalls*. He also was one of the toughs in the Michael Jackson video "Bad," directed by Martin Scorsese. For a time, Snipes had a strong following in Europe, which was not always the case with African American stars.

Lee's most important film of the decade was his 1992 epic *Malcolm X*, which starred Denzel Washington. The film traces Malcolm Little's life from his days as a hustler to his brief period of incarceration, where he experiences a political and spiritual awakening thanks to the knowledge imparted by an older convict, played by another great actor, Albert Hall. He joins the Nation of Islam and becomes Malcolm X. Under Lee's direction, Washington captured Malcolm X's intensity and commitment. He also conveyed a mystery about him, signaling the fact that we may never really comprehend certain aspects about the man—such as the full torment and disillusionment with leader Elijah Muhammad. We get glimpses of his complicated feelings, and Washington himself,

great actor that he is, knows exactly what his character feels, yet he understands the complexity of human identity. Does anyone fully reveal himself or herself to others? There was not one dishonest moment in his celebrated performance.

Lee's direction of crowds had a large-scale cinematic majesty while throughout the pacing was assured and mesmerizing. He follows Malcolm on his pilgrimage to Mecca where he converts to the original Islam. At the film's climax, as Malcolm X is headed for his death, moviegoers knew the outcome but hoped somehow that it would be averted. The film was a stellar achievement. Also in the cast were excellent actors: Delroy Lindo as West Indian Archie; Al Freeman Jr. as Elijah Muhammad; Angela Bassett as Betty Shabazz; Ernest Thomas; James McDaniel; Kate Vernon; and again Lonette McKee as Malcolm's emotionally fragile mother. At the film's conclusion, Ossie Davis delivered Malcolm's eulogy, just as he had done in real life in 1965.

For *Malcolm X*, Lee also brought on his "team" of highly talented artists, a number of whom (like his stock company of actors) would have

lauded careers. The cinematography was by Ernest Dickerson, who shot most of Lee's films during this period. Later, Dickerson became a respected director with the film *Juice*, which starred rapper Tupac Shakur and Omar Epps, and with episodes of such television series as *The Wire*, *Treme*, and *The Walking Dead*. Once again the production design was by the gifted Wynn Thomas, and the costumes were by the fiercely creative Ruth Carter, who won an Oscar nomination for her designs—a first for an African American. In 2018, Carter would design the costumes for the black superhero film *Black Panther*. Denzel Washington earned an Oscar nomination as Best Actor, but unjustly neither Spike Lee nor Dickerson received Academy Award nominations.

Films directed by Lee appeared through the rest of the decade. *Crooklyn*, *Clockers*, *Girl 6*, *Get on the Bus*, *He Got Game*, and *Summer of Sam*. His *4 Little Girls* (1997), a documentary about the four girls—Addie Mae Collins, Carol Denise McNair, Carole Robertson, and Cynthia Wesley—killed by a bomb in a Birmingham church in 1963, was nominated for an Academy Award.

THE NAMES DOMINATING THE DECADE

Denzel Washington's career continued as a dominant force in the 1990s with *Mo' Better Blues* and *Mississippi Masala*, each a love story of sorts. With his great looks and relaxed charm, Washington was clearly a heartthrob. But it was said he avoided love scenes whenever possible.

Eager to play a variety of roles, Washington appeared as Don Pedro in *Much Ado about Nothing*.

(He would do Shakespeare again when he starred on Broadway in *Julius Caesar*. One wonders what kind of Hamlet he would have been.) In *Philadelphia* (1993), he costarred with Toms Hanks, who played an AIDS patient seeking Washington's lawyer character to represent him in a court case. In *The Pelican Brief*, Washington costarred with Julia Roberts. It should have been a full-fledged romance

Washington and Julia Roberts, an ideal couple in *The Pelican Brief*, but no romance.

which Roberts herself said she was in favor of, but one senses the studio's unease about an interracial pairing with such a megawatt white movie goddess as Roberts. Interracial love between major white female stars and black actors remained something that Hollywood feared would be too controversial. Both *Philadelphia* and *The Pelican Brief* were hits. But when Hanks won a Best Actor Oscar for *Philadelphia* and Washington was not even nominated, discussions rose about the Academy Awards voting system—and its membership. These discussions remained throughout the 1990s and into the new millennium.

In the 1990s, Washington also worked with African American director Carl Franklin, who had come to prominence with his edgy and much praised crime thriller *One False Move*. When Franklin brought African American writer Walter Mosley's novel *Devil in a Blue Dress* to the screen, Washington played detective Easy Rawlins. The story revolved around Easy's investigation of the disappearance of a beautiful, mysterious woman (Jennifer Beals). *Devil in a Blue Dress*, a fascinating look at post-World War II Los Angeles, was also a play on the old tragic mulatto theme, from a different point of view.

Washington appeared in a variety of other films: *Crimson Tide*, *Courage Under Fire*, *The Preacher's Wife* (with Whitney Houston), *Fallen*, *The Siege*, and *The Bone Collector* (with Queen Latifah and a young Angelina Jolie). In Spike Lee's *He Got Game* (1998), he had one of his most interesting roles, as a convict trying to reconcile with his basketball star son—whose mother he was convicted of killing. Washington and Lee would make four films together.

Also working again with Norman Jewison, the director of *A Soldier's Story*, Washington scored another Best Actor Oscar nomination for his gritty performance as imprisoned boxer Rubin "Hurricane" Carter, who fights to prove his innocence in *Hurricane*. If Washington's career had ended in the 1990s, he still would have been a major movie icon, but his career would extend into the new century with more artistic triumphs.

Washington with Jennifer Beals in Carl Franklin's *Devil in a Blue Dress*.

Another actor whom audiences gravitated to was the ubiquitous Samuel L. Jackson. Starting his career in a little-known 1972 film *Together for Days*, Jackson worked in television and did bits or small roles in *Ragtime*, *School Daze*, *Coming to America* (as the Hold-Up Man), *Do the Right Thing*, *Def by Temptation*, *Mo' Better Blues*, *The Exorcist III*, *Goodfellas*, *The Return of Super Fly*, *Jurassic Park*, *True Romance*, and *Fresh*. The list went on and on. It was also pleasurable to see him find a substantial role such as in *A Time to Kill*, as the bereaved father in Mississippi on trial for killing two white men who raped his daughter. The film established Matthew McConaughey (playing Jackson's attorney) as a movie star. But McConaughey had to share the screen with Jackson, a character actor who was also a star. Working nonstop with such directors as Spike Lee, Martin Scorsese, the Hughes Brothers, Steven Spielberg, and Oliver Stone,

Jackson seemed to be everywhere. Later generations would sometimes howl with laughter when they saw him suddenly turn up in some older films.

Jackson also began a long association with director Quentin Tarantino. In Tarantino's 1994 *Pulp Fiction*, he was a hit man Jules Winnfield, with John Travolta as his partner, Vincent Vega, sent by mob boss Marsellus (Ving Rhames) to find a stolen suitcase. With a cast that included Bruce Willis, Uma Thurman, Amanda Plummer, and Tim Roth, *Pulp Fiction* was a violent, frenzied, frightening, and surprisingly funny potboiler directed to sadistic perfection. Oddly enough, if there was a redemptive character, it was Jackson's Jules, who undergoes an unexpected religious awakening. For his performance, Jackson was nominated for an Academy Award as Best Supporting Actor.

In 1997 he starred with Pam Grier, Robert DeNiro, Chris Tucker, Robert Forster, and Bridget

Samuel L. Jackson with John Travolta in *Pulp Fiction*.

Fonda in Tarantino's *Jackie Brown*. Playing a drug lord, he reigned with unabashed trashy flair over another of Tarantino's violent, perverse worlds, bringing to mind the familiar buck type. In this film and others, Tarantino was criticized by Spike Lee and others for his overuse and exploitation of the n-word. Somehow Jackson said the word with various inflections that rang true to the lowlife character he played. In the next century, he would work with Tarantino in *Kill Bill, Vol. 2*, *The Hateful Eight*, and *Django Unchained*.

◇◇◇◇◇◇◇◇◇◇◇◇◇

Such actresses as Joie Lee, Theresa Randle, Nia Long, Vanessa Williams, Queen Latifah, Jada Pinkett Smith, Thandie Newton, Regina King, Vivica A. Fox, Kimberly Elise, Tyra Ferrell, and Halle Berry were well-known, in some cases (but not all) primarily to African American moviegoers. Then there was Kasi Lemmons. A former actress who had appeared in such films as *The Silence of the Lambs* and *The Five Heartbeats*, Lemmons was one of the few black female filmmakers in Hollywood in the 1990s. Her 1997 film *Eve's Bayou* was a complicated weave of family secrets and lies that offered a compelling portrait of African American women, played by Lynn Whitfield, Meagan Good, Jurnee Smollett-Bell, Ethel Ayler, Lisa Nicole Carson, Debbi Morgan, and Diahann Carroll. Independent filmmaker Cheryl Dunje also directed *The Watermelon Woman* (1996).

Other black filmmakers created movies with strong roles for African American women. In *Set It Off* (1996), F. Gary Gray directed a quartet of actresses—Queen Latifah, Jada Pinkett Smith, Vivica A. Fox, and Kimberly Elise—as heroines, frustrated and angry about the course their lives

have taken, who band together as bank robbers. Corny as the premise of *Set It Off* might sound, the women's lives (as delineated by screenwriter Takashi Bufford) resonated with African American female moviegoers, who also responded to the film's theme of womanly frustration *and* womanly self-empowerment.

Other films by African Americans presented diverse images of women: writer/director Theodore Witcher's *Love Jones*, starring Nia Long Larenz Tate, and Lisa Nicole Carson, and writer/director George Tillman Jr.'s family drama *Soul Food*, which featured Vanessa Williams, Vivica A. Fox, Nia Long, Mekhi Phifer, Michael Beach, and Irma P. Hall. Later Tillman transformed *Soul Food* into a popular TV series. He also directed such feature films as *Men of Honor* (2000), the biopic *Notorious*, about slain rapper Biggie Smalls, and he executive-produced such films as *Barbershop* and two sequels, *Beauty Shop*, and, in 2017, *Mudbound*. In 2018, he directed the gripping *The Hate U Give*.

Less successful (commercially) but not less significant was Jonathan Demme's adaptation of Toni Morrison's novel *Beloved*. A complex story of a slave "visited" by the spirit of her dead child, the film starred Oprah Winfrey, Kimberly Elise, Thandie Newton, LisaGay Hamilton, Danny Glover, and that acting wonder Beah Richards as Baby Suggs. Just seeing Richards was an extraordinary movie-going experience.

Loosely based on a true story, *Why Do Fools Fall in Love* (1998) featured Halle Berry, Vivica A. Fox, and Lela Rochon as the three "wives" of rock-and-roll singer Frankie Lymon (Larentz Tate), who battle over his estate. An uneven film directed by Gregory Nava with a script by Tina Andrews, it nonetheless had spirited performances. Black British actress Marianne Jean-Baptiste won a Best Supporting Actress Academy Award nomination for her performance in Mike Leigh's *Secrets and Lies* (1996). Here she played a young black woman who, having been given up for adoption, is reunited with her biological white mother, played by Brenda Blethyn.

As good as the actresses were, none had the kind of star-making role that could transform a career. A great exception in the 1990s—an actress who did arrive at stardom—was Angela Bassett, whose career took off after she had served a long apprenticeship. Though born in New York in 1958, she and her sister D'nette had grown up in St. Petersburg, Florida, with their mother, a social worker. Winning scholarships, she earned a bachelor's degree from Yale and then a master's of fine arts degree from the Yale School of Drama. She cut her teeth on television on everything from the daytime soaps *Ryan's Hope* and *Search for Tomorrow* to prime time's *The Cosby Show*, *Thirtysomething*, and *The Jacksons: An American Dream*, in which she played Katherine Jackson.

Jackson and Pam Grier in Tarantino's *Jackie Brown*.

Then came 1993's *What's Love Got to Do with It*, the biopic in which she gave a rousing and moving performance as music legend Tina Turner. Playing Tina's talented but abusive husband, Ike Turner, was Laurence Fishburne. In their depiction of the successful showbiz marriage that the physically and emotionally battered Tina Turner had to escape, Bassett and Fishburne were in precise artistic accord. Both were nominated for leading-role Oscars. Bassett won the Golden Globe for Best Actress in a Musical. She had the on-screen presence of a Bette Davis or Joan Crawford—pure star power. But without a studio system to support and showcase her talent, she might have easily fallen through the cracks. Instead, she went on to star in Kathryn Bigelow's futuristic *Strange Days*, as well as *A Vampire in Brooklyn*, *Waiting to Exhale*, and *How Stella Got Her Groove Back*.

Bassett in action as Tina Turner in
What's Love Got to Do with It.

◇◇◇◇◇◇◇◇◇◇◇◇

Surprisingly, the African American actress the studios were most eager to support in the belief that she could become a major box-office star was singer Whitney Houston. By the early 1990s, Houston was already a celebrated performer. Born in Newark, New Jersey, in 1963, Houston practically grew up in the music business. Her father, John Houston, was a former military man and theatrical manager. Her mother, Cissy Houston, was a gospel singer and backup performer for innumerable stars, everyone from Aretha Franklin to Elvis Presley. Early on, Houston became a successful model and the first African American cover girl for *Seventeen*. As a teenager she often traveled with her mother on tour, sometimes taking center stage to sing a song or two. Right away word went out that she had an extraordinary voice.

Music mogul Clive Davis of Arista Records signed her and carefully groomed her for stardom. In what is now a classic television appearance, the teenage Houston, accompanied by Davis and her mother Cissy, was a guest on *The Merv Griffin Show* in 1983. In 1985, her debut studio album *Whitney Houston* shot to the top of the charts and won a Grammy as Album of the Year. Other hit albums followed. With record sales hitting $200 million worldwide, she emerged as one of the bestselling artists of all time. In videos of her music, she was

Whitney Houston as the threatened singer in *The Bodyguard*.

dramatically at home in front of the camera.

Hollywood could not fail to take notice. Courted by the studios, she signed to star with Kevin Costner in *The Bodyguard* (1992). The script by Lawrence Kasdan had been lying around for years, having first been conceived as a drama to star Diana Ross and Ryan O'Neal. In *The Bodyguard*, Houston played Rachel Marron, a pop star terrorized by someone set on harming her. Hired to protect her is a former Secret Service agent played by Costner. The two clash but, true to the movies, they also fall in love. Directed by Mick Jackson, the film was an effective suspense/love story. Houston projected the hauteur, the supreme confidence, and at times the narcissistic arrogance that the role required. Its supporting cast included such accomplished actors as Bill Cobbs, Ralph Waite, and actress Michele Lamar Richards. The musical numbers were sensational. It grossed $410 million worldwide. The soundtrack sold 45 million copies worldwide, then the bestselling soundtrack of all time.

Afterward, Houston costarred with Angela Bassett, Loretta Devine, and Lela Rochon in a film directly aimed at female audiences, *Waiting to Exhale*. Based on the bestselling novel by African American writer Terry McMillan, the film followed the dilemmas of four women as they deal with romance and most significantly, the attitudes of men about women. Directed by Forest Whitaker, the film also featured Gregory Hines, Mykelti Williamson, Donald Faison, Jeffrey Sams, and Michael Beach. *Waiting to Exhale* opened as the number one movie in the country. It stayed in that position the following week. Black women went to see the film in groups and sometimes saw it more than once, excited about a film that was at least touching on their experiences. But the film also drew white moviegoers *and* African American men. It proved that mainstream audiences would

see black films—and films about black women, in particular. It was a hopeful sign.

The box-office success of *Waiting to Exhale* was too often attributed to Houston. Granted, she helped generate moviegoers' interest, but so did the other actresses, notably Bassett, and the topic itself. Nonetheless, Houston remained the African American actress the studios wanted to do business with. She next appeared opposite Denzel Washington and Courtney B. Vance in Penny Marshall's *The Preacher's Wife*, a remake of 1947's *The Bishop's Wife,* which starred Loretta Young, Cary Grant, and David Niven.

Houston occupied a unique place in Hollywood history: she was the single African American woman the studios were eager to create projects for. No other black actress, before or after, had such clout. Forming the production company BrownHouse, she and her production head Debra Martin Chase were the producers of the 2001 *The Princess Diaries* and the 2004 *Princess Dairies 2: Royal Engagement*, as well as executive producers of *The Cheetah Girls* TV movies and the 2012 remake of *Sparkle*. At one point, she also planned to play Dorothy Dandridge.

Sadly, Houston's personal life and consequently her career began unraveling. Her troubled marriage to singer Bobby Brown, after heavily publicized discord, collapsed. Houston herself also had a well-known drug addiction that led to canceled appearances. Most publicized was her abrupt dismissal from the Academy Awards broadcast in 2000. Seeing Houston during these troubled years was similar to what an earlier era might have felt as Judy Garland publicly fell apart. It was heart-wrenching to see a great talent coming to an inexorable tragic end. Not long after playing her last movie role in *Sparkle*, Whitney Houston died at the age of forty-eight in 2012 at the Beverly Hills Hotel, from what was deemed an accidental drowning with complications of heart disease and drug use. With her career decline and death, there came an end to a possible new phase for African American film actresses.

Sisters unit: Houston and Bassett with Loretta Devine and Lela Rochon in the backseat in *Waiting to Exhale.*

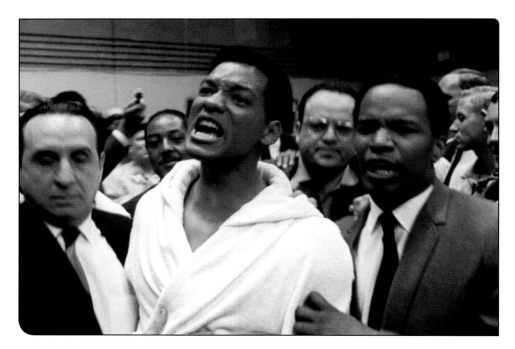

WILL SMITH: BOX-OFFICE CHAMP

By the late 1990s, Will Smith emerged as a major star. It's doubtful anyone could have predicted the extraordinary level of his success. The career of this Philadelphia native—born in 1968, the son of a mother who was a school board administrator and a father who was an engineer—had begun when he teamed with Jeffrey Townes to form the hip-hop duo DJ Jazzy Jeff and the Fresh Prince. Their song "Parents Just Don't Understand" won the first Grammy Award for Best Rap Performance. Though their music was considered soft rap, never the kind of hard-driving, edgy music associated with rap, the two had a vast following and won over suburban kids just discovering hip-hop.

Smith came to the attention of NBC executive Brandon Tartikoff, who believed the rapper had the stuff to be become a star. Tartikoff signed him for the series *The Fresh Prince of Bel-Air*, which was built around Smith and ran from 1990 to 1996. The auspicious TV debut introduced him to a dedicated fan base,

While starring in the series, Smith played supporting roles in the movies *Where the Day Takes You* and *Made in America* (which starred Whoopi Goldberg and Ted Danson). In 1993, he wisely played the young man who pretends to be the son of Sidney Poitier in the screen adaptation of John Guare's play *Six Degrees of Separation*, under the direction of Fred Schepisi. Truth be told, he did not seem totally right for this serious, disturbed character, and it is debatable if he held his own with such experienced stars as Stockard Channing

Will Smith with Jamie Foxx in *Ali*.

and Donald Sutherland. But the movie brought him to the attention of the critics and a wide movie audience.

Afterward, much like the young Denzel Washington, Smith made astute career choices, but with a difference. While Washington searched for challenging dramatic roles, Smith found films that had great commercial appeal without a pressing race theme and which also cast him in a heroic mode. He costarred with another TV star, comedian Martin Lawrence (star of the series *Martin*) in *Bad Boys*. As two Miami policemen, Lawrence was the frazzled family man while Smith was the dashing dude who captivates the ladies. Produced by Jerry Bruckheimer and directed by Michael Bay, *Bad Boys* was fast-moving, action-packed, purely commercial entertainment that was later followed by a sequel, *Bad Boys II* (2003).

Most impressive were Smith's roles in the 1996 disaster film *Independence Day*—as the dashing Captain Steven Hiller, who battles aliens coming to take over the earth—and *Men in Black*—in which he and veteran actor Tommy Lee Jones play agents who monitor and battle extraterrestrials again; this time around it was absurdist comedy. Two sequels followed. In all these films, Smith's tall, muscular frame enhanced the heroics. Looking as if he could physically handle any situation, he paradoxically also had an appealing light touch. His attitude seemed to be that he didn't feel it was any big thing to be able to do his exploits. It came naturally to him. His was never a heavy-handed kind of machismo.

One of his best films during the period—in which the Smith persona had an added maturity—was Tony Scott's 1998 political thriller *Enemy of the State*. In the film were such accomplished actors as Gene Hackman and Jon Voight as well as younger-generation actresses (both veterans of TV series)

Will Smith, born to play heroic roles.

Lisa Bonet (of *The Cosby Show*) and Regina King (of *227*). By now, he had developed as an actor and he could hold the screen with just about anyone. Throughout, the film reverberated on its self-created paranoia and menace. *Enemy of the State* also seemed to take pains not to have African American cultural markers or references. Tony Scott wanted mainstream moviegoers to feel comfortable with a film that may have a black star but which is not a black movie. This was to be true of such Smith films as *I, Robot*; *Hitch*; *I Am Legend*; and *Hancock* in the next decade, the new millennium.

Smith had some duds—such as the disjointed *Wild Wild West* (1999) and the embarrassing *The Legend of Bagger Vance* (2000). In the latter, he found himself cast as a *magical negro*, an extension of the old tom type, the basically agreeable, kindly

Smith and Gabrielle Union

black man out to miraculously transform the lives of troubled white characters, in this case Matt Damon (as a one-time golf champ who has lost his "swing") and Charlize Theron.

Another magical negro around this time was Michael Clarke Duncan's John Coffey in *The Green Mile*. Unjustly imprisoned and put on death row for rape and the murder of two little girls, Coffey is far more concerned about others than himself. He not only cures a prison guard (Tom Hanks) of a bladder infection but as a consequence restores the guard's sex life with his wife. He also breathes life into the once-dying wife of the prison's warden. Duncan won a Best Supporting Actor Oscar nomination for his efforts.

Though African American images in Hollywood had obviously changed, *The Green Mile* and *The Legend of Bagger Vance* indicated that the old types had not entirely disappeared. Their tired heads popped up more frequently than

realized—and, in the case of *The Green Mile*, in an otherwise absorbing movie.

In most films, however, Smith was so agreeable a presence that he might have appeared not to be acting. Yet Smith's talents when put to the test could not be dismissed. Cast as heavyweight champion Muhammad Ali in Michael Mann's *Ali* (2001), Smith worked wonders in capturing Ali's voice—the speech rhythms, the inflections, and, in a crucial scene, the champ's anger. For his performance, he won an Oscar nomination as Best Actor of 2001. Another Best Actor Oscar nomination came for his performance in *The Pursuit of Happyness* as a homeless man trying to reestablish his career and to care for his son, played by Smith's real-life son Jaden Smith.

Throughout the late 1990s and well into the new millennium, Will Smith's career was in high gear. One blockbuster after another opened with moviegoers lining up in record numbers to see him. In 2007, he would be called "the most powerful actor in Hollywood" by *Newsweek*. In 2014, *Forbes* would rank him as the world's most bankable star. By 2016, his films would gross $7.5 billion worldwide.

But Smith's career hit other bumps. When he departed from his basic heroic screen persona in *Seven Pounds* in 2008, *Concussion* in 2015, and *Collateral Beauty* in 2016, the results were lackluster, at best. *After Earth* in 2013 was an outright disaster. When he appeared with an ensemble cast (including Viola Davis, Margot Robbie, Jai Courtney, and Adewale Akinnuoye-Agbaje), playing DC comics superheroes in *Suicide Squad* in 2016, he seemed back in stride and connecting with young moviegoers eager for superhero dynamics.

Smith closed one century and opened another as one of America's most popular stars.

Men in Black

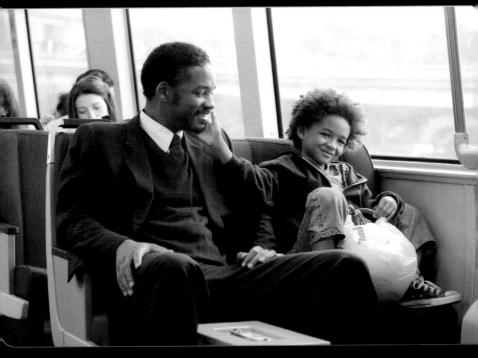

Smith and his son, Jaden Smith, in *The Pursuit of Happyness*

CHAPTER

9

THE NEW MILLENNIUM

NATIONAL TRAUMA AND FRESH TALENTS

A new century and a new millennium optimistically rolled in. But within a short period of time, the new age would be affected by great political, social, and racial shifts. Tragedy struck on September 11, 2001, when terrorists, using airplanes as weapons, crashed into the World Trade Center in New York. Another plane struck the Pentagon. Still another plane with passengers crashed into a field in Pennsylvania. In total, nearly 3,000 were killed; 6,000 injured. A stunned nation slowly regained its equilibrium.

As the first decade of the new century progressed, other significant more forward-looking developments occurred. In January 2009, Barack Obama was sworn into office as America's first black president. It would be the first of two terms. In time, movies would reflect the Obama presidency. Also in time, the issues of race and racism—which some incorrectly assumed were things of the past in a supposed new post-racial age—would again be on the front pages of American life. In one way or another, American movies would again reflect changes in society.

Imaginative, fresh talents altered the look, the tone, and the subject matter of the movies. More black filmmakers, some of whom had worked in the previous era, came to prominence: Antoine Fuqua, Steve McQueen, F. Gary Gray, Justin Simien, Malcolm Lee, Tim Story, Tyler Perry, Lee Daniels, Nate Parker, Bille Woodruff, Keenen Ivory Wayans, producer Will Packer, and the big stars,

Barry Jenkins and Jordan Peele, and the *big, big* star, Ryan Coogler. Women broke down barriers of the old boys' club to join the ranks of directors. From the previous era there were Kasi Lemmons and producer Debra Martin Chase. In the new era, directors Gina-Prince Bythewood, Ava DuVernay, and Dee Rees arrived on the scene; so did such writers as John Ridley, Geoffrey Fletcher, Kenya Barris, and Tracy Oliver. Set decorator Wynn Thomas and costume designer Ruth Carter continued their imaginative work. Also coming to the screen—as in the past decade—were music stars as diverse as Jennifer Hudson, Beyoncé Knowles, Snoop Dogg, Queen Latifah, Mos Def, Macy Gray, and Mary J. Blige. Stars were still important in Hollywood— *and* to moviegoers.

Controversies, debates, and discussions still swirled around movie images—and awards. Now such discussions, as well as a myriad of other issues pertaining to movies, were conducted on social media. As the new millennium progressed, Facebook, Twitter, Instagram, Tumblr, and blogs were the new media networking formats that grew in influence and power—and became firmly embedded in American life and culture. In time, movies and television would also appear on new online outlets such as Netflix, Amazon Prime, and Hulu. Even tickets could be reserved and purchased online. Online reviews would appear; so would trolling of films and stars. Movies were a part of a whole brave new world.

Though Will Smith reigned supreme as the new millennium opened, in Hollywood, he was still considered the prince. The king was Denzel Washington, one of the best actors, black or white, in the movies, and one of the most lauded with a lineup of Academy Award nominations and an Oscar win. Starting the decade with the high school sports drama *Remember the Titans*, he next starred in one of his most controversial films, *Training Day*. Costarring with Ethan Hawke, Washington played the corrupt Los Angeles cop Alonzo Harris.

Violent, cruel, devious, and manipulative, Alonzo, in many respects, looked like the brutal buck type of the past. Working under the direction of Antoine Fuqua with a script by David Ayer, Washington, however, gave a blistering performance, compelling and frightening at every turn. Having departed from his fundamentally decent-guy persona, he had gone in a daring direction that Poitier, despite his greatness, had never ventured. It was thrilling to watch him. In the end, he won a second Oscar as Best Actor of 2001.

CONTROVERSY, STARDOM, AND OSCAR: HALLE BERRY

Also walking to the stage to accept an Oscar—the same night as Washington—for her Best Actress performance in Marc Forster's *Monster's Ball* was Halle Berry. A Cleveland native and the daughter of a Caucasian mother who was a psychiatric nurse and a black father who was a hospital attendant, Halle Berry had already worked long and hard in films and television. A former beauty contest winner, she had first won some attention in the short-lived TV series *Living Dolls* in 1989 and two years later on the series *Knots Landing*. In films, she played a variety of roles in *Jungle Fever, Strictly*

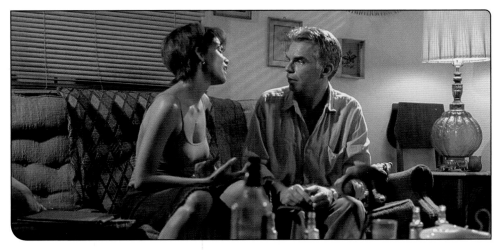

Halle Berry and Billy Bob Thornton in the controversial sex scene in *Monster's Ball*.

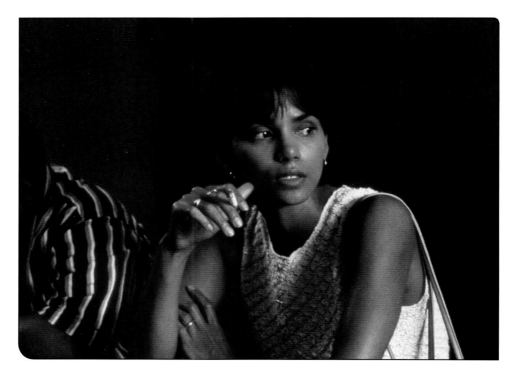

Halle Berry as the emotionally fragile Leticia in *Monster's Ball*.

Business, *The Last Boy Scout*, *Boomerang*, *Losing Isaiah*, and *The Rich Man's Wife*. She also appeared as the character Storm in the very successful *X-Men* movie franchise.

She projected a ladylike quality and a healthy Americanism. Never was there anything coarse about her. Greater success, however, came with her more sexualized image in *Swordfish* with John Travolta and Hugh Jackman in which she appeared bare-breasted, and then as one of the Bond "girls" in the James Bond film *Die Another Day* (2002). That sexualization was a reminder of the demands put on actresses that their male counterparts were not faced with.

Finally, *Monster's Ball* gave her the role she had been searching for. Here Berry played Leticia Musgrove, a woman who is at loose ends after her husband (Sean Combs) has been executed in the penitentiary and her young son has been killed when hit by a car on a highway. Emotionally battered and scarred, she finds herself evicted from her home and then taken in by the very racist law enforcement officer (Billy Bob Thornton) who had led her husband to his death. But she does not confront him. Nor does she appear to need an explanation from him. *That* generated part of the controversy that ultimately surrounded the film.

But there was more. Throughout *Monster's Ball*, she was left culturally and racially adrift, depicted as having no family members or African American friends who might comfort her. *Monster's Ball* also had a graphic sex scene between Berry and Thornton. Online criticism shot up about the film and her character. Even Angela Bassett, who said she had turned down the part (which one of the producers, Lee Daniels, denied), was critical. "It's about *character*, darling," she told *Newsweek's* Allison Samuels. "I wasn't going to *be* a prostitute

on film. I couldn't do that because it's such a stereotype about black women and sexuality." Actually, Berry's character was not a prostitute, but there was validity in the point Bassett made. To her credit, Berry, however, was vulnerable and touching as a woman who is lost and struggling to pull her life together. In the past, a problem for Berry may have been her soft, girlish speaking voice that seemed to lack authority and made her appear vague, bland, almost characterless, all of which ironically worked touchingly well for her character in *Monster's Ball.*

Halle Berry's Oscar acceptance speech proved memorable. She acknowledged movingly the African American women who preceded her in Hollywood, citing first Dorothy Dandridge, whom she had portrayed in the HBO production *Introducing Dorothy Dandridge* that earned her an Emmy, then referring to Lena Horne and Diahann Carroll and her contemporaries Angela Bassett and Jada Pinkett Smith. At the same ceremony in which Berry and Washington won their Oscars, Sidney Poitier was also honored for his lifetime of work in the movies, breaking down barriers. Despite the controversies, the evening was an emotional and deeply moving one in Academy Awards history.

Halle Berry's post-Oscar career, however, included a series of disappointing roles. Her *Catwoman* proved to be a dud, killing any hopes she may have had for a franchise series. She drew some attention for her role as a dancer struggling with a psychiatric multiple personality disorder in *Frankie and Alice.* The B-movie style suspense drama *The Call*, however, was fun and a modest success. But other films—*Perfect Stranger, Things We Lost in the Fire, Cloud Atlas*, and *Kingsman: The Golden Circle*—hardly advanced her career.

DENZEL: POST-OSCAR

Denzel Washington's post-Oscar career was as successful as ever. Greatly respected within the industry, he lived relatively quietly with his wife Pauletta Pearson and their four children at one time in a home designed by the great African American architect Paul Williams. Cognizant of movieland culture, Washington made no false moves. Flexing his acting muscles, he periodically performed on Broadway in *Julius Caesar*, August Wilson's *Fences*, and Eugene O'Neill's *The Iceman Cometh.*

Forming a production company, he carefully selected projects. In 2002, he directed his first film *Antwone Fisher*, the story of a violent sailor (newcomer Derek Luke) who must undergo treatment by a naval psychiatrist (Washington). Uncovered is the young man's painful childhood. Five years later, Washington directed *The Great Debaters*, based on the true story of a debate team in the 1930s at Wiley College in Texas, a historically black college. He played Melvin Tolson, the African American poet of the Harlem Renaissance. In *The Great Debaters*, Washington was unearthing a significant chapter of history (though it took dramatic liberties with the story) that might otherwise be lost to us. *The Great Debaters* was also a tribute to the important work and achievements of past African American institutions of higher learning.

Washington continued to seek a variety of

challenging roles in such movies as *Out of Time*, under the direction of Carl Franklin; *Man on Fire*; and the less successful remakes *The Manchurian Candidate* and *The Taking of Pelham 123*. In 2010's futuristic post-apocalyptic drama *The Book of Eli*, he worked under the direction of Albert Hughes, of the Hughes brothers.

Washington's best performances included roles as the detective out to foil a bank heist in Spike Lee's taut and tense *Inside Man* and as the real-life drug lord Frank Lucas in Ridley Scott's *American Gangster*, which also featured Russell Crowe and Ruby Dee. Here again, he played a ruthless, complicated character. Like *New Jack City*, *American Gangster* might be viewed as an update of *Super Fly* in its depiction of a drug lord in a changing New York drug scene. It's now a big international business. In 2012's *Flight*, he played an alcoholic airline pilot who ultimately must face his demons.

He returned to directing with an adaptation of August Wilson's *Fences*. In 2017, he played the title role in *Roman J. Israel, Esq.*—one of his most eccentric characters, a highly principled, idealistic attorney who is part nerd, part savant. Ultimately, he violates his own principles, which leads to tragedy. With a puffed-up, old-school Afro, large eyeglasses, and ill-fitting clothes, Washington managed to touchingly move completely away from all previous characterizations. Quite a feat. Though *Roman J. Israel, Esq.* was not widely seen, Washington won a well-deserved Best Actor Oscar nomination for the film and for *Flight* and as actor and producer of the Best Picture nominee *Fences*. In total, he had eight Oscar nominations as an actor with two wins; nine Golden Globe nominations with three wins, one of which was the noncompetitive Cecil B. DeMille Award; and twenty-three NAACP Image Award nominations, with seventeen wins.

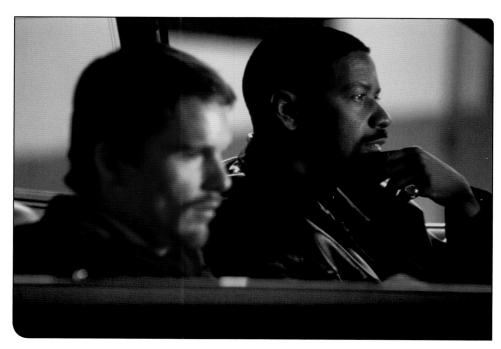

Ethan Hawke and, as the corrupt cop, Denzel Washington, in *Training Day*.

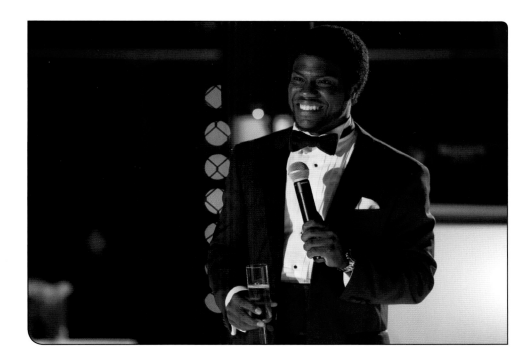

WORKING INSIDE THE HOLLYWOOD SYSTEM

More African American directors navigated their ways through the rough corridors of Hollywood. A generation emerged that had now grown up watching the long careers of such directors as Spike Lee and John Singleton. One such filmmaker was Tim Story, who looked in many ways like a child of Hollywood. Born in 1970 in Los Angeles, he attended high school with future stars Regina King and Nia Long and studied film at the University of Southern California. His breakout movie was the 2002 comedy *Barbershop*, a look at the comings and goings of a black barbershop in Chicago. Directing Ice Cube, Cedric the Entertainer, Anthony Anderson, Michael Ealy, and singer Eve, Story created a black meeting place,

indeed a cultural center, of barbers and patrons alike who shared social and political stories, anecdotes, observations, and opinions. Sequels followed.

Story also benefited from a shift in attitudes within the executive offices of Hollywood. Occasionally, the film studios could be persuaded that African American directors could helm commercial films—without racial themes—that might be blockbusters. Thus in 2005, Story directed the franchise film *Fantastic Four* and in 2007, *Fantastic Four: Rise of the Silver Surfer*. He also returned to directing black comedies such as *Think Like a Man* in 2012, based on comedian Steve Harvey's bestselling book *Act Like a Lady, Think Like a Man*, and its sequel, *Think Like a Man Too*. Here he

New millennium star, Kevin Hart.

worked with the stars of the period: Michael Ealy, Gabrielle Union, Meagan Good, Regina Hall, and, especially, comic Kevin Hart and actress Taraji P. Henson. Some of the cast had been around for a while but now they clicked in a film that spoke to African American moviegoers about the age-old battle of the sexes from a black perspective—in this case mainly a black male perspective. Directing the action comedies *Ride Along* and *Ride Along 2*, starring Ice Cube and Kevin Hart, Story was important in the career of Hart, who became one of the era's new stars.

Hollywood also paid attention to director Antoine Fuqua. Having studied electrical engineering, Fuqua veered into directing with music videos of Stevie Wonder, Prince, and Arrested Development. His debut feature film was not an African American project. Instead, he directed Chow Yun-Fat in the action movie *The Replacement Killers*. Other films followed in which he revealed a hard-edged, perhaps hypermasculine style in *Bait,* with Jamie Foxx, and especially the films in which he directed Denzel Washington: *Training Day, The Equalizer* and its sequel, and the remake of *The Magnificent Seven*. Like Quentin Tarantino, Fuqua's films at times had a controlled sadomasochistic thread running through them that heightened tensions and suspense—that kept moviegoers uneasily on the edge of their seats. A highly skilled filmmaker, he also reworked a timeless legend with *King Arthur*, starring Clive Owen and Keira Knightley.

SUCCESS AND CRITICISM: TYLER PERRY

Of the new directors, few generated more attention—and criticism—than Tyler Perry, whose arrival on the scene was wholly unexpected. In his background were some of the dilemmas and themes that he explored in his films. He had been born Emmitt Perry Jr. in New Orleans in 1969, the son of a devout churchgoing mother and a terrifying father who, according to Perry, had brutalized him. Other nightmares flared up during the boy's early years. He was sexually abused by a woman friend of his mother as well as by three uncles. As a young adult, he changed his name, moved to Atlanta, and, unsure what to do with his life, found a refuge in writing about his experiences in letters to himself. Those letters served as the basis for his first play, a musical drama titled *I Know I've Been Changed*. Using his life savings, he mounted the play. It bombed. Afterward, Perry's finances were so low that he ended up homeless.

He bounced back and eventually proved himself a very adept businessman. Still writing, he began producing his new plays in rented theaters. He also promoted those plays to churches and community groups in Atlanta. His productions, which were tales of struggle, faith, redemption, and personal salvation, began attracting big audiences. The productions touched on the needs of black theatergoers who were hungry for stories that dramatized their struggles and their religious beliefs, and offered hope. He began videotaping the productions and sold them at the theaters where his plays ran. He also took his shows on the road. Perry

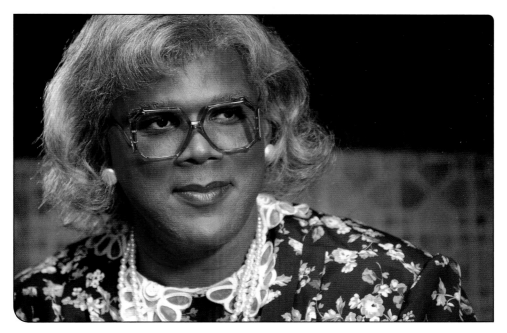

Tyler Perry as Madea

built up a large black following. In many respects, the plays and soon the movies were like the race movies of the past.

The first Tyler Perry film was *Diary of a Mad Black Woman*. Perry had hoped Hollywood might back his production, but at first there was no interest. Finally, he secured backing from Lions Gate and also invested his own funds to do the film on a budget of $5.5 million, with Darren Grant hired to direct. Perry was off and running. The movie starred Kimberly Elise as the emotionally fragile Helen, a battered wife who is dumped by her affluent lawyer husband (Steve Harris). To her rescue comes her grandmother, Madea, a physically towering no-nonsense woman well over six feet tall who carries a gun and cannot be trifled with. Madea was a term of endearment used by some African Americans, a way of saying "Ma Dear" (or "Mother Dear"). In a wig and dress, Perry himself played the role, as he had onstage. Madea helps Helen get her life back in order—by first putting

her in touch with her roots. In the process, Helen also meets (or is *rewarded* for her return to her roots with) a solid, decent good black man (Shemar Moore)—a prince of sorts.

Dairy of a Mad Black Woman was a comedy/drama combination of revenge fantasy, morality tale, and movie-style romance. It was also a testament to female self-empowerment. That self-empowerment would be as much Madea's as Helen's, but it also was a cautionary tale: a warning for upscale (or educated women) who strayed from their sense of identity. The movie resonated with African American moviegoers—predominantly women—and became a hit.

Afterward, Perry himself directed, wrote, produced, and frequently starred in his films: *Madea's Family Reunion*, *Daddy's Little Girls*, *Why Did I Get Married?* and its sequel, *Meet the Browns*, *The Family That Preys*, *Madea Goes to Jail*, *I Can Do Bad All By Myself*, *Madea's Big Happy Family*, *Madea's Witness Protection*, *Boo: A Madea Halloween*, and

on and on. Most were box-office successes, notably those in which he appeared as Madea.

In 2010, Perry adapted Ntozake Shange's iconic choreopoem *for colored girls who've considered suicide/when the rainbow is enuf* that dramatized issues, dilemmas, fears and aspirations of seven black women. He titled his film *For Colored Girls*. It featured a stellar cast: Phylicia Rashad, Whoopi Goldberg, Janet Jackson, Thandie Newton, Loretta Devine, Kerry Washington, Macy Gray, Anika Noni Rose, Hill Harper, and Richard Lawson. Though it was way too literal a dramatization of Shange's work and could never match the impact and artistry of the original, the movie was Perry's attempt to extend his talents and to speak to African Americans in a personal, direct way.

Perry also starred in *Alex Cross* (2012) and gave a convincing performance as an attorney in David Fincher's *Gone Girl* (2014). In time, he created such TV series as *Meet the Browns*, *House of Payne*, and for Oprah Winfrey's OWN network *For Better or Worse*, *If Loving You Is Wrong*, and *The Haves and the Have Nots*.

Ultimately, Perry's films were criticized by Spike Lee and by some African American women. Much criticism was directed at his simplistic stories that seemed to punish more educated or professional African American women who had to be brought back to their down-home roots—and that also relied on stereotypical images, which included Madea. Still, Perry's movies boosted the careers of such African American actors and actresses as Taraji P. Henson, Idris Elba, Jill Scott, Janet Jackson, Tasha Smith, Sharon Leal, and Cicely Tyson in *Dairy of a Mad Black Woman*, *Madea's Family Reunion*, and *Why Did I Get Married Too?* Frankly, it was wonderful to see Tyson back on the big screen. For much of the new era, Perry was the most commercially successful African American filmmaker. Significantly, though he was rarely given credit, he had shown Hollywood that films centered on African American women could pull in moviegoers.

Kimberly Elise as the wife abused by husband Steve Harris until the avenger Madea shows up in *Diary of a Mad Black Woman*.

ACTION STARS AND DRAMATIC POWER

Working steadily and becoming a reliable box-office star was Vin Diesel, who played street car racer Dominic Toretto in the long-running *Fast and the Furious* franchise. Producers attributed some of Diesel's success to the fact that the biracial actor was racially ambiguous to movie fans. Because many moviegoers did not seem to know for sure what race Diesel actually was, it was believed that audiences could project onto him whatever ethnicity or race they felt comfortable with. Perhaps. As the *Fast and Furious* series continued, Diesel was joined in the racing exploits by Tyrese Gibson and Dwayne "The Rock" Johnson. Also biracial, Johnson, who had first made a name for himself as a wrestler called the Rock, was a more relaxed and agreeable figure than the sometimes stilted Diesel. Generally, however, moviegoers appeared to identify him as black. He became a fan favorite in such films as *Pain & Gain*, *Central Intelligence*, and the huge hit *Jumanji: Welcome to the Jungle*.

Standup comedian Chris Rock made a pitch for a place in Hollywood's constellation as star and director of *Head of State*, *I Think I Love My Wife*, and *Top Five*. Ice Cube underwent an image change from one-time revolutionary rapper to stoner in F. Gary Gray's 1995 hit comedy *Friday* (which Ice Cube co-wrote) to family man in such films as *Are We There Yet* and *Are We Done Yet?* In the latter, he again played Nick Persons, who moves with his wife (Nia Long) to the suburbs. But he is confronted with one hassle after another with the contractor for the renovations of the new suburban digs. If the plot sounds vaguely familiar, it's because *Are We Done Yet?* was a replay of the Cary Grant/Myrna Loy/Louise Beavers comedy *Mr. Blandings Builds His Dream House*.

Other actors found work in Hollywood. One of the finest was Kansas City-born Don Cheadle, who had first come to attention as the buddy of Denzel Washington in *Devil in a Blue Dress*, then worked in such movies as *Rosewood*, *Boogie Nights*,

Dwayne "The Rock" Johnson

Forest Whitaker in his Oscar-winning role as Ugandan dictator Idi Amin in *The Last King of Scotland*.

the misbegotten *Bulworth*, and *Hotel Rwanda*, a disturbing look at the genocidal battle within Rwanda's population, between the Tutsis and the Hutus. He also starred in Kasi Lemmons's *Talk to Me*. British-born actor Chiwetel Ejiofor, the son of Nigerian parents, was a striking presence in Steven Spielberg's *Amistad*, Stephen Frears's *Dirty Pretty Things*, *Inside Man*, and *American Gangster*. Another British-born actor, Wentworth Miller, the son of American parents, had the intensity of a young Montgomery Clift as an emotionally divided young man who crosses the color line in Robert Benton's *Human Stain* (2003), based on Philip Roth's novel. It was an unforgettable performance—as was that

of Anna Deavere Smith as his mother. He was also the star of TV's *Prison Break* series.

West African actor Djimon Hounsou appeared in *Amistad*, Ridley Scott's *Gladiator*, *Blood Diamond*, and in an Oscar-nominated performance as Best Supporting Actor in *In America*. London-raised Idris Elba was a skilled actor (and often a heartthrob) in such films as *28 Weeks Later*, *Daddy's Little Girls*, *Mandela: Long Walk to Freedom*, *Beasts of No Nation*, and *Molly's Game*. Terrence Howard—the Chicago-born great-grandson of actress Minnie Gentry—had appeared in movies since the previous decade, notably as the likable cad Quentin in Malcolm Lee's *The Best Man*. But in

2005's *Hustle & Flow*, he clicked with moviegoers in a whole new way with his raw performance as a Memphis pimp Djay, trying to get a record produced. He won a Best Actor Oscar nomination for that performance.

Howard was also one of the stars of another film that was widely discussed, Paul Haggis's *Crash*. Through interconnecting stories of multiple characters and situations, *Crash* drew a disturbing portrait of race and class divisions in Los Angeles, the City of Angels known for its ethnic and cultural diversity. Underneath its seemingly open-ended surface were simmering tensions, many based on long-held racial fears and misconceptions. Los Angeles is revealed as a twisted urban center that has failed to come to grips with its own discontents and cultural identity. Often contrived with emotions and attitudes not fully sorted out or examined, yet on occasion insightful, *Crash*'s diverse cast included Don Cheadle, Thandie Newton, Sandra Bullock, Matt Dillon, Daniel Dae Kim, Loretta Devine, Michael Pena, Beverly Todd, Jennifer Esposito, Chris "Ludacris" Bridges, and one of Hollywood's most underrated actors, Larentz Tate. *Crash* won the Academy Award as Best Picture of 2004.

Clint Eastwood and Morgan Freeman in *Million Dollar Baby*.

There was great excitement when established actors who had toiled in Hollywood since earlier eras finally won the greatest recognition the industry had to offer, the Oscar itself. The year 2004 was historic for black Oscar nominations. Nominated in the Best Supporting Actor category were both Jamie Foxx in Michael Mann's *Collateral* and Morgan Freeman in Clint Eastwood's *Million Dollar Baby*. That year Foxx was also nominated in the Best Actor category for his portrayal of legendary singer Ray Charles in *Ray*. In this category he was in the company of Don Cheadle for *Hotel Rwanda*. Sophie Okonedo was nominated for the Best Supporting Actress award for the same film.

The cynics assumed that none of these talented actors would win: in the acting categories, the black contenders were bound to cancel each other out. So it was thought. There was surprise and elation, however, when Freeman won a long overdue Oscar for his performance as Eddie-Scrap "Iron" Dupris. Before the night was over, Foxx walked off with the Best Actor award. Two years later, Forest Whitaker was awarded a Best Actor Oscar for his performance as Idi Amin in *The Last King of Scotland*. That "supreme prize" in the mythology of the cinema that Federico Fellini had spoken of seemed to open its mighty portals for black talents in a way unprecedented in past Hollywood history. In the new millennium, a record number of black actors and actresses would win Oscar nominations *and* awards.

An uncanny resemblance: Jamie Foxx as the legendary Ray Charles in *Ray*.

ACTRESSES ALTERING THE LANDSCAPE

Gradually, Hollywood turned its eye in a more serious way to African American women. A prime example was the stardom of Queen Latifah, who discovered an industry more receptive to a full-figured African American woman than it had been previously. Born Dana Owens in 1970 in Newark, New Jersey, she first made her mark in hip-hop, a musical genre dominated by men. Seeing herself indeed as a queen, Latifah wore power hats, carried herself like royalty, and was for her generation an emblem of bold female self-assurance with her debut album *All Hail the Queen* and her "Ladies First" single, both of which climbed the music charts.

Moving from rap/hip-hop to jazz to standards, she made the transition to TV and movies, as the star of the popular black sitcom *Living Single* and in supporting roles in such films as *Living Out Loud* and *The Bone Collector*. In a role that reportedly was sought by Kathy Bates and Whoopi Goldberg, Queen Latifah played Matron Mama Morton in the 2002 Rob Marshall–directed Oscar-winning musical *Chicago*. Working with Catherine Zeta-Jones, Renée Zellweger, and Richard Gere, she had a prized moment when she sang "When You're Good to Mama." Her performance earned her a 2002 Best Supporting Actress Oscar nomination. She also starred in *Bringing Down the House* with Steve Martin and Eugene Levy and in the musical version of *Hairspray* with John Travolta. For a spell, she was one of the few bankable African American actresses in the movies as she starred in—and sometimes was a producer of—films made primarily for African American audiences, such as *Cookout*,

Queen Latifah

Beauty Parlor, and *Barbershop 2: Back in Business*.

An underrated Queen Latifah film, which brought out her warm vulnerability, was Wayne Wang's *Last Holiday* (2006) with French star Gérard Depardieu, LL Cool J, and Timothy Hutton. Here her character, who believed she had only weeks to live, went off on a European holiday to enjoy the pleasures she's always denied herself. It was an endearing, simply stated performance. Later she starred in *Just Wright* with rap star Common, Paula Patton, and Phylicia Rashad, which Latifah produced along with another producer important in Black Hollywood, Debra Martin Chase.

Latifah and LL Cool J in *Last Holiday*.

The major film of the new decade that focused on African American women was *Dreamgirls* in 2006. It had been a long time in coming. *Dreamgirls* had been a hit Broadway musical that opened in 1981 under the direction of the imaginative Michael Bennett. Its music was by Henry Krieger and Tom Eyen. Loosely based on the experiences of the singing group the Supremes, *Dreamgirls* followed a singing trio of young black women in a cutthroat music business. Groomed for crossover stardom, the young women go from black venues and black record buyers to the big mainstream arenas and to white record buyers. Along the way, the group's central talent, the heavy, earthy Effie, is dumped as lead singer in favor of the more "acceptable" sound *and* look of the sleek and slender Deena.

In real life, Motown Records had dropped soulful background singer Florence Ballard from the Supremes while it promoted Diana Ross. Ultimately, Ballard's life ended tragically. Shockingly, she died at age thirty-two from cardiac arrest. *Dreamgirls* told a compelling story, although it gave the story a happy ending. The Ballard-inspired character Effie has a comeback and is reunited for a big number with the group.

Dreamgirls was always perfect for the movies, but nothing happened for years. At one point, talk sprang up that a movie version would star Whitney Houston as Deena. But again nothing happened. The rights were held up by producer David Geffen, one of the financiers of the original Broadway production, who wanted to preserve the integrity of the show. Once Geffen finally granted permission, Bill Condon wrote and directed a cast that included Beyoncé Knowles (one of music's biggest stars, who reportedly lobbied and tested for the role of Deena), Jamie Foxx, Anika Noni Rose, Sharon Leal, and Eddie Murphy (as soul singer James "Thunder" Early, the raucous, funky, brilliant soul singer inspired by James Brown).

For the pivotal role of Effie—which was played onstage by the acclaimed Jennifer

A young trio on the rise to fame in *Dreamgirls*,
with Anika Noni Rose, Beyoncé Knowles, and Jennifer Hudson.

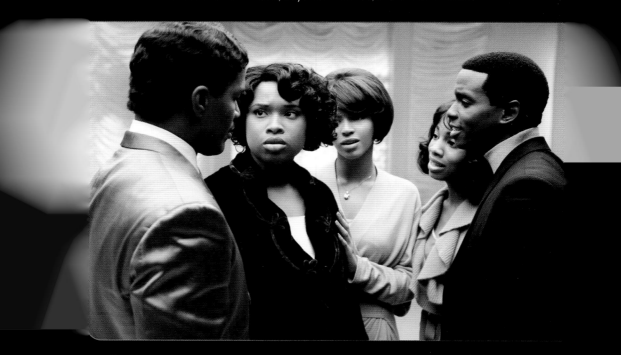

Jennifer Hudson (center) in her Academy Award–winning role as the rejected Effie in *Dreamgirls*.

Holliday—Condon considered various actresses, then decided on Jennifer Hudson. A former contestant on TV's *American Idol*, she projected both the vulnerability and the assurance the role demanded. Special care was taken in filming her big, showstopping number, "And I Am Telling You I'm Not Going." In the end, all the performers were solid. Beyoncé captured some of the hardness and disillusionment that sets in for a woman aware of the sacrifices she has made to attain stardom. Eddie Murphy brought the appropriate funk and manic drive to his character. It was one of his best performances. But it was Hudson's undeniably moving Effie that propelled the film.

Jennifer Hudson won an NAACP Image Award for Supporting Actress. She and Murphy won Golden Globes and Screen Actors Guild Awards. The film earned eight Academy Award nominations, but there was disappointment that it was not a nominee for Best Picture. Nor was Condon up for Best Director. Both Hudson and Murphy were among the nominees. Murphy had a good chance of winning but was the victim of a backlash against his caricatured portrait of an overweight, vulgar woman in the movie *Norbit*, released not long after *Dreamgirls*. Hudson, however, walked off with the Oscar for her debut movie.

As was the case with *Waiting to Exhale*, sometimes black women went in groups to see the film—and they sometimes saw *Dreamgirls* more than once. It was one more indication that African American

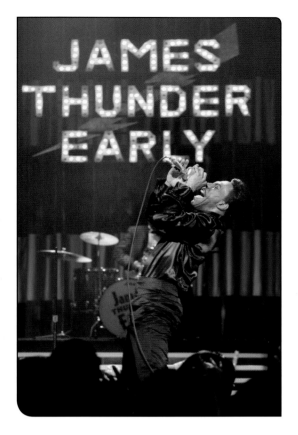

Eddie Murphy in one of his best performances, in *Dreamgirls*.

women were hungry for films that explored in one way or another issues they believed pertained to them. Here moviegoers found vivid female characters juggling personal and career conflicts in a profession controlled by men—against a backdrop of a racially charged and changing America.

◇◇◇◇◇◇◇◇◇◇◇◇◇

Other films focused on a diverse group of African American women. *Something New* explored an interracial relationship between a professional black woman (Sanaa Lathan) and her white landscaper (Simon Baker). At the same time, it examined issues of working women as well as of class within the African American community. Behind the camera were three black women: screenwriter Kriss Turner, director Sanaa Hamri, and producer Stephanie Allain.

Gabourey Sidibe as the outcast Precious.

In 2000, Gina Prince-Bythewood directed the offbeat love story *Love and Basketball*. Eight years later, she directed an adaptation of Sue Monk Kidd's novel *The Secret Life of Bees*. Queen Latifah, Sophie Okoneko, and Alicia Keys played three bee-keeping sisters who take in a runaway young white girl (Dakota Fanning) and her older friend (Jennifer Hudson)—and, as might be expected, help lead the girl to a new self-awareness. Bythewood also directed Gugu Mbatha-Raw as a troubled biracial singer in *Beyond the Lights*.

A remake of the cult film *Sparkle*—directed by Salim Akil, written by Mara Brock Akil, and produced by Debra Martin Chase—was released in 2012. This time the trio was played by Jordin Sparks, Tika Sumpter, and Carmen Ejogo as the oldest sister. Ejogo's kinetic and forceful performance was the remake's focal point. Most touching was Whitney Houston's last film appearance as the mother of the trio who tries alerting her daughters of the dangers ahead.

Director Lee Daniels brought *Precious: Based on the Novel* Push *by Sapphire* (2009) to the screen.

Executive-produced by Oprah Winfrey and Tyler Perry, *Precious* was a harrowing portrait of an African American teenage girl named Precious (newcomer Gabourey Sidibe) who is tormented at every turn: raped by her father, physically abused by her psychotic mother (played by Mo'Nique), and turned into a societal outcast. Though excessive with gothic horrors, *Precious* gave both its primary actresses once-in-a-lifetime roles. The film garnered multiple Academy Award nominations, including Sidibe for Best Actress, Daniels for Best Director, and *Precious* itself as Best Picture. On Oscar night, Mo'Nique won as Best Supporting Actress. Writer Geoffrey Fletcher became the first African American to win an Academy Award for Best Adapted Screenplay.

Then there was Quvenzhané Wallis, born in 2003, who became the youngest Best Actress nominee in the history of the Oscars for her performance in 2012's *Beasts of the Southern Wild*. She later appeared in the title role in a remake of *Annie*, *12 Years a Slave*, and Beyoncé's *Lemonade*.

Oscar-winner Mo'Nique as the violent, disturbed mother in *Precious*.

Among the actresses rising to prominence and critical recognition after long periods in Hollywood were Taraji P. Henson, Viola Davis, and Octavia Spencer. Both Henson and Davis were nominated for Best Supporting Actress Oscars for their 2008 performances, respectively, in *The Curious Case of Benjamin Button* and *Doubt*. A graduate of Howard University, Henson worked in such television shows as *Boston Legal* and *Person of Interest*. Her breakout performance came as the gentle pregnant prostitute in *Hustle & Flow*. Afterward, she played down-to-earth and outspoken women in Tyler Perry's films *I Can Do Bad All By Myself* and *Acrimony*, and the *Think Like a Man* comedies. But her great success came as Cookie Lyon in the hit television series *Empire*.

Then came a surprise hit, *Hidden Figures*, an entertaining film that uncovered what might have been a lost piece of American history. Set in Hampton, Virginia, in 1961, *Hidden Figures* starred Henson, Octavia Spencer, and Janelle Monáe as the real-life black female NASA mathematicians who proved crucial in America's determined efforts to excel in space. Excellent as the women are in their professions, they repeatedly must combat systemic attitudes about race and gender. Moviegoers would not forget those scenes in which Henson's character Katherine G. Johnson must leave the lab where she works to rush a half mile to another building to use a bathroom because there is no Colored-Ladies restroom where she is stationed. Nor would moviegoers forget Octavia Spencer's solemn power as she fights for a much-deserved position as a supervisor in her division. Early on, Barbra Streisand had read the script and wanted to direct the film. But *Hidden Figures*'s cowriter Theodore Melfi ended up directing. Providing fine support were Kevin Costner, Kirsten Dunst, Mahershala Ali, and Jim Parsons. Octavia Spencer received a Supporting Actress Oscar nomination for her performance.

By this point in the new century, Octavia Spencer had waded through a plethora of TV and

Taraji P. Henson

Octavia Spencer

movie roles: from small parts on series such as *Moesha*, *ER*, and *The X-Files*; to small roles in such movies as *Big Momma's House* and *Halloween II*. At times, her career had to be disheartening because there was little she could sink her teeth into, and she looked as if she wasn't headed anywhere special. She had been born in Montgomery, Alabama, had graduated from Auburn University, and, with dreams of acting, moved to Los Angeles at the urging of her friend, future director Tate Taylor. When she landed a job behind the scenes on Joel Schumacher's *A Time to Kill*, she asked the director if she could audition for a role. That marked her movie debut. Later she had impressive sequences as a home cure nurse in the Will Smith film *Seven Pounds*.

The direction of Spencer's career changed when she played the role of Minny Jackson in *The Help* (2011), which was written, directed, and produced by Tate Taylor. An adaptation of Kathryn Stockett's novel with a cast that included Viola Davis, Emma Stone, Bryce Dallas Howard, Aunjanue Ellis, Allison Janney, Jessica Chastain, and Cicely Tyson, *The Help* told the story of African American maids working in Jackson, Mississippi in the 1960s. Daily, the women endure on-the-job humiliations, both subtle and blatant. A young white aspiring journalist, Skeeter (Emma Stone), encourages the domestics to tell their stories for a book. Throughout, *The Help* seeks to give the maids Aibileen (Viola Davis) and Minny (Spencer) agency as they summon the courage to speak of their lives.

The Help was often funny and entertaining, which was problematic. Well-intentioned as the movie was, the pivotal African American women were still portrayed, despite moments of rebellion and protest, as being devoted caregivers. Aibileen bonds with the neglected daughter of her white employer. Minny has a real moment of assertion with an infamous pie that she has baked for her employer, but ultimately she, too, is shown to be the comforting friend of a young white woman (Jessica Chastain). The domestics also are spurred to action to tell their stories by a white protagonist. For the most part (except for a minister), African American men were missing from the drama. Minny has an abusive husband who is never seen. Aibileen grieves for her dead son. *The Help* was a contradiction of sorts, both a rebuke to past images of nurturing African American women as well as a reinforcement of those same images.

The actresses, however, excelled. Spencer didn't need dialogue to express her dismay nor her interior elation during the key moment of revenge on her former employer. It's all in her eyes. Both Viola Davis and Octavia Spencer were Oscar-nominated, the former as Best Actress. That award went to Meryl Streep for her performance as Margaret Thatcher in *The Iron Lady*. But Spencer won for Best Supporting Actress of 2011. Afterward, she appeared in Ryan Coogler's indie hit *Fruitvale Station* as well as the big-budget franchise series *The Divergent: Insurgent*, and worked for Tate Taylor again in his biopic on singer James Brown, *Get On Up*. In two subsequent films, *Hidden Figures* in 2016 and *The Shape of Water* in 2017, Spencer won back-to-back Supporting Actress Oscar nominations.

For those following the career trajectory of Viola Davis, from the early years on television and her movie roles in the Steven Soderbergh films *Out of Sight* and *Traffic*, to more substantial roles in *Far from Heaven*, *Antwone Fisher*, and Soderbergh's *Solaris*, it seemed to take forever for her to land a signature role. But a breakthrough occurred with her performance in *Doubt*, as the complicated mother of a son who possibly has been sexually abused by a priest. Her big moment came in a dramatic confrontation with a rigid nun played by Meryl Streep. Here were two remarkable actresses matching one another in intensity, and with neither being intimidated by the other's talent. Critics and moviegoers sat spellbound. Davis won a Best Supporting Actress Oscar nomination. New opportunities indeed came in big movies with big stars: Tom Cruise's *Knight and Day*, Julia Roberts's *Eat Pray Love*, and later Tom Hanks and Sandra Bullock's *Extremely Loud & Incredibly Close*. But appearances were deceptive.

Denzel Washington and Viola Davis in *Fences*.

"I always got the phone call that said: 'I have a great project for you,'" Davis told the *New York Times* in 2014. "You're going to be with, hypothetically, Vanessa Redgrave, Julianne Moore, Annette Bening." Then she would receive the script in which her role ran merely a page or two. "I have been given a lot of roles that are downtrodden, mammy-ish." Her professional characters could be problematically written. "A lot of lawyers or doctors who have names but absolutely no lives. You're going to get your three or four scenes, you're not going to be able to show what you can do. You're going to get your little bitty paycheck, and then you're going to be hungry for your next role, which is going to be absolutely the same. That's the truth."

Davis finally attained another level of stardom with her hit TV series *How to Get Away with Murder*, which premiered in 2014. Here she played a multidimensional and often ruthless attorney and law professor who was also sexual and often glamorous. Those were traits that darker African American women, since the early years of Hollywood, did not possess in most films.

For Davis, real artistic achievement came with her role as Rose in the film version of August Wilson's *Fences* (2016), directed by Denzel Washington. A few years earlier, Washington and Davis had starred in the Broadway revival of Wilson's play. As Rose, Davis delineated a character that was warm and stoic yet revealed to be strong-willed and ultimately uncompromising. She won the Academy Award as Best Supporting Actress of 2016.

OBAMA-ERA FILMS: CHARTING HISTORY

Following the historic election of President Barack Obama, filmmakers were drawn to reexaminations of the past: of American history in George Lucas's *Red Tails*: the World War II exploits of the African American US Army Air Corps unit of the Tuskegee Airmen; *Lee Daniels' The Butler*: the experiences of an African American butler at the White House through various administrations; *42*: Chadwick Boseman as Jackie Robinson at the time of his 1947 entry into major league baseball; Steven Spielberg's *Lincoln*: President Lincoln's struggle in 1865 to get passage of the Thirteenth Amendment that would abolish slavery; Ava DuVernay's *Selma*: the three-month events in 1965 in the struggle for equal voting rights that culminated in the epic march of Dr. Martin Luther King Jr. and other civil rights leaders from Selma to Montgomery, Alabama. Heard on the soundtrack of *Selma* was "Glory," by John Legend and Common, which won the Academy Award for Best Original Song of 2014.

Also appearing were reexaminations of previous movie images about the past. Quentin Tarantino's *Django Unchained*, influenced by Blaxpoitation cinema (namely *Mandingo* [1975]) and Italian spaghetti westerns, was a bloody, violent, defiant reworking of the old planation films. It starred Jamie Foxx, Christoph Waltz, and Kerry Washington. Most exciting were the performances of Leonardo DiCaprio as a horrifying plantation owner and Samuel L. Jackson as his faithful slave Stephen. Here Jackson reconfigured the old tom

Director Ava DuVernay with David Oyelowo and Oprah Winfrey during filming of *Selma*.

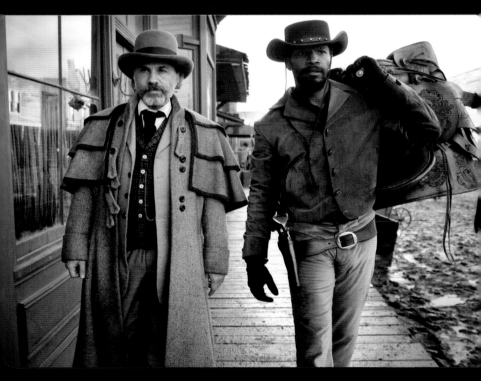

Christoph Waltz and Jamie Foxx as the avengers in Tarantino's *Django Unchained*.

stereotype, creating a character that was cunning, manipulative, and menacing (to other slaves) yet still devoted to his white master.

Also turning past plantation movies on their heads was Afro-British director Steve McQueen's *12 Years a Slave*. Based on a true 1853 narrative titled *Twelve Years a Slave* by Solomon Northup, the film recounted the experiences of Northup (Chiwetel Ejiofor), an educated free black man, born in New York and living with his wife in Saratoga Springs, who is kidnapped and sold into slavery by two white men. Brutalized as he is moved from one plantation to another, he develops strategies that will enable him to survive. Never can he reveal his intelligence, nor his ability to read and write. Nor can he speak out about the injustices he sees and endures. On one plantation, he is under the cruel grip of the psychotic owner Edwin Epps (Michael Fassbender) and witnesses the debasement of the slave Patsey (Lupida Nyong'o), who is Epps's prized possession because she picks over 500 pounds of cotton a day. Epps has also repeatedly raped her. Through the help of a Canadian worker, Samuel Bass (Brad Pitt), who is appalled by the American slave system, Northup is finally able to win his freedom and return to his wife and children. African American writer John Ridley wrote the Oscar-winning Best Adapted Screenplay. Lupita Nyong'o won the Oscar as Best Supporting Actress of 2013. *12 Years a Slave* was awarded the Best Picture Oscar—the first time a film with a black producer had taken the coveted prize.

Both *Django Unchained* and *12 Years a Slave* had stripped the past plantation film of its romanticism, its gilded view of an ideal era where master and slave lived in harmony. Television's 1977

Lupita Nyong'o in her Oscar-winning role in *12 Years a Slave*.

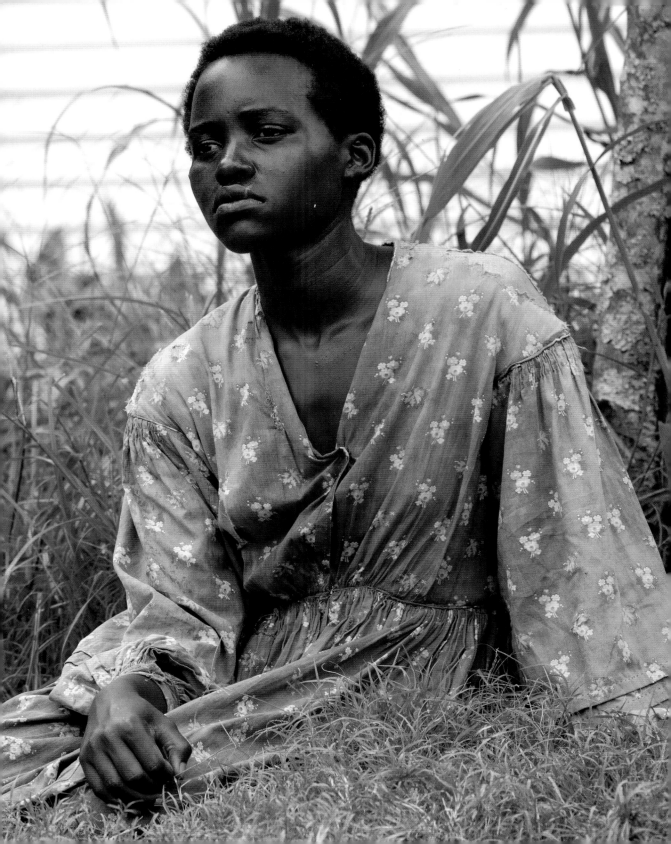

mini-series *Roots* had shown slavery's brutalities. But such a view of slavery was late getting to the movies. Now these two successful new films brought in the violent realities and heartbreaking exploitation that were ignored in films like *Gone with the Wind*. In turn, the new films left an indelible mark on American motion pictures. The same was true of actor-turned-director Nate Parker's 2016 film *The Birth of a Nation*. It was not a remake of Griffith's work. Rather, it was a dramatization of the horrors that led to the real life 1831 slave insurrection of Nat Turner. Movies were revealing historic horrors and rewriting movie history at the same time.

⟡⟡⟡⟡⟡⟡⟡⟡⟡⟡⟡⟡

In the new century, movies changed in another significant way. From 2001 to 2013, the voters of the Academy of Motion Pictures Arts and Sciences had both nominated *and* awarded more Oscars for African Americans than in any previous era. But for the year 2014, which had marked the release of *Selma* in which David Oyelowo had given a fine performance as Martin Luther King, Jr., no black actors and actresses were nominated for any Academy Awards. Though the film itself was nominated for Best Picture, its director Ava DuVernay was not. Nor were there any African American nominees in the twenty acting categories in the following year, 2015. A outcry was posted online under *#OscarsSoWhite*.

The outcry ultimately led to an examination of the Academy of Motion Picture Arts and Sciences. In 2012, the *Los Angeles Times* had revealed that of the nearly six thousand members of the Academy who voted on the Oscars, nearly 94 percent were white; 77 percent were male. The median age of Academy voters was sixty-two. Only 14 percent were younger than fifty. By June 2016, under the leadership of its first African American (and third woman) Cheryl Boone Isaacs, the Academy underwent an overhaul. Some older members were eased out. Six hundred and eighty three new members were brought in, 46 percent of whom were women; 41 percent of whom were non-white, representing fifty-nine different countries.

FILMMAKERS TAKING THE NEW MILLENNIUM FORWARD

As the second decade of the new century drew to a close, there was a surprising development for African Americans in Hollywood. Independent filmmaker Barry Jenkins, who directed *Medicine for Melancholy* in 2008, had struggled to find a second film project for years. Then he decided to direct and produce a film adaptation of Tarell Alvin McCraney's play *In Moonlight Black Boys Look Blue*. The two co-wrote the screenplay, retitled simply *Moonlight*. It was both a black coming-of-age story

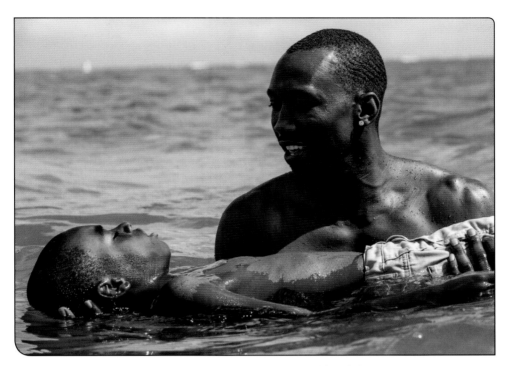

Mahershala Ali with Alex Hibbert in *Moonlight*.

and a gay one. In three separate sections or acts, *Moonlight* follows the evolving life and identity of a young African American, Chiron, as he comes to terms with his sexuality. The first act reveals his impoverished childhood in Florida's Liberty City as he withdraws into himself amid his feelings of isolation—and the neglect of his drug-addicted mother (Naomie Harris). He is befriended by a local drug dealer, Juan (Mahershala Ali). The second act follows the character through his sexual awakening during his teenage years. The third act follows him into early adulthood. He himself becomes a drug dealer, serves time in prison, and then renews a friendship with a former high school friend whom he has loved.

Throughout, Jenkins created a moving and solemn beauty—and then an emotionally transcendent ending. Three different actors—Alex R. Hibbert, Ashton Sanders, and Trevante Rhodes—portrayed

the central character. As the drug-ridden mother, Naomie Harris, who was hesitant about playing the part because of concerns it might be stereotypical, brought a touching desperation to a character trying to save herself. Janelle Monáe, Andrew Holland, and Jharrel Jerome gave *Moonlight* a warm sensitivity. As Juan, Mahershala Ali also played a part that might have slipped into stereotype. That was a perplexing aspect of the script. But he makes Juan a perceptive, reflective character whose strength and maturity save the very young Chiron.

Moonlight had eight Oscar nominations, including one for Naomie Harris as Best Supporting Actress. Previously, Hugh Robertson had been the first black nominee for editing for *Midnight Cowboy* in 1969. Now Joi McMillon became the first African American woman nominated for editing an Oscar nominated film (along with her co-editor, Nat Sanders). In the end, Mahershala Ali

won the Best Supporting Actor Oscar. Jenkins and McCraney won for their Best Adapted Screenplay. On Oscar night, there was a glitch—one of the most serious in Oscar history. At first it was announced that *La La Land* had been named Best Picture, but once that film's producers stood on stage, a stunned audience was informed that a mistake had been made. The incredible news was that *Moonlight* had actually won Best Picture—the first time a film with an all-black cast had done so, which made it the first black film to win and also the first LGBTQ film to take home the big award. Movie history had truly advanced.

By the next year, other films by African American directors invigorated old forms and genres. Formerly of the comedy team of Key and Peele, Jordan Peele made his movie directorial debut with *Get Out*. In one respect, *Get Out* was a horror movie complete with the familiar tropes: the ideal young couple visit the home of the young woman's parents, where terror awaits; the mysterious, robotic servants; the house itself, which turns out to be haunted; and at the climax, the creature or character that seemingly will not die! That form or genre was infused this time with racial satire in a tale that was reminiscent of Amiri Baraka's scathing play *Dutchman*. Here the couple was integrated—the young man, black (Daniel Kaluuya); the young woman, white (Allison Williams). At every turn, race rears its head, starting from the moment they are stopped in their car by a white cop. The title itself was a play on comments by black moviegoers at horror films, especially when black characters look as if about to be in a place of danger; "GET OUT," were the shouts heard in movie theaters at such times. A big hit with audiences black and white, *Get Out* won Oscar nominations for Best Picture, Best Director, Best Screenplay, and Best Actor, Daniel Kaluuya. Peele became the first

Four friends off on a journey to reconnect: Regina Hall, Jada Pinkett Smith, Queen Latifah, and Tiffany Haddish in *Girls Trip*.

African American to take home a Best Original Screenplay Oscar. Afterward he served as the executive producer of Spike Lee's rousing satirical drama *BlacKkKlansman* in 2018.

Director Malcolm Lee's *Girls Trip* also played comic havoc with the "chick flick." With his earlier films, *The Best Man* and *The Best Man Holiday*, Lee had examined the dynamic of friendships of a generation of educated African American professionals: their values, rivalries, aspirations, betrayals, loyalties. Some of the same friendship themes and issues were explored in *Girls Trip* as its four African American heroines—Queen Latifah, Regina Hall, Jada Pinkett Smith, and the breakout star Tiffany Haddish—are off on a visit to New Orleans. Unlike such movies as *Waiting to Exhale* and *Dreamgirls*, *Girls Trip*—with a script by Kenya Barris and Tracy

Oliver—used comedy as the primary mode for uncovering painful truths and joyous realities for the women. It too was a huge hit that reconfigured the traditional "chick flick" with its cultural markers and again its *attitudinizing*.

Also making an impact in 2017 was female director Dee Rees's *Mudbound*, which followed two families—one black, another white—in post-World War II Mississippi. As a war veteran of each family returns home from battles in Europe, the two men (Jason Mitchell, Garrett Hedlund) are confronted with new battles in their racist community. Like Ava DuVernay, Rees was one of the important African American female filmmakers of the era. Having studied film under Spike Lee at New York University's Tisch School of the Arts, Rees turned her short film *Pariah* into a feature. It was a groundbreaking coming-of-age story of a black teenager (Adepero Oduye) discovering her identity as she explores her lesbian attractions, while in opposition to her strict mother (Kim Wayans). Rees also directed the TV biopic *Bessie*, about blues singer Bessie Smith, starring Queen Latifah. Released on Netflix and at limited theaters, *Mudbound* represented a whole new kind of movie financing and distribution. The film received four Oscar nominations: for Rees and cowriter Virgil Williams for Best Adapted Screenplay; singer Mary J. Blige for Best Supporting Actress as well as for Best Original Song; and Rachel Morrison for Best Cinematography, becoming the first woman ever nominated in that category.

These new films—and the critical and audience reception—were optimistic signs for the future, though one would not want to assume that the familiar issues and images of the past had vanished. Time would only tell if this was an interlude in film history.

But the high point of the late years of the new millennium's second decade—and of the entire era—came with the work of director/writer Ryan Coogler. Born in 1986 in Oakland, California, the son of a mother who was a community organizer and a father who was a juvenile probation officer, Coogler graduated from Sacramento State (where he had a football scholarship), then enrolled at USC's School of Cinematic Arts. His first film, *Fruitvale Station* (2013), the true story of Oscar Grant, who was killed by a police officer in Oakland's Fruitvale local transit station—won critical accolades. So did his second *Creed* (2015) which was the seventh in Sylvester Stallone's *Rocky* franchise. *Creed* starred Michael B. Jordan—who

Three remarkable women almost lost to history—as played by Janelle Monáe (Mary Jackson), Taraji P. Henson (Katherine Johnson), and Octavia Spencer (Dorothy Vaughan) in *Hidden Figures*.

The elite guard led by Danai Gurira, who protect T'Challa in *Black Panther*.

had played Oscar Grant in *Fruitvale Station*—as the boxer son of Rocky's onetime opponent and friend Apollo Creed. Stallone reprised his role as a now older Rocky who trains the young Creed. It was an inspired idea that took the series in an unexpected direction.

Then Coogler entered the world of Marvel Comics, or rather the Marvel Cinematic Universe, to direct the superhero film *Black Panther* (2018). Throughout much of the decade, a younger generation had feasted on action-packed superhero movies: *Spider-Man*, *Iron Man*, *Captain America*, among many others. Though black superheroes had appeared in such movies as *Blankman*, *Spawn*, *The Meteor Man*, and *Catwoman*, none had fully clicked with a new generation. Possible exceptions had been Wesley Snipes's *Blade* and Will Smith's

Hancock. Still, moviemakers became aware of the void. The *Star Wars* sagas brought in black characters played by John Boyega and Donald Glover.

Created by Stan Lee and Jack Kirby, the Black Panther superhero had appeared in Marvel Comics in 1966 as part of an adventure that featured the Fantastic Four. Finally, in 2016's *Captain America: Civil War*, Black Panther (Chadwick Boseman) appeared alongside other superheroes: Captain America, Iron Man, Black Widow, Ant Man, and Anthony Mackie as Falcon and Don Cheadle as War Machine. Word went out that Black Panther would soon have his own movie.

By the time of Coogler's film, audience anticipation had built up as fans eagerly awaited the

Chadwick Boseman as T'Challa in *Black Panther*.

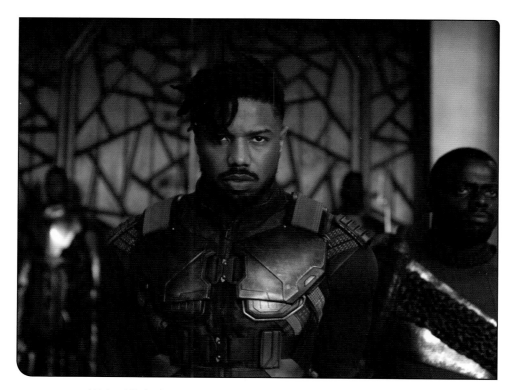

Michael B. Jordan as the glorious villain Killmonger in *Black Panther*.

superhero's appearance. In 2017—before the film's release—*Black Panther* was the most tweeted about movie on Twitter. Written by Coogler and Joe Robert Cole, the film's hero—Black Panther—was T'Challa, who after the death of his father assumes the throne of the fictional African nation of Wakanda. He must preserve the peace and the idealized isolation of his nation, whose power is built on vibranium, a wondrous element that was left on earth from a meteor and which is found nowhere else. Vibranium must be protected from the reach of a greedy arms dealer (Andy Serkis) and colonizers who have already plundered other African nations. But there is also T'Challa's rival—his cousin Erik Killmonger (Michael B. Jordan), who has grown up in Oakland and has a different world view. He wants to use vibranium for oppressed people around the globe. Theirs is a fascinating battle not only of physical might but of political ideas.

T'Challa is a composed, forceful man of action, bonded to his country and his people. When he is dressed in his black body suit (made of vibranium), he is the sleekest, most elegant of movieland superheroes and a sterling statement on black masculinity.

Significantly, T'Challa is guarded by an all-female corps, the Dora Milaje, led by the general Okoye (Danai Gurira). Also assisting him is his lover Nakia (Lupita Nyong'o), his younger sister Princess Shuri (Letitia Wright), and his majestic mother Queen Ramonda (Angela Bassett). With its heroines, the movie veered into radical territory. Strong, resourceful, and in command, they are also browner and darker, bringing into focus the kind of black female empowerment and, yes, beauty that Hollywood often ignored or denied.

Part of the appeal for moviegoers was the film's skillful use of the best of traditional Hollywood entertainment values and storyline. T'Challa's kid sister, Princess Shuri, commands an arsenal of gadgets and weaponry that brings to mind Q from the James Bond series. The same might be said of T'Challa's lover, Nakia, a glamorous spy. A rousing sequence in South Korea that features the heroines as they rescue kidnapped Nigerian women also seems influenced by Bond. But it's all now re-contextualized. The rescue has political implications. At one point when the warrior Okoye wears a flowing wig to disguise herself, there is the insider joke for the black community of the way straight-haired women flip their hair. When Okoye has had enough of the Western disguise, she pulls the wig from her head and throws it away—with relief. It is a cultural joke that audiences love. And when during a car chase, she stands and throws a spear to assault her victim, it is a glorious moment.

Throughout the language and the accents in Wakanda, the song, the movements, the set design, and the costumes created by Ruth Carter with their beads and their vibrant colors, were all cultural statements unto themselves, bringing to the big screen the aesthetic wonder of Africa. The film was also steeped in Afrofuturism in his view of Wakanda—a concept that in the future blacks will not only be an extraordinary part of the new world but will also triumph through technology. And so while *Black Panther* had elements of old-school Hollywood entertainment (at its best), it was also revolutionary cinema.

Something else was present in *Black Panther* through its innovative inclusion and the casting of Angela Bassett as Queen Ramonda. When Ramonda/Bassett is first seen, Coogler's camera presents us with a regal and stately "elder" goddess, wearing head gear that calls to mind a Zulu headdress. For Coogler, Angela Bassett is both the queen of Wakanda and one of the venerated queens of black movie history. As audiences watch her—after he has delayed her entrance so we might better marvel over her arrival—Bassett seems to embody black film history itself. Seeing Angela Bassett, moviegoers are taken both within the movie and outside it to ponder over more. Here is an actress, much like the great Cicely Tyson, who was deserving of more than Hollywood was willing to grant her. Viewers may assume that Coogler is giving her a gracious curtain call and that she will soon exit from the screen. But Coogler turns everything around when we see that she's an integral part of the adventure. Later in the film, her headdress has been replaced by a crown of magnificent graying dreadlocks. She is a sight to behold as she joins a younger generation to save her son, and their country.

Black Panther proved to be an extraordinary success that called a lie to Hollywood's long-held misconception that there was not a large audience, especially abroad, for mostly black-cast films. There were only two significant white characters in *Black Panther*. Within a short period of time, the film became the highest grossing of 2018. Worldwide it grossed $1.3 billion. This was only the beginning for a film destined to keep going.

Angela Bassett as Queen Ramonda in *Black Panther*.

HISTORY, PAST AND PRESENT, CONTINUES

The new millennium pointed to a dazzling new direction for African American actors, actresses, writers, directors, producers, and behind-the-scenes artists. Black movie history indeed seemed to be rewriting itself. One hoped that this period would not be a mere interlude, that indeed it would lead to more mighty cinematic achievements. Yet one can never predict history.

From the past, we see that the history of blacks in the movies had its own statements—from the silent period when Noble Johnson and Oscar Micheaux fought to make movies with a different vision, on through the arrival of sound, when African American performers used their voices and their presence to make names for themselves while often struggling against demeaning roles.

Certain artists formed an evolutionary link that led from one unexpected breakthrough to another, whether it be the arrival of distinctive stars such as Eddie "Rochester" Anderson, Lena Horne, Juano Hernandez, Dorothy Dandridge, and Sidney Poitier; to the assertive heroes Sweetback and Super Fly; to Cicely Tyson and Paul Winfield in *Sounder*; to Pryor and Murphy; to the emergence of Spike Lee, Julie Dash, Charles Burnett, and a new independent film movement; to Jordan Peele and Ryan Coogler—and the supreme achievements of Denzel Washington. It was a long, epic journey that moviegoers followed, always eagerly waiting to see the next turn in the road, the new path, where it would all lead and what it would tell us. And so the journey continues.

NOTES TO THE TEXT

"an elaborate new motion": Review of *The Birth of a Nation*, *The New York Times*, March 4, 1915.

"It is like writing": Rachel Janik, "Writing History With Lightning: *The Birth of a Nation* at 100," History. Movies, *Time*, February 8, 2015.

"the race's daredevil movie": Bill Cappello, *Classic Images*, no. 199, January, 1992.

"America's premier Afro-American": "The Trooper of Company K," *California Eagle*, March 14, 1916.

"There were practically no": Lillian Gish and Ann Pinchot, *The Movies, Mr. Griffith, and Me* (Englewood Cliffs, N.J.: Prentice Hall, 1969).

"just signed a 5": "Sunshine Sammy to Receive $10,000 a Year," *California Eagle*, February 25, 1922.

"the future of the": Robert Benchley, *Opportunity*, April, 1929. "Wall St. Lays an": *Variety*, October 30, 1929.

"truly one of the": *California Eagle*, December 21, 1928.

"the best actor I": Harry and Michael Medved, *Son of Golden Turkey Awards* (Angus and Robertson Publishers, Australia, 1986). "Eddie Anderson (Rochester), as": Review of *Man About Town*, *Variety*, June 14, 1939.

"I never felt the": Fay M. Jackson, "Actress Compares Race Company to Hollywood films," *California Eagle*, August 26, 1937.

"a simple, enchanting, audience": Review of *Green Pastures*, *Variety*, July 22, 1936.

"My career as an": "Rex Ingram, the Actor, Dies in Hollywood at 73," *New York Times*, September 20, 1969.

"Dark Manhattan was the": Ralph Cooper with Steve Dougherty, *Amateur Night at the Apollo: Ralph Cooper Presents Five Decades of Great Entertainment* (New York: HarperCollins Publishers, 1990).

"Bring that nigger over": Eugene Jackson with Gwendolyn Sides St. Julian, *Eugene "Pineapple" Jackson: His Own Story* (Jefferson, N.C.: McFarland & Company, 1999).

"coming from a real": Ruby Dee in conversation with Donald Bogle.

"the Negro as a": Jill Watts, *Hattie McDaniel: Black Ambition, White Hollywood* (New York: Amistad, 2005).

"I sang seperately, by": R. Couri Hay, "LENA!," *Interview*, January, 1973.

"The image I chose": Joan Barthel, "Lena Horne: 'Now I Feel Good About Being Me,'" *The New York Times*, July 25, 1968.

"Mr. Wilson's performance as": Bosley Crowther review of *Casablanca*, *New York Times*, November 27, 1942.

"This last, as a": Bosley Crowther review of *In This Our Life*, *The New York Times*, May 9, 1942.

"Who is going to": Mark Harris, *Five Came Back: A Story of Hollywood and the Second World War* (New York: The Penguin Press, 2014).

"to show that not": Marsha Hunt, "Letters to the Editor," *Los Angeles Times*, February 18, 1990.

"One passage where one": Review of *The Foxes of Harrow*, *Variety*, September 24, 1947.

"Ford's Negroes were Aunt": Mel Gussow, *Darryl F. Zanuck: Don't Say Yes Until I Finish Talking* (New York: Doubleday, 1971).

"they were all worth," Ralph Ellison, *Shadow and Act* (New York: Vintage, Reissue Edition, 1995).

"it was the first": Kenneth L. Geist, *People Will Talk: The Life and Films of Joseph L. Mankiewicz* (New York: Da Capo, 1978).

"charged scenes showing blacks": Ibid.

"has only a few": Review of *Tarzan's Peril*, *Variety*, March 21, 1951.

"Hollywood's Newest Glamour Queen": *Ebony*, April, 1951.

"Commercial possibilities are obvious": Review of *The Harlem Globe-Trotters*, *Variety*, October 17, 1951.

"courageous, thought-provoking and": Review of *Edge of the City*, *Variety*, January 2, 1957.

"Poitier, always a capable actor": Review of *The Defiant Ones*, *Variety*, August 6, 1958.

"What is surprising is": Bosley Crowther review of *The Jackie Robinson Story*, *The New York Times*, May 17, 1950.

"gets a very capable": Review of *The Jackie Robinson Story*, *Variety*, May 17, 1950.

"Marshall, who could be": Review of *Lydia Bailey*, *The New York Times*, May 31, 1952.

"an outstanding Stanley Kramer": Review of *Guess Who's Coming to Dinner*, *Variety*, December 6, 1967.

"a most delightfully acted": Bosley Crowther review of *Guess Who's Coming toDinner*, *The New York Times*, December 12 1967.

"the first truly revolutionary": Huey P. Newton, "He Won't Bleed Me: A Revolutionary Analysis of *Sweet Sweetback's Baadasssss Song*," *The Black Panther #6*, June 19, 1971.

"the first great black": Pauline Kael review of *Sounder*, *The New Yorker*, September 30, 1972.

"Is Morgan Freeman the": Pauline Kael review of *Street Smart*, *The New Yorker*, April 20, 1987.

"That's the room you": John Singleton TCM interview with Donald Bogle, April 29, 2016.

"the most powerful actor": Sean Smith, "The $4 Billion Man," *Newsweek*, April 9, 2007.

"It's about *character*, darling": Allison Samuels, "Angela's Fire," *Newsweek*, July 1, 2002,

"I always got the": Amy Wallace, "Viola Davis Says Hollywood Gives Her 'Mammy-ish' & Small Roles That Pay Little," *New York Times Magazine*, September 14, 2014.

BIBLIOGRAPHY

Blair, Betsy. *The Memory of All That*. New York: Knopf, 2003.

Bogle, Donald. *Bright Boulevards, Bold Dreams: The Story of Black Hollywood*. NewYork: One World/Ballantine Books, 2006.

Bogle, Donald. *Brown Sugar: Over One Hundred Years of America's Black FemaleSuperstars*. New York: Continuum/ Bloomsbury, 2008.

Bogle, Donald. *Dorothy Dandridge: A Biography*. New York: Berkley, 1999.

Bogle, Donald. *Heat Wave: The Life and Career of Ethel Waters*. New York: HarperCollins, 2012.

Bogle, Donald. *Toms, Coons, Mulattoes, Mammies, and Bucks: An Interpretive Historyof Blacks in American Films*, 5th Edition. New York: Bloomsbury Publishing, 2016.

Bowser, Pearl, and Louise Spence. *Writing Himself into History: Oscar Micheaux, His Silent Films, and His Audiences*. New Brunswick, NJ: Rutgers University Press, 2000.

Capra, Frank. *The Name Above the Title*. Cambridge, MA: Da Capo, 1997.

Copper, Ralph with Steve Dougherty. *Amateur Night at the Apollo: Ralph Cooper Presents Five Decades of Great Entertainment*. New York: HarperCollins Publishers, 1990.

Ellison, Ralph. *Shadow and Act*. New York: Vintage, Reissue Edition, 1995.

Geist, Kenneth L. *People Will Talk: The Life and Films of Joseph L. Mankiewicz*. New York: Da Capo, 1978.

Gish, Lillian, and Ann Pinchot. *The Movies, Mr. Griffith, and Me*. Englewood Cliffs, N.J.: Prentice Hall, 1969.

Green, J. Ronald. *Straight Lick: The Cinema of Oscar Micheaux*. Bloomington: Indiana University Press, 2000.

Harris, Mark. *Five Came Back: A Story of Hollywood and the Second World War*. New York: The Penguin Press, 2014.

Horne, Lena, and Richard Schickel. *Lena*. Garden City: Doubleday & Company, Inc., 1965.

Jackson, Eugene, with Gwendolyn Sides St. Julian. *Eugene "Pineapple" Jackson: His Own Story*. Jefferson, N.C.: McFarland & Company, 1999.

Koppes, Clayton R. and Gregory D. Black. *Hollywood Goes to War: How Politics, Profits and Propaganda Shaped World War II Movies*. Berkeley/Los Angeles: University of California Press, 1987.

Harry and Michael Medved: *Son of Golden Turkey Awards*. Australia: Angus and Robertson, 1986.

Gussow, Mel. *Darryl F. Zanuck: Don't Say Yes Until I Finish Talking*. New York: Doubleday, 1971.

McGilligan, Patrick. *The Great and Only Oscar Micheaux: The Life of America's First Black Filmmaker*. New York: HarperCollins, 2007

Osborne, Robert. *85 Years of Oscar: The Official History of the Academy Awards*. New York: Abbeville Press, 2013.

Lawrence, A. H. *Duke Ellington and His World*. New York: Routledge, 2001.

Poitier, Sidney. *This Life*. New York: Knopf, 1980.

Pryor, Richard. *Pryor Convictions and Other Life Sentences*. Los Angeles: Rare Bird Books, A Barnacle Book, 2018.

Sampson, Henry T. *Blacks in Black and White: A Source Book on Black Films*. Metuchen, N.J.: The Scarecrow Press, Inc, 1977.

Stearns, Marshall. *Jazz Dance: The Story of American Vernacular Dance*. New York: Schirmer Books, 1979.

Waters, Ethel, with Charles Samuels. *His Eye Is on the Sparrow*. Garden City, NY: Doubleday & Company, Inc, 1950.

Watts, Jill. *Hattie McDaniel: Black Ambition, White Hollywood*. New York: Amistad, 2005.

White, Walter. *How Far the Promised Land*. New York: Viking Press, 1955.

Wiley, Mason, and Damien Bona. *Inside Oscar: the Unofficial History of the Academy Award*. New York: Ballantine, 1986.

INDEX

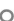

Robinson, Mack, 110–111

Robinson, Matt, 143

Robson, Mark, 86

Rochon, Lela, 190, 204, 206–207

Rock, Chris, 190, 192, 223

Rocky series, 177–178, 243–244

Roemer, Michael, 131

Rogers, Alva, 184, 193–194

Rogers, Ginger, 36, 67

Rogers, Howard Emmett, 38

Rogers, Roy, 53

Rogers, Will, 26, 32

Rollins, Howard, Jr., 171–172

Roman J. Israel, Esq., 218

Romero, George, 132

Rooney, Mickey, 48–49

Roosevelt, Franklin Delano, 64

Roots, 165, 240

Rosa Parks Story, The, 194

Rose, Anika Noni, 222, 229–230

Rosemond, Clinton, 49, 60

Rosewood, 197, 223

Ross, Diana, 146–147, 160, 206, 229

Rossen, Robert, 84, 94, 104, 148

Roth, Philip, 224

Roth, Tim, 202

'Round Midnight, 180

Roundtree, Richard, xvi, 139, 141

Rufus Jones for President, 128

Russell, Alice B., 50

Russell, Rosalind, 28

Ryan, Robert, 113

Ryan's Hope, 204

Rydell, Mark, 135

S

Sackler, Howard, 138

Safe in Hell, 19, 55

Sahara, 49

Salt and Pepper, 130

Salute, 25

Sams, Jeffrey, 206

Samuels, Allison, 216

Sanchez, Elvera, 128

Sanders, Ashton, 241

Sanders, Henry Gale, 192–193

Sanders, Nat, 241

Sanders of the River, 21, 44

Sands, Diana, 120, 145, 150–151

Sanford, Isabel, 93

Sanford and Son, 143, 160

Sankofa, 194

Sarafina, 189

Sarandon, Susan, 183

Saratoga, 57

Saturday Night Live, 167

Savage, Archie, 102

Save the Children, 143

Schatzberg, Jerry, 180

Schepisi, Fred, 208

School Daze, 184, 202

Schrader, Paul, 161

Schultz, Michael, 143, 161

Schumacher, Joel, 234

Sciorra, Annabella, 198

Scorsese, Martin, 199, 202

Scott, Hazel, 74, 76, 95

Scott, Henry, 114

Scott, Jill, 222

Scott, Oz, 161

Scott, Ridley, 112, 218, 224

Scott, Seret, 166

Scott, Tony, 209

Scream, Blacula, Scream, 142

Screen Actors Guild, 55, 82, 112, 231

Search for Tomorrow, 204

Secret Life of Bees, The, 232

Secrets and Lies, 204

See No Evil, Hear No Evil, 161

Selma, 176, 197, 236–237, 240

Selznick, David O., 58, 97

Separate But Equal, 157

Sepia Cinderella, 84

Sergeant Rutledge, 126–127

Sergeants 3, 130

Serkis, Andy, 246

Sesame Street, 143

Set It Off, 203–204

Seven Pounds, 210, 234

Sgt. Pepper's Lonely Hearts Club Band, 161

Shadow of the Thin Man, 43

Shaft, xiii, xvi, 135, 139, 141–142, 197

Shaft in Africa, 142

Shaft's Big Score, 135, 142

Shakur, Tupac, 197, 200

Shange, Ntozake, 222

Shanghai Cobra, The, 78

Shape of Water, The, 235

Shaw, Stan, 170

Shawshank Redemption, The, 179, 181

She Wouldn't Say Yes, 28

Sheba, Baby, 145

Sheriff, The, 12

Sherwood, Robert, 49

She's Gotta Have It, 85, 102, 183–184

Shoemaker, Ann, 56

Shoot to Kill, 157

Show Boat, 43–44, 71

Show People, 16

Shrek, 191

Shuffle Along, 15

Sidewalk Stories, 183

Sidibe, Gabourey, 232

Sidney, Sylvia, 38

Siege, The, 201

Silence of the Lambs, The, 203

Silver Streak, 160

Silvera, Frank, 133

Simien, Justin, 214

Simms, Hilda, 93

Sinatra, Frank, 100, 128, 130

Since You Went Away, 61, 97

Sinclair, Madge, 170

Singleton, John, 195–197, 219

Sirk, Douglas, 112, 117

Sissle, Noble, 15

Sister Act, 189

Sister Act 2: Back in the Habit, 189

Six Degrees of Separation, 208–209

Skala, Lilia, 121–122

Skelton, Red, 33

Slaughter, 142

Slaughter's Big Rip-Off, 142

Sloane, Paul, 16, 55

Smalls, Biggie, 204

Smart Alecks, 13

Smith, Anna Deavere, 224

Smith, Bessie, 15, 243

Smith, Clara, 15

Smith, Dwan, 154

Smith, Jada Pinkett, 191, 203, 217, 242

Smith, Jaden, 210

Smith, Kent, 39

Smith, Maggie, 189

Smith, Mildred Joanne, 93

Smith, Roger Guenveur, 185

Smith, Tasha, 222

Smith, Will, xiv, 208–211, 215, 234, 244

Smollett-Bell, Jurnee, 203

Sneakers, 157

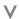

ACKNOWLEDGMENTS

No book is ever completed without the assistance, encouragement, and generosity of others. It is a pleasure to acknowledge the many individuals as well as the research institutions and archives which proved important during the period it took to complete *Hollywood Black: The Stars, the Films, the Filmmakers.*

Foremost I want to thank my astute, knowledgeable, and indefatigable editor, Cindy De La Hoz, who consistently provided suggestions and insights that proved important. Also appreciated are her energy, humor, *and* patience—for the delivery of the manuscript. From Running Press, I also want to thank designer Joshua McDonnell and publisher Kristin Kiser. My deep gratitude is also extended to my agent, the enterprising Jennifer Lyons, who shrewdly negotiated my contract and as always, is encouraging, on top of so many things, and ever-ready with fine suggestions and unflagging support.

I also want to extend my appreciation to the staff at Turner Classic Movies. It is a phenomenal group of people that has always been helpful and congenial—both during my presentations at TCM's annual film festival as well as during my on-air appearances. During the writing of this book, they were often on my mind. Warm regards and gratitude are extended to: the resourceful Dori Stegman; Susan Biesack; the terrific Genevieve McGillicuddy; Lauren Kehrli and Mark Wynns, who have been immensely helpful during my Club TCM presentations; Leslie Wong; Courtney O'Brien; Quatoyiah Murry; Sean Cameron; Liz Winter Alvarado; and Susana Zepeda Cagan. I am also appreciative of the support of TCM's General Manager Jennifer Dorian and the primetime host Ben Mankiewicz, with whom it has been a pleasure to work. And, of course, I am delighted to thank the enterprising and optimistic Darcy Hettrich and in memory, the late Robert Osborne. I'd also like to express my gratitude to TCM's John Malahy and Heather Margolis and Aaron Spiegeland of Parham Santana, all of whom were instrumental in having me write the book.

My great gratitude is also reserved for the very talented Charlie Tabesh, TCM's Senior Vice President of Programming and Production. I'm always impressed with his knowledge, his focus, his fundamental kindness to people, and his uncanny ability to keep his cool when others might be in a panic. I've truly enjoyed and valued all my conversations with him, not only about films but politics, current events, sports, and the daily ins and outs, and ups and downs of life itself. He is not only the most welcomed of professional colleagues but a terrific friend.

In researching the book, I dug into my personal archives of interviews which stretched back over a number of years and were important in previous books and again useful in this one: my very youthful interview with the great Hollywood director King Vidor, who provided stunning insights into very early Hollywood and the making of his black-cast 1929 film *Hallelujah* and other classics; the truly amazing, admirable, and highly intelligent Fredi Washington, star of the 1934 *Imitation of Life*; the larger-than-life Otto Preminger, director of *Carmen Jones* and *Porgy and Bess*, who shared his professional memories with me; Geraldine (Geri) Branton, the best friend and confidante of Dorothy Dandridge; Vivian Dandridge; actor, singer,

and cowboy star, Herb Jeffries; actress Ruby Dee and actor/writer Ossie Davis, who were gracious hosts and insightful interviewees at their home in New Rochelle, New York; Fayard Nicholas of the Nicholas Brothers, who had a remarkable memory of the old Hollywood; Harold Nicholas of the Nicholas Brothers, who shared stories not only of his movie experiences but his ill-fated marriage to Dorothy Dandridge; Isabel Washington Powell: Dorothy Nicholas Morrow and her husband Byron Morrow; Bobby Short; Mantan Moreland; Rigmor Newman Nicholas, widow of Harold Nicholas; Dorothy McConnell; Phil Moore; Tony Nicholas and his wife Vanita Nicholas; and so many more.

Also useful were the public interviews I conducted at TCM's annual film festival. It was enlightening to hear firsthand accounts of movie-making from Spike Lee; John Singleton; Katharine Houghton (from *Guess Who's Coming to Dinner*); singer Lulu (from *To Sir, with Love*); Claude Jarman Jr. (from *Intruder in the Dust*); and the cool, hip, and sharply intelligent Richard Roundtree (*Shaft*).

Of course, no book of this scope could be written without the resources of research institutions and archives. Research always moves more smoothly when you are fortunate enough to have librarians and staff members who open more doors for you. Again relying on great research I had gathered in the past and is now a part of my personal archives, I'd like to express my gratitude to the staffs of: the New York Public Library for Performing Arts at Lincoln Center; The Schomburg Center for Research in Black Culture, especially my friend Sharon Howard; and the Margaret Herrick Library of the Academy of Motion Picture Arts and Sciences. As has so often been the case, I have to thank Howard Mandelbaum of Photofest, who helped me track down otherwise long-lost photos.

His knowledge is astounding. I also want to express my gratitude to TCM for making its vast photo archives available to me.

Friends and colleagues who proved especially important during the writing and research of this book include: my very dear friend Carol Leonard; my very good friend Sarah Orrick; Catherine Nelson, a friend like no other; Ronald Mason; Kim Mason; Edyth Mason; Edythe Brooks; Alice Mason; my long-standing friends from a special summer at Harvard—Susan Peterson and Nigel Forrest; Tink Alexander; Julia Forrest; my good friends from my days at *Ebony*—Steven Morris, Barbara Reynolds, and Herma Ross Shorty; Robert Katz; Martin Radburd (who always comes to the rescue when I have computer problems); Alan Sukoenig and Hiroko Hatanaka; my friends at the Newark Museum's Black Film Festival board—Gloria Hopkins Buck, Mary Sue Sweeney Price, Jane Rappaport, and of course, Pat Faison; writer Allison Samuels; Judith Osborne; Mary Lou Norvalh; Joyce Setten and her husband Philip Setten; Nels Johnson; Cathie Nelson; Billie Johnson; Elliot Orrick, Jim Malcolm, Jeff Christiansen, and Emery Wimbish.

Other associates, friends, and family members, who I cannot thank enough for their patience and enthusiasm, include: Jacqueline Bogle Mosley; Robert Bogle, publisher of *The Philadelphia Tribune*; Roslynne Bogle; Jeanne Bogle Charleston and her husband Fred Charleston; Janet Bogle Schenck and her husband Jerry Schenck, both of whom are great movie enthusiasts and always encouraging; Roger Bogle; Gerald Grant Bogle; Jay Kevin Bogle; Fred "Pele "Charleston; Ayana Charleston; Hassan and Denise Charleston; Bettina Glasgow Batchleor; Sean Batchleor; Robert Bogle Jr.; Mariska Bogle; Luellen Fletcher; Michelle Mosley Palmer and Hermond Palmer; Sherea Mosley; Janelle Mosley; Shaaron Bogle; Mark Mosley; Sylvia Gholston

Mosley; Carol White; Carolyn and Chris Jackson; Ann Marie Cunningham; Patricia Ferguson; Margaret Crosthwaite; David Crosthwaite; Michael Pascuzzi; Denise Pascuzzi; Deesha Hill; Josslyn Luckett; Daniel Beer; Logan Johnson; Kathe Sandler; Jennifer Calderone; Heidi Stack; Doug and Liza Rossini; dear Rae Taylor Rossini; the Lagow family—Barbara, Ellen, James, Molly and Steven; Arthur and Joanie Rossi; Linda "Doll" Tarrant Reid and Stuart Reid; Annette Johns; Betsy Curtis; Franklin Lara; Jeanne Franz; Clerio Demoraes; Jamie Vega; film historian Ed Mapp; Margaret McDowell; Joerg Klebe of German Educational Television; Keiko Kimura; Mimi Goldstein; Merleann Taylor, Simon Aminzade, Karin Leake, Alex Bogle, and to the dearest of the dear, Yemaya Bogle.

Also providing assistance was my former researcher, now a director, and great friend, Phil Bertelsen. In Los Angeles, Jerald Silverhardt was always good to bounce ideas off. He knows contemporary Hollywood as few others do. The same can be said of the phenomenal drama coach and acting teacher Janet Alhanti. David Aglow proved to be a solid researcher. My friend Bruce Goldstein of Film Forum has always been a great person to discuss films with. He has a remarkable knowledge of film history. I'd also like to thank Eric Di Bernardo and Adrienne Halpern. It has also always been invigorating and exciting to discuss films and film history with my very dear friend and terrific film producer Debra Martin Chase. There is no one I'd rather talk about the old and the current Hollywood with than the very imaginative Debra. Also of great encouragement were my good friend, the novelist and attorney Enrico Pellegrini and his wife Katrina Pavlos. Heartfelt gratitude also goes to my former editor Evander Lomke, his wife Fotini Lomke, and their dear, late daughter Elizabeth Lomke.

I will forever be in the debt of literary agent Marie Brown, my editor on previous books, Elisabeth Dyssegaard, and of course, the fabulous Marian Etoile Watson.

Special thanks are extended to Maggie Huang, Dr. Tina Wong, and especially Dr. Steven Hobson. To my colleagues at the University of Pennsylvania, Gale Garrison and Carol Davis. To my colleagues at New York University's Tisch School of the Arts, Janet Neipris, Richard Wesley, and Terry Curtis Fox. I also want to express my gratitude to a number of my former students: my round table of former Penn students with whom I frequently have lunch to catch up on films and television: Gigi Kwon, Raj Gopal, Jake Stock, and Nadine Zylberberg. Special thanks also go to my former students, Marcel Salas, Kyle Webster, Wesley Barrow, Kenja-Rae Farquharson, and especially Robin Williams and the very best of my teaching assistants, Mia Kai Moody. They were all great students from whom I have learned much.

Lastly, to John Singleton, for his foreword.